BASURA

Under the Sign of Nature: Explorations in Ecocriticism

Serenella Iovino, Kate Rigby, and John Tallmadge, Editors

Michael P. Branch and SueEllen Campbell, Senior Advisory Editors

BASURA

CULTURES OF WASTE IN CONTEMPORARY SPAIN

SAMUEL AMAGO

UNIVERSITY OF VIRGINIA PRESS
CHARLOTTESVILLE AND LONDON

University of Virginia Press
© 2021 by the Rector and Visitors of the University of Virginia
All rights reserved
Printed in the United States of America on acid-free paper

First published 2021

9 8 7 6 5 4 3 2 1

Library of Congress Cataloging-in-Publication Data
Names: Amago, Samuel, author.
Title: Basura : cultures of waste in contemporary Spain / Samuel Amago.
Description: Charlottesville : University of Virginia Press, 2021. | Series: Under the sign of
 nature : explorations in ecocriticism | Includes bibliographical references and index.
Identifiers: LCCN 2021001499 (print) | LCCN 2021001500 (ebook) | ISBN 9780813945910
 (hardcover) | ISBN 9780813945927 (paperback) | ISBN 9780813945934 (epub)
Subjects: LCSH: Refuse and refuse disposal—Social aspects—Spain. | Refuse and refuse
 disposal in art. | Refuse and refuse disposal in literature. | Refuse and refuse disposal in
 motion pictures. | Spain—Environmental conditions. | Spain—Civilization.
Classification: LCC HD4485.S7 A43 2021 (print) | LCC HD4485.S7 (ebook) |
 DDC 363.72/80946—dc23
LC record available at https://lccn.loc.gov/2021001499
LC ebook record available at https://lccn.loc.gov/2021001500

Cover art: peeterv/iStock

Contents

Preface

This book begins with an easy chair and ends with a baby rattle. It is a book about the material affordances of trash that explores how contemporary Spanish culture has engaged variously with the debris it has created and cast aside. Readers will find that the methods and theories it employs are eclectic, perhaps unsatisfyingly so; there are chapters on cinema, digital and chemical photography, archaeology, drawing, comics, literature, and ecology, each one deploying theoretical and critical approaches dictated mainly by those media but also by the stuff that inspired this book: *basura*.

This book puts forward an experimental counternarrative of contemporary Spanish culture from the perspective of wasted things. It asks questions like, What makes trash trash? How do we decide what to throw away? What transpires once our discards have been cast aside? What happens when sanitation workers stop taking away our rubbish? Who benefits from keeping things "clean"? Why do some parts of Spain look so sterile today, and what happened to the rubbish that used to be more visible? Why is Pedro Almodóvar obsessed with plastic and actual physical trash? What does Spanish waste-space look like, and where is it located? Who gets to live in the city, and who is ejected from the body politic? How does waste shape our experience of time? What happened to the Spanish past? Are we junk?

More than putting forward a broad new theory of contemporary Spain, this book is comprised of a series of case studies that rehearse different ways of answering those questions. Inspired in part by the purposefully promiscuous modes of noticing that recent ecocritical and new materialist theory and philosophy have put forward, I set out like a *trapero* (ragpicker) to assemble a series of objects that might convey some of the redolence and affective power of contemporary Spanish ejectimenta. I am not the first to take this approach. My colleague Maite Zubiaurre and her alter ego Filomena Cruz got here first, the former with her computer and the latter

with her camera and art materials. Their book, *Talking Trash: Cultural Uses of Waste,* is an enchanting gambol through the wastepaper basket of Western culture, from Berlin to Barcelona, and from Los Angeles and New York to the North American Borderlands.

The scope of my book, which focuses on contemporary Spain, is more modest, but the project began some time ago. Fragments of chapters 4 and 6 appeared in 2007 and 2011, in the form of two unrelated essays: "Narratives, Bodies and the Self in Rosa Montero's *La hija del caníbal,*" published in the *Bulletin of Spanish Studies* 84, no. 8 (2007): 1029–42, and "On the Archaeological Impulse in Contemporary Spanish Narrative Fiction," also printed in the *Bulletin of Spanish Studies* 88, no. 7–8 (2011): 327–43. Portions of chapter 2 appeared in electronic format, in Spanish, in *Revista de ALCES XXI: Journal of Contemporary Spanish Literature & Film,* with the title "Basura, cultura, democracia en el Madrid del siglo veintiuno," 2 (2014–15): 32–69. Those earlier forays into trash studies are included here in revised form with permission from the publishers. Rather than evidence of self-plagiarism, I would like to propose that the reappearance of those earlier essays is a reflection of the way that all things have a tendency to come back after we think we are done with them. Rummaging through my past work I found reminders that I have always liked digging in the dirt. This book is not just an archaeology of contemporary Spanish culture but also an archaeology of my own intellectual archive.

One of the theses of this book is that encounters with waste can be transformative. On the one hand, they create new ways of seeing and thinking, and, on the other, they create new relations between people and things. My work on waste has been sustained by an array of relations with people, places, and things over the last fifteen years. In addition to my students, I want to acknowledge Sindo Amago, Javier Herrero, Juan Carlos González Espitia, Cristina Carrasco, Matthew Marr, Emil Keme, Teresa Chapa, Celia Mora Amago, Jordi Marí, Oswaldo Estrada, Iñaki Prádanos García, Jessica Folkart, Kathy Everly, Eugenia Afinoguénova, Joanne Britland, Emiliano Guaraldo, Nieves González Fuentes, Charlotte Rogers, Kate Good, Rhi Johnson, Neil Anderson, Miguel Valladares Llata, Megan Saltzman, Susan Larson, Jill Robbins, Federico Luisetti, Serenella Iovino, Palmar Álvarez Blanco, Debra Ochoa, the Department of Spanish, Italian, and Portuguese at the University of Virginia, the Department of Spanish and Portuguese at UT Austin, and the Department of Romance Studies at UNC–Chapel Hill. To the class of Fellows with whom I shared a transformative spring 2017 se-

mester in residence at UNC–Chapel Hill's Institute for Arts and Humanities, I express my fond appreciation, especially to Morgan Pitelka, Dan Sherman, Lien Truong, Dave Pier, Gabe Trop, Meenu Tewari, Bev Taylor, Deborah Gerhardt, Molly Worthen, Philip Hollingsworth, and Michele Berger.

I am particularly grateful to Juan Mora Amago, who posted to Facebook the Bankia image that emerged from the 2013 sanitation workers' strike and that set up my later thinking on waste and space in Madrid, and his father, Juan Ramón Mora Ruiz, who in the 1980s guided me through the vitally filthy Madrilenian bar scene, well before I was of age. My aunt, Dolores Amago Flórez, taught me a lot about the neoliberal logics of waste and recycling in democratic Madrid, especially in and around Majadahonda. JoAnn and Gary Keenan have been lively and supportive interlocutors on the topic of obsolescence, planned or otherwise. Adam Cohn played a crucial role in taming the manuscript, its citations, and its images. Barbara Amago is the best indexer and editor ever. Boyd Zenner, senior acquiring editor extraordinaire, was a joy to work with, as was Susan Murray, my book's eagle-eyed copy editor. I thank Mark Saunders for taking an interest in my project, enlisting me with the University of Virginia Press, and treating me to a sandwich at the Oakhurst Inn. You will be missed.

Benjamín and Joaquín: thanks for sorting the recycling and taking out the trash.

And finally, I thank my partner in material engagement, Amy. There is no matter more vibrant than you.

The writing of this book was completed at a historical moment in which social and material relations are being radically transformed by the cultural and economic consequences of the COVID-19 pandemic. The United States leads the world in infections and deaths, and Spain is among the hardest-hit nations in Europe. Concurrently, in the United States, the killings of Ahmaud Arbery, Breonna Taylor, and George Floyd triggered a long overdue reckoning regarding white supremacist state apparatuses and the institutionalized violence those systems have levied against Black and Indigenous people in order to sustain themselves. In Spain, fascist monuments and reminders continue to be pulled down, and across the United States and the world, statues and memorials celebrating colonialism and white supremacy are being removed from their privileged places.

As I write these words now, in November 2020, there is no way to know

what the world will look like in the aftermath of the novel coronavirus pandemic. Nor can we predict if real antiracist structural change will come to Western liberal democracies like ours, but we can be certain that some of the things once held to be valuable and worthwhile in our societies will be trashed.

BASURA

Introduction

Waste, Theory, Method

¡Dependo de las cosas!
(I depend on things!)
—Jorge Guillén, *Cántico*

Vivió en lucha contra la anarquía de los objetos.
(Her life was a battle against the anarchy of objects)
—Carmen Martín Gaite, *El cuarto de atrás*

In his well-known paean to quotidian plenitude, the Spanish poet Jorge Guillén describes an easy chair as a sublime example of a well-made world:

¡Beato sillón! La casa
corrobora su presencia
con la vaga intermitencia
de su invocación en masa
a la memoria. No pasa
nada. Los ojos no ven,
saben. El mundo está bien
hecho. El instante lo exalta
a marea, de tan alta,
de tan alta, sin vaivén.[1]

(Happy armchair! The house
confirms its presence
with the vague interval
of its total invocation
to memory. Nothing
passes. Eyes don't see,

they perceive. The world is well
.made. The moment lifts it
tideward, so high,
so high, without coming or going.)[2]

The composition is one of several poems authored during Guillén's op-
timistic early phase, before he turned toward more somber social-realist
themes. The *Cántico* (Canticle)—of which the *décimas* form an important
part—has been described as a masterwork of aesthetic idealism springing
from a quintessentially modern vision of the world.[3] The collected works
represent an everyday life bathed in shimmering new light.[4] The armchair
décima, like several others included in the collection, invites the reader to
notice the artistry and balance inherent in the humblest of everyday places,
moments, and things.

It is difficult to imagine rubbish existing anywhere in Guillén's perfectly
assembled world. I begin this book on trash with "Beato sillón" because the
poem renders precisely the clean sense of form, purpose, and value that
modernity and its cultures have always held dearest. The easy chair that pro-
pels the poet into the symbolic realm is itself elevated, through poetry, to a
conceptual domain of plenitude and perfection. The chair-object transcends
more workaday notions of use-value and aspires instead to an aesthetic
sublime. In Guillén's *décima,* the word follows perceived form: nothing
happens; there is no before, no after, no history; the eyes do not see, they
simply know. The poem reflects an epistemology without apparent pro-
cess. Aesthetic form conveys the flash of comprehension emanating from
material presence. With the exception of William Carlos Williams's red
wheelbarrow—upon which so much depends—perhaps no other poem
crystalizes so clearly a poiesis of object-oriented ontology.

In Guillén's poems of plenitude, even the most unassuming things buzz
with animistic power. Biruté Ciplijauskaité describes how every object that
captured the poet's eye had a life of its own, participating actively in "en
el gran milagro de la Creación" (the great miracle of Creation).[5] It is the
vital power of the object that triggers the poet's exalted response. Without
the chair, there would be no evidence of a well-ordered world, no balance
point for the construction of the poet's interpenetrating group of image-
concepts. In Guillén's realm, value is intrinsic to the thing created by and
for humankind.

But what happens when the easy chair outstays its welcome in the poet's
world? Does a sagging, threadbare cushion still substantiate the existence

of a well-made demesne? Does an out-of-style—or out-of-time—piece of furniture still enjoy the same claim to transcendent thought and memory? Bill Brown, in an influential introduction to a special issue of *Critical Inquiry,* posits that the answer is "yes," because "we begin to confront the thingness of objects when they stop working for us: when the drill breaks, when the car stalls, when the windows get filthy, when their flow within the circuits of production and distribution, consumption and exhibition, has been arrested, how-ever momentarily. The story of objects asserting themselves as things, then, is the story of a changed relation to the human subject and thus the story of how the thing really names less an object than a particular subject-object relation."[6]

Guillén prefers to efface his touch on the object world he contemplates. (Other poems, such as "Perfección," maintain a similar gestural distance.) Through his use of an objective language of observation, the poet seeks to record or reflect, through language, an already-existing material perfection and symmetry. Christopher Soufas proposes that "it is not the specific object that is valued, but rather the 'better' image that emerges from the activity of contemplation."[7] In other words, the armchair is most useful as a referent for being.[8] "Instants," "worlds," and "eyes" register things, but the poet remains mostly invisible behind third-person-present indicatives and neutral nouns. The objects that these poems describe—the easy chair, the rose, Williams's red wheelbarrow—exist at the epicenter of things without knowing it or trying. As Guillén pronounces in "Perfección," objects are "central sin querer" (central without trying). The poems are less about the objects themselves than about the special "subject-object relation" to which Bill Brown alludes in his essay on "Thing Theory."

Ciplijauskaité proposes that in his early poems Guillén is enriched by his discovery of the essence of those objects he finds around him.[9] In another poem, Guillén expresses,

Hacia mi compañía
La habitación converge.
¡Qué de objetos! Nombrados,
Se allanan a la mente.[10]

(Toward my company
The room converges.
What objects! Named,
They fill the brain.)[11]

Throughout the *Cántico,* Guillén's poetic consciousness is unencumbered by the past or the future. He is all present tense and plenitude.[12] This is precisely the temporality that modernity's authors have imagined as the shimmering perfection of human industry.

Basura: Cultures of Waste in Contemporary Spain traces the afterlives of things—like Guillén's easy chair—that have been ejected from their favored places, focusing on the time that ensues *after* use. If, as the cultural anthropologist Néstor García Canclini has argued, "consumption is good for thinking,"[13] the chapters that follow propose to understand what kind of thinking we can do with waste. The trashed objects appearing over the next six chapters tell different kinds of stories: about Spain's evolving relationship to time and temporality, about how it engages with its cultural others, about the ways in which Spanish culture mediates meaning and value, and about the places where all these operations occur.

Waste, in Vinay Gidwani's words, is "the specter that haunts the modern notion of 'value.'"[14] Value, on the one hand, signifies the logic of capitalist wealth accumulation, and on the other, it represents a moral template for proper bourgeois conduct. One of the ways that the citizens of Western societies signal their wealth and status is through their capacity to produce and discard commodities in ever-greater quantities. It is only when people stop discarding their trash that they become coded as somehow abnormal, as hoarders or pack rats. Marie Kondo has become a global symbol for precisely those modern values. While Kondo advocates for a heightened respect for those objects that "spark joy," the flip side to her equation requires that unjoyful things be jettisoned. Happiness comes through the moral rejection of unwanted objects.

Perhaps nowhere else has the apparent tension between use and refuse, consumerism, value, and trash evolved more rapidly than in contemporary Spain, where the transition to democracy from the late 1970s through the 1980s (and which preceded the country's rapid transformation into one of Europe's most spectacular economic successes by the mid-1990s) provides a dynamic image of rapid neoliberal capitalist modernization, urbanization, and, of course, the evolving social dynamics of trashmaking and the politics of disposal. The last twenty-five years or so have seen a massive proliferation of waste in Spain, a consequence of the exponential growth of tourism, rampant urbanism, and an increasingly derelict regulation by state and local authorities.[15] This book traces the afterlives of things and asks what Spain's trash tells us about the country's modern condition.

Basura: Cultures of Waste in Contemporary Spain has been conceived as

a cultural archaeology that examines the materiality of abandoned, used, discarded, trashed, junked things in terms of what those things have to say about Spanish modernity. The book is archaeological in the sense that it engages with things and with the sensible world, taking seriously Alfredo González-Ruibal's proposal that art and archaeology be studied together, since both share an aesthetic regime, working visually and materially to stage and make things visible. The archaeological point of view is a material one.[16]

The book is divided into six chapters. The first three are grouped into part 1, titled "Waste Matters," which focuses on how urban and exurban spaces have been shaped by the interrelated processes of design, consumerism, trash production and disposal. The three chapters comprising part 2, "Waste Humanism," center on the ethical and humanitarian questions that arise when we think about waste, space, and value. Chapter 4, for example, puts forward a critique of the antiseptic historical logic of Spain's transition to democracy, which was predicated on the pacted erasure of collective memory; it focuses on the ways that narrative fiction has sought to understand the country's violent past through the exercise of an archaeological narrative mode. Chapter 5 explores how Spanish comics have deployed trash as a way to think about the politics of representation and social belonging in the age of austerity. And chapter 6, which considers the relations between junk and selfhood in Rosa Montero's fiction, analyzes how language and narrative function as ballasts against the garbaging of the body.

WHY TRASH?

Having spent two decades thinking about modern Spanish culture—first as a graduate student at the University of Virginia (where I first encountered the Guillén poem), then as a professor of Spanish studies employed in the North American academy—my interest in Spanish trash was inspired by a Madrid sanitation workers' strike. In November 2013, as I perused the online archive of people's photographs of the event posted to Twitter, Instagram, and digital news outlets, I began to perceive the reverse side of Guillén's fascination with well-ordered lifeworlds, an emergent junkscape where discarded objects—plastic bags, cardboard boxes, mattresses, sofas, and food scraps—took over the city, asserting themselves in plain view. A chair, a chicken bone, a discarded piece of intimate clothing, an obsolete answering machine, a decomposing shoe, an abandoned building: these were all objects that, having exhausted their welcome in the domestic and consumer

spheres, began new lives on the streets of Madrid alongside piles of other more mundane castoffs and garbage-filled plastic bags strewn throughout the city. As days turned into more than a week without regular garbage removal, Madrid itself came to resemble a municipal dump where evidence of its inhabitants' most intimate lives was displayed for everyone to see. Many of the photographs appearing on Twitter were editorial in their aims, expressing indignation and calling on municipal authorities to meet sanitation workers' demands for a fair wage and to clean up the streets again. But as time passed, Madrid's discarded objects spawned new narratives and entered into new relationships. Most entertainingly, one *Guardian* correspondent documented, via Twitter, the evolution of a days-long relationship shared by a ham bone and a discarded brassiere found on the street outside his apartment.[17]

Following the sanitation workers' strike, I began to look for trash in other places: in the mise-en-scène of Almodóvar's campy films of the 1980s; in the galleries and exhibition spaces of Madrid's and Barcelona's robust art scenes; in the abandoned places and rural spaces outside of Spain's urban centers; in the mass graves that, since 2000, have yielded mounds of material evidence of the violence upon which an unfinished Spanish democratic project was built. What became clear to me was that the story of contemporary Spanish culture can be told through the objects that it has discarded, ignored, and forgotten.

The growing consensus among environmental scientists, geologists, archaeologists, sociologists, geographers, urban planners, and engaged citizens is that trash—and especially plastics—will remain as one of the most lasting and visible monuments to human existence on Planet Earth. Waste is visible and invisible, large and small; it is liquid, gas, solid; it is sensed and absorbed locally and globally, individually and collectively.[18] Waste is disruptive. It also creates new networks, makes connections visible, sparks new social relations. Trash, like all things, tends to bring other things together.[19] And the existence and circulation of trash reveals the ways in which industrial modernity functions. Indeed, the global growth of waste has spawned a subgenre of environmental and cultural studies analyzing the global impact of production, trash and disposal. *Garbage Land* (2005), *Junkyard Planet* (2013), *Waste* (2019), and *Secondhand: Travels in the New Global Garage Sale* (2019) are four recent works that have taken this angle, but the bibliography on ecology, ecocriticism, environmental humanities, and the Anthropocene is growing every day.[20]

But trash is not always catastrophic. Discards themselves are also sym-

pathetic objects of interest and artistic inquiry throughout the world, from El Anatsui's massive metallic quilts constructed from bits of consumer waste to Robert Rauschenberg's found-object assemblages, and from Marcel Duchamp's urinal to Maurizio Cattelan's golden toilet or Tetsuya Ishida's *Toilet Refuge*.[21] Looking at international artists' engagement with litter, Maite Zubiaurre has made the compelling case that narratives of empathy and belonging can be gleaned by attending to small and apparently insignificant pieces of trash. From the dawn of modernity, the cast-off, the depreciated, the underused, and the devalued have wriggled their way into the center of the art world.[22]

Waste has always held a special place in modern aesthetics. Nicolas Bourriaud notes that "figures of exclusion traverse the unconscious, ideology, art and History."[23] At the University of Virginia, Mark Dion's public art installation, *Virginia Curiosity Shop* (2016 & 2017), is a carefully curated cabin-sized cabinet of curiosity that melds art, history, and archaeology. The temporary building gives the initial impression of having existed in the same spot for many years, one of the American South's many tholtans and abandoned structures, yet upon closer examination, the viewer can see that the building contains a surprising array of cultural artifacts. As a kind of Wunderkammer, the Dion installation draws attention to the ways in which art itself functions materially to de- and recontextualize things, places, and people.

Aesthetic engagements with waste also have ecocritical functions. Recent scholarship by Nicole Seymour has explored how art and activism have deployed humor, satire, perversity, parody, and irony to elaborate a "bad environmentalism" that nonetheless functions self-reflexively to comment on the ways in which environmental crisis is shaping global ecologies.[24] The artist Robin Frohardt's *Plastic Time Machine,* for example, focuses attention on the permanence of plastic in the world, while also having a bit of fun with audience expectations and participation. Members of the public are invited to place a piece of plastic into Frohardt's apparatus, shift a lever to a date far in the future, then collect the piece below; of course, the piece of plastic trash looks exactly as it did when it was placed into the machine. And in Caribbean contexts ravaged by hurricanes and postcolonial neoliberal economic policies, the photographers Sarabel Santos Negrón (*Groundscapes,* 2018) and Jo Cosme (*Welcome to Paradise,* 2018) have inverted traditional landscape paradigms to visualize a dystopian present shaped by ruins embedded in ruined nature (fig. 1).[25]

Waste is a crucial matter of contemporary life that has manifold func-

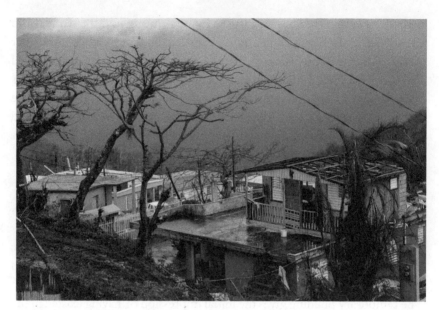

Figure 1. *Personal Look at Hurricane María,* Jo Cosme,
in *Welcome to Paradise* series, 2017.

tions: it is an index of the past, a marker of cultural value, a trigger for
feelings and memories about the past, and a conduit for perceiving the way
that late-capitalist modernity continues to transform planetary natures and
ecologies. One of the hypotheses that I will test over the coming chapters
is that by looking at waste we can see how things really work. In order to
study systems of production, it is extremely useful to consider the systems
of waste that support them.[26] In other words, trash is good for thinking.

In Spain, as elsewhere, the waste externalized by neoliberal economic
processes is carefully managed in order, on the one hand, to keep lived envi-
ronments clean, and, on the other, to minimize any real reckoning with the
material profligacy of a system designed to create ever-greater quantities of
rubbish. Contemporary wastescapes are material evidence of the economic
fantasy that a finite planet can accommodate infinite growth. In fact, the
veiled operation of disappearance is crucial to the continued function of
capitalist societies. We know that neoliberal capitalism depends on privat-
ization and appropriation in order to extract value from nature and life, and
that, perversely, the same system relies on common spaces for its discards.
Capitalism depends on the externalization of the costs associated with the
wastes, emissions, and pollution that it projects into public air, water, land.[27]

This is one of the many ways in which the commons have been instrumentalized by and for capital.

We rely on regional and municipal authorities to make the material evidence of our economic activities disappear and thus to make invisible the indivisible link between economic growth and pollution.[28] Usually this operation occurs under the cover of night. Television crates and packing material, leftover food, cardboard boxes from online shopping deliveries, e-waste, milk cartons, plastics, newspapers, dongles and cables whose use we have long ago forgotten: all these things go to the curb, where they vanish while we sleep. The logic of disappearance is crucial to the neoliberal logic of economic growth.[29] Even large items—a sofa, a mattress, a table— disappear nocturnally. As I elaborate in chapter 2, it is only when the state-sponsored circuits for waste removal cease functioning that we begin to perceive just how much trash is being produced every day by a society that is addicted to constant economic growth. Following the Madrid sanitation workers' strike in November 2013, citizens armed with cameras and camera phones documented the weeklong process by which the capital city's streets and thoroughfares were transformed into a dumping ground.

The state assumes most of the responsibility for making waste disappear from our lived environments, but trash never vanishes altogether. Our contact with things represents only a fraction of the long lifespan of those things, since after they have been ejected from the realm of human use, discards keep on existing, exerting their vital force in ways that are not always visible: leaking, leaching, rusting, decaying, evaporating, decomposing, remaining. Like the world we inhabit, trash is alive.[30] These are the energetic powers of material formations that Jane Bennett describes in her political ecology of things.[31]

Trash will likely be one of humanity's greatest contributions to the geologic record. The Spanish philosopher José Luis Pardo notes that no other culture—previous or external to ours—has produced waste in a quantity, quality, or velocity that compares to modern Western society.[32] Concluding a photographic survey of the transnational geopolitics of the garbage business, Pierre Bélanger has documented how "the residual topography of landfilling will be one of the lasting monuments of the North American Empire."[33] Measuring nearly ninety meters high when they are finally topped off and closed, the modern sanitary landfills photographed by Bélanger stand ten times larger than the Great Pyramids of Egypt.[34] Mary Douglas noted, in 1966, that "where there is dirt there is system."[35] We can invert the

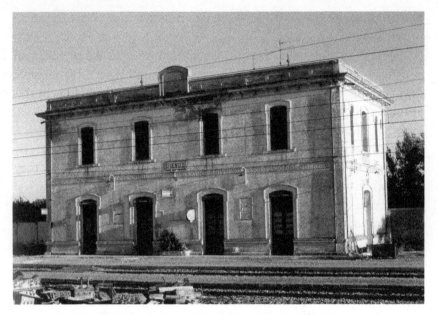

Figure 2. *Hotel de Fuentes de Ebro,* Lara Almarcegui, 1997.

equation to say, quite correctly, that where there is a system, there is dirt. All systems require sinks. As long as our economic system continues to depend on growth, waste will always be a problem. And we cannot always see or perceive it. In 2017, 32.5 gigatons of carbon were released into the atmosphere.[36] And e-waste is not just a postconsumer problem: contamination is produced during all phases of the production of electronic materials. Seventy-eight percent of the total carbon emissions related to the iPhone 7, for example, were produced during the production phase.[37]

If the connections between economic growth and environmental despoilment are the blind spot of neoliberal political ecology,[38] ecocritical art endeavors to make it visible again. The artist Lara Almarcegui's place-based installations and accompanying photographs draw attention to urban and suburban transitional spaces where buildings are in the process of decaying or being demolished. In her work *Hotel de Fuentes de Ebro* (1997), for example, the artist transformed an abandoned train station into a free hotel (fig. 2). Following Almarcegui's weeklong experiment, residents of the town later decided to keep the space open as a meeting place and community center. In Almarcegui's more recent work (*Construction Rubble of Secession's Main Hall,* 2010; *Abandoned River Park,* 2013 14), monumental mounds of construction debris smashed into gravel occupy exhibition spaces, nearly blocking the

public's access to gallery rooms. Aesthetic engagements with waste and wasted spaces have the power to transform trash and space into something else.

Chapter 3 of this book describes how ecological place-based art makes visible the unseen links between operational landscapes and urban spaces that are not always observable from the exurbs.[39] Therein lie the ethics of ecocritical aesthetics, which focus, in Neil Brenner's words, on the "global ecological plunder that is permanently altering the earth's climate while infiltrating the earth's soils, oceans, rivers and atmosphere with unprecedented levels of pollution and toxic waste."[40] It is this rapacious growth and expenditure that leads José Luis Pardo to argue that wealthy societies in fact require new "useless" places in which to dispose of their waste. Otherwise we would drown in our own castoffs.[41] This is part of the logic of the "cheapening" of nature that Patel and Moore have traced from the colonial era to the present.[42] The material cheapening of nature is made possible by the philosophical and ideological maneuver by which "useless" space is at once constructed as beyond "use," even while it is simultaneously being transformed into a new place propitious for new use as a dumping ground.[43]

ART AND THE ANTHROPOCENE IN SPAIN

Modern and contemporary artists in Spain and beyond have deployed a variety of approaches to thinking about waste, its human relations, and its ecological impacts. The Spanish art collective Luzinterruptus, for example, focuses its work on processes of urban waste production, recycling, and disposal through the construction of ephemeral public art installations that envelope their audiences in plastic and artificial light. One place-based apparatus, titled *Laberinto de residuos* (Residue labyrinth), which occupied a central section of Madrid's Plaza Mayor in July 2017, transformed one of the city's most picturesque central squares into a light-filled maze constructed from translucent plastic bags filled with plastic bottles that had been used and contributed by neighbors and residents.[44]

The visual artist and environmental activist Zireja combines performance, photography, sculpture, and environmentalist pedagogy in her place-based art installations and Instagram stories. Much of her work focuses on the environmental impact of tourism, cultural heritage practices, and commerce in and around the island of Tenerife. Since 2017, her yearly collections of photographs of the aftermath of Carnaval celebrations in Tenerife have combined photography and perfor-

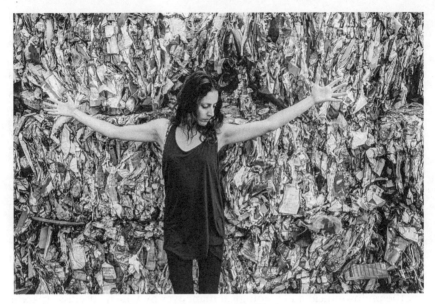

Figure 3. *The Waste Colors,* Zireja, 2013.

mance with environmental activism. Her more recent *Maga vestida* project pictures the artist in traditional garb, standing among monumental mounds of discarded automobile tires stored at Tenerife's waste processing complex in Arico. The photographs create a visual and material linkage between local specificity and space with the global flows of industrial waste.

Zireja's work stands as a reminder that all engagements with art have a bodily aspect (fig. 3).[45] I would posit that in ecocritical art, the embodied nature of the art confrontation is especially vital to the ways that they make meaning. Crucially, ecocritical aesthetics trigger viewers' awareness of their own material connection with their environments. Therein lies the subversive potential of Lara Almarcegui's construction debris installations, or Blake Fall-Conroy's contribution to the Museum of Capitalism, which is a model factory that pollutes its own exhibition space.[46] His work, titled *Factory (Wheelabrator Baltimore) (2016–2017),* is a scale model of a Baltimore factory that emits smoke into the exhibition room. The machine functions as a critique of how "invisibility" is used to mask toxicity, and stands as a critique of the corrupt logic of industrial waste, which is pumped constantly into the finite confines of our shared atmospheres.[47]

The Spanish Luzinterruptus project is reminiscent of other place-based art that has shed light on the increasing ubiquity of plastic in the world.

In spite of appearances, waste matter is never inert, since it is always producing the conditions for the creation of new systems, assemblages, and relations between natures and cultures.[48] Caribbean artists have been especially interested in thinking through the global impact of waste on local landscapes and of visualizing these kinds of relations. Tony Capellán's *Mar Caribe* (1996) and *Mar invadido* (2015), Hervé Beuze's *Machinique* (2007), Jean François Boclé's *Tout doit disparaître! Everything Must Go* (2014) are works that reflect on the ways in which free-floating waste materials interact with Caribbean ecologies and create new groupings. And the Brooklyn-based artist Alejandro Durán's installations, such as *Espuma* (2011), *Algas* (2013), or *Amanecer* (2011)—in which the artist arranges and rearranges plastic bottles on the beach—make visible the links between the natural and the unnatural, the biological and the chemical, the designed and the random.[49] In all of these works, trash suggests connection without cause, and the linking together of far-flung planetary outposts through the global circulation of waste produced by neoliberal capitalism.

The unregulated flows of trash through oceanic space create new networks and circuits animated by global ecological systems, wind, water, biological movement. Scholars have devoted increasing attention to exploring the links between human-centered history and the geologic force of the ocean in the age of anthropogenic climate change, marking what has been called the "oceanic turn" in the humanities.[50] Serpil Oppermann describes the twofold condition of the ocean, on the one hand as a broad physical geographical site, and on the other as "a vast domain of imagination that can never be conclusively charted."[51] It is this double-coded valence that "invites figurative submergence in the sea's entangled physical, social, ideological, scientific, and aesthetic modalities."[52] The Madrid-based art collective Basurama has dedicated scholarly and art projects to exploring the political economy of waste in the Caribbean, with a work titled *Tsunami,* which makes visible the toxic links between nature and culture and the destructive global and local networks of waste in the Dominican Republic.[53]

The aesthetic engagements with trash outlined above demonstrate how waste is never just a symbol and the discard is never just an allegory. In this line, for example, oil and acrylic images authored by Tomás Sánchez imagine the ruination of tropical landscapes where the disastrous diffusion of human waste exceeds and spills out beyond the urban space that lies outside of the frame.[54] His paintings—like the photographs and installations by the other Caribbean artists mentioned above—reveal how the local can

become dislocated through profligate local expenditure, failed recycling regimes and waste-disposal schemes, and global garbage flows.[55] Zireja's photographs of "side b" of Tenerife's Carnaval celebrations create a similar sense of a ruined island world in danger of disappearing under layers of plastic waste and sedimented garbage.[56] This is not a new contemporary *real maravilloso:* waste ecosystems such as the Pacific Ocean Plastic Gyre are real, even though we cannot always see them.[57] It is estimated that Henderson Island, a tiny uninhabited atoll in the South Pacific, contains more than seventeen tons of debris.[58] And while the world's seas are indeed packed with thousands of tons of waste, the vast majority of ocean plastics are less than five millimeters in size.[59] Islands are not the only places where waste accumulates, but their location, open geographical borders, and exposure to flows of wind and sea make them particularly vulnerable to receiving the flowing waste of far-flung geopolitical systems.[60]

Trash is not only a problem, a network, or an ecosystem. It is also a medium for artistic expression. Mierle Laderman Ukeles, for example, has worked since the 1960s as the artist-in-residence in the New York City Department of Sanitation, creating private and public art projects combining environmentalism, feminism, and social justice activism.[61] Annie Lennox's monumental self-portraiture project, titled *Now I Let You Go . . .* , combined artifacts and objects of personal significance embedded in a massive mound of dirt. The piece, which appeared at the Massachusetts MoCA through spring 2020, combined the affect of the burial mound and the archaeological site. The Barcelonan street artist Francisco de Pájaro transforms urban waste into performative works of art that call viewers to reconsider ideas of value and prestige, and the cultural systems that police levels of cultural distinction (fig. 4).[62] In her groundbreaking work on trash, Maite Zubiaurre has described how de Pájaro's work functions critically to address human misery through the use of scatological humor and dark symbolic assemblages of waste.[63] The Madrid-based art collective Basurama has taken a more critical and perhaps humane approach to exploring the aesthetic possibilities of the material afterlives of wasted things. Basurama's diverse interventions on waste and space harness the syncretic powers of waste to create new social spaces and public places where people can thrive and flourish.[64] Basurama has lent its imprimatur to an array of place-based art installations throughout the globe from social activism and curation to exhibition, research, and public space.[65]

Of course, trash art is not new. Early in the twentieth century, Marcel Duchamp had already dragged rubbish into aesthetic contexts,[66] and

Figure 4. *Palma de Mallorca,* Francisco de Pájaro, from *Art Is Trash.*

Maurizio Cattelan and an array of other twentieth- and twentieth-first-century artists picked up where he left off. Michelangelo Pistoletto's *Venus of the Rags* (1967, 1974), for example, is an iconic example of the Italian Arte Povera movement that juxtaposes the classical aesthetics of Venus statuary with a more contemporary, formless mound of cast-off clothing. In Spain, Antoni Tàpies's early experimentation with discarded clothing, rags, newspaper, canvas, wood, and papier-mâché function similarly to question the limits of representation by incorporating mundane materials into experimental art assemblages.[67] Mike Kelley's installation *John Glenn Memorial Detroit River Reclamation Project (Including the Local Culture Pictorial Guide, 1968–1972, Wayne/Westland Eagle)* (2001), which he constructed for the city's tercentennial celebration, is a re-creation of a statue of the astronaut John Glenn that stood in the artist's high school library. The sculpture is constructed from discarded kitchen utensils and shards of glassware dredged from the Detroit River.[68]

In the early twentieth century, the Spanish avant-garde played a lot with rubbish. Maruja Mallo and Rafael Alberti explored the expressive possibilities of castoffs in their graphic and poetic art. In his poem "La primera ascensión de Maruja Mallo al subsuelo," Alberti writes, "Emplearé todo

el resto de mi vida en contemplar el suelo seriamente / ahora que ya nos importan cada vez menos las hadas."[69] (I will devote the rest of my life to the serious contemplation of the ground / now that fairies interest us less and less.) Alberti proposes to devote his future attention to the things he finds on the floor: "Mira siempre hacia abajo" (always look down).[70] The poet's *Sobre los ángeles* (1929), especially "Los ángeles muertos," is chock full of rubbish, waste, castoffs. This aggregation of objects functions to make the poem a kind of "verbal dumping-ground," in Anderson's estimation.[71] Zubiaurre's perceptive alter-ego Filomena Cruz takes a similar approach in the photographs in her *Roadkill Series,* which are oriented toward litter that has been mashed into the ground—sidewalks, streets, plazas—over time.[72]

Maruja Mallo was equally interested in the waste of the world. Speaking of her series of paintings *Cloacas y campanarios* (Sewers and bell towers), realized between 1928 and 1929, she writes:

> Sobre el suelo agrietado se levanta una aureola de escombros; en esos panoramas desoladores la presencia del hombre aparece en las huellas, en los trajes, en los esqueletos y en los muertos. Esta presencia humana de realidad fantasmal, que surge en medio del torbellino de las basuras, está integrada a las piedras sacudidas, a los espacios cubiertos de ceniza, a las superficies inundadas por el légamo, habitada por los vegetales más ásperos y explorada por los animales más agresivos.[73]

> (Across the cracked ground a halo of rubble rises up; across those desolate panoramas the human presence appears in the traces, in the costumes, in the skeletons and in the dead. This ghostly human presence, which emerges from the middle of whirlwind of trash, is integrated in the tumbling stones, the spaces covered in ash, the surfaces flooded by clay, inhabited by the roughest vegetation and explored only by the most aggressive animals.)

Through all of these cultural engagements with waste, trash, garbage, we can see how the arts absorb discards—alongside many other things even more foul-smelling—in order to draw attention to the uncertain and sometimes absurd lines that shape modern art practices, aesthetics, and the putative values that the market assigns to works of art. At the same time, popular and avant-garde engagements with discards also function as ways of reconsidering the crucial links between waste and creation, disruption, migration, tradition, and modernity. Cattelan's golden toilet, Duchamp's urinal, Tetsuya Ishida's *Toilet Refuge,* Mallo's sewers, and Piero Manzoni's *Artist's Shit*

(1961) are all concerned with the exploration of what John Dewey describes as the superficial membrane between organisms and environments.[74] As Kreitman notes, "nothing permeates the membrane between nature and culture quite so effectively as shit."[75] Shit, sewers, sinks, and spillage remind us of the diaphanous distinction between nature and culture, self and environment, proving that, in Amitav Ghosh's words, "once again . . . there is no difference between the without and the within; between using and being used."[76]

Literature, too, has been drawn increasingly into exploring and representing the junkworld. Patricia Yaeger outlined, in an influential *PMLA* essay, four hypotheses for why literature and art have turned so urgently toward waste: "residue is a way of haunting the commodity";[77] trash is an attractive "rebellion against Enlightenment dialectics";[78] "trash has a history of moving in and out of the circle of exchange";[79] and "scenes of waste and detritus dominate texts because our epistemologies are shifting."[80] Pollution, as Mary Douglas outlined five decades ago, is defined culturally as matter out of place.[81] Bennett proposes a perhaps more pithy way of describing demoted objects, things that have been "released from the tyranny of judgement."[82] But the process of deciding *what* matter is out of *what* place is never neutral. Socially determined processes of remembering and forgetting, inclusion and exclusion, are always embodied by power relationships.[83] When we attend to displaced matter, we begin to apprehend what is really important to our society, and we start to understand the cultural practices used to police the tenuous distinction between the sacred and the profane, the useable and the disposable, the dirty and the clean, the national and the non-national. But the question arises, in the contemporary moment, as to what the place of waste really is anymore. Trash is one of the most expressive material traces of supermodern excess,[84] and it can be found everywhere—even in outer space. The exponential expansion of waste in the world has exceeded human capacity to control or corral it. Trash is literally everywhere.

Everything always occupies a place on a sliding scale somewhere between *morceau de musée* and unwanted junk. Following foundational work by Susan Strasser, John Scanlan, and others, literary scholars have devoted increased attention to the links between waste and words. Waste, as Susan Signe Morrison remarks, can be literal and literary.[85] There is a handful of scholars and thinkers working on trash and material culture in Spain.[86] Agustín Fernández Mallo's *Teoría general de la basura* (2018; General theory of trash) proposes to reread the contemporary era in relation to the cultural artifacts, quotations, texts, trash left over from previous times.

Maite Zubiaurre has complemented her research on litter and ruins with cutting-edge experiments with pedagogy, photography, and community outreach.[87] Diana Burkhart's work on Montxo Armendáriz's film *Las cartas de Alou* (1990) analyzes the visual and symbolic rhetoric of waste and the biopolitics of immigration in contemporary Spain. And most recently, in their essay on trash, recycling, and urban ecology, Matthew Feinberg and Susan Larson have examined how artists and activists working at the fringes of the culture industry in Madrid have repurposed urban landscapes trashed by the economic crisis as a way to reassert citizens' rights to the city.[88] But there is still a lot more to say about Spanish waste. I am not aware of the existence of a book-length study of trash in contemporary Spain; this book ventures into a field partially explored to take a sustained interdisciplinary approach to thinking about *basura* in contemporary Spain.

Culture is embodied through and in stuff. All objects are subject to valuation, categorization, and changes in fortune, value, and status. Those shifts in value say more about us than about the things themselves. Culture depends on these kinds of decisions, which can be conscious or subconscious.[89] Zygmunt Bauman, one of the foremost theorists of the circuits and flows that shape the ways of late-capitalist life, describes how modernity has always been about "rejecting the world as it has been thus far" in order to create it anew.[90] Waste is but one of the products of the modern project of design.[91] The modernist project of refinement, the separation of culture from nature, results in the creation of leftovers—material, human, epistemological, architectural, spatial, temporal—and those leftovers tell us a great deal about what our cultures hold most valuable.

WASTE, METHOD, THEORY

What happens to trash after it has been dropped at the curb, or inserted into the pneumatic tube? Who sorts the recycling and where does it go? What does our detritus tell us about our world? What does the abandoned thing communicate about our "well-made" social lives, lived environments, cultural values? When does space become waste-space? How has Spanish culture learned to distinguish between what Andreas Huyssen calls "useable pasts" and disposable ones?[92] Who makes those decisions?

Basura: Cultures of Waste in Contemporary Spain aims to answer these questions through six case studies analyzing the ways that trash functions within a Spanish cultural context that has tended to organize its public spaces and political discourses around a logic of cleanliness, modernity, progress.

Four presuppositions hold this book together: (1) that we can understand a culture by analyzing the trash that it produces and the ways that it disposes of it; (2) that waste has symbolic functions, but it also has agency; (3) that the decision to trash things can be personal, economic, psychological, political, aesthetic; and (4) that waste never disappears completely, and its value is never stable.

The interpenetrating activities of design, refinement, disposal, and separation—of past from present, of useable from disposable, of urban from rural, of the authoritarian from the democratic, of capitalist from socialist—are always incomplete and ongoing. The ebbs and flows of those processes of cultural, political, or social distinction—which, in turn, establish putative notions of value—are necessarily always in a constant state of flux, an unceasing process of becoming, and therein lies the value of "remains," discards, rubbish as objects of study. In an early essay entitled "The Slaughterhouse of Literature" (2000), for example, Franco Moretti noted that 99.5 percent of literary works vanish from sight. The Western canon is sedimented with discards.[93] Why do we select some things for inclusion in the museum, the archive, the Ph.D. reading list, while other things are destined, almost from the beginning, for the dustbin? What can be learned when we go back to our culture's abattoir to regard those things that have been discarded, trashed, cut off, forgotten?[94]

At this point, I should make clear that this book has been written from the disciplinary vantage point that is Hispanic studies, which, as a field, is itself comprised of a geographically diverse, dispersed network of people who employ a broad range of methodologies and approaches to studying the cultural production of the Hispanic world, alongside the non-Hispanic, non-Latinate traditions, languages and cultures with which they have come into contact historically. As Mabel Moraña noted nearly twenty years ago, there are an array of "tensions, contradictions, and paradoxes that cut across the field," but these are the things that "keep it alive."[95] Thematically, geographically, theoretically, and methodologically, departments of Romance studies and Hispanic studies were interdisciplinary before interdisciplinarity had become an institutional buzzword. The "plurality and difference"[96] that Paul Julian Smith sees as constitutive of the field of Hispanic studies is reflected today in the scholarship of people who work with assorted philological, historical, political, economic, literary, cultural, visual, medial, linguistic, gender, racial, intersectional, urbanistic approaches (and combinations thereof) to studying geopolitically diverse regions and temporal moments from (roughly) the seventh century to the present. And while

some colleagues have lamented—if not overtly, practically—the end of the hegemony of the European, the Northern, the Peninsular, or the literary, I think a more constructive case can be made for the opportunities that deeper interdisciplinarity has brought to departments of Hispanic studies. As the Moraña volume demonstrates, even people working within scholarly Hispanism have sought to uncover the biases, implicit or otherwise, of the field as epistemological and institutional project. Part of my aim with the present volume is to look at some of the cultural practices and objects that have not been emphasized or perceived in even the most cutting-edge or comprehensive cultural studies of Spain. David Gies's otherwise definitive *Cambridge History of Spanish Literature,* for example, makes no mention of trash, garbage, junk, *basura,* detritus, residue, or debris. Other earlier cultural surveys of Spanish culture, curated by Labanyi and Graham (1995), Gies (2007), and Jordan and Morgan-Tamosunas (2000), have similarly overlooked the crucial importance of discarded materials as diacritics for thinking about modern culture.

This book offers a fresh theoretical framework for rereading contemporary Spanish studies from the perspective of trash. Responding in part to Jo Labanyi's 2010 call to seek out new forms of cultural research that "have not been tried in Spanish studies,"[97] and informed by interdisciplinary work emerging from the fields of archaeology (Olsen 2010; González-Ruibal 2006, 2019), anthropology (Rathje and Murphy 1992), history (Scanlan 2005), literature (Boscagli 2014), ecocriticism (Iovino and Opperman 2014), philosophy (Viney 2014), political science (Bennett 2010) and cultural geography (Hawkins 2006), *Basura: Cultures of Waste in Contemporary Spain* analyzes the rich interactions between Spanish waste and Spanish cultural practices, including narrative fiction and film, documentary, photography, comics, and social media. It takes seriously the idea that it is in the peripheral regions of social reality and practice that the urgent critical work must be undertaken, those areas that Buchli calls the "realm of the abject, the realm of the wasted," where we find the stuff that has been "released, given away, wasted, taken away, sacrificed or disposed of."[98] As such, this book harnesses an archaeological approach to doing the work of cultural criticism.[99]

Waste cuts across a broad array of human activities, cultural, economic, social, and political. It has ecological impacts, aesthetic effects, and ethical import. Accordingly, this book adopts archaeologist Bjørnar Olsen's "bricoleur attitude" that aims to reassemble useful shards and fragments along with other pieces. Inspired by Olsen's combinatory theoretical bricolage, I have

tried to think across paradigms and disciplines while also avoiding some of the conceptual limitations arising from firmer adherence to only one theoretical or methodological school, aiming to shed new light on old and new texts and contexts.[100]

I am not the first to assemble a theoretical bricolage in a work of cultural criticism. There is a similar penchant visible in the "purposefully promiscuous" "modes of noticing" that Gan, Tsing, Swanson, and Bubandt find in recent ecocritical theory.[101] This approach is the way of the ragpicker, the *chatarrero,* the *chiffonier,* the mudlark, the *trapero* who appear in late nineteenth- and early twentieth-century accounts of urban space. The ragpicker was the engine that ran the nocturnal economy of recycling and recovery in the nineteenth-century industrial city.[102] The nighttime efforts of the scrap-collector who roamed the modern city in search of saleable bits of discarded material form the core of Walter Benjamin's own methodology as he wandered the Parisian arcades in search of the material manifestations of modernity's past. He borrowed the technique from Baudelaire, who described the *chiffonier* as the person who "sorts things out and selects judiciously; he collects, like a miser guarding a treasure, refuse which will assume the shape of useful or gratifying objects between the jaws of the goddess of Industry."[103]

We know that, in the nineteenth century, Madrid's municipal "servicio de limpieza" (cleaning service) included the licensing of ten thousand *traperos,* or ragpickers, who—just as prostitutes were required to keep out of public view—were only allowed to circulate at night.[104] The *trapero*—who was in fact produced (displaced) by nineteenth-century processes of rationalization of urban space—came to represent a thoroughly modern roaming subject. Benjamin, in his book on Charles Baudelaire, describes how, much like the ragpicker, "poets find the refuse of society on their streets and derive their heroic subject from this very refuse."[105] I cited earlier Maruja Mallo's interest in the desolate panoramas of human presence—whirlwinds of trash, tumbling stones, spaces covered in ash—that inspired her painterly practice. The activity of the ragpicker is, in Baudelaire's account, an "extended metaphor for the poetic method."[106] Benjamin is very fond of this idea, since, "ragpicker and poet: both are concerned with refuse, and both go about their solitary business while other citizens are sleeping."[107] The concept of the modern artist as a ragpicker appears across an array of art critical works.[108] Chapter 2 explores how a similar nocturnal dynamic functions in *Mujeres al borde de un ataque de nervios* (Women on the verge

of a nervous breakdown), which not only features background images and stories of disposal and recycling but also lenses the work of the garbage men who clean up the city at night.

In the early twentieth century, Ramón Gómez de la Serna wrote a guide to Madrid's open-air market, the Rastro, where he cheerfully went to observe "la menuda basura reunida en pequeños montoncitos" (the pretty trash arranged in little mounds).[109] This was the place where jettisoned things could be found again, "abandonados a sí mismos, desprestigiados, sin castidad ni justificación ninguna" (abandoned to themselves, disgraced, without chastity or any justification).[110] The Rastro began in the mid-eighteenth century near the Matadero de la Villa (slaughterhouse) and took its name from the "trace" (rastro) of blood that reportedly flowed through the streets below the buildings. By the 1980s, during the country's transition to democracy, in addition to being the place to buy secondhand things, the Rastro also offered books that had been prohibited by the government, erotic magazines, and, increasingly, meetings of a political nature. Violent confrontations between police and unauthorized political groups were common in the late 1970s.[111] But there has always been something radical about the Rastro, where objects unattached to their original contexts, aesthetic or political, could be repurposed, reused, given new life. Pedro Almodóvar, as one of Gómez de la Serna's contemporary heirs, appropriately begins his second feature-length film, *Laberinto de pasiones* (1982; Labyrinth of passions), with traveling shots in a randy Rastro where anything could happen.[112] Even today, *El País* periodically releases digitized photos of the Rastro from the 1970s and 1980s.[113] The Rastro, as chaotic place and vernacular practice, is one of the cultural spaces that makes Madrid Madrid.

As we can see in Gómez de la Serna's descriptions of the secondhand market, in Baudelaire's reflections on the *chiffonier*—and in Benjamin's appreciation of Baudelaire—detritus, trash-picking and rag collecting have always held a special place within the material and aesthetic assemblages of modernism and the avant-gardes. In the introduction to their study of the visual structures of Spanish modernity, Susan Larson and Eva Woods liken the process of writing their book to reading "fortunes from tea leaves, in *trastos*."[114] Benjamin took a similar approach to exploring the Paris arcades to glean evidence of the remains of nineteenth-century modernity, and we can perceive a similar appreciation in Michel de Certeau's theoretical-sociological descriptions of the promiscuous activities of city walkers and poachers, the people he calls the "users who are not the makers."[115]

Baudelaire, Benjamin, Mallo, and Gómez de la Serna have an heir in Ángeles Villarta, a Madrid-based investigative journalist who, in the mid-1950s, embedded herself in a community of ragpickers in the neighborhood she called the "Ciudad de la Basura" (City of Trash). The book she wrote about her experience was groundbreaking for its time. It aimed to address *madrileños'* ignorance of the ways that their city really functioned: "No hay escrito ningún libro que hable de la geografía ni de la historia de la tierra de los traperos o, si los hay, yo no pude encontrarlo, ninguno de mis conocimientos la había visitado, y en las agencias de turismo parece que desdeñan el itinerario que conduce a las chozas y chavolas [*sic*] de la basurería."[116] (There is no book about the geography or history of the land of the ragpickers and, if there is one, I was unable to find it. Nor had any of my acquaintances visited it, and the travel agencies appear to disdain any itinerary leading to the sheds and shacks of the trash workers.)

Villarta was one of the first Spanish cultural observers to take a humanistic interest in the politics of waste and recycling in a modernizing Madrid, living in a *trapero* community and learning about the practices of their everyday lives. Writing later about her experiences, she concluded that she was probably the first "exploradora de Basuralandia" (explorer of Trashland).[117] Madrid's recycling communities were so far removed from working-, middle-, and upper-class people's experience of the city that she also called it the "Far West" *madrileño*,[118] remarking that the "barrio de la busca es un poco como ir al Oeste americano" (gleaners' barrio is a little like going to the American West).[119] (Gómez de la Serna, for his part, described himself as a "legitimate Arctic explorer" of the Rastro.)[120]

It was through her experiences in the Madrilenian City of Trash that Villarta sought to understand the hidden itineraries of waste and the people whose livelihoods depended on it. This was a world inhabited by people who worked from dawn to dusk doing a little bit of everything: "componer las patas rotas de una silla que les han dado porque ya está fuera de uso, arreglar una muñeca para la chiquilla de la vecina, remendar la ropa del padre, atender a los cochinos. Desde las cinco de la madrugada hasta las diez de la noche. Un día y otro día. Una clase trabajadora que sube por sí misma, que no escatima esfuerzo en la labor."[121] (To repair the broken legs of a chair they received because it was no longer useful; to sew up a doll for the neighbor's daughter; to darn Dad's clothing; to attend to the pigs. From five in the morning until ten at night. Day after day. A working class that raises itself up by itself, and that does not eschew the labor required by honest work.) Like

the Victorian London described by John Scanlan, mid-twentieth-century Madrid was a place where the wealthy created waste and the poor collected it and extended its life.[122]

Villarta spent a week in this frontier society in the northern periphery of Madrid known then as Tetuán de las Victorias (and now as Tetuán), and whose inhabitants made their living gleaning from the castoffs harvested from the city's wealthier neighborhoods. The working poor occupied—then as now—the outer, less visible regions of Madrid's peripheries. In the 1950s, Tetuán de las Victorias was an area still devastated by the Civil War and not yet incorporated into the city: "El suburbio, para vivir, no le ha quedado otro recurso que trabajar. Y lo ha hecho. En el último de sus extremos, donde ya ni siquiera era Madrid, se dedicó a la industria de la basura."[123] (In order to make a living, the suburbs have had no choice but to work. And they have done it. In the most extreme outposts of the city, beyond the city limits of Madrid, people devote themselves to the industry of Trash.)

Villarta's book is not sensationalistic; it is extremely humane. There is a similar ethical engagement operating in the social-issue comics of Cristina Bueno and Isaac Rosa, and Jorge Carrión and Sagar Forniés, and in the photography and written-word collaboration by Javier Pérez Andújar and Joan Guerrero Luque, all of which forge connections between the city's most vulnerable (and all but invisible) people, the places where they live, and their readers. The Madrid TV station Be Mad's program *Callejeros,* which on July 11, 2019, aired an episode called "La caída de los Ángeles," takes a similar interest in documenting the lives of Madrid's peripheries, in Vallecas, where municipal neglect, forced evictions, and economic precarity have created whole communities of contemporary *chatarreros* who can barely make ends meet.[124]

MAKING THE CASE FOR SPANISH WASTE

Although the seeds of capitalist modernity were already being sown by Franco's technocrats in the 1960s, the liberal democratic project that accelerated after the death of the dictator in 1975 was based, in large part, on a version of coerced consensus. As Graham and Sánchez have described, the country's "rapid process of belated modernization" had a negative side that resulted in what they call a form of social "schizophrenia": "It is precisely this rapidity, alongside an increasing heterogeneity, that gives Spanish society its vertigo-inducing postmodernist identity. It is a world where the archaic and the modern coexist."[125] Teresa Vilarós offers a much more critical account,

describing how the country's cancerous transition to democracy went on existing within the body politic like an invasive cyst, a "fisura sin fondo, boca y agujero negro que tal como vomita sus entrañas en los primeros momentos del fin de la dictadura pasa muy pronto a invertir la dirección del flujo de desecho" (bottomless fissure, a mouth or black hole that just as it had vomited its guts out during the beginning of the end of the dictatorship soon began to reverse the flow of waste).[126] In his introductory comments to *CT o la cultura de la transición*, Guillem Martínez portrays the "Cultura de la Transición" (Culture of the Transition) as a cork stopper, a cultural aberration that ultimately meant the restriction of liberty. As a consequence of this process, Martínez describes Spain as having the "strangest" and "most surprising" culture of Europe.[127]

During the Transition, political leaders agreed, for a variety of reasons, to forget the country's violent history and embraced, instead, in a purposeful kind of amnesia. To reach a workable compromise, during the drafting of the 1978 Constitution progressive reformers were forced to find a middle ground with Francoists. One of the signal features of that consensus was the "pacto de silencio" (pact of silence) by which the country's political elites agreed to sweep the past under the rug and grant amnesty for all. As Fishman and Lizardo note, "the principal political constraints and strategies of the Spanish transition gave priority to the search for wide sociopolitical consensus and, consequently, avoidance of polarizing initiatives in all spheres."[128] In the end, "the assumptions underpinning the Spanish transition discouraged radical and transformative endeavors."[129] Indeed, it was during the Transition that the country's socialist party turned its back on the working classes.[130] (Spain's pact of silence has been criticized from a variety of perspectives; I return to this theme in chapter 4.) Teresa Vilarós has labeled this process a "borradura histórica" (historical erasing) or "lavado de imagen" (whitewashing), whose effects were immediately clear in the country's cultural production of the 1980s and 1990s: "Muerto Franco, nuestro pasado es desperdicio y aquellos que lo recuerden son desechos que deben relegarse al pozo del olvido."[131] (After Franco died, our past became waste and the people who remembered it were discards relegated to the pit of oblivion). Accordingly, the Spanish Constitution of 1978 makes scant reference to the past, even though the country's violent history likely weighed on the minds of its authors.[132] The narrative and temporal structures of the Transition era evaded any historical mode of address in favor of a neoliberal temporality, or what Fredric Jameson defines as the perpetual present of postmodern culture.[133] But this has always been the time of modernity.[134]

More recently, Germán Labrador Méndez has explained how the cultural politics of the Spanish Transition were built upon a logic of transferal and constant negotiation, whereby both the Franco regime and the political opposition by turns infected and sanitized each other in order to be able to inhabit the same space of representation. The price paid by both sides was mutual contamination in the ideological realm.[135] Indeed, there was more continuity between late Francoism and the "new" Spanish democracy than the more celebratory accounts of the Transition have allowed, since many aspects of the state apparatus and the liberal capitalist economic model that undergirded it were inherited from the previous regime.[136] Even today, the Spanish Right tends to distance itself rhetorically from its historical roots in Francoism.[137]

The cultural logics of pollution—real and symbolic—can be seen in the remnants, the residues, the waste products that the Spanish democratic project has tried to leave behind. As the narrator of Benjamín Prado's novel *Mala gente que camina* (2006; Bad people walking) puts it—echoing the archaeologist González-Ruibal—even decades after the death of the dictator, cultural life in Spain continues to be "una mezcla mareante de pasado y presente, de realidad y ficción" (a dizzying mix of past and present, of reality and fiction).[138]

CHAPTER OUTLINE

The "cultural archaeology" that I employ in this introduction and across the following chapters is intended as a dual gesture. On the one hand, it describes the approach that I have taken to cultural analysis. Taking a cue from Rathje and Murphy, I have spent the last five years reviewing films and documentaries, surveying Spain's streets and alleys, sorting through recycling bins, libraries, social media, bookstores, and message boards in search of things that have been forgotten, jettisoned, forsaken. The project is archaeological in the sense that it deals with discarded artifacts, materials that make the past perceivable in the present time. Each chapter aims to read those objects in terms of what they say about the country's uneven process of political, social, and cultural modernization. I have placed these waste objects into dialogue with the disciplinary fields, cultural practices, and corollary structures of power that have produced them. By looking at how cultural media and social practices interact and collaborate with rubbish, this book takes seriously Rita Felski's call to revise "the concept of context in order to render it more fragrant."[139] Some objects described in this book

are more fragrant than others: the Madrilenian ham bone of momentary Twitter fame, a sodden mattress, a discarded LP, a cassette tape, an obsolete answering machine, a mound of cardboard boxes, a photograph, an unmarked grave containing personal effects. Each discarded object furnishes an encounter that in turn reveals the problematic, ever-evolving process of discarding and, inevitably, of recovering meaning and value in contemporary Spain.

The principal interest of garbage lies in the fluidity and contextual variability of its values as both *thing* and *sign:* once stuff has been expelled from "the networks that give it economic and affective significance," it becomes junk, but it also acquires a new power to signify.[140] This is the process by which waste reveals what Benjamin called "unconscious optics."[141] The objects submitted to analysis in this book are things that, for one reason or another, have been deemed useless, relegated to the status of waste, or that have (apparently) completed their life cycles and slipped from view. But as I mentioned in the opening pages of this introduction, the ontology of trash falsely suggests completion or exhaustion; we know that waste is not done doing things even after we are done with it. Our time with stuff encompasses only one small portion of its life. The American poet Arthur Sze captures the essence of this notion in his poem "First Snow," in which he writes, "you think you own a car, a house, / this blue-zigzagged shirt, but you just borrow these things."[142]

Chapters 1 and 2 analyze the ways that Spanish visual culture has engaged with waste in order to imagine and understand urban space. Chapter 1 focuses on how Pedro Almodóvar's 1980s films responded to Madrid political elites' project of transforming the Spanish capital city into an ahistorical place propitious for architectural transformation and capital investment. It begins with an overview of the ideological and material processes that altered Madrid's lived environments, and asks what role the country's most internationally recognized auteur had in visualizing a Transition culture populated by neurotic inhabitants obsessed with disappearing any traces of the past.

Chapter 2 is about Madrid's more recent skirmishes with waste. Taking the 2013 sanitation workers' strike as a case study, it analyzes how social media and digital journalism shed light—through a critical engagement with the urban trash that piled up over seven days in the capital city—on some of the same political and economic processes that we can see operating in Almodóvar's early films. Focusing especially on Twitter and *El País* online, chapter 2 reflects on the power of detritus to reveal the underlying political

and economic dynamics by which multinational capital flows through and within Madrid, and it speculates on how the accumulation of the waste products of urban capitalism exert political and economic power.

Chapter 3 surveys the work of two photographers who have drawn productive attention to the afterlives of wasted spaces in Spain. Óscar Carrasco's *Madrid Off* project is a visual cartography of abandoned spaces in the Spanish capital city. His photographs outline the spatial contours of what Rem Koolhaas has called "Junkspace," whereby physical space itself has been used and then abandoned by rapacious processes of capitalist "improvement." We can see some of the same logics functioning in the images of the Barcelona-based photographer Jordi Bernadó, which satirize capitalism's relentless commodification of public lands, community spaces, and natural reserves.

Franco's regime sought purposefully and systematically to cleanse the body politic of undesirable human others through carefully enacted processes of differentiation, assassination, and disposal. The "wasted lives" that Franco's brand of authoritarianism created in its efforts to cleanse his neo-imperial Castilian world of unwanted political, historical, and ethnic others still demand to be recognized and memorialized. Chapter 4 explores how the country's more recent interest in recovering historical memory has relied on discarded objects and material evidence in order to build the case for collective history. Following Alfredo González-Ruibal's lead, this chapter proposes that perhaps archaeology is a better way of conceptualizing how Spain's violent history continues to inhabit the present. Because archaeology is done through the related activities of digging and visualizing objects from the past, it is a more porous and vital disciplinary and theoretical model for thinking about how contemporary Spanish culture actually works materially. To my mind, archaeology works extremely well as a complement to historiography, which as a discipline tends to keep the past sealed off from the present.[143]

The literal work of forensic archaeology undertaken by the Asociación para la Recuperación de la Memoria Histórica has been accompanied in the literary realm by a form of narrative archaeology. Chapter 4 analyzes how the Spanish historical novel has absorbed memory discourse in order to draw attention to the ways that the Spanish past inflects present-day structures of feeling. The chapter centers on Benjamín Prado's 2006 novel *Mala gente que camina,* placing it within a broader shift that has pushed Spanish fiction toward a more sustained and reflexive unearthing of the traces of Franco's repression. The novel tells the story of a professor of Spanish

literature who stumbles upon the testimony of a Republican woman whose child was stolen from her and adopted by a Francoist family. The book is characterized by an archaeological impulse that responds to the ongoing cultural dynamics of the movement to recover historical memory, and it functions to reconcile more relativistic approaches to historical representation with an ethical desire to contribute to the uncovering of past violence. Recent Spanish historical metafiction is about distinguishing and salvaging useable pasts from disposable ones;[144] it consequently foregrounds research and investigation as its central diegetic elements, positioning the archive, not just as a historical source but as the subject of narrative development.

In chapter 5 I look at how social-issue comics literally draw attention to how neoliberal processes of urban design and capitalism have excluded certain people from the social fabric of the city. This is the proletariat that Nicolas Bourriaud traces "through the whole of the social body" and that comprises "a people of the *abandoned*": the immigrant, the homeless person, the undocumented worker.[145] The chapter examines two long-form comic books about the Spanish housing crisis, *Aquí vivió: Historia de un desahucio* (2016; She used to live here: A tale of eviction) and *Barcelona: Los vagabundos de la chatarra* (2015; Barcelona: The scrap metal vagabonds), in terms of how they bear witness to humanitarian problems produced by the country's economic crisis. Both texts feature empathetic protagonist-narrators who connect themselves to the unseen, undifferentiated people living in the city's most economically precarious spaces. Harnessing the ethical potential of the comics medium, these comics give a visual form and voice to the Spanish city's poorest citizens, literally drawing them back into the visual and emotional structures of mainstream civic life.[146]

The book's final chapter analyzes how Rosa Montero's fiction employs metafiction and a focus on bodily materiality to understand the recurring processes of aging, decay, time, and mortality. In novels such as *La hija del caníbal* (1997; The cannibal's daughter) and *La carne* (2016; Flesh), the author meditates on the junking of the body, exploring the relations between narrative (consciousness) and body (materiality) in the construction of the self. The chapter outlines the primacy of junk and the materiality of the body to Montero's evolving concern with understanding what makes human consciousness happen.

Javier Escudero has described Spain's Transition-era citizens as "seres desmemoriados que viven en el momento presente y que no están interesados en enfrentarse al pasado reciente del país o al suyo propio" (beings without memory who live in the present moment and who are not inter-

ested in confronting either the country's or their own recent past).[147] Despite the country's better efforts to silence or falsify its history and transform itself into a shining postmodern society oriented toward Europe, there is still a lot to learn from the things the country has tried to forget. Spain's special brand of modernity came with an aggressive disavowal of history and memory, but cultural interactions with waste and waste disposal reveal the unseen side of that project. The cultural archaeology outlined in this book demonstrates how the country has experienced neoliberal modernity and the ahistorical modes of thinking that go with it.

I Waste Matters

1 Pedro Almodóvar's Modern Projections

Te quiero porque eres sucia
guarra, puta y hortera,
la más obscena de Murcia,
y a mi disposición entera.
¡Sólo pienso en ti murciana!
porque eres
una marrana.

(I love you 'cause you're dirty
Filthy, whorish and cheap,
The obscenest lady from Murcia,
And you are all mine.
I'm only thinking of you, Murcian!
Because you are
A pig.)
—Alaska, in *Pepi, Luci, Bom y otras chicas del montón*

During the 1980s Madrid's regional authorities worked to forge a new identity that would distinguish the city from its historical association with the dictatorship. This process was implemented through the convergence of three principal institutional factors: (1) the gradual diffusion of centralized, national control of the country; (2) the establishment of an independent municipal administration after the elections of 1979; (3) the creation and consolidation of the autonomous community of Madrid.[1] According to Hamilton Stapell, Madrid's particular experiment with regionalism functioned as a way to distance the Spanish capital from its antidemocratic history, "in part because of the need to 'forget' the past and in part because of the direct association of Francoism with Spanish nationalism."[2] In Madrid, this process required a complete overhaul of the city's public spaces: "urban renewal and the physical transformation of Madrid, the renovation of the capital's

historical and cultural patrimony, reform of the city's administration, and a broadly defined renewal of Madrid's culture."[3] Civic authorities devised a plan to cleanse the city from top to bottom, which included the restoration of monuments (with twenty-seven large-scale restorations occurring in 1986),[4] limiting commercial development, rationalizing transportation systems, especially rail, bus, metro, and pedestrian access to city centers,[5] the recovery and partial reform of the Manzanares River, the construction or creation of new museums and cultural centers, and the reclamation of city streets and plazas for cultural events of all kinds.[6]

The creation of a different civic identity in Madrid depended on a new city plan that revolved around capital city cleanup. Although the dictatorship had already begun a modernization project beginning in the 1960s,[7] by many accounts Madrid was still a dirty place to live. With rat and mosquito infestations proliferating in stagnant water in the city's peripheral neighborhoods, and the Manzanares River containing industrial discharge from thirty years of dumping, Madrid was a prime example of how Francoist neglect was felt in the country's urban spaces, especially in the peripheries.[8]

At the same time that the country's political (and cultural) elites worked to clean up the country and build a magnificent postmodern society oriented toward Europe, local cultural producers armed with garbage, detritus, trash, and rubbish did their part by reminding Spaniards that the country's emerging neoliberal society could never be perfectly clean. As Labrador Méndez notes, the Transition produced a significant "cultura de la mierda" (shit culture) that worked in opposition to the "política higiénica" (hygienic politics) of the era: "Frente al deseo del poder político de ocultar lo excrementicio, una determinada cultura de la época buscará dirigir toda esa herencia problemática hacia el centro del debate."[9] (As a response to politicians' desire to hide the era's excrement, there was a particular culture that sought to drag that problematic legacy into the center of debate.) The 1980s thus saw the emergence of a broad cultural production celebrating shit and trash, which artists used to "mark," or tag, their environs. Through the celebration of shit, it became possible to blow up the social sewer, definitively dirtying society in the process.[10] The so-called *cultura quinqui* of the era was a crucial part of this contestatory trash culture revealing the unseen underbelly of Transition society. *Quinqui* culture was most visible in films directed by José Antonio de la Loma and Eloy de la Iglesia, but it also made an appearance in novels and comics depicting the lives of marginal youth subjects living in the extreme suburbs of Madrid where drug abuse, marginalization, eco-

nomic hardship, and the emergence of AIDS were impacting the lives of the city's most vulnerable populations. This marginal *quinqui* culture existed as a counternarrative of the official version of material progress and social welfare in Transition-era Spain.[11]

The musical numbers "Murciana," performed by Alaska and members of her band Kaka de Luxe in *Pepi, Luci, Bom y otras chicas del montón* (Pepi, Luci, Bom and other average girls 1980), and "Suck It to Me," performed by Pedro Almodóvar and his onetime collaborator Fabio McNamara in the 1982 film *Laberinto de pasiones*, are illustrative of the subcultural celebration of sewage.[12] Both songs reflect the director's early career shabby aesthetic and form part of the broader cultural celebration of rubbish that Joaquín Florido Berrocal, Luis Martín-Cabrera, Eduardo Matos-Martín, and Roberto Robles Valencia describe in their accounts of alternative cultures of the Transition. The Alaska verses included in the epigraph to this chapter are echoed in Almodóvar's next film, *Laberinto de pasiones* (1982), in which the director appears in drag onstage with Fabio McNamara. With a funky accompaniment, the two sing, "Buscando tu calor he bajado a las cloacas / y las ratas me dieron su amor. / Amor de rata, amor de cloaca, / amor de alcantarilla, amor de basurero. / Lo hago sólo por dinero. (Searching for your warmth, I went down to the sewers and the rats gave me their love. Rat love, sewer love, gutter love, trashman love. I only do it for the money.) Talking dirty is naughty and fun. Songs and art celebrating trashiness provided a satisfying alternative to the buttoned-down culture imposed by Franco and his superficially progressive heirs. More broadly, Michel Serres suggests that it is precisely pollution that makes laying claim to our habitats possible (it is what he calls *malfeasance*, a "soiling gesture" by which humans appropriate things for themselves.)[13] In Spain, Transition-era trash culture was a way to create a novel sociality that belonged not to the ruling elites, but to the people—youths, women, LGBTQ—who were never invited to sit at the table the *progres* (progressive elites) set for themselves.[14]

Vilarós and Pérez-Sánchez have shown how the egalitarian promise of early democratic culture in Spain eventually gave way, over the course of the 1970s, to a more institutionalized culture that the PSOE, the socialist party, used to legitimize its national and Europeanist policies. Guillem Martínez observes that Transition culture invested in a depoliticized, individualistic brand of aesthetic modernity that eschewed genuine critical engagement, preferring instead to commodify culture and the cultural contributions of artists and activists in order to transform them into a Spanish "brand" to

be marketed abroad.[15] Almodóvar's films were quickly absorbed into this project. Moreno-Caballud describes a "degraded" type of individualism that was born in the Culture of the Transition. This process that "facilitated the 'buying and selling' of artists (and intellectuals) by those in power during the so-called Culture of Transition derived in part from the artists themselves, in exacerbating the individualism that was latent in the tradition of aesthetic modernity (to the detriment of its civic potential)."[16]

This self-interested cultural refinement sees its allegorical apotheosis in Almodóvar's late-1980s films, which more often than not feature moderately successful cultural professionals living an urban milieu in constant transformation. This chapter takes a look back at the Spanish Transition and proposes a new reading of a handful of Almodóvar's canonical texts of the era in terms of how they reflect the ongoing skirmish between a cluttered, dirtier past and the clean, antiseptic future that the country's elites were trying to construct. I focus especially on the director's reflexive engagement with the cultural logic of urban cleanliness that was having its heyday between 1979 and 1986, as the city's socialist mayor, Tierno Galván, led Madrid's efforts to clean up the capital while building a new regional identity. The chapter charts the neoliberal turn in Spanish cultural life, viewed through the audiovisual production of the filmmaker most closely associated today with Spain's international projection.[17]

Over the course of the late 1970s and early 1980s, Tierno Galván's regional government sought to create a new Madrilenian identity and infrastructure from scratch. As I noted earlier, the city's regionalist experiment was viewed as one way to distance itself from its antidemocratic past.[18] This process was not unproblematic, nor was it ever complete. As Vilarós observes, one of the foundational problems implicit in this project was the fact that Spanish democracy was built upon a Francoist substrate. The Transition was not so much a new politics as a new aesthetic, a "lavado de imagen" (whitewashing) that did not go far enough to break with the authoritarian Spanish past. Although the pact of silence certainly functioned through the late 1970s and early 1980s to allow for the forging of a broad and functional political consensus, the desire to turn the page on history resulted in what would later be described as a "borradura histórica" (historical erasure), in Vilarós's words, that had important cultural and political repercussions. Spain's Transition represented a broad desire to construct a new history that not only hid its blemishes but also reshaped the past.[19] That historical whitewash ran parallel to a process of cultural invention by which a relentless insistence on the present was used to cover up past (and present) problems. The result is

that even today there are still traces of contamination of Francoist ideology and discourse embedded in the cultural present.[20]

THE POLITICS OF WASTE IN TRANSITION-ERA MADRID

The Transition-era cleanup of Madrid was not only ideological, cultural, economic, or discursive. It was also literal and material, requiring the deployment of thousands of trash cans, the removal of abandoned vehicles from city streets, the separation of different classes of waste, the establishment of the city's first recycling program and glass collection in some parts of the city, the washing of building facades, remediation of air pollution, creation of green spaces and extension and reform of parks, wastewater purification, and tree-planting campaigns.[21] These processes of urban refinement and sanitation were crucial to political elites' strategy of modernizing the capital city. The films directed and produced by the Almodóvar brothers through the 1980s function as *musées imaginaires* where filmgoers could see this urban transformation taking place before their eyes.

When Agustín Almodóvar first appears in *Mujeres al borde de un ataque de nervios,* as a real estate broker, he is playing with a scale model of Madrid apartment buildings (fig. 5). That El Deseo's executive producer should be depicted in the film as a person who profits from the commodification of urban space is fitting, since audiovisual culture has always played a part in packaging and promoting space. Viewed more than thirty years later, the film also provides present-day viewers with a temporal-historical perspective

Figure 5. From *Mujeres al borde,* Pedro Almodóvar, 1988. (© El Deseo)

on a modern Madrid in transition. That same Madrid was a place where the architects of Spanish democracy worked to create a clean, glossy mise-en-scène for the consolidation of the aspirationally ahistorical market-oriented society that we know today.

Every process of modernization, every project of refinement, creates residues. Madrid's urban and architectural development is a case in point. Dumpsters filled with construction waste were a constant enough presence on Madrid's streets throughout the 1980s and 1990s that they can be seen in *Átame* (1989; Tie me up, tie me down), *Mujeres al borde de un ataque de nervios*, and *Carne trémula* (1997; Live flesh). There was sufficient construction debris occupying Madrid's streets that public service announcements funded by the Ayuntamiento sought to inform Madrilenians of the importance of separating consumer waste from construction waste, and by the early 2000s the massive urban projects undertaken by Ruiz Gallardón's administration required a sustained—and much criticized—publicity campaign that recommended, rhetorically, that Madrilenians ask themselves, "¿Qué pasaría si nunca pasase nada?"[22] (What would happen if nothing were ever to happen?)

Trash, waste disposal, and public service announcements played vital roles in Tierno Galván's plans to forge a fresh new Madrid from the ashes of Francoism. As part of his regional government's efforts to restore faith in public institutions, an array of city bureaus was reformed or reorganized in the 1980s, including the restructuring of the Departamento de Saneamiento (Sanitation Department).[23] The city began to systematize its garbage processing and disposal practices, and in so doing, the Autonomous government exercised increased administrative control over local authorities; this was part of the political project of consolidating the new autonomous political organization stipulated by the Constitution of 1978. In July 1985, Eduardo Mangada, the Community of Madrid's consul of the Ordenación del Territorio, Medio Ambiente y Vivienda (Bureau of Land, Environment and Housing) stated in a press conference that the Autonomous Community of Madrid had the "moral and political authority" to demand that the region's Ayuntamientos respect their agreements with local authorities to install and maintain dumps for trash and industrial waste.[24] A document authored in 1984 reported on the existence of more than 250 "vertederos incontrolados" (unregulated dumps) in and around Madrid.[25] As part of the amalgamation of diverse waste-disposal operators in Madrid, a plan was put in place to create ten waste treatment facilities within the Autonomous Community of Madrid that would supplant the numerous unregulated

waste sites throughout the region. (One of these sites appears in *Mujeres al borde* when Candela [María Barranco] discards her ex-lover's suitcase.)

A report presented in Rome by the Unión de Regiones Capitales de la Comunidad Europea (URCCE, European Community Union of Regional Capitals) in November 1986 noted that Madrid was producing 1.5 million tons of solid waste, of which 64,000 tons were toxic or dangerous. A key goal of Madrid's autonomous government was to eliminate what were called "puntos negros" (black spots), or unregulated dumps—of which there were approximately 180—made up of "urban waste" and seventy others composed of industrial waste. Alongside the closing of these unauthorized dumps located throughout the city, the government pursued the creation of a system of "estaciones de transferencia" (transfer stations) and "reconversión de residuo" (waste conversion) that would precede the transfer of waste to regulated dumps controlled by the Community of Madrid.

In the spring of 1986, there were eight independent dumps functioning in the municipalities located in the southern peripheries of Madrid that were closed with the inauguration and opening of a larger waste facility in Pinto. These smaller dumps were then sealed and reformed for subsequent urbanization.[26] Following a lengthy negotiation between local and autonomous community authorities, the Ayuntamiento de Pinto and the Comunidad de Madrid signed an agreement by which the Pinto solid waste facility would treat and eliminate the solid waste from those eight municipalities. The comments of Carlos Penit, the Communist mayor of Pinto, offer a useful snapshot of how politics in Madrid were still being negotiated at the local and municipal levels through patronage and compromise: "Se ha ganado una batalla en relación con la autonomía municipal y se ha sentado un precedente importante. La Comunidad ha cedido, y nosotros hemos aceptado algo que no nos gusta a cambio de prestaciones económicas importantes. En el momento de la firma recibimos 85 millones de pesetas, y la Comunidad se compromete también a realizar obras por valor de 200 millones."[27] (A battle has been won for municipal autonomy and we have set an important precedent. The Community relented and we have accepted something that we don't like in exchange for important economic benefits. In signing the agreement, we received 85 million pesetas and the Community has promised to realize projects in the amount of 200 million pesetas.)

A year later, in April 1987, the industrial waste dump in San Fernando de Henares would also open, once again in spite of strong local opposition. While the mayor of San Fernando refused to authorize construction of the

facility, the Consejo de Gobierno Regional (Council of Regional Government) finally overturned his decision based on a controversial interpretation of the *ley del suelo* (land law). This process of centralization of solid waste treatment had begun as early as 1984 with the Plan del Tratamiento y Eliminación de Residuos Sólidos Urbanos (Plan for Treatment and Elimination of Urban Solid Waste), whose main purpose was to eliminate the more than 250 unregulated dumps that were in existence in the region, while accommodating the twelve million metric tons of "residuos urbanos e industriales y de escombros" (urban and industrial residues and construction waste) of which it was estimated that six million were being dumped into natural areas. The plan also envisioned the construction, between 1985 and 1987, of nine new regional dumps with sanitary controls, two transfer stations, and one recycling plant.[28]

Alongside these negotiations between regional and municipal interests, local authorities worked to build public awareness of sanitation and cleanliness. Madrid's Ayuntamiento initiated a series of public information campaigns, such as the *Lo natural es dejar limpio* (The natural thing is to keep it clean) of 1987, whose object was to "concienciar a los madrileños para que respeten el entorno y eviten su degradación no dejando abandonadas las basuras" (raise Madrilenians' awareness, promote respect for their surroundings, and avoid environmental degradation by not disposing of their trash indiscriminately).[29] Environmental education programs and public service campaigns aimed to "elevar el nivel de eduación ciudadana" (elevate levels of citizen awareness) and to draw attention to domestic waste production and how that waste was causing problems locally.[30] These kinds of "informal" educational projects were part of both the Community and Ayuntamiento of Madrid's ambition to foster greater citizen participation in the reformation and cleanup of the city and region. These campaigns continued through subsequent administrations. Sadly, later politicians and city managers would push these citizen-oriented programs to their neoliberal limits, so that today recycling schemes in Madrid rely almost exclusively on consumer participation. Szasz and Maniates have shown that the very idea of consumer awareness campaigns, which relies on the premise that individuals are the best unit for thinking about changing behavior, is in fact a strategic way to slow change down, fragmenting and redirecting it to less effective routes.[31]

Public service announcements promoting cleanliness and civic responsibility have always played a part in the state-sponsored externalization of economic costs of a growing capitalist consumer economy and the increased

waste production that necessarily comes with it. A survey of Almodóvar films of the era demonstrates that the director was clearly perceiving and filtering these new systemic regimes of urban transformation on-screen: garbage trucks and sanitation workers trundle through the streets of Madrid in *Mujeres* and *Entre tinieblas* (1983; Dark habits); Tina receives a refreshing blast of water from a street cleaner's hose, and Pablo Quintero's typewriter lands explosively in a curbside dumpster at the end of *La ley del deseo* (1987; The law of desire); Becky del Páramo steps in dog shit upon her arrival in Madrid after a long hiatus (*Tacones lejanos [1991;* High heels]); a drunken, slumbering Ricky (Antonio Banderas) is awakened by a street-cleaning truck in *Átame;* and many of the parodic commercials appearing in Almodóvar's films promote sundry cleaning products, including laundry detergents and fart-masking perfumed undergarments for women. Throughout the Transition, discourses of urban cleanliness functioned as a purposeful method of shifting Madrilenians' attention away from the past and onto the present. In the urban environment of Transition-era Madrid, news outlets reported on events such as the *gran barrida* (cleanup) taking place in the Puerta del Sol, where one thousand people were given brooms to sweep the sidewalks. The *gran barrida* coincided with a study by Cogesep, a sanitary contractor hired by the Ayuntamiento, which found that some 7,400 syringes and nearly a million and a half cigarette butts were collected in one day in February 1987.[32] The syringes were likely the result of illegal dumping by medical clinics, not individuals.

This is not to say that Madrid was not an objectively dirty place to live in the 1980s. Spain's right-leaning newspaper *ABC* corroborates the widely held view of Madrid as, by European standards, extremely disorderly and grimy. A two-page photographic spread published in the Sunday, October 4, 1987, paper shows piles of garbage on Madrid's streets, with a caption reading: "Las imágenes muestran el aspecto indecoroso que presentan las calles del centro de Madrid. Los montones de basura acumulada, las cajas y los desperdicios en medio de las calles confieren a la capital de España una imagen impropia de una ciudad desarrollada."[33] (These images display the indecorous appearance of the streets in the center of Madrid. The piles of accumulated trash, boxes, and castoffs in the middle of the street convey an improper image of Spain's capital as a developed city.) A letter to the editor signed by the Spanish ambassador José María Campoamor published a few months earlier, in *El País,* complained that even toward the end of the 1980s the city was still one of the dirtiest in Europe (February 28, 1987). What is noteworthy about these editorial complaints about Madrilenian trash is how

both *ABC* and *El País* corroborated a generalized idea that the appearance of trash on the street was somehow antimodern or "improper" for a developed nation with European aspirations. The political rhetoric of hygiene overlaps with Madrid's efforts to consolidate its authority and to "clean up" Spain, yet always with an eye toward perceptions from abroad. One also has the sense that politicians saw the "dejunking" of Madrid's streets as a way to free Spaniards from perceived links to a dirtier authoritarian past while also confirming, for their European neighbors, that Spain had left its filthy provincial history behind. Journalistic and political discourses on cleanliness had the further effect of identifying readers as consumers who somehow might also take individual responsibility for some of the mess.

It is worth remembering that the interrelated procedures of real garbage production, disposal, and processing continued alongside the cultural and symbolic processes by which the entire country sought to sanitize its public spaces, removing many monuments to Franco and his followers. These measures were not without opposition, and they continue to be controversial today. Stapell attributes increasing civic confidence in Madrid, in part, to the removal of more than two dozen street and plaza names honoring Franco-era political and cultural figures. The Paseo de la Castellana (formerly called the Avenida del Generalísimo) was one of the more noteworthy avenues to revert to a less repugnant title.[34] Tierno Galván remarked, in defense of that particular onomastic project, that "we are ready for the Civil War to erase itself from [our] consciousness and have it remain only with the intelligentsia as a historical memory."[35] One of Almodóvar's most quoted comments of the era had to do with his rejection of Franco's memory.[36] Viewed alongside the themes and forms of his 1980s films, Almodóvar would seem to share Tierno Galván's approach to history. Aguilar and Payne have outlined more recently how the Transition was, for a variety of reasons and with an array of consequences, always loathe to recognize or account for past violence. Thus, the dominant critique of Spain's Transition was the near absence of any kind of cultivation of "contentious coexistence," especially in terms of the country's acknowledgment of and reparations for the brutal Francoist repression.[37]

It was largely Tierno Galván's vision that remade Madrid after Franco. The mayor's aim to integrate diverse stakeholders in the political and cultural project of creating a new Madrilenian identity was based on a politically progressive, at times utopian, projection of integration that relied on the participation of district councils, exhibitions and planning committees, the organization of popular festivals, and the revitalization of popular cul-

tural practices. But it was not without its costs, since the recent Spanish past was one of the things that were lost to Galván's egalitarian program.

NEW URBANISM AND ALMODÓVAR

In his book *On Garbage,* John Scanlan describes how any kind of "enlightened" process of urban or ideological design, no matter how well arranged and employed, always leaves traces of what he calls a shadow existence. One of the key philosophical maneuvers of Enlightenment thought was the construction of the Nature/Culture binary, which allowed Culture to submit Nature to its control. The Western pictoral tradition was subsequently built on the notion of an expansive, possessable exteriority.[38] Trash is the spectral leftover of this political, aesthetic, and philosophical operation. Waste is one of the traces we leave in the world, material evidence of how capitalist modernity flourishes by constantly cheapening Nature: the paper napkin tossed into the wastepaper basket, the plume of carbon dioxide escaping from the exhaust pipe of the car or bus or motorcycle, the chicken bones left on the plate, the early-model iPhone resting in the back of a bedroom drawer. We know that the logic of consumer capitalism is also ruled by a temporality that is always prepared to send objects into oblivion, with its "sell-by" dates and planned deaths of objects through programmed obsolescence, relentless regimes of newness, new versions, updates, upgrades, new operating systems, packaging, platforms, and beyond. As Gabrys notes in another context, the inevitable disposal of consumer products is part of their life cycle, but it is not the end of it.[39] We might extend this formula to encompass urban space, which, in a neoliberal market society, is always earmarked for future obsolescence, as the city is written and rewritten in the service of marketing space for capital investment. We can see this dynamic played out in the photography of Jordi Bernadó and Óscar Carrasco (chapter 3), whose cameras capture the decaying spaces created by rural-urban migration, inner-city development, industrial pollution, and architectural design.

There is perhaps no film that depicts more coherently the dynamics of Madrid's transformation from quaint center of Francoist society to late-capitalist European capital than *Mujeres al borde de un ataque de nervios* (1988). The film was written and produced just after Tierno Galván's death, during a time when Madrid's experiment with regionalism was ending. The elections of 1986 marked the moment when the PSOE's national leaders tacked toward neoliberal economic policy and European convergence, seeking cen-

tralization over social mobilization.[40] As one of the Transition's foundational fictions, the film was the first to bring Pedro Almodóvar to mainstream global prominence as democratic Spain's most visible and colorful *auteur*. The movie demonstrates how the field of cultural production worked hand in hand with market capital and the Spanish political class in imagining a democratic state populated by emotionally damaged citizens obsessed with getting rid of any traces of the past.[41] The film also corresponds to a moment when the robust youth-oriented regional culture known as the *Movida madrileña* gave way to a Europeanist neoliberal model of democratic culture.[42] Stapell has described how national pressures coming from the leadership of the PSOE effectively ended Madrid's more open regionalist identity and, "as madrileños relied less on active cultural engagement and more on passive material consumption to define themselves, the active form of democratic identity that initially developed during the first half of the 1980s was replaced by more passive forms of identification by the 1990s."[43] The friction between consumerism and citizenship as competing bases for democratic belonging continues to this day.

It is fitting that a film produced in Madrid toward the end of the 1980s should figure housing and the disposal of domestic waste as central narrative and thematic elements. Without spoiling the film's considerable pleasures, it is nevertheless useful to outline some of its main plot features, since they have so much to do with dumping: Pepa has just been left by her lover, Iván, with whom she works as a voice actor dubbing foreign (American) films. She at once wishes to communicate to him that she is pregnant, but she also wants to get rid of the sentimental souvenirs he has left in her apartment. Her attempt to sublet her apartment leads to the film's climactic encounter, in which potential renters, a telephone repairman, local police, and an array of Pepa's friends and family end up together drinking the gazpacho she has spiked with barbiturates. The film ends when Pepa saves Iván's life during a melodramatic standoff with his ex-wife, Lucía, staged at Madrid's Barajas Airport.[44]

Appropriately, *Mujeres* opens with an establishing shot of a miniature housing block, which purports to represent the protagonist Pepa's home in a fashionable part of the city. Gorostiza points out that "the scene is that of a fake, upscale penthouse, which can be considered as a reproduction of Madrid [*sic*],"[45] located, most likely, on Calle Alcalá, although characters mention the address as Montalbán 7. The same mockup of the apartment building appears in a later scene, when Pepa visits her real estate agent to put her penthouse apartment on the market (fig. 5). As noted above, the ap-

pearance of Pedro Almodóvar's brother Agustín—who is also his executive producer and cofounder of their production company El Deseo—in the role of real estate agent is a noteworthy detail. When he first appears on-screen he is gluing a Captain America toy to a scale model of a new Madrid apartment building. The image is particularly evocative because it is a reflexive moment in a film that is single-mindedly concerned with the aesthetics of urban and interior design. This picture of Almodóvar's executive producer playing with a miniature Madrid in transition (other establishing shots of the real city show construction cranes, and background images contain dumpsters filled with building debris) acknowledges the close relationship between processes of transnational capital investment and the creation of urban space, and it signals the crucial role that cinema and TV have always played in promoting those political and economic activities.

In what remains of this chapter, I want to read this film as an example of the kind of thinking we can do with trash, elaborating first on how Almodóvar represents a crucial moment in Madrid's history when the more open and exuberant Madrid of the *Movida* that we saw in his first films (*Pepi, Luci, Bom y otras chicas del montón* [1980; Pepi, Luci, Bom and other average girls]; *Laberinto de pasiones* [1982]) begins to cede its claim to the city as the PSOE's Europeanist model of neoliberal consumer economy takes center stage. If the earlier Tierno Galván ideal was ostensibly arranged in order to create civic pride and promote cultural feelings of belonging in the Spanish capital city, the PSOE model that supplanted it sought similarly to instill a logic of cleanliness, but with an eye toward attracting transnational capital. I am offering a reading of the film's narrative and temporal structures that shows how it forces viewers out of a historical mode of address and into a presentist-capitalist temporality, or what Fredric Jameson has described as the perpetual present of postmodern culture.[46]

The concepts of time and space in *Mujeres al borde de un ataque de nervios* are rigidly circumscribed. The film takes place over two days and two nights, mostly in Pepa's Madrid apartment. Temporality as motif is established in the opening sequence in which Pepa appears unconscious upon her bed, surrounded by clocks of various sizes, shapes, and colors, all ticking away while she sleeps. The movie's melodramatic plot depends entirely on timing for its narrative and symbolic meaning. In turn, that timing is made visible in the film through the mise-en-scène of timepieces and the narrative thematization of coincidence.[47] Characters are constantly either arriving at the places others have just vacated or finding themselves in the same places as others. Pepa's inability to occupy the same time and place as Iván is what drives her

to the "verge of a nervous breakdown." Many of these coincidences happen when people come into contact with the discards of others: a framed photograph of Iván's son is tossed from an apartment window precisely where Pepa occupies a phone booth; the seemingly random tossing of an LP from Pepa's apartment hits Iván's girlfriend in the head; Pepa discards Iván's belongings in a dumpster just as his new girlfriend arrives to pick him up; a fallen shoe reappears minutes later in the *portera's* hands. These coincidences of time and place structure the film from beginning to end, creating the illusion—common in Almodóvar's pictures—of the existence of a coterminous community of creative elites going about the business of curating their space.

In *Mujeres al borde de un ataque de nervios* coincidence is not just a melodramatic mode; it is also a reflexive one. Most of the actors appearing onscreen work as voice actors. Dubbing and the postproduction recording of sound depend on the mastery of temporal coincidence; the voice actor must time his and her voice to coincide perfectly with the moving lips of the actors on screen. But in this film, dubbing is not only a motion picture industrial practice; throughout the movie, there are numerous instances in which one character reads aloud words written by another, which, when read, are heard in the voice of the writer. Characters are constantly picking up and delivering lines penned by others, as in the case of Pepa's note to Iván, which is read aloud not just by his ex-wife but also by a sanitation worker who finds the paper on the sidewalk, and Iván's autographed photos and postcards are constantly turning up in the hands of others who read his words aloud. These offstage instances of informal "dubbing" outside the sound studio point to the functional flexibility of language, as words are written, uttered, or sung by one character in one context and then mouthed, imitated, or recited by others in another. (Dubbing is also how most Spanish viewers experience Hollywood films in Spain.)[48] The concept of recycling language is clearly relevant to the linguistic and narrative structures of the film, as words, sentences, and phrases are cast off then picked up by others to be uttered again in new and novel contexts. This dynamic of quotation and appropriation can also be related to Almodóvar's highly allusive, anthropophagic approach to filmmaking.[49]

One of the things I am trying to convey here—in talking about timing and coincidence—is how waste works to trigger an emergent mode of temporal thinking in 1980s Spain. Waste, waste-making, and waste disposal are related to a melodramatic "present-time" that is always coming into being. At the beginning of the film, Pepa, like the other women who give the film

its title, are disconnected, temporally and spatially unmoored during the dramatic two days and two nights that unfold in Madrid. They are all "out of time" or "out of sync." For them, the present is a time out of time. The idea of obsolescence that is suggested symbolically by these characters is incarnated in the film through the repeated visual instances of garbage, trash, debris, detritus, and rubbish, which all denote an expended use-value. Dumpsters are constantly popping up in the mise-en-scène, where Iván's suitcase is discarded by Pepa, then reclaimed by his new girlfriend; Candela appears atop a mound of garbage at an unregulated dump at a graveyard on the outskirts of Madrid, where she gets rid of the evidence that her terrorist lover has left in her apartment; Pepa's note to Iván is thrown away by his ex-wife, then recovered from the bin by Pepa, then found again by sanitation workers on the sidewalk. Garbage trucks trundle through Madrid as nocturnal witnesses to the romantic dramas unfolding throughout the city. These are trash specters, the agents of urban order that we normally do not see but that are always functioning at night, preparing the city for the diurnal circulation of people, goods, and capital.

When Pepa ejects the answering machine from her apartment, she also begins the process by which she will eventually reject the temporal, medial, and spatial logics for which it stands. The machine's totemic value within her lived environment is emphasized in its monolithic appearance within her mise-en-scène. There, the medium really is the message, since the answering machine and telephone do not function as intermediaries at all.[50] The technologies of connection that are figured so prominently in the film— the screen, the projector, the movie camera, the telephone, the answering machine, the microphone—are all devalued as modes of contact. In the end, communication is possible only when unmediated human presence happens.

MUJERES AS MUSEUM OF FAILURE

Viewing the film decades later, we can also see how Pepa's expulsion of the answering machine from her apartment also prefigures that device's future technological obsolescence (at the same time that it prefigures the dominance of social media as constitutive of social relations in the global/digital era). Technological artifacts appearing within the film are figured, quite literally, as material debris left over from obsolete technologies. In this regard, the film itself functions as an archive of technological obsolescence, offering contemporary viewers images of failed or outdated technologies

and their utility.[51] The cinema has long been considered an archival medium, on the one hand capturing visual and audible evidence of the historical material world and, on the other, recording some of the cultural aspirations and obsessions of the people who make and view movies.[52] *Mujeres* at once provides images and sounds of what Dudley Andrew describes as "the facticity of teeming life" of which all movies are made. It also operates as what the media historian Will Straw calls a "museum of failure," providing a lasting record of technological obsolescence that in turn reveals the permanent impermanence that underpins consumer capitalism.[53]

Plastics, according to Bernadette Bensaude Vincent, are "the archives of the twentieth century."[54] Accordingly, plastic is a major player in 1980s Madrid. Its mutability, relative economy of production, and consequent ubiquity in the consumer-driven Spanish society of the 1980s makes it an important material, too, in Madrid's *Movida*. This makes sense, since global cultures have been permeated by the distinctive plasticity of the synthetic polymers that make up plastic. In 1971, Roland Barthes described the material as "a wonderful molecule indefinitely changing."[55] The material's abundance, cheapness, disposability, ephemerality, make plastic a utopian material for the confection of postmodern Western aesthetics. And plastic is what makes Almodóvar's world go 'round: from acrylic furniture to obsolete cassette tapes, and from vinyl discs and polyester pants to latex dildos, plastic is everywhere. Silicone, too.[56]

Plastic, which Gabrys calls "the archetypal material of invention,"[57] also stands as the sign and symptom of mass consumption, ecological contamination, and disposal. If, in *Qué he hecho yo para merecer esto* (1984), the main characters were constantly being hailed by consumer products to which they had limited economic access, by the time *Mujeres al borde* is produced four years later, there is so much plastic stuff and junk, so many unwanted devices and things that Almodóvar's women now have to find ways to get rid of them. Lucía (Julieta Serrano) is the only character to hold onto things, but it is her inability to let stuff (and people) go that in some way codes her as imbalanced or psychologically unstable. Girelli notes how "Lucía's acquisition of subjectivity is heavily regulated by patriarchal manipulation" in the film, and suggests that one of the manifestations of her psychosis is apparent in her "maniacal identification with bygone fashion."[58] Although Girelli suggests that the film allows for the possibility that Lucía's insanity is a masquerade, there is nonetheless a link established in the film between the performance of emotional instability and an inability to relinquish the souvenirs that she uses to remember the past. In this regard, she, like Pepa,

is a quintessential denizen of 1980s Madrid. But this is not the only thing to be gleaned from the film. The reiterated returns of jettisoned materials throughout the narrative demonstrate repeatedly that any permanent form of discarding is impossible. If, as Stouffer put it, "the future of plastics is in the trash can,"[59] then the future of trash is plastic. And plastic is forever. Throughout *Mujeres*, objects are constantly returning to their owners or being picked up by new ones, demonstrating that there is never a "simple periphery to which objects can be jettisoned."[60] Like a bad penny, plastic always comes back. Is there a more fitting material metonym for the project of postdictatorship Spanish culture and urban space?

Design is an increasingly crucial component of Almodóvar's macro-melodramatic film world. As Marsha Kinder has shown over several important essays, "Almodóvar's all-accommodating form of macro-melodrama led him to treat all of his films as part of the same super-text, as an unfolding narrative network of melodramatic tales in a wide range of tones whose boundaries frequently dissolve and re-congeal into new patterns."[61] Those texts in turn have drawn from an array of cultural materials external to his film world, part of the "database" from which he draws images, sounds, people. In keeping with this chapter's focus on waste and Madrilenian space, I want to insist that the plasticity of Almodóvar's film world responds to and reflects the dominant political and economic commonplace that viewed— and continues to view—the Spanish capital city as utterly, fundamentally, and permanently plastic. By "plastic," I mean capable of being molded, shaped, twisted, formed into an image befitting the late-capitalist modernity to which its politicians and financiers aspire.

Personal design, urban design, plastic design, biological design: these have always been important aspects of how Almodóvar perceives and represents the world. But what I want to emphasize in the concluding pages of this chapter is how the logic of disposal—the throwing away or casting off of things, usually plastic things—functions in the 1980s films to create new social relations. Images of electronic artifacts and plastic castoffs in *Mujeres* draw attention to the ways in which obsolescence delineates duration,[62] or brackets time. As Jennifer Gabrys elaborates in an evocative essay on media in the dump, "when we insert these failed objects into the archive, we encounter their impermanence in high relief."[63] Impermanence, though, does not mean disappearance. Relations between people and things remain fluid, always allowing for new possibilities, new uses, new roles, new relations. Disposal is but one phase of the existence of consumer electronics and plastics. In Almodóvar's films, the notion of "using up" and discarding

are constitutive of social relations in the modern city. Plasticity character-
izes the relations between men and women in *Mujeres* at the same time
that the plastic souvenirs that people discard represent a sentimental past
that they would just as soon forget. The movie is all about getting rid of
inconvenient traces of the past: a suitcase, a vinyl record, a cassette tape, a
synthetic-leather shoe, a social relation. But these things are always coming
back. What Almodóvar's films demonstrate is that stuff and people become
entangled and attached. Things are not done with us even if we are done
with them. Nor are people. Plastic in Almodóvar's world is imbued with
an animistic power to return, to spring back into place, to stake its claim to
our environment.

In the aspirationally ahistorical milieu of 1980s, people use plastics to
maintain psychic and emotional attachments. In Almodóvar's world, the
idiosyncratic curation of outmoded plastics is a way of creating meaning.
I noted above that Lucía is a collector of outdated fashion. But the Almo-
dóvar film universe is populated by an assortment of eclectic collectors of
stuff. Pepi (Carmen Maura), in the director's first feature-length film, *Pepi,
Luci, Bom, y otras chicas del montón* (1980), lives in an apartment decorated
with superhero paraphernalia, and asks her archrival—the rapist police
officer—mischievously, "¿Y no sabe usted que las plantas de plástico están
de moda?" (Don't you know that plastic plants are in fashion?). In *Matador*
(1986) María (Assumpta Serna) keeps a personal museum of Diego mem-
orabilia in her home. Toy dinosaurs, a cowgirl Barbie doll, and a porcelain
Marilyn Monroe are part of the altar that Tina (Carmen Maura) keeps in *Ley
del deseo* (1987; The law of desire). And, in *Átame*, Marina (Victoria Abril) and
her neighbor both display dolls and action figures in their bedrooms. Plastic
action figures appear in Esteban's room toward the beginning of *Todo sobre
mi madre* (1999; All about my mother). As Benigno (Javier Cámara) roams
through the house that Alicia (Leonor Watling) shares with her psychiatrist
father in *Hable con ella* (2002; Talk to her), carefully arranged rows of col-
lectible toys (cars, mostly) can be seen next to the bedroom. There are the
"joyas" (jewels) ("es un plástico buenísimo" [it's a very high-quality plastic])
that Agustina curates as keepsakes from her disappeared mother in *Volver*
(2006; Return) and the *muñecas* that Soledad (Lola Dueñas) brings with her
from her aunt's house, and that later Raimunda's (Penélope Cruz) daughter
plays with while talking to Irene on the bed ("¿Te gustan las muñecas?" [Do
you like dolls?]). In *Los abrazos rotos* (2009; Broken embraces) Mateo Blanco
(Lluis Homar) has a collection of toy robots in his living room; they are vis-
ible when he and Lena (Penélope Cruz) are making love. The aging director

played by Antonio Banderas in *Dolor y gloria* (2019; Pain and glory) lives in a carefully curated apartment that an ex-lover describes as a museum.

If we picture these plastic toys and pop-art collections, and consider the architectural mock-ups appearing in Almodóvar's movies (figs. 5, 6, and 7), a series of interrelated hypotheses arise in response to the question I asked, in the opening pages of this chapter, about what Almodóvar has to say about the politics and design of postdictatorship Madrid. Gorostiza describes the mock-ups appearing in Almodóvar's early films mainly as icons of Madrid. In *Kika*, for example, the miniature Madrid that appears in the mise-en-scène is a model of a city seeking to define itself.[64] But the architectural replicas in Almodóvar's 1980s films do a lot of other things, too. Most importantly, the models serve as a way of registering precisely the ongoing regional and municipal efforts, described above, to twist and pull Madrid's urban spaces, to exploit its plasticity. The models are also a way of introducing into the films a reflexive notion of urban scale: large-scale family melodrama is made bigger when Rebeca looks down on a small-scale Barajas Airport. This is a mise-en-scène positioned also as a melodramatic mise-en-abyme: Rebeca surveys a toy-sized airport at the same time the viewer watches her in the airport (fig. 6); meanwhile, Almodóvar is able to hide himself behind the maximal design of his nested dollhouses, the architect of his melodramatic worlds of excess.

The architectural replicas appearing in Almodóvar's films of the 1980s are scale models standing for the actual lived spaces that their Madrilenian protagonists inhabit. They are also icons of the urban as (1) constitutive or reflective of personal identity; and (2) as a place that is inherently and

Figure 6. From *Tacones lejanos*, Pedro Almodóvar, 1991. (© El Deseo)

constantly in a process of change. If Madrid itself was being modified by the less visible forces of politics and economic investment, the authorship of change in Almodóvar's mise-en-scènes belongs to creative men invested with the power to move people around and to alter their cityscapes. The picture of Agustín Almodóvar placing plastic dolls within a scale mock-up of a housing block is especially evocative because this is what the El Deseo enterprise has always done: move bodies through postmodern plastic spaces. That movement, in turn, moves Almodóvar's audiences.

As Stapell has illustrated, Tierno Galván ambitiously built a more livable city center around an improved transport system, new green areas, cleaner streets, and rationalized processes of waste removal and disposal. The mayor's aim to integrate diverse stakeholders in the political and cultural project of creating a Madrilenian identity was based on a politically progressive, at times utopian imagination of social integration that relied on the participation of district councils, exhibitions and planning committees, the organization of popular festivals, and the revitalization of popular cultural practices. But it was not without its costs, as the recent Spanish past was one of the things that were lost to this utopian program.

Pedro Almodóvar is both a logical product of the plastic 1980s and their most eloquent defender. He was one of the *Movida*'s most enduring poster boys, and his early Madrid films capture the dynamism and plasticity of Tierno Galván's progressive urban vision. The plastic lifeworlds that capitalist urbanism created for modern Spaniards became, logically and fruitfully, Pedro's playground (fig. 7). This is not to say that history is completely absent from the Almodóvar universe. The rural world is always figured in his films as an unchanging if distant *locus amoenus* where characters retreat when they need to find a temporal and emotional anchor. Geographic dislocation is often accompanied in his movies by a nostalgic yearning for a lost maternal-rural space, represented by the Manchegan towns appearing in *Qué he hecho yo para merecer esto?!* (1984; What have I done to deserve this?!), *Matador* (1986), *¡Átame!* (1990), and *Dolor y gloria* (2019). Fittingly, *Kika* (1993) ends with its eponymous character (Verónica Forqué) confiding in a handsome hitchhiker, "Eso es lo que necesito: un poquito de orientación" (That's just what I needed: a little orientation), as she leaves plastic Madrid behind.

MELODRAMA, MODERNITY, DEBRIS

Trash, electronic or otherwise, is a fitting material metonym for the women appearing within *Mujeres*, because they are all pictured, at first, as victims

Figure 7. From *Kika*, Pedro Almodóvar, 1993. (© El Deseo)

of impermanent romantic relations, failed communication technologies, wasted objects of desire cut loose within a rapidly changing urban milieu. The failed logic of disposal is what sets in motion the melodramatic plot, which depends on the continued circulation of these people with a Madrid loosely organized around objects and their human owners. Recalling Gabrys, it is important to remember that neither acquisition nor disposal are final moments in the life cycle of the commodity (human or otherwise).[65] In *Mujeres al borde de un ataque de nervios*, trash and trash-making serve temporal functions, marking specific moments in the life cycle of things and people (objects of consumer desire, objects of masculine sexual desire) as they pass from being wanted, to not being wanted, and back again. As Mauritzia Boscagli notes in her radical materialist account of stuff, "the discarded object makes visible how much both subject and object are co-implicated in the networks that produce each of them."[66] Consumer items exist as such only insofar as consumers exist to purchase them. But what happens when there is no one to behold the shiny new product? What happens to the people we leave behind?

The numerous time-keeping devices appearing in the film, considered alongside the motif of coincidence, sound design, dubbing, and the temporal-spatial logics that make those motifs function in the film, recall the precarity of things and people generally and the uncertain nature of their status. The relations between people and things are always in flux, and their use-value is always being negotiated, reevaluated, and reconsidered by a society organized increasingly in terms of market value. In this regard,

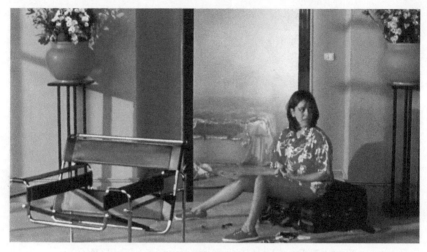

Figure 8. From *Mujeres al borde de un ataque de nervios,*
Pedro Almodóvar, 1988. (© El Deseo)

Almodóvar's subjects are thoroughly modern subjects. The work they do onscreen is the work of modernity itself, crafted to a human scale.

In figure 8, Pepa has tried to clear her apartment of all mementos of Iván, to shed her past in order to begin a new future based, perhaps, on independence and female solidarity. I have suggested that the movie's plot revolves around her attempts to curate her space—to throw away the objects of her affective history—and as such *Mujeres* encapsulates the neoliberal structures of postdictatorship Spain. Modernity, as Zygmunt Bauman notes in his book *Wasted Lives,* is all about "rejecting the world as it has been thus far and the resolution to change it."[67] Modernity, along with the modes of living and being that it requires, "depends on the dexterity and proficiency of garbage removal."[68] Almodóvar's characters are compelled by the desire to expel the material leftovers from their affairs. Iván's ex-wife Lucía (Julieta Serrano) cannot let go, and thus she is coded socially as "crazy." Her father wonders why she holds on to old wigs and hats rather than throwing them away. Her inability to jettison the past is figured in the film as a kind of psychosis; she is the character least equipped for survival in the modern urban milieu that is 1980s Madrid.

The reading of trash I am proposing here could be deployed across other Almodóvar films, which—well into the 1990s—feature protagonists who wrangle with varying degrees of success against the aesthetic and political structures of an urban environment that offers no place for the past. Steven Marsh has noticed that "Almodóvar has always been fond of bathrooms,

dressing rooms, and offstage spaces, locations on the sidelines of the conventional main action. These are threshold locations, intermediary sites, and zones of transit that often work to accentuate the flexibility of identificatory processes."[69] But as Almodóvar progressively refines his aesthetic, waste becomes more difficult to spot; bathrooms and dressing rooms—the thresholds and interstitial spaces—cede their importance in the Almodóvar film world until, in *La piel que habito* (The skin I live in), any sense of concrete time and space is completely effaced.

I mentioned earlier that in *Tacones lejanos,* Becky steps in some dog shit upon her return to her birthplace. In *Flor de mi secreto,* Leo (Marisa Paredes) and Paco refer to the Roca brand of toilets as secret code for their terminal love. But in what we might call Almodóvar's dirtiest movie yet—*La piel que habito*—the director disavows garbage, waste, trash, completely. The pieces of clothing that Vera disappears with an integrated HVAC system are only a few of the things that go conspicuously missing in that movie, vanished behind the cinematic sleight of hand that is suture. The other thing to disappear from that film world is any sense of historical space or time.

Melodrama is an appropriate register for a filmmaker obsessed with the present tense. In his influential essay on the classic Hollywood cinema, Thomas Elsaesser described how domestic melodrama has been traditionally considered an "excessive" genre whose unhappy protagonists are examples of the failures of liberal idealism.[70] Offering a genealogy of the form, Elsaesser notes that "industrialization, urbanization, and nascent entrepreneurial capitalism have found their most telling literary embodiment in a type of novel clearly indebted to the melodrama."[71] The dynamic orchestration of spatial and musical categories is crucial to the melodramatic form.[72] In melodrama, speech and discourse tend to be devalued in favor of sound and, most importantly for this discussion of Almodóvar's aesthetics, other physical aspects of the mise-en-scène. Space and sonic structures take precedence over intellectual content or "story-value." Elsaesser proposes that the aesthetic effects of Hollywood melodrama are derived mostly from lighting, composition, and décor, so that external action is sublimated to internal conflict and emotion. The melodramatic character's emotional states and psychological conditions are often transferred into mise-en-scène, "décor, color, gesture and composition of frame."[73] This is part of the cinema's constitutive formal attributes, which, unlike the novel, must rely on "concentrated visual metaphors and dramatic acceleration" in order to convey compressed meaning.[74] Mise-en-scène becomes an objective correlative of characters' "pervasive psychological pressure."[75] Feelings, in other words,

are expressed not only through action and plot but also through proxy visual structures of the mise-en-scène, through overdetermined symbolic objects (or what Elsaesser calls "condensation of motivation into metaphoric images") that reinforce and reify emotional structures.[76]

Pedro Almodóvar is Spain's most prominent heir of the self-conscious Hollywood stylists Vincente Minelli and Douglas Sirk, and his appreciation of the power of mise-en-scène has been analyzed from an array of perspectives.[77] I propose that waste objects in Almodóvar's film worlds function as formal "leftovers" of his melodramatic plots, a temporal sign of people and things that have been "used up"—or dumped—following the climactic expression of emotion. "Expression" in this case functions doubly, since it also evokes a thing that is expunged, pushed out, or excreted. We have already seen the excremental logic of the early Almodóvar films, in which vomit, piss, blood, spit, and cum are expressed by many characters at key moments. These fluids, like tears, are physical manifestations of the melodramatic mode. We can read trash, too, as yet another part of this expulsive aesthetic system. Waste is both metaphor and metonym for Almodóvar's moving Madrilenians.

In his theory of film, Siegfried Kracauer underlined two important functions of the cinema vis-à-vis physical reality that distinguish the medium from photography: recording functions and revealing functions. Movement is inherently cinematic, he writes, since the camera allows the filmmaker to record chases, dancing, nascent motion, and inanimate objects. Alongside the recording functions of the cinema, Kracauer also elaborates on its revealing functions, which may divulge things normally unseen, phenomena overwhelming consciousness, or special modes of reality.[78] Things that are normally unseen might range from the very small, which are made visible through the close-up, to the extremely large, in the form of crowds, the transient (through the use of slow motion and fast motion),[79] and the overly familiar ("only in deliberately scrutinizing, and thus estranging" reality can we truly see it").[80] The cinema is also capable of revealing phenomena that either overwhelm consciousness (atrocity, for example) or escape consciousness by occupying what Kracauer calls blind spots of the mind. In these ways, films "alienate our environment by exposing it."[81] In a subsection devoted to "The refuse," Kracauer writes that "most people turn their backs on garbage cans, the dirt underfoot, the waste they leave behind. Films have no such inhibitions; on the contrary, what we ordinarily prefer to ignore proves attractive to them precisely because of this common neglect."[82] It is the cinema's capacity to reveal stuff that we would normally be happy

to ignore that makes it such a propitious medium for perceiving the residues that have been otherwise masked, hidden, concealed by our quotidian practices of vision. Indeed, as Chris Thill notes, "our films are littered with litter; our galleries are heaped up with photos and sculptures; and stagings are overrun with trash."[83]

At the same time, though, the cinema contributes to the building of an image of national space. At the beginning of his career, Almodóvar's films revealed the dirty if extremely utopian nascent reality of Spanish urban space and culture. But over decades, as he progressively refines his aesthetic, the "revealing" functions of the director's apparatus begin to lose favor as he develops a more sophisticated mode of "veiling." His vision becomes increasingly sanitized. *Mujeres al borde de un ataque de nervios* marks a transition point in the development of garbage aesthetics in Almodóvar's oeuvre; trash in the later films becomes progressively abstracted and next-to-invisible. An early film like *Pepi, Luci, Bom y otras chicas del montón* (1980), for example, explored the aesthetic possibilities of trash to question the hierarchies of taste that regulate the world of bourgeois culture and politics. Subsequent films made a space for the productive possibilities of garbage, materiality, stuff within their audio and visual structures. But after 2001, from *Todo sobre mi madre* on, Almodóvar's films begin to present a tidier response to Spain's material reality. It becomes increasingly difficult to find evidence of unruly material in these films, which clearly eschew trash and trash culture in favor of the cultivation of a prestige aesthetic more in line with global art cinema.[84]

La piel que habito is the result of a thirty-year process of aesthetic refinement by which Almodóvar has gradually selected, perfected, and otherwise "improved" his filmmaking, leaving to one side or eliminating trash elements that had once enjoyed a privileged place in his world. The radical contingency, coincidence, and unplanned events that (dis)organized the early films are replaced in that film by control, planning and refinement. Tracing Almodóvar's plots from their exuberant campy beginnings with *Pepi, Luci, Bom* to their Gothic endings in *La piel que habito,* we can see a progressive movement by which bodily emphasis has moved from the south to the north, from the body to the mind, from below the waist to above it, from the somatic to the psychological, from the septic to the antiseptic. The back-end issuances and bodily signs that made his early films such a naughty, nasty mess have all but disappeared behind a highly polished art cinema aesthetic. Now, when these liquids do appear, it is always within the safe institutional confines of labs, hospitals, and clinics.

On the one hand, the formal extravagance and all-encompassing referentiality of *La piel que habito* can be explained as a sign and symptom of Spanish postmodernity: by including images of diverse media within his films, Almodóvar goes further than almost any other Spanish filmmaker to capture the intermedial complexity of Iberian life in the twenty-first century. Paul Julian Smith proposes that Almodóvar's collected films function as a kind of time capsule in which we can see played out the major themes and issues of the country over the last twenty years.[85] The director's collected work reflects aesthetically the excess, multiplicity, complexity, flux, contingency, and difference that Scott Lash has found at the center of "the predicament of the contemporary self,"[86] and that Jim Collins has identified as one of the constitutive characteristics of postmodern culture.[87] In Almodóvar's late films, aesthetic reflexivity denotes an awareness of the particular embedded as it is in the global cultural array; it is, in Lash's words, both a "sense of being situated in a more contingent component of subjectivity" and a "sense of being more rooted, more foundational" in an age of reflexive modernization.[88]

Writing in the early 1990s, Graham and Sánchez described how Almodóvar's films conveyed the "schizophrenic dislocation—the 'fall out' from the dual process of fast-track modern and postmodern transformation—which typifies contemporary Spanish identity," and that his films exemplified "the apparent contradiction between being genuinely 'national' and, at the same time, modern European."[89] Harnessing the revealing functions of Almodóvar's cinema to see Spain's refuse, we can see how the director himself reflects the process of aesthetic modernization by which the country has sought, over the last forty years, to polish its international image in a bid to lure international investors, travelers and tourists. In just over forty years, Madrid went from being one of the dirtiest capital cities in Europe to being perhaps one of the continent's cleanest.[90] Through the centralization of waste-disposal authority in the 1980s, which shifted responsibility for garbage disposal from neighborhoods and municipalities to the newly formed regional governments, to the high-tech privatized trash-disposal methods inaugurated in the 1990s, Spain became a European leader in making its ever-increasing quantities of garbage disappear.

2 Trash, Culture, and Democracy in Contemporary Madrid

Están vendiendo un mundo de U.S.A. y tira.
Un planeta desechable sin póliza de seguros
y envase no retornable.
(They are selling a single-use world.
A disposable planet with no insurance policy
in nonreturnable packaging.)
—Danza Invisible, "U.S.A. y Tira"

Rubbish collectors are the unsung heroes of modernity.
—Zygmunt Bauman, *Wasted Lives: Modernity and Its Outcasts*

Over the course of a week in November 2013, a strike organized by Madrid's sanitation workers succeeded in radically changing the face of a city that had sought, over the course of the previous fifty years, to project an image of a clean, modern, hygienic metropolis open for international business.[1] June 1 of that same year marked the beginning of an advertising campaign funded by the British telecom giant Vodafone, which in exchange for three million euros ensured that the city's historic center would be known as "Vodafone Sol" for the following three years. Feinberg and Larson have described how this particular agreement was only one of "the latest in a series of reminders of how in Madrid, as in other large cities, the 'right to the city' . . . is falling more and more into the hands of the private sector,"[2] and how the "dual economic engines of finance and real estate" have increasingly shaped the lives of Madrilenians.[3]

The progressive privatization, sanitation, gentrification, and aestheticization of urban space was a central goal of the Spanish state after 1975. Through the lens of Marxist urban studies, Malcolm Compitello has traced the contours of how Spain constructed and reconstructed the country's urban space: "One of the most conspicuous ways this occurred was through

architecture and the processes of urban planning that surround it. Architecture becomes one of the most important ways in which these transformations are validated, and one of the most visible manifestations of this new Spain."[4] Building on signature work on urban theory authored by David Harvey (*The Urban Experience*, 1989; *The Condition of Postmodernity*, 1990; *Justice, Nature and the Geography of Difference*, 1996),[5] Compitello explains how Madrilenian urban space was produced in order to create a modern urban consciousness and a European image modeled on neoliberal ideology and aesthetics.[6] Those same capitalist processes depended on increasing amounts of municipal and personal debt, which increased and accelerated after 1990, to overcome moments of economic stagnation.[7] These were the neoliberal economic policies that led the country to its well-known dénouement of crisis and collapse after 2008, and that are still being felt by its people more than a decade later. The Spanish economic crisis never ended.

We know that capitalism reproduces itself through the very processes by which it appropriates space, but it is in the city where this process is perhaps most visible. (Chapter 3 considers the broad exurban operational geographies that sustain urban space.) Deploying Harvey, Compitello outlines how the increasing urbanization of Madrid—that is, the processes by which capital has molded the means by which humans experience time and space—functions within five areas of citizens' cognitive formation.[8] Harvey's strategy for attacking the question of how consciousness becomes urbanized is based on what he calls the "five primary loci of power and consciousness formation": individualism, social class, community, the state, the family (and "other forms of domestic household economy").[9] This is what Harvey calls the "urbanization of consciousness."[10] It is important to remember that within Harvey's theoretical formulation, the idea of the urban is not a thing, but a process, "a particular exemplar of capital accumulation in real space and time."[11] The urbanization of consciousness is also the neoliberalization of consciousness.

In the first epigraph to this chapter, the Spanish New Wave band Danza Invisible levies a critique of the neoliberal logic of accelerated consumerism and obsolescence that has taken control of contemporary Spain's collective consciousness. The song from which the epigraph is taken is titled "U.S.A. y Tira," which deploys an easy homonym (usa—to use) to capture the band's pointed commentary on U.S.A.-style capitalist culture: "dinero, más que la gravedad mueves al mundo / produces más basura en un segundo / de la que cabe en ningún basurero" (money, more than gravity you move

the world. You produce more trash in a second than can fit in any landfill).[12] It is this idea of a constant process of accumulation and obsolescence—of capital and its waste—to which this chapter will return shortly. Following a brief summary of how capital (aided and abetted by its state and municipal partners) has molded Spanish urban space through strategic partnering with the Spanish image industries, which, in turn, have contributed to those same processes in order to promote that space for capitalist reproduction, this chapter reflects on the power of detritus to reveal the underlying political and economic dynamics by which multinational capital flows in and through Madrid. It will also speculate on the ways in which the accumulation of the waste products of urban capitalism exert a power to expose the same processes that create them.

Although this chapter is related and indebted to theories of urban space and cultural geography, my analysis of Madrilenian trash draws more from the foundational texts coming from the field of trash studies.[13] It focuses principally on one form of media: popular digital photography. In what follows, I sketch out some of the different kinds of thinking we can do with images of trash, and what they say about our relation to what Danza Invisible calls our "single-use planet."

TRASH AND URBAN IDENTITY

In another important essay, Compitello describes how cities in democratic Spain endeavored to create and impose new urban identities through interrelated processes of cultural and capitalist production. He notes especially how cities, culture, and capital work together to reorganize and reinvent ideas about the urban.[14] It is worth remembering that these same dynamics of creating a "new" urban image had already begun during the Francoist 1950s, where a burgeoning tourism sector, the abusive expansion of construction throughout the country (ladrillo), and the intensification of a consumer society based on services and products were already the main economic drivers of the state.[15] Gómez López-Quiñones has outlined quite elegantly some of the unbroken links between the dictatorship's political and economic policies through to the present day, noting how these same processes transformed the country into an international laboratory where political and economic elites practiced an explosive alchemy: deindustrialization, the dismantling of production sectors, the expansion of debt underwritten by central European banks, noncompetitive salaries, the

limiting of social infrastructure and spending, the real estate bubble, and the exponential growth of finance industries.[16] In other words, the seeds of the 2008 financial crisis had already been sown decades before.[17]

As part of a longer discussion of the evolution of Madrid as a cinematic city, Compitello describes how on-screen images of architecture function to visualize the insertion of capital in space. In this way, city movies can be interpreted as products of "urbanized consciousness" that give form to subsequent evolving visions of the city, cultural, social, economic, and political.[18] As I noted in chapter 1, Almodóvar's collected films work as object lessons in how audiovisual culture works, alongside capital, to construct certain kinds of urbanized present-centered personhood. If his earlier films offered a special vision of Madrid in which a more radical critique of bourgeois culture and sociality could be discerned, by the mid-1990s any kind of critical distance from hegemonic culture had given way to a more consumer-oriented aesthetic.

But this dynamic does not flow in only one direction, for visual culture does not only reflect and promote urban space and culture within its projections of urban experience; it also impacts, at the same time, alongside capital, those same material spaces of the city. The transformational liquid processes that embody late capitalism require a multidirectional flow between reality and representation, between image and lived space, by and through which they impact each other. If a film, as Compitello argues, functions as a product of an urban consciousness, in the context of postmodern Spain the city can be understood also as the product of the politics of the moving-image. Landscape, urban or otherwise, has multiple functions in the cinematic text, as place, as space, as spectacle, as metaphor.[19] But the same filmic text or group of film texts (that is, cinematic culture in general) also impacts the interpretation of real spaces themselves, and has the power to absorb them into an image machine that works to form the same capitalist consciousness described above, but molded to fit a visual and aesthetic consciousness. The Spanish director of production Tedy Villalba remarked, in 2014: "Madrid is well prepared to film. It's cheap, it has infrastructures, and great human resources."[20] Those same lived spaces of the city have been transformed over time—through an audiovisual logic that emphasizes precisely those characteristics—in order to create a Möbius strip comprised of representation, reproduction, investment.[21] Even if a spectator has never been to a place before, the repeated appearance of icons representing places and buildings in film and television can create a representational legacy that constructs and establishes a cognitive map of the place, and a sense of

space,[22] which allows the spectator—national or international, domestic or foreign—to exercise a kind of filmic tourism.

Within disciplinary discourses of business and marketing, the connection between movies and tourism has been studied extensively.[23] Local and state cultural organisms have taken advantage of movie culture to sell Spain abroad. For example, the Turespaña webpage offers international travelers opportunities to engage meaningfully with "la España de Woody Allen," as seen in *Vicky Cristina Barcelona:* "Viva en persona la preciosa estética y el encanto que Allen retrata en el filme. Déjese cautivar por la sensualidad mediterránea de Barcelona o por los paisajes de Oviedo ideales para dar paseos en bicicleta. Compruebe que el cálido sol que reflejan los planos de la película es una realidad."[24] (Live, in person, the beautiful aesthetic and charm that Allen depicts in the film. Let yourself be captivated by Barcelona's Mediterranean sensuality, or by Oviedo's landscapes that are ideal for bicycle rides. Discover that the warm sun reflected in the film's frames is a reality.)

Long-term collaboration between Spain's local, regional, and national ministries of tourism and the country's leisure and cultural industries have had other impacts on Spanish space. In the contemporary Spanish cultural context, movies and movie culture have moved beyond the movieplex in order to meet the public outside theaters and living rooms. Describing a Canadian context not unlike the Spanish one, Charles Acland has explained how movie culture has become an inextricable part of our lives, especially in the city: "Marquees adorn our cities; video rental outlets dot local malls; star interviews and production news inhabit our television schedules; film posters decorate bedrooms, offices, and construction sites; promotional T-shirts are worn; entertainment sections occupy space in newspapers; celebrity gossip forms ordinary sociability; and stars' faces and styles hail us in commercial venues."[25] Spanish filmmakers and producers have become increasingly adept at exploiting the investment possibilities made possible by the expansion of movie consciousness.

Before shifting my focus back to the detritus that will be the principal focus of this chapter, I want to describe a few examples of how creative capital has contributed to the reflexive development and marketing of urban and rural space in Spain, beyond the Barcelona and Asturias lensed by Woody Allen in *Vicky Cristina Barcelona*. I have written elsewhere that part of the promotion of Agustín Díaz Yanes's *Alatriste* (2006) was comprised of a synergistic exposition on the topic of the "Madrid de los Austrias," where tourists and interested locals could walk the streets of the Austrian empire

where Díaz Yanes and his crew had shot key scenes from the film.[26] In the same city, in 2008, the "Manzana del cine" was formed, as a collaboration between Madrid's city hall and the various media and film companies that are housed at "Kilometro 0,8," near the Plaza de España, including the Renoir, Princesa, and Golem movie theaters and the Ocho y Medio film bookshop.[27] Meanwhile, tourism authorities in Castilla–La Mancha created the "Ruta cinematográfica Almodóvar," in collaboration with the director's production company, El Deseo, in order to promote tourist interest in the towns of Almagro, Calzada de Calatrava, Granátula de Calatrava, and Puertollano, where the director filmed key sequences for some of his movies.[28] The promotion of Pedro Almodóvar's birthplace by the tourism offices of Castilla–La Mancha demonstrates how the motion picture industry in Spain has functioned also to sell Spanish space to national and international audiences, offering cinephile travelers a way of experiencing physically and materially the visual geographies of the country and of accruing some cultural prestige in the process.

The shared efforts of politicians, artists, filmmakers, and multinational capital in Madrid (and in an array of global cities from Mexico to New York, Dubai to Shanghai) have contributed to the transformation of urban centers into urban spaces hospitable to tourists and international finance. This process represents a concerted effort to "recover" urban space through improvements in public transportation, the creation of green spaces, the cleanup of streets and rivers, the rationalization of sanitary services and public order, and the invention of new cultural initiatives (festivals, libraries, theaters, clubs, movie houses). These same processes coincided in Spain with the invention of a new regionalism—or regional identity—that had some progressive democratic outcomes during the "golden years" of the postdictatorship era in Madrid, but that later accelerated during the neoliberal phase after the national consolidation of the PSOE after 1986. The link between capital and its impact on the creation and evolution of urban consciousness in Spain is not arbitrary, since a crucial aspect of selling Spanish space to multinational capital has always depended on the creation of a national trademark ("marca nacional") that might generate new icons that could sell Spain.[29] Although the movie experience, much like that of the city itself, may activate all our human senses, John Urry emphasizes that it is the visual and auditory that tend to dominate the experience of tourism. The visual sense in particular "facilitates the world of the 'other' to be controlled from afar, combining detachment and mastery."[30]

TRASH, LABOR, ENVIRONMENT

Given the close link that exists between capital investment, development of urban space, reflection and representation of space within the media, and reproduction of capital, it was not surprising that when the streets of Madrid, in November 2013, began to fill with garbage, the mayor, Ana Botella, should receive strong criticism not only from citizens but also from her own political party (Partido Popular) for allowing the city's image to be tarnished by the material accumulation caused by the workers' strike. Nor is it entirely surprising that news and media treatments of the walkout should draw special attention to the *visual* damage that it was inflicting on Madrid as a tourist destination. In an article published in *El País,* the authors emphasized how municipal politicians perceived a clear danger of the city losing its favorable image, especially in other parts of Europe: "Las fotografías de contenedores desbordados y calles repletas de desechos en los principales diarios europeos (*Le Monde, Frankfurter Allgemeine, The Guardian* . . .) hicieron saltar ayer la alarma entre comerciantes y empresarios, preocupados por el impacto en la imagen de la ciudad y su efecto en el malogrado sector turístico, en caída libre. Madrid ha perdido un 6,7% de viajeros extranjeros en un año, según el Ministerio de Industria."[31] (The photographs of overflowing trash bins and streets filled with waste that appeared in Europe's main daily newspapers [*Le Monde, Frankfurter Allgemeine, The Guardian* . . .] set off alarm bells among the city's business owners and impresarios who were worried about the impact that they would have on the city's image and its damaged tourism sector, which was already in freefall. According to the Business Ministry, over the course of the year, Madrid has lost 6.7% of its foreign visitors.) Indeed, *Le Monde* published a video showing how the city's urban image had degraded, and the *Frankfurter Allgemeine* published an article in which a smiling Ana Botella, suitcase in tow, appeared in Madrid's Barajas Airport. The question was, where was the mayor going during this municipal crisis?[32] A pro-labor observer from Comisiones Obreras (CC. OO.) pointed out that during the holidays there was more economic activity and thus more trash, and this explained in part the surge in waste on Madrid's streets.[33]

The Madrid sanitation workers' strike represents only one of many skirmishes between labor and capital in contemporary Spain, but when we are talking about sanitation and health services, these kinds of conflicts take on an added material dimension, which, as we could see in national and international reportage on the strike, leads to a special kind of panic. On the

one hand, clearly residents were concerned about living amid the malodorous garbage that was amassing on the streets, but on the other, there was a clear concern among business leaders and politicians that the country's international image was taking a hit. There are many ways in which labor may register its discontent with unfavorable working conditions—boycotts, marches, picket lines—but those methods do not have the same kind of impact on aesthetics and environment. A sanitation workers' strike is special.

The relative success of the 2013 strike was owed precisely to its power to engage citizens, at first, visually, but then, as the strike continued over the course of a week, somatically, as waste began to rot and stink. In other words, the results of a sanitation workers' strike are more immediately perceptible because they impact the way people experience their city physically and bodily. There is a special affect that is triggered by garbage; waste moves people. Other kinds of strikes by other kinds of municipal service laborers have very different material repercussions. A public transportation strike, for example, causes its own kinds of inconveniences, principally of a temporal or spatial nature. Access to the city is slowed, and reliable transportational timeframes become more difficult to maintain. But when garbage gathers in the streets, in entryways, alleys, municipal buildings, everyone becomes enmeshed in a new kind of environment and a new kind of temporal frame. When trash stops disappearing, it has the power to transform public space into a visible, perceivable, feelable, odiferous dump. In this regard, trash always has the potential to be a social leveler.

In 2013, articles published in El País and elsewhere reflected how the city's political class viewed the sanitation strike primarily as an aesthetic crisis and, therefore, an economic one, since Madrid's untidy streets and uncollected garbage were impacting the capital's ability to represent itself as a propitious place for multinational capital to come and play. (For citizens, the crisis brought with it another list of problems, discussed below.) The fact that the Spanish capital now looked like an overturned dumpster led Hilario Alfaro, the president of Madrid's Chamber of Commerce, to declare that the sanitation strike was "un arañazo a la marca España" (a blemish on the Spain Brand).[34] Alfaro called upon the Ayuntamiento to increase cleaning services in the main commercial and tourist centers of the city, asked the striking workers to respect the required minimum services, and requested help from the Delegación de Gobierno (the Spanish state's representatives to the Community of Madrid). Online, El País published photographs taken by citizens. The images, archived under the title "Así ven la huelga de limpieza los lectores" (This is how our readers saw the sanitation workers' strike),

offered web users the ability to stroll virtually the streets of a city that had become, over the course of a week, an urban waste dump.

My research on the sanitation workers' strike suggests that few areas of the city were left untouched by the accumulation of garbage on the streets. In the *El País* digital archive of photos, piles of trash can be seen on street corners located throughout the city, piled next to containers, in front of residential buildings, on sidewalks and thoroughfares. Captions on the photos identified neighborhoods throughout Madrid, north, south, east, and west, from Chamberí and Salamanca, to Moratalaz and Caraban-chel. Zubiaurre notes that "trash is not born big."[35] But once it has been born, it becomes bigger through its own ontology and, increasingly, through its growing place in the material world we have made for ourselves. Litter starts small, but it gets big quickly.

Perusing the collected images, one can perceive visually a kind of temporal logic of accumulation and growth: earlier in the strike, the pictures suggest that residents began to leave their bags of waste in orderly piles near the appropriate receptacles. But as days went by, smallish piles became mountains of trash. Thus, these photos of uncollected garbage convey an image of their own temporality, establishing within their own visual structure a concept of extended time, a time during which the municipal waste system—and, importantly and by extension, an entire capitalist urban system—had ceased to function. The failure of the system lies, on the one hand, in its inability to mitigate the effects of the strike and to arbitrate the conflict between workers and municipal politicians aiming to deregulate and cut costs, but on the other, there is a clear failure of the system to disappear its own waste.

There are few events that make more visible the failure of the state systems that undergird neoliberal capitalism than the accretion of rubbish. When municipal sanitary services cease to dispose of the waste produced in the city, everyone coming into contact with the trash becomes aware of the immensity of waste as a social and economic problem. Capitalism depends on the externalization of the problem of waste onto state and municipal political authorities; this is one of the ways that the government subsidizes an economy that, in an array of markets and submarkets, depends increasingly on the logic of "usa y tira" (single-use). Gay Hawkins argues that it is precisely the system of waste management that allows capitalism to function, since "constant serial replacement is the backbone of commodity culture."[36] Commodity culture is the superstructure upon which late capitalism has built itself; capitalism is organized more around what Slavoj Žižek calls

the "global company,"[37] as opposed to traditional national or civic senses of belonging.[38] Similarly, the late Zygmunt Bauman argued that modernity itself depends on an epistemological logic of rejection and "garbaging" of old forms. This continual process of refinement, use, and commodification has always created residues.[39]

The creation of junk is a necessary condition of modern society and culture, but when castoffs cease to disappear they make visible those systems and practices that have created them, calling attention to the logic of disappearance upon which global capitalism depends for its continued function. I noted in the introduction that things often do not appear to us as things until they cease to function as they should. The material links between humans and things are often invisible until something goes wrong. As Ian Hodder suggests, "our entrapment in material webs often occurs because things have different temporalities."[40] But when we look at the trash, or an image of the trash, we are forced to recognize something that we normally do not see or want to perceive. Trash has a revealing function.

Waste is what Gay Hawkins has called "the shit end of capitalism," a thing that is left unseen, disposed of, invisible to everyday experience: it is "the part we like removed and disappeared as efficiently as possible; when it hangs around there is a chance we'll be reminded of the ethical and ecological consequences of constant accumulation."[41] Yet, in spite of our better efforts to make it disappear, garbage can be seen virtually everywhere, not just in the world but also in the global media: in documentaries such as *Trashed* (Jeremy Irons and Candida Brady, 2012), *The Gleaners and I* (Agnes Vardá, 2000), and *Consuming Images* (Bill Moyers, 1990); in big-budget animated features like Disney-Pixar's *Wall-E* (Andrew Stanton, 2008) and Alfonso Cuarón's sci-fi dystopia film *Children of Men* (2006); and in art movies produced in Korea (*Castaway on the Moon*, Hey-jun Lee, 2009), Austria (*Museum Hours*, Jem Cohen, 2012), and the Americas (*Nostalgia for the Light*, Patricio Guzmán, 2010). All of these works make visible the processes of producing, disposing of, or otherwise dealing with the presence of leftovers in the world, and each proposes different ways of learning from the trash we make, the residues we encounter, the material evidence that continues to exist in the world. In different ways, these visual meditations on trash are important because they ask us to reconsider the ontological permanence of the objects with which we fill our lives (or with which we share our existence), allowing us to begin to understand the vitality and diversity of things.

Perusing the digital archive of photos published online by *El País*, one begins to appreciate those capitalist processes described by Hawkins, Bau-

man, Scanlan, and Žižek, but playing themselves out in the aspirationally clean and modern Madrilenian mise-en-scène described by Compitello. Although in their captions the citizen photographers and journalists tend to direct blame for the mess toward municipal authorities—among them Ana Botella—particularly for their inability or unwillingness to meet the city's sanitation workers' demands, the problem in part involves all citizens since we all contribute to the creation of garbage in increasing amounts.[42] This is not to infer that individuals are wholly to blame for environmental degradation. As I noted in the introduction, consumer-awareness campaigns have been an effective strategy by which industry—working alongside the state—has sought to slow down meaningful systemic change. The ultimate responsibility for the global waste problem belongs to the economic and political system that values unlimited economic growth above all other things. If there is to be a meaningful response to systemic profligacy and anthropogenic climate catastrophe, it will have to involve degrowth.[43]

Looking at the photographic evidence, it is not difficult to understand why Spain continues to be one of the European countries that produces the most trash.[44] That being said, the entire Mediterranean corridor offers examples of how intensifying urbanism and economic growth has deepened the multiple flows of commodities, migrant laborers, materials, energy, tourists, and waste.[45] The Madrid trash strike begins as a cosmetic problem, but in the images captured and posted online by nonprofessional photographers we can also see that it is a crisis that has the potential to trigger— if temporarily—an ethical consciousness of the problem of waste.

One would like to imagine that, as the garbage accumulated in November 2013 and time passed, perhaps citizens' indignation began to transform itself into a new kind of material consciousness. Perhaps I am being overly optimistic, but I would like to imagine that people began to ask themselves, "Why do we produce so much trash?" and perhaps even, "How might we reduce our creation of rubbish?" Is there another way to dispose of all these castoffs? Is this amount of packaging necessary? It is here that perhaps the more politically or ethically engaged citizens began to transform trash into editorial material. The photos appearing in the digital archive on El País and circulating through social media such as Twitter and Facebook showed how trash is never just trash. There is evidence that waste exerts chaotic power. Photographs can channel that power to critique dominant modes of capitalist production and waste.

Most people will have seen—on the metro, in a bus, on a kiosk, at a busstop shelter or within other public spaces—pithy political commentary and

Figure 9. *Ciudadano/ Consumista,* unknown artist. (© Samuel Amago)

sardonic responses to propaganda of different kinds in the form of graffiti. Some of this amateur graphic-visual critique functions better than others. The themes vary, from institutionalized corruption to environmental degradation and the death of political commitment in a population that has been transformed (not always unwillingly) from citizens into consumers. In figure 9, a series of well-rendered marker lines trace the contours of the transformation of a citizen into consumer, burdened happily with bags of stuff. The picture, drawn by an anonymous guerrilla artist, functions temporarily as an occupation of the Madrid public transportation advertising apparatus, with the aim of critiquing the dominant neoliberal municipal order.

The gradual transformation of individuals into business-units who were understood only in market terms was one of the social facts to which the 15M movement responded.[46] What I like about figure 9 is how it uses the city's advertising infrastructure to speak against this transformation of people into consumers. In his evocative analysis of stickers as queer political

commentary, José Esteban Muñoz outlines how guerrilla art of this kind has the power to transform public space into a place for debate, where people can "work through pressing social issues in a space away from the corrupt mediatized majoritarian public sphere."[47] As an inexpensive mode of political activism, the propitiously placed sticker or poster functions as a form of public pedagogy, reterritorializing urban neoliberal space, making it more hospitable to alternative ideologies.

The political transformation of an engaged citizenry into passive consumers is a central piece of the late-dictatorial and postdictatorial neoliberal project in Spain.[48] Figure 9 appropriates the commercial advertising apparatus—which at the same time occupies public space at a Madrid bus stop—in order to denounce neoliberal politics and culture in graphic terms. In a similar register, Figure 10 functions as a critique of the Ayuntamiento de Madrid's advertising campaign, which promoted and defended mayor Ruíz de Gallardón's massive and ongoing urban projects occurring just before the dawn of the financial crisis in 2007. Guerrilla artists replied to the Ayuntamiento's campaign with strategically placed stickers that responded to the conditional clause posed by the campaign, "¿Qué pasaría si nunca pasase nada?" (What would happen if nothing ever happened?). In figure 10, the white sticker appearing below the hypothetical question suggests that there would be "+ árboles, + silencio,—deuda,—contaminación" (more trees, more silence, less debt, less contamination). The guerrilla counterpublicity campaign was enacted through the distribution of postcards, the placement of stickers, and the hanging of posters, which functioned together as a critique of Ruíz de Gallardón's reckless mortgaging of the city's future in the service of realizing a series of Pharaonic urban projects.

Discards, too, can function as political commentary. The relative power of the sanitation workers' strike was owed in part to its massive scale and the fact that so many citizens of the city contributed to the creation of those mountains of refuse. One of the points I am trying to make here is that the placement of a bag of trash on the street can be a political act and the expression of community consciousness. While the more favored objects with which we fill our homes are, in Bennett's words, "encrusted with a thick coat of cultural meanings," the discarded thing—the demoted object—allows us "a glimpse into uncooked material power."[49] Context harnesses the material potential of things, channeling their energy toward socially established affects. But when materials are ejected from their context and stripped of their veneer of cultural meanings, they are freed to become something else and to act in other ways.

Figure 10. *¿Qué pasaría si nunca pasase nada?*, unknown artist. (© Samuel Amago)

The combustibility of the mounds of trash deposited throughout Madrid offered perhaps the most obvious and most dangerous mode by which indignant city dwellers expressed their frustration with municipal authorities who had doubled down on economic austerity and the expansion of the politics of precarity. The burnt trash containers, some of which were

located—unfortunately for their owners—alongside parked cars, stand visually and materially for the vehement rejection of the same public space curated by municipal politics. The blackened, destroyed dumpsters and bins evoke war zones or damage from domestic terrorism, unleashed material power. Burned dumpsters and trash bins are reminders that trash is never completely inert and that in any moment garbage can transform itself into an improvised weapon, magma for the confection of destruction.[50]

The forceful images of destroyed cars, recycling bins, and overflowing garbage receptacles remind us of the danger that trash has always had for the social and political order. As Maurizia Boscagli notes in her analysis of Douglas's work Purity and Danger (1966), "Just as the figure of the unassimilated immigrant opens the issue of possible change in the host culture, trash, refusing to give up its foreignness and otherness, becomes a threat, for it suspends any opposition between a classificatory order and the chaos of hybridity."[51] The burning of garbage is part and parcel of this feeling of unease, threat, possible danger; it is a symptom of the disquiet that residues cause when they are allowed to accumulate in the city. There is power in things. They have agency, vitality, and the power to move us.[52]

John Scanlan, also via Mary Douglas, observes that garbage is the stuff that allows us to establish a barrier between order and disorder within our lived environments.[53] And as Boscagli argues, there exists a logic within more official traditional discourses on trash that "only by reinforcing this liminal status and assigning trash to the negative tout court can order be reestablished."[54] In this sense, we ought to consider the burning of garbage in Madrid as perhaps the least effective method of resolving the conflict between labor and capital in the city. A more pedagogical engagement with waste might allow us to think about how capital works or does not work in the urban sphere. (It is worth repeating here that capitalism depends on the ever-more-efficient disappearance of its waste products for its function.) Trash burning is perhaps the least inventive of the political engagements with garbage that we can see in the photographs of the sanitation workers' strike; it is the most chaotic and least helpful way of transforming the trash into a weapon with critical power. What we see in other images is how trash is not just a negative thing to be destroyed or of which we must otherwise liberate ourselves. What I would like to suggest in the following pages is that trash—especially as it appears in some of the citizen photographs reproduced below—possesses a representational, critical, and political potential.

In many of the photographs, the location of garbage suggests the existence of a critical collective conscience. There appear piles of plastic bags,

used containers of myriad varieties, and detritus just adjacent to municipal centers of bureaucracy in the capital city, architectural spaces, and bank branch offices where capital and its representatives do their business. In the image of the "Centro de Salud La Alameda," in which we see a pile of rubbish in front of a medical center, mise-en-scène and camera positioning signal the insalubriousness of trash, but they also insinuate, thanks to a municipal metonymy of waste, a sickness of a broader social kind. The semiotics of the phrase "Centro de Salud" (Health Center), combined with the accumulated waste in front of the building, suggest that the well-being of the urban center is decadent, decaying.[55] The irony implicit in the juxtaposition of the building's name, which denotes this as a place of healing, and the detritus that appears in front of it creates a conceptual tension that allows us to consider the limits that separate sickness and salubriousness, interior and exterior, the municipal and the individual, and draws attention to those entryways and transit zones that link public space to the state entities that occupy and regulate it.

We might offer similar readings of the image accompanying the tweet published by Fernando Rubio, in which the entrance to an emergency clinic is obstructed by garbage, suggesting once again that Madrid is a city under siege by its own castoffs.[56] Similarly, another image credited to Juan Manuel Vidal, taken near the Plaza de España, interpolates the viewer within a suggested national geography extending beyond the capital city. The indicators of directions and places appearing on the street sign in the background (calle Bailén, Badajoz, Casa de Campo) suggest the possibility that perhaps this municipal mess stretches beyond the city center, a modern Community of Madrid filled with its own castoffs.[57]

Yet another image shows mounds of trash lying in front of monumental recycling receptacles whose openings conjure the idea not of "reception" but of eruption: the piles of containers, cardboard boxes, and plastic bags appear to have been expelled from inside the containers, belying the idea that discards could ever be contained. In the background, another billboard announces that this is a "local disponible," a place available for purchase or rental.[58] In literal terms, the phrase "local disponible" refers to the capitalist acquisition of (and speculation with) urban space, but in this image, the incidental text becomes, through collective collaboration (neighbors laden with their plastic bags and other debris) and individual artistic license (choice of point of view, mise-en-scène of trash, angle and inclusion of background lettering), a propitious locale for the elaboration of a performative and visual critique of the materiality of garbage and its presence within urban

space. In this way, citizens performing quotidian acts of domestic maintenance (the placement of domestic ejectamenta) have created a collaborative piece of urban art, a contemporary work of Arte Povera, which is in turn captured by the lens of a passerby with a camera (Juan Fran Valera), who frames and posts the image to an online archive. Thus, the interaction of domestic waste and urban space work together to suggest political action and critical commentary, not without irony. The concept of "availability" suggested by the background sign is further reinforced by the open garage door that can be seen in the background on the left of the image. The trash appearing in the foreground, however, creates an implicit dialogue with the real estate advertisement above it: yes, this is a space that is available, but it is also a place that contains garbage, that holds residues, and that in this particular moment does not repudiate its situation within a concrete urban milieu and a historical moment, imbricated in an implacable process of acquisition and consumption of products, space, and their waste. A less optimistic interpretation of the image might propose that the neighbors are simply intractable in their habits, dropping their trash willy-nilly. But I am choosing to emphasize the material affordances that trash conveys to its human producers. When we interact with things, there is more at stake than pure instinct.

What kinds of concepts are produced by the interaction of trash and urban space? In a citizen photograph of the facade of the Madrid branch of the World Wildlife Fund (WWF), there is a sense of a perceived threat of a generalized municipal contamination. The high-angle shot offers visual evidence of the corporeal situation of a specific citizen with documental proclivities (the photo is credited to Fuencisla Miguel), who has devoted herself in this moment to denouncing the fact that the stench of the garbage has reached the homes above ("el olor que produce la acumulación de basura llega hasta los domicilios" [the stench produced by the accumulation of garbage reaches the dwellings above]).[59] The high angle, combined with point of view, captures the spatial dynamics of malfunctioning municipal space. The three containers appearing on the right are reminders of the logic of sorting upon which the process of recycling relies: the separation of bottles from paper and cardboard, organic material from electronic waste, paper from plastic. And, finally, both recycling and trash pickup are designed to separate—efficiently and imperceptibly—waste from domestic space. In the Fuencisla Miguel image, though, the containers have failed to achieve their principal charge; they can no longer contain what they must contain; nor do they manage anymore to separate recyclables into their constitutive

categories. Nor do the containers appear to be poised or prepared to transport castoffs away from the urban center. Point of view and mise-en-scène combine in the image to expose the fragility of the municipal system of waste treatment and disposal, giving the lie to the logic of externalization of economic waste.

The panda bear—the global trademark of the WWF—stands as a visual juxtaposition of an environmental problem that has immediate localized impacts but also has a broad global reach. *Midway* (2013), Chris Jordan's beautifully photographed feature-length documentary on the plight of the Laysan albatross, which has been plagued by the ingestion of discarded trash in the Pacific Ocean, offers a moving reflection on how nature has been impacted everywhere by the trash—most of it plastic—that global society pitches overboard. The mummified birds, whose plastic content has fatally exceeded their stomachs' capacity, are visual evidence of the deadly exorbitance of global plastic waste. The images also trigger what Oppermann calls a vast terrain of imagination, evoking a mysterious avian curatorial impulse: why are some pieces of plastic more attractive to the birds than others?

Every time there is a media report on beached whales or birds found suffocated by plastics, we are reminded that local trash is a global problem with dire ecological impacts. Of the three things that can be done with waste—burning, burial, recycling—none makes it disappear totally. The American archaeologist William Rathje and his coauthor Cullen Murphy note that trash will be one of the most lasting physical legacies left by humans on Planet Earth. Their influential book on the archaeology of the contemporary era argues that one of the best ways to understand contemporary material culture is by digging through its apparently useless waste.[60] And as Gabrys, Hawkins, and Michael note, "more than any other material, plastic has become emblematic of economies of abundance *and* ecological destruction."[61]

In perhaps the most evocative of the Madrid trash images, a woman attempts to make her way through a mound of garbage blocking access to a branch office of the Bankia bank.[62] The words "Bienvenido a Bankia" (Welcome to Bankia) can be made out faintly in the glass. The photo conveys a genial reflexivity—literal and figurative—in that it also shows the reflection, in the glass door, of the title of the newspaper in which the photo later appeared online: *El País*. Few images of the effects of the sanitation workers' strike represent in such a lucid way the ambivalent relationship between urban subjects, urban capital, and trash in modern Spain. Gemma Fernández's photograph intensifies the vexed interactions between capital,

citizens, and their waste, as the three do battle for access, on the one hand, to the public spaces of the city, and, on the other, to the spaces of finance and capital investment. At the same time, the image situates the viewer within a historical relation in which the present moment of sanitation crisis dialogues with a moment not long before, in 2012, when Bankia failed as a financial institution and was rescued and nationalized by the state. Reflecting on this image now, one would like to imagine that the accumulation of trash bags in this precise locale sprang from a kind of communal critical impulse, whereby neighbors and residents of this neighborhood of Madrid began to leave their waste not next to the proper waste receptacles, as we see in other images, but rather directly in front of this Bankia branch office.

In all these images of the streets and alleys of Madrid, public thoroughfares have been transformed into images not of the flow of people, vehicles, merchandise, but rather of obsolete products, used junk, castoffs, and debris. The streets paved with containers, ruined cushions, waste paper, and other refuse more difficult to identify, represent inert channels that reflect, in their stagnancy, those same economic and social processes that have ceased to function (one assumes) as they functioned before, and that now in their paralyzed state have come to create a more accurate picture of the cultural reality of capitalist Madrid at the beginnings of the twenty-first century. The streets seen in the pictures serve as visual evidence of a multitude of humans who scarcely appear in the images, drawing attention to the vitality of trash, which acts with its own agency long after its creators have ceased to care about it. This material power of rubbish—which stubbornly holds on to its ability to do things even after it has been discarded—is part of its power to perform as a political actant.[63]

When Madrilenian trash ceased to disappear with its customary predictability in November 2013, it began to acquire its own lifeforce, appropriating for itself expressive power and agency. In another image, taken near the Plaza Tirso de Molina, an abandoned sofa sits in the foreground. A nocturnal city alleyway where enormous plastic bags, probably containing debris from a home-improvement project, lie behind the bollards appearing in the foreground. The sofa is not too dilapidated to hint at a world more comfortable and better made (to return to the Jorge Guillén poem with which this book begins) than the present one, when it occupied a central and useful space in someone's home. No specific or apparent house corroborates the presence of this particular sofa, but even after it has been ejected from the domestic sphere, it continues to hold onto its power of "invocación en masa / a la memoria," a memory of the materiality of human existence and of the

things we use in our lives to make meaning of our intimate experiences, of curating our personal spaces and symbolic geographies. The bollards in the foreground reinforce the idea of retarded movement, of a pause in the life cycle of the object, since the sofa appears just beyond them, on its way perhaps to another kind of future, independent of the photographer and its previous home. The sofa, expelled from its intimate milieu, now stands monumentally within public space. There it lies, the protagonist of a new plot, beginning a new vital trajectory, either as an object that will be reclaimed and recontextualized within a new domestic environ, or perhaps recycled or discarded, transformed into new material. Gay Hawkins, reflecting on Bill Keaggy's photographic work, titled *50 Sad Chairs,* posits that this kind of waste functions to remind us of "a relation in which we can see the force of conversion and transience, and sense other uses and possibilities emerging."[64] Bennett would take this notion one step further, since these new uses and possibilities of the discarded thing are not always or necessarily semiotic or cultural. There is an animacy in the itinerant item that promotes a different kind of thinking about dependency and dichotomy between organic and inorganic matter.[65] At the same time, the exiled piece of furniture invites us to reflect on our own interactions with things, from our acquisition of them to their disposal. There is an affect of intimacy triggered by the picture of a discarded chair that reminds us perhaps of the continued passing of objects through our lives as they go from being useful to worthless, between humble object and, later, obstinate things with their own destiny beyond us.[66] The things we use and throw away are products and indexes of their own temporality.

There is something especially poetic about the abandoned sofa. As I noted in the introduction, we only begin to see things as things when they cease to function as they should. In a poem dedicated to Maruja Mallo, Rafael Alberti wrote that "El último ruiseñor es el muelle mohoso de un sofá muerto" (The last nightingale is the rusty spring in a dead couch).[67] What links Alberti's poetic image to the Tirso de Molina sofa described above is that trashed furniture makes us feel things. This is what Bennett calls "Thing-Power," "the curious ability of inanimate things to animate, to act, to produce effects dramatic and subtle."[68] In all of the images of the sanitation workers' strike, Thing-Power is made visible, sensible, perceivable.

The pictures of empty industrial-size containers of paint, discarded vegetable boxes, plastic bags, piles of cardboard boxes, broken toilet bowls and bidets, used mattresses, organic and inorganic waste, burnt cars and dumpsters, which, in 2013, functioned for a week as physical material evidence

of yet another scuffle between capital and labor in democratic Spain, also demonstrate the power of waste to tell us things about our cultural reality. Even when we discard some *thing*, the concentrated energy found in a consumer product may slacken, but it never disappears.[69] As some philosophers of nature have posited, "nothing disappears; nor does the planet import matter from elsewhere. Instead, matter is just reconstituted in new forms, perhaps in different places."[70] When our castoffs cease to disappear from the streets where we placed them, they reveal the interconnected circuits connecting capital, labor, and materials, and they remind us that society and culture always produce garbage, and that our relation with things does not cease when we throw them away. The citizen photographs of the effects of the sanitation workers' strike are cues pointing to the spatial and temporal connectedness of things and people entangled in urban space.[71]

This book began with a brief overview of some of the processes by which democratic Madrid—especially after 1986—engaged in a prolonged and purposeful project of continued democratic consolidation based on neoliberal urbanism. In his study of Transition-era Madrid, Hamilton Stapell describes how, following a period of progressive democratic initiatives between 1979 and 1986, the socialist party (PSOE) pursued a Europeanist agenda built upon neoliberal policy. The outcome was increased "corruption, less social equality, decreased mobilization, and the willingness to favor stability and economic growth at almost any cost."[72] Robert Davidson and others have shown how Barcelona's political elites engaged in similar projects but with perhaps more damaging outcomes for its residents.[73] In the early 1990s, the so-called Barcelona Model transformed the city into a tourist mecca through development, speculation, and the transformation of working-class neighborhoods ahead of the 1992 Olympics. While revenues from tourism buoyed the city's economic outlook and projected the Barcelona brand globally, the impact on residents' ability to aspire to a livable urban experience has been extremely uneven.[74]

In Madrid, the waste populating the city's streets during the 2013 sanitation workers' strike was an indicator of the existence of a community of humans living behind the shining facades and construction scaffolding emblazoned with precisely those promotional images and advertising slogans that have come to embody the vision of the capital city promoted by its state tourism and industry organisms. The gradual accumulation of trash and its ensuing photographic documentation and digital archivization stand as virtual reminders not only to the desires of a specific group of workers to receive an equitable wage for their efforts and a regular workweek but

also of the intertwined processes of accumulation, use, and disposal upon which all capitalist systems have been built. Indeed, the material and visual evidence remaining from the workers' strike stood as a temporary yet extremely vibrant monument to the work that those very workers do to keep Madrid's economic and sanitary systems in working condition (for now). Bearing in mind the second epigraph of this chapter, it is worth remembering that trash collectors are the forgotten heroes of modernity. When trash stops disappearing, modernity stops being attractive. The moment a piece of shit hits the floor, the future stops shining. Critical and theoretical work on waste has shown extensively that if it were not for the state's willingness to collect, sort, and dispose of trash, the current consumer capitalist system would cease to be sustainable.[75] Once waste systems stop functioning, growth-oriented economics falls apart.

The documentary images analyzed in this chapter demonstrate the narrative, symbolic, and political power that trash exerts in the urban environment. If, as I noted above, the Spanish image industries and their state representatives in Madrid value the city as a *tabula rasa* for the construction of national and international visual narratives ("Madrid is ready to film"),[76] the photographs emerging from the 2013 strike exhibit the potential that the city and its inhabitants have to create their own stories about life in the city, using a broad array of expressive strategies.

Rubbish is special because its ontology suggests completion, or perhaps exhaustion; yet trash is seldom done doing things when we decide we are through with it. It goes on to lead other lives long after we have moved on and forgotten about it. In that way, the same waste that is the product of the Western brand of modernity also contradicts one of modernity's central lies: the belief that we might control our lives.[77] It also shows that all that is solid does not necessarily melt into air. We are also controlled by the material world and our own interactions with things both useful and wasted. Things, in Bennett's words, "act upon and change us. . . . [T]he human mind-body is susceptible to the affections endeavored by things."[78] At the same time, castoffs are always transforming into other things.[79]

Residents' photographs of Madrid's 2013 sanitation strike revealed how the urban environment was transformed materially into a space where people were forced to cohabitate with the waste they produced, thus confirming—if not enhancing—the otherwise unseen dynamics of waste production in the capital city. In the photos of Madrid's streets appearing on Twitter, Instagram, and in the digital archive curated by *ElPais.com*, we can see thoroughfares paved with trash, containers, plastic bags, and other

discards. Nearly devoid of human subjects, the streets of Madrid became—for a few weeks near the end of 2013—stagnant channels of circulation that reflected the failures of precisely those economic and social processes initiated during the transition to democracy and promoted by politicians and economists through the 1990s and early 2000s. Those pictures—much like the visual evidence of other clashes between multinational capital and labor, community activists, and citizens emerging from Rio de Janeiro (Brazil), Agbogbloshie (Ghana), Naples (Italy), and beyond—work to engage our consciousness of late-capitalist reality at the beginning of the twenty-first century, while drawing global attention to local material conditions.

3 Junkspace Photography

Oh, viejo cubo sucio y resignado,
desde tu corazón la pena envía
El llanto de lo humilde y lo olvidado.
(Oh, you resigned dirty old container,
from your heart, sorrow transmits
the lament of the humble and the forgotten.)
—Rafael Morales, "Cántico doloroso al cubo de la basura" (Painful
song to the trash can), *Canción sobre el asfalto* (1954)

It often seems as if waste and photography were made for each other.
—Brian Thill, *Waste*

In her book on the cultural uses of trash, Maite Zubiaurre begins by remarking on the broad bibliography on landfills and the monumentality of waste.[1] Indeed, there is a growing catalogue in trash studies that has sought to keep abreast of the expanding body of art made out of discards, of rubbish artists, of trash aesthetics. Olsen and Pétursdóttir propose that the "new and dedicated concern with *real* things, broken and soiled things" might be considered part of a broader contemporary "archaeological moment."[2] The thing-based, archivally oriented art by Mark Dion, Joseph Cornell, Vik Muniz, Tara Donovan, Sarah Sze, Wangechi Mutu, Nick Cave, Judith Scott, and others demonstrates that while aesthetic interest in waste is not new, it is extremely diverse. The broad aesthetic experimentation with stuff has coincided with a sustained scholarly, popular, and artistic interest in trash. Perhaps most importantly, the emergence of waste as object of aesthetic inquiry has ecocritical functions, pointing to the unsustainability of an economic system predicated on infinite growth and unlimited production of things on a finite planet.

Rather than recapitulating Zubiaurre's important work on litter aesthetics in the city, this chapter focuses on how Spanish photography in particu-

lar has imaged the wasted spaces produced by Spanish modernity. It looks principally at the work of Jordi Bernadó and Óscar Carrasco, who aim their cameras at modern ruins, the decaying or ruined postindustrial spaces of Madrid, Barcelona, and their exurbs. Inspired in part by Neil Brenner's notion of "operational landscapes," the pages that follow explore the semiotics of placed-based photography of wasted spaces, and how contemporary Spanish photographers have visualized modern ruins and postindustrial landscapes that exist beyond the country's urban centers.[3]

SPAIN'S WASTED SPACES

Brenner has outlined how, in order to support and sustain urban life, capitalism's operational landscapes have drastically transformed planetary ecologies in their need for "resource extraction; fuel and energy generation; agro-industrial production and biomass appropriation; transportation and communications; as well as water supply, waste disposal and environmental management."[4] Brenner's work is useful for the way that it includes non-urban spaces within the theoretical discourse on urbanization. When we talk about urban space, we are not just talking about high-density population centers, global cities, metropolitan regions, megacities, and interurban networks. In order to understand how urban places and spaces and modes of living and being function, we must also consider those spaces "in relation to the ongoing, if profoundly uneven, speculative and conflictual, operationalization of the entire planet, including terrestrial, subterranean, fluvial, oceanic and atmospheric space, to serve an accelerating, intensifying process of industrial urban development."[5] This is the neoliberal operation of externalization, by which modernity has transferred its costs over broad swaths of time and space.[6]

The economics of urbanization have impacted nearly all planetary ecosystems and landscapes, visible and invisible. As Prádanos observes, in Spain accelerated processes of urbanization have had the effect of depleting "all ecologies within the Spanish territory in unprecedented ways."[7] The visual art of Bernadó and Carrasco and the critical architectural photography of Julia Shulz-Dornburg draw attention to those wasted geographies through the activation of what I am calling an archaeological photographic practice. This visual practice signals the fragmentation and decontextualization that the dominant cultural-economic paradigm has used historically to hide the flows of colonial capitalist metabolism.[8]

Although the Junkspace photography of Bernadó and Carrasco is thor-

oughly contemporary, it is worth mentioning, as an introduction to the theme, that the abandoned and decaying place has always held a special place in the modern imaginary. It is difficult to imagine the nineteenth-century Romantic landscape without the ruin and its accompanying nostalgia effects. Romantics and modernists alike attached melancholy to decrepit landscapes and ruins. The same aesthetic interest in ruin and rubble can be traced through the Spanish realist novel of the late nineteenth century, where wasted spaces begin to appear more clearly as products of the growing hegemony of liberal capitalist modernity. In Emilia Pardo Bazán's *Los pazos de Ulloa* (1886), for example, the decrepitude of the rural Galician aristocracy is represented metonymically by the ruinous spaces that it inhabits.[9] The anthropological orientation of Pardo Bazán's work has been discussed mostly in terms of the social and cultural practices and customs that receive attention, but she is also interested in the material and architectural underpinnings of the modern experience.[10] The novel's central chapter, which serves as a pivot point in the plot, describes the voyage that the newlywed couple Nucha and Pedro take from the regional capital of Compostela to their home in Ulloa. Along the way, they make stops to play their respects to "la aristocracia circunvecina" (neighboring aristocracy),[11] including the aging Marquis of Limioso, whose home is irreparably ruinous. Following an embarrassing stay with their dilapidated relatives, the couple departs anew to return home. As they leave, they look back at the Limioso *pazo* and the portentous landscape it occupies. The narrator describes how both protagonists are captivated by the inexplicable sadness of decaying things ("los oprimía la tristeza inexplicable de las cosas que se van" [they were crushed by the inexplicable sadness of dying things, or things on their way out]).[12] Of course, some of the affect of the ruin operating in the late nineteenth-century imaginary is related to the rise of industrialism, the rapid social change that it brought with it, and the concomitant production of an ever-stronger sense of nostalgia for the past.[13] Cultural production of last third of the nineteenth century was characterized by a decadent sensibility inspired by a conviction that Western culture was in its final days.[14] Looking at some of the same zones represented in more contemporary Galician narrative, Neil Anderson has described certain rural spaces in Galicia as "the refuse of the historical process of urbanization."[15] In other words, the production of urban modernity has always implied the corollary and interconnected production of wasted rural spaces and what has been called, somewhat problematically, "la España vacía" (empty Spain).[16]

This chapter explores how pictures of modern ruins promote a similar kind of cognitive and emotional engagement with temporality and how

that engagement activates, on the one hand, the "inexplicable sadness" that comes with looking at things that are "on their way out," and, on the other, a critical awareness of the ecological impact of industrialization and capitalist modernization in Spain. The affect evoked by the ruin is key to a certain kind of modernist structure of feeling, and it is clearly present in Pardo Bazán's decadent modern vision, attuned as it is to what Edensor calls the "fluidity of the material world."[17] More recently, Robert S. Emmett has traced the Romantic aesthetics of the ruin through the modernist interest in the fragment and into the present where "Anthropocene objects" inspire "declinist and futurist studies" of a world after us.[18] Modern architectural ruins are special because they signal both the end of the use of those spaces and their "muted remainder" whose continued existence stands for an ongoing conflict between "continuity and cessation."[19] Ruins are the material form that crystalizes when time is allowed to work on space; they suggest, in part, the triumph of the temporal over the spatial. Edensor proposes that modern ruins especially are "emblems of the fragility and destructiveness of unfettered capitalist production."[20]

Glossing Marc Augé (2003), the Spanish archaeologist Alfredo González-Ruibal has suggested that ruins in general are less about history and more about time.[21] Similarly, in his materialist philosophy of wasted spaces, William Viney proposes that the power of the ruin lies in its embodiment of "the productive oscillation between permanence and decay."[22] The supplementary logic of the ruin, according to Viney, "includes a commingling of tense, continuities and discontinuities, presence and absence, collation and dispersal, all of which are central to the system of contradiction that makes waste an articulated and articulate thing in time."[23] Benjamín Prado's novel *Mala gente que camina,* which is analyzed in chapter 4, harnesses this commingling temporality as a way to understand how Spain's past can still be sensed in the lived environments of its present. This is what Néstor García Canclini calls the "multitemporal heterogeneity" of late-capitalist postcolonial modernity, a place and time in which (or when) people are constantly entering and leaving modern time.[24]

González-Ruibal proposes that modern ruins "are essential to understanding modernity at large."[25] Ruin porn has emerged as a subgenre of ruin photography that has found enthusiastic publics online and in galleries dispersed throughout the world. The genre has ample practitioners in Spain.[26] Noting the abundance of webpages devoted to ruins, González-Ruibal argues that the contemporary fascination with rubble signals not simply an aesthetic impulse but that it is especially "derelict modern landscapes" that

seem to demonstrate how "our post-industrial, supermodern identities are strongly influenced by the ephemeral nature of the material world we live in."[27] Modernity is forged through destructive processes.[28] But by attending to the ruins produced by that modernity, we can begin to construct a critical archaeology that acknowledges the entanglement of past and present that recognizes the interconnectivity of far-flung operational landscapes and the urban spaces that they make possible.

JORDI BERNADÓ

Some places lend themselves more actively to thinking about ruin. They tend to be precisely those places left behind as urbanization drags or draws people away and into other landscapes. In the United States, following dein-dustrialization and its concomitant economic and political catastrophes, Detroit's abandoned buildings provided fodder for photographic works that used urban decay to comment on the spectacular localized failures of capitalism. Jordi Bernadó, a photographer based in Barcelona, has photographed ruined urban landscapes in Detroit, Berlin, Lleida, Barcelona, and beyond. Throughout his work on Spanish landscapes, the country's relentless commodification of public lands, community space, and natural reserves is satirized through absurdist framing and a critical eye for juxtaposition. Juan José Lahuerta has compared Bernadó's work to a rhopography, using the term more commonly associated with the work of classical painters interested in representing humble objects. Lahuerta describes Bernadó's photographs—graphic examinations of objects that might normally be invisible to the traveler's eye—as "rhopo-foto-grafías de nuestros tiempos" (rhopo-photographs of our time).[29]

Bernadó's *Welcome to Espaiñ* (2010) is a visual tour of the country in which warehouses, parking lots, and real estate signage produce or denote apparently useless spaces. His photographs of what we might call architectural remainders are not exactly ruins, but they do convey a strong sense that we are looking at spaces that are heading in that direction. Bernadó's images capture frozen moments, unfavorable times and places where Spain's working classes mingle with Europe's more budget-conscious tourists in spaces that would otherwise escape the attention of a more highbrow architectural photographer. In this regard, Bernadó's work might be profitably compared to Robert Venturi's work on Las Vegas, since both projects focus on nonplaces inscribed with promotional imagery and language, local brands and municipal areas appearing just beyond the cities' more visible thoroughfares.[30]

Bernadó's photographs outline the visual contours of "Junkspace," a term coined by the architect Rem Koolhaas to describe the material residue that humankind leaves on the planet.[31] Koolhaas's essay is an early document in what is now a substantially broad bibliography on operational landscapes and nonplaces. As such, he does not gesture toward the specific social, economic, and political conjunctures that have produced Junkspace globally. We know that all "humankind" has not played an equal role in the urban expansion and attendant ecological devastation that have accompanied the rise of neoliberal modernity. Junkspace is just one word to describe the landscapes that mostly Western late-capitalist modernity has left behind. We know that supermodernity is a great producer of wastelands, edgelands, *terrain vague*.[32] Like Marc Augé's "non-place," Junkspace is the material left over by modernity, an expansive interconnected architecture of space made inhabitable by large-scale land modification, air-conditioning systems, and automotive transportation, "a vast potential utopia clogged by its users."[33] Koolhaas suggests that "Junkspace is postexistential; it makes you uncertain where you are, obscures where you go, undoes where you were."[34] José Luis Pardo, for his part, suggests that nonplace is essentially trash-space; its uniformity and lack of cultural specificity is precisely what makes it saleable and transferable on the global real estate market.[35]

Like the nonplace, Junkspace strives to be ahistorical: both are zones designed to be places where nothing in particular is supposed to happen beyond the purely functional. It is the place shorn of context, sociality, or cultural specificity, serving only the flow of goods, capital, and people. Augé suggests that the nonplace is perhaps the "real measure of our time,"[36] since it exists apparently "trouble free"[37] and "without problems."[38] Again, like Koolhaas, we can perhaps take his comments with a grain of salt, but both Koolhaas and Augé are concerned principally with capturing a central phenomenon that deserves attention. Ruthlessly efficient, these spaces are designed to promote the unimpeded flow of people and goods.

The efficacy of Junkspace and nonplace relies on those spaces' ability not to signify anything except a present-tense function predicated on the ephemeral, generalized, ongoing pace of commerce. Marc Augé describes the nonplace in this way: "If a place can be defined as relational, historical and concerned with identity, then a place which cannot be defined as relational, or historical, or concerned with identity will be a non-place."[39] This is not to say that the airport lounge, the McDonald's dining area, the service station, the parking lot, the big-box store are not also historical or contextual but rather that they have been designed, most often by multinational capital,

to frustrate the creation or memory of specific stories. As a photographer, Jordi Bernadó is concerned precisely with illuminating those stories through camerawork.

Bernadó's fondness for capturing images of architectural symmetry works frequently to illuminate Spanish nonplaces as a constantly emergent and artificial capitalist present. His images picture a degraded and chintzy form of the Marca España promoted by the Spanish state's culture and tourism entities, and which stands emblematically for an urbanization process that has always been unevenly articulated and environmentally unsustainable. This is the tourist-oriented investment and real estate speculation that has tended to dominate the Euro-Mediterranean region.[40] It is difficult to overstate the negative impact that this kind of development—most of which was realized thanks to widespread institutionalized corruption—has had on the Spanish landscape.[41]

The specificity that Bernadó deploys in the titles to his photographs works ironically to accentuate the visually nondescript nature of the built environments he prints on the page. Most of his pictures carry place-names taken from specific locales dispersed throughout the Iberian Peninsula—Muela, Campo de Criptana, Torre Pacheco, Lleida, Barcelona—but the images tell another story about the less favored spaces of a tourism-oriented Spanish supermodernity. Indeed, the pictures function as a kind of photographic map that allows us to perceive what Brenner describes as the "rapidly changing geographies of our planetary-urban existence."[42] The photos are also remarkable for the way that they frame otherwise nondescript places where, in Augé's words, "people are always, and never, at home."[43]

Augé proposes that the nonplace is where "solitary individuality" comes into contact with "non-human mediation (all it takes is a notice or a screen) between the individual and the public authority."[44] They are lonely places because they do not promote sociality; relations in the nonplace are transactional, transitory, and temporary. The traveler walking through Barajas Airport, for example, is surrounded by people and familiar visual cues but never truly at home. Even when people appear in Bernadó's images, there is a sense that they are only slightly more animated than the wax figures that tend to be favored objects of the photographer's lens. The stillness and isolation of Iberian wasted spaces—which conjure what Augé calls the "ethnology of solitude" of the nonplace—is what produces the melancholy of supermodernity.[45] These are modern spaces whose main purpose is to promote social relations based exclusively on the transactional commodi-

Figure 11. *Mega-Park,* Jordi Bernadó, 2009.

fication of experience: the strip club, the bar, the amusement park (fig. 11), the event space.

A particularly evocative series of Bernadó images reproduces the white-washed exterior walls of apartment buildings, where ambiguous messages appear stenciled above: "Fortuna Urbana," "Bar," "Glamour," "Italian Fashion," "Jesús vive," "Pizzeria Ali Baba. Comuniones, Bautizos, Comidas de Empresa, Despedidas de solteros/a." Geographic nonspecificity combines with linguistic nonspecificity to generate a photographic semiotics of Spanish nonplaces. The image in figure 12, titled *San Roque,* dynamizes the otherwise inert aesthetics of the other apartment building pictures. The company name, "Etnodesign," which appears on the top of the building, just below the roof, functions as a brand or moniker for the process that is suggested below: a symmetrical window from which a construction-waste chute emerges, connecting to a dumpster on the street. There is a sense here, as in the other images of exurban blight lensed by Bernadó, that the buildings we see in the images are in the process of being emptied of content and context, prepared for a new future as modern ruins. And as I noted in the introduction, there is no design without residue.

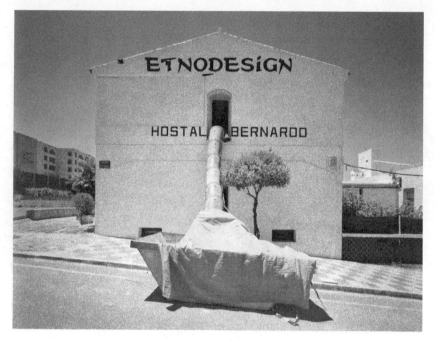

Figure 12. *San Roque,* Jordi Bernadó, 2009. (© Jordi Bernadó)

ÓSCAR CARRASCO: "NO IDEAS BUT IN THINGS"

Part of the attraction of the modern ruin lies in its interstitial or liminal value, standing somewhere between newness and ruination, between being somewhere and nowhere, between past and present, solidity and fluidity. Tim Edensor suggests that "derelict sites are in a fluid state of material becoming" and that photographs of ruins are "particularly valuable because . . . they can reveal the stages and temporalities of decay."[46] Both photograph and ruin denote a frozen moment in time, intensifying a moment of nostalgic affect. Even though every photograph is caught up in a matrix of varying temporalities, as Drucker notes, it is the fixed moment of the photograph that "defines it as a kind of image and as a way of seeing and thinking."[47]

The historical and disciplinary link between photography and archaeology is well documented.[48] Photography's capacity to fix or capture surface traces of the past so they could be inspected subsequently, in the present, is what gave the medium an important role in the historical development of the disciplines of geology, archaeology, and paleontology.[49] Today, archaeologists use photography to record digs, sites, finds, landscapes, ruins, rubble.

To this end, Hauser describes how "photography cannot help but represent the world archaeologically, since it cannot help but record its objects and landscapes in a temporal context, the traces of the past scattered across their surfaces."[50] As a method of reading, archaeology also shares a lot with the literary, which also records its objects, landscapes, and consciousnesses in a temporal and historical context.

Óscar Carrasco, like Jordi Bernadó, uses his camera to capture the temporalities of decay that exist alongside and within the unfavored spaces created by Spanish supermodernity. Koolhaas is similarly concerned with precisely that fluctuation in the material structure and cultural value of the Junkspace. He describes how "sometimes an entire Junkspace—a department store, a nightclub, a bachelor pad—turns into a slum overnight without warning: wattage diminishes imperceptibly, letters drop out of signs, air-conditioning units start dripping, cracks appear as if from otherwise unregistered earthquakes; sections rot, are no longer viable, but remain joined to the flesh of the main body via gangrenous passages. Judging the built presumed a static condition; now each architecture embodies opposite conditions simultaneously: old and new, permanent and temporary, flourishing and at risk."[51]

It is noteworthy that Koolhaas uses human and biological nouns and verbs to describe the ruination of material Junkspace—embodiment, rot, flesh, gangrene—since these terms underline the lively activity of the built world as it decays. There is a vitality that can be sensed in the modern ruin even before it has experienced the full effect of time. The ruinous spaces described by Pardo Bazán in *Los pazos de Ulloa,* which molder in the rural Galician countryside, have suffered from centuries of neglect, but the places appearing in Bernadó's and Carrasco's images have only felt the impact of a few decades of decay. One also senses that perhaps the metal, gypsum, brick, and wood favored by modern building practices will not fare as well as the stone edifices that even today can still be found throughout the Galician countryside. The modern ruin is built to be operationally ephemeral, even if its afterlife has a longer duration.

But what happens to Junkspace when it is junked? What would Marc Augé say about the abandoned nonplace? Is it doubly "non"? The modern ruin is no longer transited in the way of the airport, service station, supermarket, mall, hotel chain, except by photographers and ruin porn aficionados. I wonder if this is why postapocalypse screen narratives always seem to begin in these kinds of places: the supermarket in *28 Days Later,* the airport in *Waltz with Bashir,* the service stations, grocery stores, and incomplete

housing subdivisions of *Walking Dead,* the motel, bars and parking lots of the *Terminator* cycle, the dog-racing track or elementary school in *Children of Men,* the supermarket of *Birdbox,* the seaside carnival spaces of *Us.* The nonplace is already so close to being nothing that its demise inspires a special kind of morbid fascination.

The apparently seamless, clean infrastructure of Junkspace and nonplace makes them blank slates prepared for the confection of dystopian visions of late-capitalist destruction. In its indistinct reproducibility, the nonplace is an ideal vehicle for imagining the end of capitalist modernity and human life. But, perhaps perversely, in its ruination—when the nonplace is trashed, abandoned—it becomes evidence and documentation of something that is still happening. The derelict nonplace relinquishes its status as extratemporal, extrahistorical limbo and enters into time itself; the crumbling nonplace marks time (finally). This is the truncated temporality of the supermodern era that is the object of González-Ruibal's radical archaeology, which points to the temporal excess, spatial impoverishment, expansion of anthropogenic ephemeral spaces that represent the "spatial waste"[52] of our destructive form of supermodernity.

An exhibition of Carrasco's photography took place in February 2014 at Madrid's Fragua de Tabacalera, a gallery space located within the Tabacalera Building, a reclaimed and reformed eighteenth-century tobacco factory and industrial warehouse that now houses art studios, community meeting spaces, and cultural programming under the auspices of Spain's Ministry of Education, Culture, and Sport. Likewise, the catalogue describes Carrasco's photos as a "topografía compuesta por diferentes tipologías arquitectónicas que conforman un particular catálogo, un espejismo temporal de ese otro Madrid, a orillas de la prosperidad, desprovisto de tránsito y espectadores, donde el tiempo persevera y el paisaje emerge" (topography composed of different architectural typologies, which comprise a peculiar catalogue, a temporary mirage of that other Madrid, on the cusp of prosperity and bereft of witnesses or travelers and where time perseveres and the landscape emerges).[53]

The Madrid OFF catalogue describes the sense of "alejamiento de la realidad" (distancing from reality) evoked by the images. Carrasco's photographs of the interior spaces found within the abandoned buildings suggest a Russian doll structure of nested spaces containing an ever-smaller "itinerario de objetos" (itinerary of objects). Photographs of the abandoned interiors of the Mercado de Legazpi (Legazpi Market) or the Algodor home (*Vivienda en Algodor*) are strewn with discarded objects that present layers of

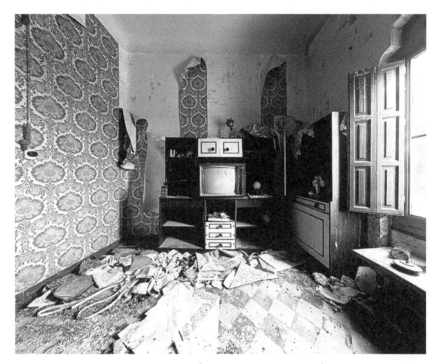

Figure 13. *Vivienda en Algodor*, Óscar Carrasco, 2014. (© Óscar Carrasco)

material detritus ripe for archaeological investigation (fig. 13). Carrasco's biography describes his interest in documenting contemporary ruins and "la descomposición del paisaje interior" (the decomposition of interior landscapes), and how his work aims to uncover "nuevas vías para evidenciar la mortalidad, el poder devastador de las masas urbanas, el regreso irrevocable de lo orgánico contra al mundo construido" (new routes to demonstrating mortality, the devastating power of urban masses, the irrevocable return of the organic against the constructed world).[54]

Ruins and rubble are arenas for creative affordances with materiality.[55] Fieldwalking and digging are methods by which archaeologists reenchant space through what González-Ruibal calls a process of "deep mapping."[56] Likewise, photography, too, has the power to orient our vision toward material objects, spatiality, and the passage of time. Óscar Carrasco's catalogue makes explicit references to how his images work almost like archaeology: "Los muebles, la televisión, los objetos, pueden leerse como pruebas *casi arqueológicas,* y son, a la vez, fragmentos del mundo y un pequeño mundo en sí mismo" (my emphasis).[57] (The furniture, the television, the objects: they can all be read as *almost archaeological* evidence and they are, at the same

time, fragments of the world and a small world unto itself).) Carrasco's photographs, Ultra-Chrome K4 pigmented inks printed on Epson paper, bring together an array of locales scattered throughout the Autonomous Community of Madrid, from the Estación del Norte to Aranjuez, and from Las Rozas to Alcalá de Henares. The images depict edifices erected at different times, from the eighteenth and nineteenth centuries (the Monasterio de Aldehuela, for example, was built in 1889) to the early twentieth, all of which function visually to capture the virtual coexistence of past and present. Considered together, the hospitals, market buildings, and abandoned monasteries offer a varied imaginary of abandoned places dispersed throughout Madrid, from the religious to the secular, from the community to the corporatist. If supermodernity is indeed an era of material and spatial excess, these abandoned buildings and their contents yield information about the economy, culture, and society that produced them. Carrasco's photographs are a map of ruined Madrilenian Junkspace.

The photo entitled *Hospital de la Barranca* features a graffito, centered in the background of the image, that intones "Res non verba" (Things not words) (fig. 14). A derelict sofa appears on the right, nestled between two columns. The picture, like many of Carrasco's photos, functions as a reminder of the recalcitrance of things over ideas in the world of abandoned places. It also evokes William Carlos William's poetical-materialist notion, repeated in *Paterson* (1946), that there are "no ideas but in things."[58] James Porter puts it another way: "matter never leaves meaning untouched."[59]

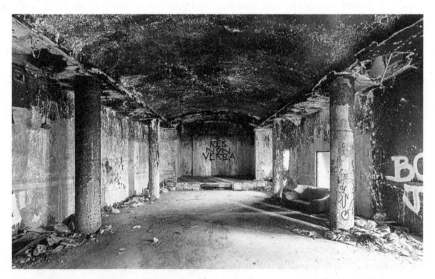

Figure 14. *Hospital de la Barranca,* Óscar Carrasco, 2014. (© Óscar Carrasco)

Carrasco's archaeological vision captures an array of temporalities that coexist within the geographical and political limits of the Autonomous Region of Madrid. There is a nineteenth-century Women's Prison on Calle de Santo Tomás de Aquino, Alcalá de Henares, built according to the panoptical logic of the time, which ceased to function as such in 1984 and remains uninhabited. Another picture is of the Gal soap factory in Alcalá de Henares, built in 1963. Interiors of homes in the town of Algodor, in Aranjuez, in the remotest, most southerly part of the Community of Madrid, reflect a more domestic vision of arrested temporality (fig. 13). Algodor is a company town populated by rail workers that was left behind when the high-speed train between Madrid and Toledo was completed, and stops are no longer made there. Following 147 years of service, the last train to Madrid from Algodor departed on 15 August 2005, and, by 2015, the town's population had dwindled to only six inhabitants.[60] Algodor is now a ruin produced by the speed required by supermodernity.

Carrasco also photographed the Carabanchel Prison, which was closed in 1998 after ceasing to receive new prisoners. It was finally demolished, following ten years of abandonment, in 2008. The pictures offer an array of geometrical and architectural perspectives on postwar Spanish regimes of social and political control. Also designed in Bentham's panopticon style, the building was erected with the labor of political prisoners. Symmetrical images of hallways and stairways create the illusion of balance on the one hand, while also suggesting an infinite geography of cells with centrally placed vanishing points, hallways that extend beyond the camera's ability to capture the end of the represented space (fig. 15). Carrasco's camera also documents the power of spray paint to transform or reinscribe the meaning of the place; graffiti by an array of artists recast dim institutional color schemes in bright neon colors and new narrative and aesthetic arrangements. *Carabanchel, 21*, for example, offers a whimsical rewriting of an otherwise bleak architectural detail in the prison, where two circular barred windows allow sunlight into a darkened room (fig. 16). Black spray paint adds a nose and mouth to the ensemble, reversing the voyeuristic illusion granted by Carrasco's wandering eye so that the prison stares back at the camera.

In their essay on cultural ecology in postcrisis Madrid, Matthew Feinberg and Susan Larson outline some of the ways that contemporary artists have sought to reclaim some of the city's least favored spaces, making them hospitable again to the commons. They note that the cultural repurposing of wasted spaces and "crevices of the city" through place-based art installations

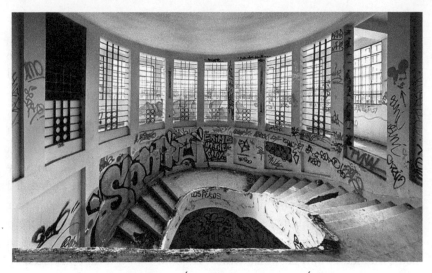

Figure 15. *Carabanchel, 16,* Óscar Carrasco, 2008. (© Óscar Carrasco)

and performances "provide[s] rich environments for the growth and proliferation of alternative forms of cultural production and organization that reject the market as the only sphere for connection in the contemporary urban environment."[61] This amounts to the creation and appreciation of a new urban ecology that permits citizens to reassert their right to the city and its spaces.

When in 2008 state and municipal authorities sought to demolish the Carabanchel Prison, local activists and neighbors protested, seeking to have at least a portion of the site preserved as a monument to Franco's repression.[62] In the end, however, the site was auctioned for seventy million euros, and the locale was transformed into mixed-use housing and retail. When the prison was demolished, a neighbor complained that even portions of the Berlin Wall were preserved in some way.[63] Thus, following the destruction of the Carabanchel Prison, Carrasco's images now function also as a site of memory, a place where people can see a virtual ruin, a locale that no longer exists but that nevertheless holds important memories for the communities impacted by the violence of Franco's dictatorship, and for neighbors who lived for nearly a half century in the shadow of this monument to authoritarianism.

Carrasco uses images of modern ruins as method of critiquing nationalism and Francoist heritage. Heritage is the way in which national cultural organizations have worked historically to glorify the status quo, its social systems, and its priorities.[64] "Heritage," as González-Ruibal notes, is all too often used to fetishize architectures of the past, preventing history from being reworked or rethought, "thus reinforcing the ideological role of mon-

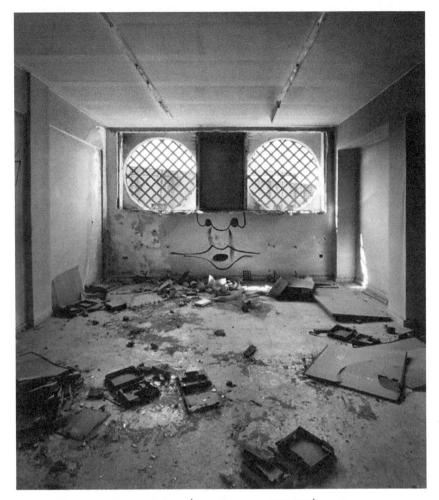

Figure 16. *Carabanchel, 21*, Óscar Carrasco, 2008. (© Óscar Carrasco)

uments."[65] By focusing on the Carabanchel Prison rather than on other more dignified monuments, the photographer is able to broaden the scope of architectural photography to include the Junkspace and landscapes of repression shaped by forty years of Francoism. While Spanish democracy has sought to erase or destroy monuments such as the Carabanchel Prison, photographers and community members attempted to preserve it as a reminder of the realities of Francoism. Pictures of waste space captured on film function to preserve vernacular memory of the places erased by gentrification and urban design. In the case of Carabanchel, Carrasco's photographs are archaeological in the way that they reveal specific stories and histories.

Another graffito, appearing in a photograph titled *Carabanchel, 16*, fea-

tures a stenciled image in red paint of José María Aznar, the former prime minister, with added Mickey Mouse ears (fig. 15). The graffiti in the image creates a busy swarming effect that works against the relentless geometry of the concrete walls and iron-barred windows. The image suggests visually a continuity between Franco-era architecture—spare and authoritarian—and postdictatorship contemporary Spanish politics. Reading the image from left to right, there is a suggested link between fascistic materiality and the country's supermodern aspirations, under the guise of the Partido Popular's neoliberal economic policy, represented by Aznar as Mickey Mouse.

Carrasco's photographs (*Tabacalera Skatepark, Club Alpino Guadarrama, Palomar de Silillos, Club el Cisne Negro*), like Jordi Bernadó's work, tend to favor the symmetrical, monolithic, monumental forms of the spaces they represent. But in their ruination, the places shot by Carrasco are counternarratives of precisely those monumental aspirations of past architects. They offer images of alternatives to the rationalized ultramodern spaces of urban spaces in Madrid's city center, which, as I elaborated more fully in chapter 2, have been increasingly shaped by multinational capital in its own image. Not unlike the ruined pueblo that Ricky visits at the end of Pedro Almodóvar's *Átame* (1990), Carrasco's ruins and rubble stand as temporal remainders and reminders. They are indexes of alternate endings, alternate modernities, other temporalities. They are "other" spaces and "other" times that are still "happening" and that continue to unfold, in their own time, beyond the supermodern metropolis. Ricky's ruined *pueblo* is a place of memory and family history—significantly, he bears a photographic archival image in his hand when he returns. We may assume that Carrasco's landscapes will evoke a similar affect for their former inhabitants. These places lie waiting for their former inhabitants to return perhaps to behold them, perhaps to tell a story about the past, a time spent in a hospital bed, a year spent in solitary confinement, a semester studying molecular biology (*Instituto de Medicina Molecular Príncipe de Asturias*).

Carrasco's *Mercado de Legazpi* is particularly evocative. The frame centers on a vintage photograph of King Emeritus Juan Carlos I (fig. 17). Geometric and regular 1960s-era cubicle walls encompass a chaotic array of plastic bags, defunct fluorescent lights, crushed cardboard boxes, newspapers, and lumber. Three distinct spaces are outlined within the frame: first, there are traces of an outside space, from where the natural light emanates; second, there is the interior of the cubicle; and third, the larger interior space beyond the cubicle. The central visual note is comprised of the framed photo of the young king who ostensibly reigned over the country's transition to

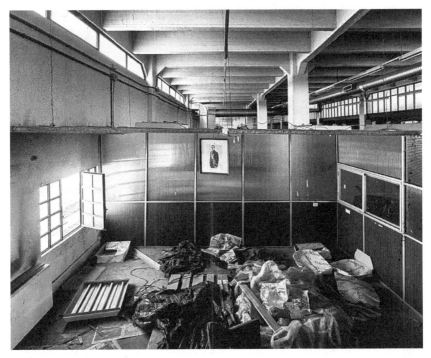

Figure 17. *Mercado de Legazpi,* Óscar Carrasco, 2014. (© Óscar Carrasco)

democracy and concurrent continuation of neoliberal modernization. Yet here, the sovereign's image stands as an ironic ode to a man whose throne was forged in the furnace of Francoism. The image of the king functions as an expired timestamp, a temporal marker of a modern project whose detritus keeps on existing.

The images of wasted space included in Oscar Carrasco's Madrid OFF project promote an archaeological mode of thinking about the use and value of space. These kinds of creative interventions with Junkspace bid the viewer to consider the creative aspects of decay and destruction. In other words, what does the destruction of a thing or place create?

I conclude this chapter by returning to Bernadó, whose photograph *Venta de Cárdenas* frames a sign, painted to evoke the Spanish flag, which appears against a background of dry grass and traces of subterranean granite (fig. 18). The sign points to the left, to a place standing two hundred meters out of frame. It is an austere image of a nondescript locale, near the town of Venta de Cárdenas, which is situated a little over fifty miles south of Ciudad Real. The sign, in fact, points to the Franco-themed restaurant Casa Pepe, located in Despeñaperros, an outpost where Francoist *nostálgicos*

Figure 18. *Venta de Cárdenas,* Jordi Bernadó, 2009. (© Jordi Bernadó)

can go to buy bottles of wine labeled with the likeness of the dictator, purchase key chains and other keepsakes evoking the authoritarian past.[66] In other words, it is a cheap heritage site where the country's history has been frozen in time, fetishized for acritical nationalist consumption. At the bottom of the image there appear shadows of Bernadó and his camera and tripod, suggesting a kind of spectral presence of the photographic apparatus and the author who wields it. The image at first seems to be a pointed commentary on the arbitrary signs and absurd signifiers that police legal boundaries and political frontiers, but the waste items appearing in the dry grass in the foreground are also remainders left behind by humans in transit. There is a sense, in this image, that the photographer is standing in a space that is constantly being passed through, a nonplace transited by humans walking those last two hundred meters to the museum to Francoism. The only human traces in the image are shadows, a semi-permanent monument to a long-dead dictator, discarded plastic bottles, and the photographic image. The picture works simultaneously to signpost heritage as an empty and retrograde cultural practice, while also evoking the deeper temporality of plastic, "the archetypal material of invention, mass consumption and ecological contamination."[67] What we get from the photography of these wasted spaces is the affect of the operational landscape and a picture of a planetary future after us.

II Waste
Humanism

4 Archaeological Fiction

Lo que sepulta, calla, encubre, disimula o silencia la
realidad de las cosas nunca es la verdad, sino la mentira.
(Whatever hides, silences, covers, disguises, or silences the
reality of things is never the truth, but rather a lie.)
—Benjamín Prado, "Yo, periodista en Malasaña"

La arqueología no es solo contar el pasado a partir de restos
materiales. La arqueología es también hacer el pasado
presente. El más horrible y el más hermoso. (Archaeology
is not just about understanding the past through its
material traces. Archaeology is also about making the past
present. The most horrible and the most beautiful.)
—Alfredo González-Ruibal, tweet, 4:00 p.m., May 26, 2020

Previous chapters have described how Spain's special brand of neoliberal
modernity depended on the simultaneous production, on the one hand, of
an urban space ready to be molded in the image of multinational capital
and, on the other, on a disavowal and purposeful disappearance of the real
operations—material, political, historical—that had made that production
possible. In this chapter I want to shift gears in order to take a closer look at
how contemporary Spanish culture has responded to those logics of disap-
pearance that obtained alongside economic modernization. I am interested
expressly in how Spanish fiction has responded to the wasteful logics of
neoliberal aesthetics and politics through a critical deployment of what I
will be describing, in this chapter, as an archaeological narrative project. In
previous chapters, I have noted how, in the interest of moving forward into
what looked, at the time, like a bright and prosperous future, a lot of shit
was buried in Spain. But not everyone was satisfied with turning the page
on history. This chapter is about how novelists are unearthing Spain's past.

Since the late 1990s the Spanish culture industry has employed a variety of methodological, generic, and ideological approaches to representing the Civil War, the authoritarian aftermath, and how those periods have been hidden. The number of works published on those events has increased, on average, by a factor of three. Between 2001 and 2018, there were 1,248 novels published on the Spanish Civil War, which amounts to an average of seventy per year.[1] In the years immediately following the turn of the twenty-first century, so much material was produced on the topic that the novelist Isaac Rosa titled a 2007 novel *¡Otra maldita novela sobre la guerra civil!* (Another damned novel about the Civil War!).[2] Critics have suggested that instead of a concrete sign of the emergence of a new historical consciousness, these cultural artifacts might best be explained as products of a capitalist consumer economy in which the ideological conflicts that gave rise to and sustained the war are no longer seen as a danger and can thus be turned into narrative fictions to be consumed by a Spanish readership.[3] While there is certainly something to be said for this hypothesis, I am more interested in understanding the aesthetic and narrative trends that have emerged within this boom in narratives about Civil War memory, in order to analyze what I am calling the archaeological impulse in contemporary Spanish narrative fiction.

This chapter marks a transition in this book from the considerations of nonhuman materiality comprising chapters 1, 2, and 3, to the politics of memory and forgetting in postdictatorship Spain. Earlier chapters outlined how Spain's long transition to democracy depended upon the pacted disavowal of history. Yet, even as I write this chapter, in 2020, the country's past continues to flash up in the present time. In June 2018, Pedro Sánchez's center-left coalition government put in motion a plan to disinter Francisco Franco's remains from the Valley of the Fallen, where the dictator had been buried since his death in 1975, for reinterment in a less conspicuous location. In October 2019, the dictator's remains were finally exhumed and flown out of the mausoleum and buried again in the Mingorrubio Cemetery near El Pardo. Sánchez remarked that the exhumation marked the end of the "moral insult that is the exaltation of a dictator in public space."[4] This was only the most recent effort to remove Francoist markers and monuments from the country's lived environments. These ongoing cultural rejections of the authoritarian past demonstrate that there is still a lot of feeling lying under the surface. This chapter explores how the novelist Benjamín Prado uses nostalgia and resentment—arrayed as part of a radical archaeological

politics—as a way to reinsert the victims of Franco's violent legacy back into the political present, reenergizing their place within the land of the living.

THE ARCHIVE AND THE ARCHAEOLOGICAL IMPULSE

In a survey of English and European art produced at the turn of the twenty-first century, Hal Foster described an archival turn in Western aesthetics, which has tended to favor material, fragmentary assemblages of found objects, images, and texts. These archival pieces aimed to make lost or displaced historical information physically present.[5] Foster makes the important observation that archival art often functions to evoke alternative knowledge and countermemory that contest official versions of the past. The archive artists that are the object of his essay—the Swiss Thomas Hirschhorn, the American Sam Durant, and the English Tacita Dean— explore the "obscure traces" of history that remain hidden in the archive. Their work focuses on the people and practices that ended up in the dustbin of history, drawing attention to the discarded, forgotten, incomplete projects that have been excluded from Western aesthetic history.[6] Archival art in Europe and North America draws on informal archives but also produces archives as places and things that may be explored by viewers in the museum or exhibition site. They function as public-facing assemblages that invite viewer participation in the construction of meaning.[7] Archive art draws attention to the archive as an embodied, living, and tactile space.

Archives are never neutral spaces. They are produced and maintained by complex systems of power that have historically excluded and misrepresented groups, things, people. In Achille Mbembe's words, the archive is constituted primarily through a process of "discrimination and of selection, which, in the end, results in the granting of a privileged status to certain written documents, and the refusal of that same status to others, thereby judged 'unarchivable.'"[8] In Spain, the archaeological impulse emerges as a response to the ongoing cultural reality of what has come to be known as the movement to recover historical memory, and it works similarly to transform the historiographic process itself into an object of inquiry and exploration. It functions to reconcile postmodern notions of the impossibility of historical representation and the exponential global growth of memory discourses, with a more or less genuine ethical desire to contribute to the uncovering and understanding of historical traumas that were deemed "unarchivable." This kind of fiction is less concerned with condemning authoritarianism

(again); instead, it seeks to rescue lost or forgotten historical happenings, making them manifest within the cultural structures of the present day.

It is worth mentioning that the contemporary interest in forensic archaeology, detective stories, dissident historiographies is not necessarily new. Carlo Ginzburg saw an "evidential paradigm" emerging in late nineteenth-century thought, in which clues and evidence became increasingly important to understanding how things really worked. In Ginzburg's formulation, infinitesimal traces "permit the comprehension of a deeper, otherwise unattainable reality."[9] Ginzburg traced the "clue" through detective fiction, philosophy, and psychoanalysis. In contemporary Spain, the archival impulse in fiction falls on this evidentiary continuum, using discarded objects as clues that grant access to alternative histories. These kinds of works foreground research and investigation as their central diegetic elements, positioning the archive, not just as a source, but as the subject of narrative exploration.

The narrative archaeology of the Spanish past is a way to make forgotten events public, contributing new dimensions to the country's knowledge of its history.[10] Revisiting history also means, in Bourriaud's words, "rendering justice to the vanquished lying in a mass grave teeming with half-erased accounts, embryonic futures and possible societies."[11] Walter Benjamin's materialist historiographical project focused on rescuing the early twentieth-century vanquished—the proletariat, left-wing intellectuals, the popular classes, minorities—from the dustbin of history. The radical potential of Benjamin's methodology was due in part to his expansion of the archive. Nicolas Bourriaud sees a similar impulse in the emergence of ethnography as a disciplinary field, which depends also on the clue, the shard, the found object for its construction of a new history. In other words, like archaeology, it depends on discards.[12]

The emergence of history and memory as dominant themes in contemporary Spanish culture might be explained in part in terms of what Fredric Jameson and others have explained as the late-capitalist commodification of the past.[13] But alternatively, we must also consider that the late twentieth-century resurgence of memory within cultural production also responds to specific political and historical developments occurring after the death of Francisco Franco and the transition to democracy. Any serious discussion of the revival of memory discourses in Spain must be linked to the ongoing social and political efforts to exhume the mass graves spread throughout the country, and, in the political realm, to the task of addressing meaningfully the claims of victims' families. This process, which began in 2000 with the mostly volunteer work of forensic archaeologists and members of the Aso-

ciación para la Recuperación de la Memoria Histórica,[14] took on a new political and juridical relevance with the Spanish magistrate Baltasar Garzón's efforts, in 2008, to condemn Franco's regime and legally recognize its victims. While the success of that process has been uneven and its ultimate political efficacy unclear, it was nonetheless a highly visible manifestation of how the *desmemoria* that arguably made possible Spain's transition to democracy has been questioned culturally, juridically, and politically. As a consequence, it has now become possible and indeed necessary for Spaniards to reflect on their past in the social, political, and cultural spheres.[15] In this respect, the country is participating in a broader international process by which democracies from Germany to the Southern Cone have paid attention to questions of history, memory, and transitional justice.[16]

As Sebastiaan Faber notes, "a nation's relationship to its troubled past has become something of an international moral touchstone."[17] It was only after Spain had already joined the European Union (EU), in 1986, that collective acknowledgment of national guilt for crimes against humanity became explicit conditions for membership.[18] Faber proposes that if Spain had applied later for EU membership, perhaps the country might have had to reckon more directly with Franco's violent legacy. Instead, Spain was never forced to engage in any kind of collective acknowledgment of historical trauma in the political or social spheres. In this line, in his 2014 novel, *Así empieza lo malo* (*Thus Bad Begins*, 2016), Javier Marías wrote that "everyone accepted this condition, not just because it was the only way the transition from one system to another could proceed more or less peacefully, but also because those who had suffered most had no alternative and were in no position to make demands."[19] Marías proposes, not unproblematically, that during the Transition years, people were more interested in living in a "normal" country than in demanding reparations or apologies from a regime that was unlikely to provide them.

We know that during the Transition, political elites subordinated historical awareness to a desire to turn the page on history and move forward with transforming the country's authoritarian institutions into democratic ones. Transition-era politicians preferred to erase any reference to or memory of unpleasant episodes from the past regarding the Civil War or Franco.[20] Cultural histories of the Spanish Transition coincide in their descriptions of a Spanish society whose citizens interiorized the era's hygienic philosophy, pushing the excrement of the past into a sanitized hole.[21]

While the social, political, and economic circumstances that have made possible or amplified the current memory boom in Spain have received

ample attention, this chapter analyses a subgenre of historical fiction in which a culturally oriented archaeological inquiry structures the narrative. Using Benjamín Prado's *Mala gente que camina* (2007) as a paradigmatic example, this chapter thinks about how discourses of memory, the archive, and the use of archaeology as motif function together to imagine how writers might engage ethically with the project of recovering historical memory. Through its reflexive narrative strategy and archival consciousness, *Mala gente que camina* reflects the democratic potential of a responsibly constructed archaeological imagination, which aims not so much to reconstruct an absent past as to reveal, in Kitty Hauser's words, "a consciousness of the ineluctable and material immanence of the past within the present."[22]

Prado's novel fits within a subgenre of self-reflexive historical fiction in which a first-person narrator investigates an episode of political violence that occurred during the war or postwar.[23] Gómez López-Quiñones describes how novels such as Andrés Trapiello's *La noche de los cuatro caminos* (2001; The night of the four paths), Javier Cercas's *Soldados de Salamina* (2001; *Soldiers of Salamis,* 2004), and Ignacio Martínez de Pisón's *Enterrar a los muertos* (2005; *To Bury the Dead,* 2009) do not exactly qualify as detective fiction, but they nonetheless are structured around the investigation of an unresolved crime about which there exist certain uncertainties.[24] He classifies these novels as *thrillers cognoscitivos* (cognitive thrillers) in which the investigation of knowledge is the ultimate objective.[25] These books' inclusion of archival photographs in particular functions to create a multifaceted, sometimes contradictory, image of the past while also betraying what Gómez López-Quiñones characterizes as a nostalgic impulse. By reflecting on forgotten or misunderstood events of the Spanish Civil War, novelists have indirectly reflected on the cultural condition of a postmodern, neoliberal, postindustrial capitalist Spain where confidence in modernity's grand narratives had begun to wane.[26] In terms of themes and style, these novels use Spain's history to reflect on the difficulties of rendering the past narratively, while also insisting on the importance of historical knowledge.[27]

MALA GENTE QUE CAMINA

Benjamín Prado is a well-known contributor to the Spanish press, and his work published in *El País* and through a handful of recent historical novels is devoted to uncovering unseemly, unethical, violent practices of the country's past. His novel *Operación Gladio* (2011; Operation Gladio), for example, deals with the killing, in 1977, of five leftist lawyers by a right-wing para-

military group supported by the CIA.[28] His *Ajuste de cuentas* (2013; Settling of scores), which, like *Mala gente que camina*, also features Juan Urbano as protagonist, focuses on the *pelotazo* years (late 1980s, early 1990s) when political and economic corruption was rampant in Spain.[29]

Prado's *Mala gente que camina* deploys an archaeological-historical narrative form to reveal a common practice of Spain's postwar years that remained largely unknown until recently: the kidnapping of babies and young children from Republican prisoners of war and their adoption by families sympathetic to Franco's regime.[30] Given the novel's clear political positioning, I wish to argue that the novel is by no means acritically nostalgic; nor is it loathe to engage in a pointed indictment of the persistence of the politics of forgetting in Spain. On the contrary, citing the epigraph to this chapter, Prado has made clear that he sees his role as author and journalist as a way to shed new light on Spanish history, since "whatever hides, silences, covers, disguises, or silences the reality of things is never the truth, but rather a lie."[31]

Thanks to the work of a growing number of scholars working on the Spanish Transition period, we know that there was—and continues to be—a lot more political and ideological continuity between the authoritarian regime and the democracy that followed it than has been traditionally acknowledged. Silence and moral-comparativism laid the foundation for the later systemic political corruption that has continued to the present day. By creating a false equivalency between crimes committed by leftist defenders of the democratic Republic and the Nationalist rebels, during the Transition period, the country's political elites tilled the soil for what would subsequently be a massive implantation of a moral relativism. That ethic of disappearance, silence, hiding, in turn developed into a generalized culture of silence and procedural opacity that allowed state corruption to metastasize.[32]

Among the more repugnant practices that were allowed to continue even after the immediate postwar and well into the country's pre-Transition period was the kidnapping of babies born to opponents of the regime and their clandestine adoption by Francoist families. The historical reality of this practice, which also conjures an automatic association with the Argentine case under Videla's dictatorship, was only brought to wider attention in Spain after the publication of the groundbreaking book *Els nens perduts del franquisme* (2002; The lost children of Francoism), authored by the investigative journalists Ricard Vinyes, Montse Armengou, and Ricard Belis, and the subsequent production of a documentary film on the topic that aired

on Televisió de Catalunya in the same year. The theft of babies continued for decades after the immediate postwar.[33]

Extant criticism of *Mala gente que camina* is nearly unanimous in its praise for its value as a documentary text.[34] Prado's extended use of documentation—letters, descriptions of photographs, testimonies, law documents—are arrayed throughout the novel in order to establish what happened, how it happened, and to assign responsibility for the atrocities committed during the long dictatorship.[35] Pablo Gil Casado claims that the novel contains, aside from its marked narrative realism, some formal characteristics of the Spanish New Novel in the style of Juan Benet,[36] but he criticizes Prado's use of reality to lend verisimilitude to his fiction, warning, somewhat problematically, that "uninformed readers" will perhaps be led to accept the fictional narrative as truth.[37]

Gloria García Urbina is less ambivalent in her appreciation of the novel, which she sees as part of a politically committed literature devoted to remembering the Spanish Civil War and vindicating the victims of the Francoist repression. This kind of literature does not aim to "re-open wounds," as some critics have suggested, but rather to give a voice to those who were never allowed to tell their stories.[38] Indeed, the discourse that has sought to critique the "re-opening wounds" is itself extremely problematic, since the closure of those wounds excluded a massive section of the population, which never had the opportunity to experience any kind of closure. The closing-over of wounds only benefited privileged parts of the body politic; there was never true resolution for the whole nation—only anesthesia and enforced amnesia that worked to immobilize and silence the people who suffered.[39]

Along with a robust cultural production that includes documentary and fiction films, television programs, theater productions, and narrative fiction, the cultures of historical memory that have emerged in postdictatorship Spain are oriented toward making the past accessible or sensible to a generation that did not experience the war or dictatorship firsthand. This archaeological impulse works to problematize traditional temporalities, while drawing the past into the present time.[40] In other words, part of the cultural work that these kinds of novels do is to show that the past is still here, gnawing on the present. García Urbina describes *Mala gente que camina* as a "a kind of historical document" whose effectiveness lies in its ability to transmit knowledge about hidden realities of the postwar period. The novel thus fills in spaces left open by historians, beyond simply listing and describing dates and events.[41]

Mala gente que camina is one of many literary examples of how historical memory has taken a privileged place in the world of Spanish letters, and how the metafictional mode continues to be a favored method of writing. The novel is narrated by a cantankerous, divorced *profesor de instituto* (high school teacher), who stumbles upon a forgotten novel of the postwar period by a fictional author, Dolores Serma. Much to the delight of the protagonist, who is currently researching an essay on the Spanish author Carmen Laforet, Serma is a contemporary and one-time acquaintance of the author of *Nada* (1945; *Nada,* 2008).

The dramatic tension of *Mala gente que camina* derives from the delayed delivery of information about the protagonist's object of study, and the process by which he tracks down and verifies biographical and historical data relating to the life and work of Serma. This dynamic begins on the second page of the novel, in which the narrator describes the conference paper he is writing—which he quotes directly—when he is interrupted by one of his colleagues, who wishes to express her dissatisfaction with one of his school scheduling decisions. The narrator establishes a pattern by which he divulges historical information and then delays its delivery with quotidian interruptions. This pattern structures the novel from beginning to end, as the narrator attempts first to find the time to devote to the object of his study and, second, to gain access to the archival materials from which he will reconstruct Serma's life and experience of postwar Spain.

The novel's structure, which alternates between anodyne stories of life in the Spanish academy and a more urgent exposition and repudiation of a reprehensible political practice, stands as an analogy for the way in which contemporary Spanish culture has sought to reconcile present-day crises with the historical happenings, events, objects, and practices that have been willfully forgotten or hidden. The ongoing efforts of an array of constituencies to uncover historical memory in Spain is a process that would seem to be forever interrupted or altogether frustrated by the ever-changing political exigencies of the present. This narrative dynamic of relentless interruption also contributes to the idea that a lot of stories about Spain's violent past are still waiting to be uncovered. They lie in the archives—personal, familial, institutional—awaiting the day when an engaged archaeologist will uncover, interpret, and contextualize them.

The novel's narrative logic of interruption also allows Prado to elaborate a more detailed descriptive account of present-day Madrid and environs, alongside, via conversations with the narrator's ex-wife, some reflections on the lasting impact that the 1980s *Movida* (which is described in more

detail in chapter 1) had on present-day Spain. Moreover, through extended conversations with his mother, the narrator sustains a critical dialogue on the theater scene as it was experienced during the long Franco years.[42] In this way the novel is structured as an historical *museé imaginaire* in which the reader may perceive the deep interconnectedness of twentieth-century Spanish literary and cultural history as reflected in the experiences, consciousness, and bibliographical production of its narrator.[43]

The novel's multitemporal framing is reflected in the narrator's discourse, which bridges wide gaps in time between experience, narration, and historical happenings. One example in particular deserves mention for the way that it reflects Prado's narrative technique, which melds past, present, and future within one discursive thread. At one point he reflects on his relationship with his ex-wife, Virginia, as he rides the bus home: "No dejaba de darme vueltas a la cabeza la situación de Virginia, a quien durante nuestro encuentro en el Café Star encontré en números rojos y contra las cuerdas. Les voy a contar la historia a grandes rasgos, antes de que el autobús en el que iba aquel martes llegue a su destino."[44] (I couldn't stop thinking about Virginia's situation. During our time together at the Café Star, it seemed like she was at the end of her rope. I'm going to tell you her story in broad strokes before the bus in which I was riding on that Tuesday arrives at its destination.) The narrator's playful engagement with temporality—mixing in one sentence the future, the past, and another future relative to that past—is also reflected in the title of the book he is writing on the life and times of Carmen Laforet in 1940s Spain. His book project is called *Historia de un tiempo que nunca existió (La novela de la primera posguerra española)* (A history of a time that never existed: The early Spanish postwar novel), which describes quite aptly the general thrust of book we hold in our hands: a narrative history of a time that never existed.[45]

The narrator expresses awareness of the pitfalls of an uncritical nostalgia, however. Following a frustrating day in the office, on another bus ride between Moncloa and his home in Las Rozas, where he lives with his mother, he muses: "Mientras avanzábamos por la carretera de La Coruña, sentí lo mismo que sentía siempre al ir hacia Las Rozas: nostalgia. Odio la nostalgia, ese moho de la memoria, esa oscura envidia de uno mismo. La nostalgia es el opio de los tristes, es una droga alucinógena que te hunde a la vez que te alivia, te hace sonreír mientras te clava en la espalda sus pretéritos perfectos e imperfectos: yo tenía, yo hice, yo estaba . . ."[46] (While we advanced along the La Coruña freeway, I felt the way I always felt when I was heading towards Las Rozas: nostalgia. I hate nostalgia, that mildew

of memory, that dark jealousy of one's former self. Nostalgia is the opium of the depressed. It's a hallucinogenic drug that buries you at the same time that it relieves you. It makes you smile while it stabs you in the back with preterit and imperfect tenses: I had, I used to, I was . . .) The narrator's critique of nostalgia—as a structure of feeling stuck in a present that is somehow less intense than the past—works well to describe how the contemporary Spanish metahistorical novel has sought to reinscribe the present with a deeper sense of time and temporality. The critical distance that the narrator maintains from the past is a way to block uncritical nostalgia in favor of a more authentic, politically engaged relation vis-à-vis history and memory.

While a novel such as Dulce Chacón's *La voz dormida* (2002; *The Sleeping Voice*, 2006), for example, uses point of view and narrative realism to situate the reader in an apparently distant time and place—in this case, the women's prison at Las Ventas in the 1940s—Prado's novel eschews this kind of fictional immersion in favor of a temporal critical distance. The temporal simultaneity I mention above, in which past and present tenses mix and interpenetrate, is one way that the novel makes time itself visible and feelable to the reader. We might describe this technique as an archaeological temporal simultaneity, or a way in which the past communicates with the present through poiesis.[47] It is also tempting to read this kind of narrative temporal experimentation in terms of Henri Bergson's notion of duration, which works usefully to conceptualize the kind of archaeological time that Prado's novel attempts to capture. Real duration, Bergson writes, "is that duration which gnaws on things, and leaves on them the mark of its tooth."[48] Prado's narrator describes an imaginary—but nonetheless feelable—kind of durational temporality that is consonant with the Bergsonian formulation. Bergson describes duration as "the continuous progress of the past which gnaws into the future and which swells as it advances. And as the past grows without ceasing, so also there is no limit to its preservation."[49] In other words, the present is conditioned by the accumulated traces of the past that comprise it.[50] I find this method of conceptualizing the relation between the present and an ever-expanding past extremely compelling, especially in terms of how durational past time leaves gnaw marks—traces—on and in the lived structures of the present. This is one of the things that objects can do as agents and representatives of a past time that pushes on the present.

The field of Spanish cultural studies has invested heavily in the hauntological as a way to describe the coexistence of past and present after the dictatorship.[51] But the past's presence in the present is not only spectral or

ghostly. In his book on the archaeology of the contemporary era, González-Ruibal describes two other modes of feeling that have the potential to disrupt historicist notions of time and temporality: resentment and nostalgia. Because resentment and nostalgia are emotions that "are the product of a non-absent past,"[52] they have an important function of expanding, in González-Ruibal's formulation, "the time of moral and political responsibility" into the present.[53] This might be described as an archaeological durational temporality. In *Mala gente que camina,* the narrator's playful manipulation of temporal markers allows the reader to sense multiple temporalities simultaneously. In the quotation above, he states, "I'm going to tell you [Virginia's] story in broad strokes before the bus in which I was riding on that Tuesday arrives at its destination." The statement is interesting because it encapsulates an unspooling present tense of narration (the novel's discourse) that contains within itself an indicative future ("I'm going to tell you the story") and a subjunctive future ("before the bus arrives") that all nevertheless exist in the past ("was riding on that Tuesday"). This is a novel way to imagine how the past, feelings about the past, and the present all coexist and intermingle within a narrative-historical duration. The novel's narrator, who does not reveal his identity until the final page, views the present through (what he might imagine to be) the perspective of the past, or what the present might look like if we were to view it from that past.

Nostalgia and resentment are sentiments that activate bodily feeling through physical pain.[54] According to González-Ruibal's radical archaeological politics, nostalgia and resentment have the power to keep the present open to the past. It is, quite literally, the opening up of a furrow in the landscape of the present where evidence of the past is revealed. Prado's novel draws together the times and places where archival research happens; it also melds the times and places where the subsequent diffusion of historical knowledge needs to happen.

The novel's events take place in Madrid and across multiple locations in the United States, and the narrator has conversations with other characters about Uruguay's twentieth-century dictatorship. At the same time that he devotes some attention to Latin American history, Prado also reveals an intimate knowledge of the workings of Spanish and American academic establishments, and inscribes his fictional tale within the very real context of literary critics and the novelists and poets to which they devote their attention in the United States and Spain. As he reads through the paper that he has been developing, he situates *Nada* within the literary tradition and notes how it was received upon publication, how Laforet's contemporaries

viewed the novel, and how critics such as Jeffrey Bruner, Ruth el Saffar, David W. Foster, Roberta Johnson, and Sara E. Schyfter have devoted significant attention to it.[55]

Prado's constant use of direct address to the reader creates a heightened sense of the reader's role in uncovering historical fact. At times, direct address has a humor function, as when he outlines the horribly banal day-to-day workings of the high school where he works, and what he must do as director of studies. He ends a long description by asking his readers, "¿Se aburren? Pues imagínese yo."[56] (Are you bored? Well, imagine how I feel.) But buried within his detailed descriptions of present-day Madrid, his relationship with his mother, his daily work as director of studies at the school, and his relationships with coworkers and restaurateurs, the narrator relays a compelling fictional tale of how Dolores Serma not only wrote a scathing veiled critique of the Francoist regime in her novel *Óxido*, but also how she exploited her connections within the Sección Femenina to track down her sister's stolen baby.

Interestingly, it is the novel's thematic and temporal heterogeneity that earned its harshest critiques in the popular and academic press, but I should like to argue that its capacious approach to citation and loose structure is precisely the point. Fittingly, the novel's central chapter—chapter 10, appearing at the novel's physical midpoint—contains sustained references to the importance of uncovering, digging, and unearthing. The citation included below encapsulates the archaeological impulse that I have been describing in this chapter and functions to visualize the mutual interdependency of past and present in the archaeological field. In the quotation, the narrator remarks on how Spain's Ley de Amnistía (Amnesty Law) of 1977 had a deleterious impact on the cultural life of the country: "Gracias a eso, la historia reciente de España, en lugar de dividirse en *antes* y *después,* se divide en *superficie* y *subsuelo:* ese subsuelo en el que siguen cerradas las fosas comunes de Víznar, en Granada; los Pozos de Caudé, en Teruel; la Sima de Jinámar, en Gran Canaria; los campos de Candelada, en Ávila, y Medellín, en Badajoz; el Fuerte de San Cristóbal, en Pamplona; el Barranco del Toro, en Castellón, o los camposantos de Lérida, Cartagena, San Salvador, en Oviedo, Colmenar Viejo, en Madrid, o Ciriego, en Santander."[57] (Thanks to that law, Spain's recent history is not divided into a *before* and *after,* but rather into a *surface* and a *subsoil:* it's the subsoil that covers the mass graves of Víznar, in Granada; in Pozos de Caudé, in Teruel; Sima de Jinámar, in the Canaries; the fields of Candelada, in Ávila, and Medellín, in Badajoz; Fuerte de San Cristóbal, in Pamplona; Barranco del Toro, in Castellón, or

the churchyards of Lérida, Cartagena, San Salvador, in Oviedo, Colmenar Viejo, in Madrid, or Ciriego, in Santander.) As he continues his research, the narrator remarks, once again deploying archaeological terminology, that "era emocionante picar en aquella especie de mina abandonada que era la vida de Dolores Serma y ver cómo iban apareciendo los personajes e historias de su época, uniéndose unos a otros como las piezas de una estatua rota" (it was exciting to pick away in that abandoned mine that was Dolores Serma's life, and to see how people and histories of her time period would appear, linking themselves together like pieces of a broken statue).[58] It is worth remembering here that this is exactly how the work of archaeology functions, piecing together discarded fragments in order to reconstruct a picture of the society, the economy, the culture that created them.

In the interview with Dolgin Casado quoted above, Prado remarks: "Es malo para un país democrático dejar en la oscuridad partes de su historia, pues en el olvido, ¿no? [. . .] lo que es abrir una herida es dejar una tumba común cerrada."[59] (It's bad for a democratic country to leave parts of its history in the dark, forgotten, right? [. . .] what they call opening a wound means leaving a mass grave unopened.) Keeping in mind the emphasis on research and investigation that structures *Mala gente que camina,* it becomes clear that archaeology is the novel's central structuring principle. Indeed, the archive described within its pages is not only the place for investigation but is also a *lugar de memoria:* a place for responsible reflection and a space where the reader may come to think about the interrelated dynamics of memory, history, archaeology, and historiography. To this end, the interview with Dolgin Casado is illustrative since the author reveals some of the sources from which he draws his narrative inspiration and political commitment.

Prado's vocabulary in the passage below points to the seriousness of his belief in the power of literature to intervene in the politics of the present. He notes that the inspiration for the novel was the fact that relatively little was known about the children who disappeared during the Franco years: "El silencio hace muy mala pareja con la literatura y hace muy mala pareja con la historia. Lo que hace una buena pareja tanto con la literatura como con la historia es la reflexión, el estudio, la investigación, la libertad. Desde este punto de vista, la literatura es lo contrario del olvido. De alguna manera preferir que no se hable de la sociedad del franquismo es legitimizarla, legitimizar el crimen."[60] (Silence is incompatible with literature and it is incompatible with history. What is compatible with both literature and history is reflection, study, investigation, freedom. From that point of view,

literature is the opposite of oblivion. In a way, to prefer not to talk about Francoist society is the same as legitimizing it, of legitimating a crime.) When literature is linked to reflection, study, investigation, it has the power to move the cultural conversation forward. Later, in chapter 13, as the narrator begins to gain momentum on his project, he pauses once again to reflect on the process. I point to his purposeful use of the term "archaeologist": "Me escocían los ojos y empezaba a sentir los dedos tan agarrotados como si me estuviese convirtiendo en mi propio fósil: si no paraba, la próxima vez que me dolieran las manos no tendría que ir al traumatólogo sino al arqueólogo."[61] (My eyes were burning and my hands were so stiff that I thought I could be turning into a fossil: if I didn't stop, the next time my hands hurt I would have to go an archaeologist instead of an orthopedist.)

BENJAMÍN PRADO'S ARCHAEOLOGY OF THE PRESENT

Walking through his neighborhood in Las Rozas, Prado's narrator reflects on how the past inhabits the material and psychological structures of the present: "Anduve por aceras desiertas y calles hastiadas de ser las mías que, como de costumbre, me parecieron una mezcla mareante de pasado y presente, de realidad y ficción."[62] (I walked along deserted sidewalks and worn-out streets which, as usual, appeared to me like a dizzying mix of past and present, of reality and fiction.) And referring once more to the reader, the narrator reflects on the relationship between the space he inhabits, memory, past and present:

> Esos sitios en los que uno pasó su infancia, creció y fue eligiendo, al azar o por convicción, las piezas de la persona en la que al final se ha convertido, nunca son inocentes, están hechos de plazas, esquinas y casas que te hablan al oído y parecen tener su propia memoria. Y, claro, en aquellas circunstancias, obsesionado con el tema sobre el que escribía mi libro, esa memoria no sólo se refería a mí, sino a todo lo que sucedió en Las Rozas, que tenía y tiene, como el resto de España, sus hechos y leyendas de la guerra civil y que, por su proximidad a Madrid, había sido escenario de durísimos combates entre las tropas constitucionales y las sublevadas. Los campos que rodeaban antiguamente la población, y que ahora se han convertido, en la mayoría de los casos, en carreteras, urbanizaciones y parques empresariales, estaban llenos de nidos de ametralladoras y de zanjas a medio cubrir que antes habían sido trincheras, y los niños encontrábamos en ellos, con

cierta facilidad, granadas, cartuchos y, en alguna ocasión, hasta obuses que no habían explotado y parecían esperar pacientemente, en su purgatorio acorazado, la llegada de nuevas personas a las que matar.[63]

(Those places in which you spent your childhood, grew up, and in which you began choosing—either by chance or conviction—the pieces of the person that you would eventually become are never totally innocent. They are made up of plazas, corners and houses that whisper in your ear and that appear to have a memory of their own. And of course, under those particular circumstances in which I found myself on that day, obsessed as I was with the theme of my book, those memories did not only touch on my own story but also upon everything that had happened in Las Rozas, a city that has and has always had—just like the rest of Spain—its events and legends from the Civil War and that, because of its proximity to Madrid, had been witness to bitter battles between constitutional troops and Francoist rebels. The fields that used to surround the town, and which now have been transformed, in most cases, into highways, buildings and industrial parks, were still full of old machine gun shelters and half-filled ruts that had once been trenches, and where as children we used to find, relatively easily, grenades, cartridges, and in some cases unexploded shells that seemed to be waiting patiently in their armored purgatory for the arrival of new people to kill.)

Like the unexploded bomb standing at the center of the orphanage in Guillermo del Toro's *El espinazo del diablo* (2001; *The Devil's Backbone*)—which waits ominously to unleash its violent power—Prado describes a contemporary Spain where evidence of the country's violent past can be perceived relatively easily, hidden in plain view within the urban and suburban edifices that surround us. As a work of archaeological fiction, *Mala gente que camina* deploys a conceptual and linguistic deep mapping of modern Madrid. Like the radical archaeology described by González-Ruibal, Prado's novel seeks to reenchant contemporary urban space by sending its protagonist out into Madrid's peripheries, fieldwalking and digging, uncovering the deep present that is hidden behind the shining exteriors of modern urban space.[64] His mode of noticing is archaeological.

I like this quotation because it distills precisely the kind of archaeological vision that I have been describing in previous chapters. This coeval existence of past and present differs radically from the fetishistic logic of heritage celebrated by official postwar Spanish culture, which aimed to bracket and

instrumentalize the past to prop up retrograde nationalism. Rubble and ruins of the kinds described by Prado's narrator exist as examples of a more unruly past that can still be perceived in the material realities of quotidian life in the city. Because it resists symbolization, the materiel that the narrator found as a child—and that no doubt continues to exist beneath the macadam and concrete of present-day Las Rozas—nullifies the idea of a present tense that exists independent of the past. González-Ruibal puts it poetically when he says that "as long as there are things, the past is not over and neither is the ethical responsibility toward the past."[65] In the second epigraph to this chapter, he proposes that archaeology is not just about understanding the past through its material traces; it is also about making the past present.

Throughout this book, I have been arguing that forgotten or discarded objects not only tell us a lot about the society that produced them, but they also serve keep the past open to us. Contemporary Spain is a place where the country's special brand of capitalist modernity has only unevenly erased the material vestiges of its history. But in spite of the better efforts of its architects, politicians, and urban planners, Spanish urban space is still a place where people can continue to enter and leave their cultural present.[66] Nearly every time a new construction project opens in Spanish urban space, the appearance of adobe bricks and other antiquated building materials reveal the coexistence of past and present within the material architecture of the city. Megan Saltzman's analyses of community artists' and activists' engagement with Barcelona's *medianeras*—half-destroyed buildings where traces of their insides are visible from the street—offer a picture of the social and political power of archaeological aesthetics in crisis era Spain. Archaeology, as a method of engaging with things and with the sensible world, offers a propitious disciplinary vocabulary and methodology for thinking about this kind of activity.[67] The work of archaeology depends on the visualization of objects discovered through digging. The novel, in emphasizing the linkages between the historical past and the cultural practices and structures of the present—banal and quotidian as they sometimes may appear—suggests that consciousness of temporal situatedness is constitutive of life in the postmodern era.

Complexity and heterochrony describe the deep present that González-Ruibal places at the center of his radical archaeology of modernity. There is an important lesson to be learned from his proposal that all pasts can become contemporary through archaeology. At the same time that supermodernity is working to erase time and to annihilate the past in order to construct an

eternal present, the subversive task of an archaeology of the recent past is to "de-modernize modernity" by accounting for its materiality.[68]

While Benjamín Prado's depiction of the convergence of time and space certainly deserves further attention, for the purposes of this chapter, I should like to focus more closely on its archival-archaeological consciousness, and how it relates to the linking of past and present through discarded material objects. As the narrator continues his account, he makes explicit the connection between his own life and that of Spain, thus continuing his reflection on the country's past, present, and future, blurring the artificial distinction between historical time and contemporary time. That is, through his reflections, Prado's narrator refuses the modernist rupture between past and present: "Lo mismo que los montes, las paredes del cementerio municipal o los muros de la iglesia, las mentes de nuestras familias también estaban llenas de metralla, ruinas y balas sin estallar que, por supuesto, en la versión de los acontecimientos que a nosotros se nos contaba, habían sido todas ellas disparadas por los rojos, esos débiles mentales e inadaptados sociales de los que hablaba en sus libros el coronel Antonio Vallejo Nájera."[69] (Just like the mountains, the walls of the municipal cemetery or the walls of the church, the minds of our families were also full of the munitions, ruins and unexploded bullets that, according to the official version of events that we were always given, had of course all been shot by the reds, those mentally weak and socially maladapted people that Colonel Antonio Valleja Nájera talked about in his books.)

The study of ruined things, rubble, and other material traces reveals information about their technology and about their own physicality. But most importantly, the study of ruins tells us about the society, culture, economy, and politics that produced them.[70] Prado's narrator describes, in the quotation above, a kind of psychological rubble that coexists with material ruins of the Spanish Civil War that surround us. Embodied psychologically in family memories are the histories, stories, tales, anecdotes of grandmothers and grand-uncles, neighbors and friends that represent an alternative site of historical research and recovery. As the narrator says a few pages later, "Yo creo que lo que se pactó en España con la Transición fue echar tierra encima de demasiadas cosas"[71] (I believe that what was agreed upon in Spain during the Transition was to bury too many things). The novelist's task, then, is to dig those things out again, to make them visible, to reflect on their importance to the democratic present, and thus to reject the spurious separation of past from present.

It is the small item or the seemingly insignificant detail (a bone, a piece

of cloth, a shard of glass) that allows the archaeologist to reconstruct a new story about the past. This is how archaeology transforms trivial objects, pieces of pottery, debitage, and debris into something meaningful. Prado's narrator is not only concerned with describing the past, but he also includes an array of extraneous details in order to document the historical present. It is perhaps instructive that the novel's dominant intertext is Laforet's *Nada*, which continues to be read and studied as a foundational document of post-war Spanish history and culture. For its part, *Mala gente que camina* represents a documentary snapshot of a twenty-first-century Spanish present that has not yet learned to recognize the gnaw marks that the past has left on it.

Mala gente que camina is at once an archive of the cultural present and an unearthing and visualization of those things that were covered in order to move forward. As such, the novel represents a self-conscious response to what Teresa Vilarós has called the historical erasure that stood at the center of Spain's transition to democracy.[72] As I noted in previous chapters, the transition to democracy was, for a variety of reasons and with an array of consequences, inhospitable to making possible any real accounting for the past. Instead, the educated urban middle class was content to pursue the individualism and consumerism of the globally hegemonic model of neoliberal capitalism.[73]

Through the efforts of his narrator, Prado would seem to suggest that there is a method of reading and interpreting late-capitalist Spain in a way that would allow us to perceive the embedded or covered history that that very society had sought, either consciously or unconsciously, to erase. The Spanish Transition was built upon a collective desire not only to bury any blemishes of the past but also to construct an antiseptic and false version of it.[74] What Vilarós calls a "whitewash" corresponds to a process of cultural invention in which "the hedonism, anarchy, aestheticism, and consumerism that marked the cultural revolt of the *Movida* ultimately speak to the failure of resolving the past in the present."[75] Prado slyly links that empty embrace of hedonism and pleasure to the culture of the present day: the narrator's ex-wife began her experimentation with hard drugs in the 1980s, and she never overcame her addiction. In a similar way, Luis López Carrasco's film *El futuro* (2013; The future) is a masterful full-length experiment in visualizing the link between the excesses of the *Movida* and the disillusion of the Transition years to the cultural, political, and economic malaise of the present day.

In partial defense of the Spanish Transition, Eduardo Subirats famously remarked, "De la noche a la mañana se tuvo que inventar una cultura, partiendo de una tradición rota, con una información muy precaria, en un

aislamiento atroz."[76] (Departing from a broken tradition and with very precarious information, a new culture had to be invented overnight.) *Mala gente que camina* shows, through its themes and forms, that the invention of a new Spanish democratic culture was never complete; nor was it altogether successful. We may read the narrator's relationship with his ex-wife, Virginia, as an allegory of how the *Movida* that came on the heels of the death of the dictator and the country's swift transition to democracy was rotten from the very beginning. Indeed, when Virginia first appears in the novel, her finances are in a shambles, and she is struggling to overcome the hepatitis C that she contracted after years of heroin abuse. The subsequent account of their relationship documents Virginia's reformation, with the narrator's help, and the rebuilding of their relationship. This allegorical rebuilding suggests that perhaps the only way forward for Spain is through the reflexive recovery of historical memory, through a responsibly enacted shared cultural archaeology.

The past endures in Spanish culture and politics. It can be found in the collective Spanish psyche, as the narrator of Prado's novel suggests, and within the lived environments of its cities and suburbs. It is found, in the form of rubbish, rubble, and ruins scattered throughout the Spanish landscape and, in the form of language, thought, memory, story, in an array of texts ranging from memoirs, historical novels, testimonial literature, journalism, television, theater, and film.[77] As Merino and Song note, contemporary Spanish culture bears the traces of "how the present still negotiates, consciously or not, with the traumas, cultural practices, and mind-shaping ideologies of the past."[78] *Mala gente que camina* is a text whose discourse offers a metaphorical method of making that buried history visible through a reflexive attention to the process of archival and archaeological research.

Benjamín Prado's novel is only comprehensible within the broader social and political context of the country's ongoing reevaluation of its Francoist legacy that has continued, into the present day, with the exhumation of Franco's mass graves. The sustained work of forensic scientists, anthropologists, and volunteer organizations in Spain has revealed, throughout the peninsula, broad evidence of a previously neglected history of repression and terror.[79] In a description that aptly describes the formal dynamics of *Mala gente que camina*, the archaeologist Francisco Ferrándiz notes that anthropologists working in the area of subaltern memory or "fugitive" memory practices have demonstrated the "slippery and unstructured nature" of these kinds of narratives, which "can be better depicted as unsteady conglomerates of partial voices necessarily characterized by their

indeterminacy . . . and lack of closure."[80] In a similar line, Ofelia Ferrán has described how, in Spanish memory texts, memory tends to be "both a central and a destabilizing force," and she elaborates on how memory has a dual function, not only as a thing remembered but also as a process or act.[81] Memories are uncovered through the process of remembering, but those processes are often triggered by objects. Things function to keep the past open to the present by disturbing historicist temporality. Digging, as González-Ruibal outlines, is an act of visibilization, an interruption of the teleological drive of historical time.[82]

By way of conclusion to this chapter, I should like to engage with one of the novel's harsher critics, Rodríguez Fischer, who has suggested that Prado's digressive narrative style detracts from the power of Serma's story. Fischer's main criticism has to do with the excess of information that Prado incorporates in his novel, and she proposes that the overwhelming—at times indiscriminate—inclusion of information gleaned from memoirs, autobiographies, cookbooks, diaries, essays on the historical period results in an information overdose.[83] The critic concludes that *Mala gente que camina* is ultimately a "mezcla mareante" (dizzying mix) that digresses unnecessarily from its central plotline. In other words, the novel is full of surfeit information, semiotic junk. Similarly, Ignacio Soldevila Durante and Javier Lluch Prats express admiration for Prado's "social responsibility," but they conclude their critique of *Mala gente que camina* by suggesting that a final editorial run-through of the text before printing might have allowed the author to eliminate unnecessary accumulation of data and information.[84]

Taking the critiques of Rodríguez Fischer and Soldevila Durante and Lluch Prats as a final point of departure, I want to propose that the novel's loose, somewhat repetitive structure, with its accumulation of historical information on diverse interrelated subjects, is in fact a crucial part of its archaeological impulse. The fictional narrative about Dolores Serma and her sister's lost child is the main narrative strand of the novel. But by embedding her story within and alongside the history of Spanish theater of the 1940s and 1950s, descriptions of mental illness, the state of Spanish public secondary education, the transatlantic world of literary academia, the culture and politics of postwar Spain, and alongside the documentary information gleaned from other sources (such as the Armengou, Belis, and Ricard book and documentary), Prado more authentically reflects the heterogeneous array of information available in the digital era.

Andreas Huyssen sees the return to memory in Western societies as part of a crisis of perception of temporality (the conceptualization of an

ever-shrinking present) brought on by virtual space and technologies of newness, which exist simultaneously with a loss of faith in the teleological drive of human history.[85] As an antidote for these crises of time perception, memory discourses have emerged globally as a way to seek "spatial and temporal anchoring in a world of increasing flux in ever denser networks of compressed time and space."[86] So, as the practice of historiography in general has shed its previous reliance on reassuring master narratives and grown skeptical of national framings of history and heritage, so have the critical cultures of memory—within which we must include novels like Prado's—sought to reenergize a politically committed memory discourse that emphasizes human rights, gender, and minority issues.[87]

What critics have characterized as a semiotic excess of Prado's novel is in fact a way of signaling the central ideologically situated practices of research, discernment, and, finally, narrativization that function to give form to that excess. I agree with Rodríguez Fischer that perhaps the novel would work better as a page-turner if Prado had eliminated materials peripheral or extraneous to the tale of Dolores Serma and her sister's stolen child. But Serma's tale is only one layer—the most important one, to be sure—of the stratigraphic substrate of an overloaded, multilayered semiotic sedimentation. The novel's import springs from its mise-en-page of archival and archaeological research, the process of recovering and corroborating what Huyssen calls "useable pasts" from the array of disposable ones within which they are embedded. If, as González-Ruibal proposes, memory has two enemies—the overabundance of recollections and oblivion—Prado's novel aims to reinvigorate the remembrance of the past while pointing to the crucial importance of discernment in recovering untold stories from an overfilled and richly sedimented archive.[88]

The overabundance of historical narratives about the Spanish Civil War and Franco era is a real danger, since it threatens, perhaps, to blunt memory and potentially to make it banal.[89] González-Ruibal proposes, somewhat problematically, that with the rise of historical and archaeological work on supermodernity, "the risk of saturating and trivializing memory remains," since "sites that are over documented and manicured lose their aura and their political potential."[90] He proposes, as a response to that danger, that "archaeologists should return ritual to the landscape . . . to help produce landscapes of counter-memory."[91] What exactly the archaeological ritual of counter-memory might look like is unclear, but in the realm of contemporary Spanish historiographic metafiction, the compelling construction of dramatic and ethically engaging narratives based on fact can move us in that

direction. By including the semiotic array within his novel, Prado increases the dramatic stakes of the fictional tale of Serma and her sister's stolen child that is buried within it, forcing the reader not only to delay the discovery of what *really* happened but also to sort through the glut of historical information and cultural context that is layered on top of and below it.

In *The Archaeology of Knowledge,* Foucault proposes that books, as artifacts, are never insulated or unitary; nor are their frontiers ever clear-cut. He reflects on how any book is "caught up in a system of references to other books, other texts, other sentences: it is a node within a network."[92] In a world of hypertext and an infinitely reproducible digital array of information, the archaeology of interconnected knowledges has only become more complex. Prado's novel, through its eclectic engagement with the widely circulating array of historical and fictional texts and discourses, draws itself into the abundantly populated matrix that is Foucault's field of inquiry. *Mala gente que camina* questions the unity—always variable and relative—of historical knowledge and thus works against itself as an object of isolated self-evidence. In other words, Prado does not disappear the *debitage,* the waste flakes and detritus formed during the elaboration of his narrator's excavation. Through the reflexive inclusion of a narrator not unlike himself who works—when he can—on uncovering this forgotten story, persisting through stumbling points, recognizing key happenings, and reorganizing the account to include them in his loose baggy monster of a text, Prado underlines the importance of his epistemological process.

Borrowing a phrase from Foucault, we might conclude that Prado's novel "indicates itself, constructs itself, only on the basis of a complex field of discourse."[93] The novel achieves this through its archival self-consciousness, which is deployed, alongside archaeology, as a tool for creating knowledge about the crucial interdependence of past and present. By making sustained references to the bibliography from which he sources his narrative, and by drawing attention to the process by which he constructs his account, the narrator bids the reader to acknowledge the impossible expanse of the archive itself and of history generally, which, already, as Foucault indicates, "cannot be described in its totality" since it "emerges in fragments, regions, and levels."[94] The *raison d'être* of the entire narrative, then, is to give form to the project that the narrator has made for himself. In fits and starts he constructs the story of the fictional Dolores Serma, her life and times, her literary and personal ambitions, all the while acknowledging the contingent, indirect access he has to her archive, and the subjective and procedural issues that affect his access to and interpretation of it. Prado preserves the political

charge of the historical past by preventing narrative catharsis and avoiding closure, ostensibly moving readers to consider the historiographic stakes on their own.[95]

The late Okwui Enwezor posited that the archival impulse "has animated modern art since the invention of photography."[96] As we can see in novels such as *Mala gente que camina*, Andrés Trapiello's *La noche de los cuatro caminos* (2001), Cercas's *Soldados de Salamina* (2001), Martínez de Pisón's *Enterrar a los muertos* (2005), and Luisgé Martín's *Las manos cortadas* (2009), there exists a simultaneous archaeological impulse functioning today in Spanish fiction, which works to transform the archive into a place for politically progressive historical reflection. In this regard, building upon Foucault's formulation of the archaeology of knowledge, "history is that which transforms *documents* into *monuments*."[97] *Mala gente que camina* takes the documentary record— much of it real, some of it invented[98]—and turns it into a monument not to a person or place or thing, but to the archaeological process itself.

Archives bear the weight of history, and therefore they are productive places for artists and writers to speculate on aesthetic, political, social, and cultural issues that have import in the present.[99] Enwezor concludes his essay by saying that "against the tendency of contemporary forms of amnesia whereby the archive becomes a site of lost origins and memory is dispossessed, it is also within the archive that acts of remembering and regeneration occur, where a suture between past and present is performed, in the indeterminate zone between event and image, document and monument."[100] It is within this theoretical framework that we may situate Benjamín Prado's *Mala gente que camina* and the archaeological Spanish novel, which, in its reflexive attention to the interrelated axes of ethics, aesthetics, and the archive, points to the potential of research, writing, and cultural archaeology for imagining a more democratic future for Spain.

5 Comics Perspectives on Spanish Crisis

Nuestra producción de basura sigue definiéndonos como ciudadanos. Trabajamos para producir basura. Cuanta más generamos, más consumimos, mejor vivimos. (Our production of trash is what defines us as citizens. We work to create waste. The more we generate, the more we consume, the better we live.)
—Jorge Carrión and Sagar Forniés, Barcelona: Los vagabundos de la chatarra

Nosotros mismos somos residuos de un sistema que obtiene ganancias de la contaminación, la degradación y la basura. (We are the residue of a system that profits from contamination, degradation and waste.)
—Carabancheleando, Diccionario de las periferias

Well beyond the 2008 economic crisis, access to affordable housing continues to be one of Spain's most pressing social issues. In 2017 there were 60,754 desahucios (evictions) in Spain for failure to pay rent or for other reasons.[1] A June 2017 article reported that evictions had increased in the country's capital city by 5.5 percent, for a total of 1,843 during the first three months of that year.[2] But even with those elevated numbers, the Community of Madrid ranked only fourth in terms of evictions during the first quarter of 2017, behind Catalonia (3,728), Andalucía (2,927), and the Comunidad Valenciana (2,358).[3] In the second quarter of 2018, Catalonia led the country in evictions.[4] In Barcelona the vast majority of those evictions were due to nonpayment of mortgage.[5] Every day national and regional news outlets have reported on families, couples, individuals, who have been evicted from their homes by banks with the help of the judiciary. As one of contemporary Spain's most visible social problems, access to affordable housing has accordingly emerged as a dominant theme for politically committed novelists, artists, and filmmakers.[6] This chapter analyzes how social-issue comics in

Spain have drawn the people most affected by the country's housing crisis back into the spaces and imagined places of the Spanish city by picturing the individuals whose lives have been wasted by rapacious processes of urban design and disaster capitalism.[7]

Previous chapters outlined how the transformation of urban space during Spain's democratic years hewed ever more closely to neoliberal models that tended to displace, damage, or otherwise fail to benefit the country's working and lower-middle classes. The neoliberalization of economic development and urban planning began in the 1950s, when Franco's technocrats pushed homeownership as a method of creating a robust middle class from scratch. By the 1950s, Madrid had doubled its population, and 700,000 people were in need of housing, while 300,000 were living in improvised shelters and shacks.[8] In the often-quoted words of José Luis de Arrese, Franco's housing minister, "No queremos una España de proletarios sino de propietarios" (We don't want a Spain comprised of proletarians, but rather of property owners).[9] Spanish political elites' desire to transform the country's working classes into property-owning bourgeoisie did not end with the dictatorship. Cultural critics, sociologists, anthropologists, and geographers have outlined how public administration in Barcelona, Madrid, and elsewhere has used culture and the culture industries as strategic modes to continue gentrifying neighborhoods, a procedure that in Spanish is also described perhaps more accurately as "social hygienization."[10] It is worth remembering that gentrification is only one of a series of interrelated processes by which neoliberalism has sought to reshape urban and suburban space, including contingent employment and evictions, austerity policies, privatization of public space, vulture funds, and so on.[11]

Nowhere have the neoliberal politics of space been more apparent than in the country's uneven access to housing and real estate, especially in the peripheries. On the one hand, voracious development and subprime mortgage schemes contributed to a glut of properties across the Iberian Peninsula, but as mortgages began to fail in the wake of the worldwide recession after 2007, people lost their primary residences even as thousands of apartments and flats remained unsold and unoccupied. Julia Schulz-Dornburg's book *Ruinas modernas: Una topografía de lucro* (2012; Modern ruins: A topography of profit), offers a photographic perspective on the abandoned houses and housing complexes in various stages of completion that dot the Peninsular landscape. Schulz-Dornburg's "topography of profit" visualizes a landscape of "planned" communities that never made it past the first stages of construction, and that continue to exist as "zombie housing" throughout the

Figure 19. *Campo de Vuelo Residencial* (Residential airfield), Julia Schulz-Dornburg, Murcia, 2012. (© Julia Schulz-Dornburg)

Iberian Peninsula. Eternally frozen in a moment of coming-into-being, the obsolescent housing tracts photographed by Schulz-Dornburg are junked Junkspace, homes and housing tracts inhabited by no one (fig. 19). As I noted in chapter 3, Jordi Bernadó's photographs also capture, through a critical lens, some of the ways in which the Spanish Commons has been privatized, commodified, and gentrified.

A 2012 article published in the right-leaning newspaper *ABC* described some of the social problems that have come with uninhabited new homes in Seville, where urban development that had been sold as progress by the city's politicians and bankers has been frozen, at once leaving many families without their life savings while also replacing olive trees with abandoned housing projects in the countryside.[12] Francesc Muñoz Ramírez (director of the Observatorio de la Urbanización) suggested that these are not necessarily a legacy of Francoism but rather of a democratic brand of urbanism that has created a landscape of shadows and unfinished projects: "Son territorios cautivos: son cautivos del automóvil. Son cautivos de la hipoteca. Cautivos del estrés."[13] (These are captive territories; they are captives of the automobile. They are captives of mortgages. Captives of stress.) The topography

of abandoned speculative housing construction in Spain is extensive. Schulz-Dornburg's book traces the national expansion of modern ruins and their impact on natural spaces and urban places. The unfinished buildings are an abundant result—and evidence—of the metastasis of fast capitalism in Spain.[14]

Not everyone is affected by economic crises in the same way; some lives are more precarious than others. Nicolas Bourriaud describes the massification of the proletariat that has accompanied processes of delocalized industrial production, the social impacts of "downsizing," shrinking social welfare, and harsh immigration politics which have "led to the emergence of grey zones where surplus human beings vegetate—whether as undocumented workers or as the chronically unemployed."[15] As a tactical response to these realities, in Barcelona the radical politics of squatting has become a major social and political phenomenon.[16] But in an era of permanent crisis, where access to fair housing has become progressively more difficult, even decidedly unradical groups have resorted to squatting as a way to survive. It is worth remembering that Spain is a country where total unemployment exceeded 20 percent until 2016.[17] A much-publicized eviction of twenty-seven families from a housing complex in Majadahonda (Madrid), for example, revealed the broad social impact of *desahucios* in Spain. The list of affected people included a family with a three-month-old baby, a twenty-five-year-old man suffering from cancer, several retirees, elderly people, and at least twenty school-age children.[18] Squatting is not just for anarchists and punks.

In his book on the wasted lives created and dispersed by late-capitalist modernity, Zygmunt Bauman describes how politics in the age of liquid modernity has been unable or unwilling to accommodate the people it has displaced. Contemporary anxieties about numbers of immigrants, asylum seekers, non-native ethnic Others connect all too easily to reactionary policies of control, containment, exclusion, producing a political logic of "waste" humans who are placeless. Bauman observes how refugees and the homeless have usually been the "late-comers" to Western-style capitalist modernity, displaced subjects of the deregulation of war and uneven modernization: "Refugees are human waste, with no useful function to play in the land of their arrival and temporary stay and no intention or realistic prospect of being assimilated and incorporated into the new social body; from their present place, the dumping site, there is no return and no road forward."[19] It is perhaps not surprising that most of the people relocated by the Majadahonda evictions came from the Americas;[20] these are the doubly displaced humans produced by neoliberal globalization, the massified prole-

tariat set loose on an ever-expanding global frontier. Depicted in the global media as an exorbitant human remainder, the refugee and the homeless person are absorbed into the undifferentiated realm of data, crowds, camps, caravans, and numbers, "pulped into a faceless mass."[21]

This chapter focuses on two collaborative graphic narratives devoted to the interrelated topics of housing, precarity, and waste: *Aquí vivió: Historia de un desahucio* (2016), with images drawn by Cristina Bueno and a script by Isaac Rosa, and *Barcelona: Los vagabundos de la chatarra* (2015), with images drawn by Sagar Forniés and words by Jorge Carrión. Both books deploy words and drawings to recover and reinsert the undifferentiated human masses produced by insatiable modes of neoliberal capitalist development into the visual and narrative frames that picture civil society. Both texts bear witness to the humanitarian problems produced by the country's relentless drive toward neoliberal modernization, and they feature empathetic protagonist-narrators who seek out and engage with the otherwise unseen, undifferentiated people living just out of plain sight. Harnessing the ethical potential of the comics medium, these contemporary image-text works aim to give a voice to the Spanish city's most precarious citizens, literally drawing them back into the visual and emotional structures of urban life.

HOUSING TROUBLES IN *AQUÍ VIVIÓ: HISTORIA DE UN DESAHUCIO* (2016)

Aquí vivió: Historia de un desahucio is a collaborative work of sequential narrative in which the novelist Isaac Rosa and the illustrator Cristina Bueno explore the social impacts of housing politics after the 2008 economic crisis. Rosa is well known for novels on the recovery of historical memory (*La malamemoria* [1999; Bad memory]; *¡Otra maldita novela sobre la guerra civil!* [2007]) and 15M (*La habitación oscura* [2013; The dark room]). Rosa's comics collaboration with Cristina Bueno continues his long-standing interest in social issues but now expanded into comics representation. He has worked more recently with the illustrator Mikko on *Tu futuro empieza aquí* (2017; Your future starts here), which draws attention to the social marginalization of the young people known as "ni-nis" (those who, given the reality of Spain's labor market, *neither* work *nor* study).[22]

From the first splash page, *Aquí vivió* works to situate readers within the point of view of Spanish society's most precarious people, who, finding themselves unable to keep up with their mortgage payments, are in danger of losing their homes. These are the extratextual urban dwellers to whom

Michel de Certeau dedicates his work *The Practice of Everyday Life:* the men and women who always come before texts. They are the people who do not expect representations but, thanks to social-issue comics and emerging forms of alternative politics, will increasingly have them. In the opening illustration, the distorted faces of six men appear through the peephole of a front door. Over the following three pages, Bueno's illustrations picture a condensed version of a confrontation between the bewildered home owner and the lawyer, bank officer, three police officers, and locksmith who have come to remove him wrongly from his home.[23] Beginning in the confines of an apartment hallway and ending at the Sede General de los Juzgados (General Division of the Courts), this opening episode turns out to be a humorous story, narrated by one of the protagonist's coworkers, about the erroneous eviction that he was forced to fight and win ("¿Qué os parece? ¡Vaya país!" [What do you think? What a country!]).[24] This opening anecdote is rendered through a series of smaller panels drawn in green monochrome, distilling into a few pages the extended confusion and frustration of the speaker, whose run-in with the housing authorities spanned several days. The book thus opens with a useful synthesis of the way that state and fiduciary institutions, which wrap themselves in the mantle of judicial procedure and law, work hand-in-hand to wrest people from their homes and insert them into an impersonal bureaucratic (time) machine.

The ensuing narrative focuses on Carmen, who has just moved with her school-age daughter, Alicia, into a tiny apartment in the city. It becomes apparent later that their new home—purchased following Carmen's separation from Alicia's father—was on the market following the eviction of its previous inhabitants. Encounters with aggressively unfriendly neighbors inspire Carmen and Alicia to wonder why they are not welcome as new inhabitants of the flat.[25] They come across traces of the former tenants, including a timeworn armchair and markings on the door jamb that a previous family used to mark the growth of a child over time. Alicia prefers to leave the markings on the door, but her mother says, "A nadie le gusta vivir con huellas de quienes vivieron antes" (No one wants to live with the traces of those who lived here before).[26] Like an amateur archaeologist, over the following pages Alicia sets out to discover more about the previous inhabitants of the flat, using the material traces they have left behind. Bueno's drawings visualize those traces on the page: an old armchair, a lost diary, a water mark on the wall, a dent in the drywall, penciled etchings of dates on a door jamb.

Aquí vivió follows Alicia's gradual coming-to-consciousness as an ethical

citizen of the city. At first, she is suspicious of her new home: a one-quarter-page panel drawing of a toilet contains a speech bubble saying, "Me da cosa sentarme. De verdad. A saber quién habrá meado aquí antes"[27] (Sitting down here gives me the creeps. For real. Who knows who peed here before?) But Alicia is an extremely sensitive and empathetic person who becomes increasingly attuned to the traces and remnants of the lives that were lived in her new home. Her curiosity about her home's previous owners is triggered when she discovers a forgotten diary.[28] When Alicia shares the diary with her father, he notes its similarity to the *Diary of Anne Frank*. The Anne Frank excerpts are a fitting intertext for the work, since they are personal testimonies of a young woman's life lived on the verge of disaster. Alicia's father, a former teacher, gives her his own "imaginary journal," in which he wrote an alternate diary when he was her age, saying: "La imaginación es la forma más barata de vivir otras vidas. Y no tiene consecuencias. No haces daño a nadie"[29] (Your imagination is the easiest way to live other lives. And it has no consequences. You can't hurt anyone.)

The link between imagination (fiction) and ethical engagement with others (reality) that Alicia's father verbalizes is in fact the central thrust of the Rosa/Bueno book, which works to create a sense of intimacy between inhabitants of this home, past and present. Will Eisner and Scott McCloud have described how the formal structure of comics—panels arranged on a page—require a certain level of reader participation in the construction of cause and effect, time and temporality. This readerly engagement is crucial to achieving an aesthetic effect of intimacy, as the reader uses his or her imagination to fill in the gutters between the frames. The resulting illusion of motion and comics' peculiar sense of time are created by the reader as she moves deliberately through the work, connecting one frame to the other and creating closure.[30] It is this filling-in of the gaps that comprises the central concern of *Aquí vivió*.

The aesthetics of framing in art and the imagination of community in politics have always relied on the problematic drawing of boundaries. The creation of political boundaries and frontiers functions to generate the categories of "inside" and "outside," "us and them," belonging and not belonging. Comics, which are usually constituted by boxes and frames on the page, are specially oriented toward asking questions about inclusion and exclusion. And as an art form linked historically to urban life, comics have always thought about the spaces and places that people occupy in the city.[31]

In *Aquí vivió*, people previously excluded from the frame are constantly coming back into it, bringing their stories with them. When an elderly

woman enters their house late one night, Alicia and her mother are con-
fronted with their home's past. A walk through the barrio with the old
woman reveals drastic changes in the urban landscape: "Se vende" signs
appear on the facades in her neighborhood, and a shop once familiar to the
old woman is now run by an immigrant family.[32] When they enter a bank
to make inquiries about the process by which the house was repossessed
and its inhabitants evicted, drawings of a cynical bank manager function
as a critique of the neoliberal logic of linking mortgages, home ownership,
and bourgeois ideas of happiness.[33] During their conversation, background
images of happy young people enjoying the fruits of "easy" mortgages serve
as a visual counterbalance to the banker's cynical explications of how evic-
tions actually happen.[34]

Throughout the book, Bueno's drawings overlay past and present on the
page to represent the previous inhabitants of the house, their travails and
history, while Alicia and Carmen learn their story. Bueno's illustrations trace
the outlines of past events in green ink, while the present-day inhabitants
sit in the living area listening to Carmen's tale.[35] The spatial dynamics of
panels on the page allow the simultaneous visualization of past and present,
collapsing temporal distinctions into panels in which time has an extended
or expanded sense of duration. This is the process through which all pasts
become contemporary through archaeology.[36]

In an interview, Isaac Rosa describes how he and Bueno wrote their story
in a way that would ensure that the protagonists' home would play a central
role, not as a material possession but as a container of lives and memories.[37]
On the one hand, the idea of a home as "container" emphasizes the archi-
tectural structure of the apartment building and the comics form that is
construed as frames on a page. On the other, the idea of "container" also
suggests the impermanence of human presence within urban space in Spain
after the economic crisis. That is, the politics of precarity and economic
insecurity transforms urban space into an impermanent nonplace in which
people are only able to live temporarily. This process benefits an economic
system that is always looking to put commodities back on the market where
they can circulate and create value. Alicia's grandmother verbalizes this
sociopolitical reality, noting that "ahora la gente se cambia de casa cada dos
por tres, y no se llevan con ellos a esos pobres fantasmas" (now folks move
a lot more frequently and they don't take their poor ghosts with them).[38]

Aquí vivió traces Alicia's coming-to-terms with the fact that her house
was once the home of other people, and, as it ends, she begins to see her
role more as custodian of her homeplace than owner of it. The structure

of overlapping stories, histories, and spaces is a key narrative and visual strategy in the book. Other anecdotes of housing troubles appear in the text: Alicia relates the story of the family that lived in her mother's new house to her father and his mother at their place; Grandma relates the story of "El Topo," a man who, having returned home from the war, was forced into hiding in an attic room. After two years spent there he finally emerged, only to be beaten and sentenced to three more years of jail. These stories are overlaid upon the physical spaces inhabited by the people in the panels, creating a deeper sense of history and time. This is the concentration of the comics form in action, or what Hillary Chute calls the density of "assembled moments."[39]

Alicia imagines the ghostly traces of inhabitants past and expresses guilt for living in the home of *desahucios* (evicted people).[40] Her mother says that every house has a past and that part of living is learning to coexist with their ghosts.[41] Bueno renders these traces in white outlines which appear perhaps as the marks left by a wax-resist print (fig. 20).[42] This is an apt and extremely suggestive method of visualizing the *huellas* (traces) of the past, since the form relies for its realization on the coloring of the spaces not marked by the wax. With the wax resist, negative space becomes positive; the represented image is formed by the negative space of the lines drawn in wax.

Although Alicia's mother is less interested in the presence of ghosts in their home, she nonetheless acknowledges the cultural and psychological function that they may play: "Cuando no hay fantasmas, te los inventas. Parece que los necesitamos."[43] (Even when there are no ghosts, you invent them. It seems like maybe we need them.) Her later comments are almost archaeological: "Nada empieza nunca de cero. Todo se construye sobre el pasado. Hay que aprender a convivir con ello."[44] (Nothing begins from zero. Everything is constructed on top of the past. You need to learn to live with it.) Alicia at first prefers not to live with the ghosts and traces ("No quiero vivir aquí" [I don't want to live here])[45] because she is uncomfortable with the ethics of her mother's decision to purchase a home from the bank at a very low price.[46]

As Alicia digs deeper into the history of her new home, she begins her ethical awakening. She attends a PAH meeting organized by anti-*desahucios* activists and marches alongside her new comrades during a social action against a *desahucio* that ends with police scuttling the crowd.[47] The PAH is the "Plataforma de Afectados por la Hipoteca (de la burbuja inmobiliaria al derecho a la vivienda)," a national social-action group known for its green shirts and advocacy in support of evicted people. It is one of the social mo-

Figure 20. From *Aquí vivió,* Cristina Bueno and Isaac Rosa, 2016.

bilizations that emerged in the wake of the 15M protests and that has been credited with playing a transformative role in progressive Spanish politics after 2008.[48] The PAH is organized as a consensus-based collective that advocates, educates, and supports people impacted by *desahucios*. The group's "green book" calls it a "movimiento ciudadano apartidista":[49] "La PAH lleva a cabo acciones en muchos campos diferentes (emocional, político, mediático, judicial, comunicativo, etc.) para promover cambios legales que den respuesta a la vulneración de derechos fundamentales que sufren las personas afectadas, y en un marco más amplio, proponer soluciones para hacer efectivo el derecho a la vivienda para toda la ciudadanía."[50] (The PAH

carries out actions in many different areas [emotional, political, media, judicial, communications, etc.] in order to promote legal changes responding to the violation of the fundamental rights of affected people, and, in a broader frame, to propose new solutions for granting broader access to housing for all citizens.) Barcelona's mayor, Ada Colau, gained prominence in the city through her political activism with the PAH. The association is visible in television, online, and print journalism on and about the housing crisis in Spain, and they advocated for the people affected by the *desahucios* mentioned in the Majadahonda story above.[51]

Bueno layers images of past and present by incorporating shadows cast across the present-day lived environments of urban Spain. Bueno also devises a way of picturing a broader view of the city through skillful insertion of urban maps. The book thus plays with the visual dynamics of the city in a way that is reminiscent of Certeau's descriptions of the strategies and tactics of the city, whereby the vernacular walkers "know" while the planners "see." There is a dramatic interplay of the large scale of the city constructed by urban planners and the street-level tactics of the people who inhabit it. Bueno's illustrations exploit the dynamic relation of scale that this story of the city elaborates. One of the ways that urban planning works is to invisibilize and marginalize the city's most vulnerable populations, transforming the city's working-class neighborhoods into centers for culture.[52] Toward the end of the book, Alicia's friend Iván, a PAH activist, remarks, "Ese es el otro problema de los desahucios: son invisibles . . . y se olvidan"[53] (That's the other problem with the evictions: they are invisible . . . and they are forgotten). One of Bueno's illustrations is a full-page aerial view of the city that is adorned with a cascading array of hand-drawn black text boxes featuring arrows and dates lettered in white signaling recent *desahucios*.[54] The page, with its overlay of temporal and spatial coordinates, pictures the expanding impact of housing inequality in the city. Bueno cleverly creates continuity on the next page with drawings of Alicia and her companion looking up;[55] Iván describes a case when a man threw himself from the window when the "funcionario judicial" (officer of the court) arrived to force him from his home. As Alicia and Iván speak, across two panels a *chatarrero* passes from the background to the foreground.[56]

Iván declares, "tras las paredes hay historias terribles" (behind these walls there are terrible stories).[57] Like the Carrión and Sagar collaboration to which the second part of this chapter is devoted, *Aquí vivió* transposes the competing optics of the city within the formal grammar of the comic, illustrating how the tactics of the system are constantly shifting with new

urban planning schemes. Bueno's drawings—like Sagar's—track the unruly, microscopic comings and goings of the city's walkers—"the ordinary practitioners of the city live 'down below'"[58]—showing how their lived experiences contest (but are also contested by) the less subtle, more violent, strategies of neoliberal capital to rewrite the city in its image.

To give her a sense of scale, Alicia's friend Iván invites her to imagine football stadiums filled with the families evicted, or to imagine if all the evictions were to happen in one day.[59] A full-page aerial image of the city teeming with *desahuciados* provides an image "de lo crueles que han sido estos años" (how cruel these years have been).[60] One of the reflexive points that Rosa and Bueno illustrate in *Aquí vivió* is that Spain's most vulnerable populations are largely invisible. As Iván points out during a walk through the city, "Cuando uno camina por la calle no lo ve. A veces no sabes ni lo que pasa en tu propio edificio"[61] (When you walk through the city, you don't really see it. Sometimes you don't even know what is happening in your own building), and, in the next panel, "Pero tras las paredes hay historias terribles" (but behind the walls there are terrible stories). On the other hand, Iván also points to the official desire to hide the true numbers of forced evictions through purposeful manipulation of data.[62] In other words, the invisibilization of precarity serves the interests of market capital. Iván narrates the story of a woman who finds a job cleaning out the homes of those who have been forcefully evicted. The job takes an emotional toll, and she finally falls victim to a *desahucio* herself.[63]

Iván explains in hopeful tones the impact that social action can have and shows Alicia a housing block recovered by the PAH to house twenty evicted families.[64] Her father's brother Víctor gives Alicia a tour of the building, outlining how families collaborate in taking back empty houses, flats, and apartments.[65] The book traces Alicia's coming-to-consciousness as a politically committed citizen of the city. Following her experience in the PAH home, she begins to research the roots of the housing problem, which began with dictatorship-era building and urban development.[66] The book visualizes the real continuity with Francoist land speculation, and the refrain, repeated over seven panels, that "el precio de los pisos nunca baja" (the value of houses never goes down),[67] which ends with the present-day fight to prevent *desahucios*.[68]

The book ends with Alicia's commitment to the *desahucios* cause; she commits herself to social action and shares her experiences with her concerned parents. A final conversation with her *tocaya*, Alicia, who used to live in the home she now shares with her mother, reveals that the elderly

Carmen was only a figment of her imagination; the woman had died shortly after the family's eviction. With the help of her parents, and with the support of the PAH community, Alicia installs a plaque on the facade of the house building in commemoration of Carmen, "Junto a su familia, fue desahuciada el 22 de febrero de 2009."[69] (Along with her family, she was evicted on 22 February 2009).

The novel's five final pages are nearly bereft of dialogue. Instead, Bueno's drawings depict the smiling faces of the multitude of people standing in solidarity in the streets, bearing placards with sunny phrases like "Sí se puede" (Yes, we can), which has become a rallying cry for the PAH movement in Spain.[70] In this regard, the work responds warmly to Zygmunt Bauman's prediction that "it is the horrifying specter of disposability—of redundancy, abandonment, rejection, exclusion, wastage—that sends us to seek security in a human embrace."[71] The book offers an optimistic response to Bauman's bleaker description of a world ruled by two Big Brothers: one that is all discipline and inclusion—"getting people into line and keeping them there"[72]—and the other that excludes—"spotting the people who 'do not fit' into the place they are in, banishing them from that place and deporting them 'where they belong.'"[73]

In the novel's final pages, the creators acknowledge the various stories that went into the elaboration of the text, including web addresses for social-action groups working in Madrid and Barcelona.[74] Through its narrative of visualization, inclusion, information, and social action, *Aquí vivió* aims to contribute to the ongoing social and political project that largely began with 15M. It not only represents—through drawn pictures and script—the important political work that is being done today by progressive groups in Spain, but it also stands as an engaged example of how socially committed art might contribute to the project of visualizing alternatives to the neoliberal status quo, and of reclaiming the public sphere from private interests.

GHOSTLY MATTERS IN THE CITY

If, as Avery Gordon noted in her book *Ghostly Matters* (1997), "haunting is the sociality of living with ghosts,"[75] the Rosa-Bueno book deploys the formal grammar of comics to illustrate how the ghosts of the past inhabit the lived environments of present-day Spain. Alicia's visual-literary imagination allows her to translate traces of the past—a water stain on the ceiling, a crack in the plaster wall, pencil marks on a door jamb—into evidence of prior human presence. These traces of the ghosts that inhabit her new home

inspire her to seek out the real people who have been displaced, and to make her home hospitable to them through an engaged form of archaeology. Prior human presence is translated—through drawings and script—into real emotional presence, a kind of ethical haunting of physical space by those displaced by the country's relentless commodification of housing. Alicia's house—its rooms, its furniture, its walls—is a place where the past is inscribed materially. It is a literal page filled with panels, rooms, chambers, where these traces of the past tell a story.

Via Raymond Williams, Gordon emphasizes that haunting is, above all, a social experience, because the ghostly objects and subjects produced by modernity exert agency upon the people they haunt, making our lives "a tangle of structured feelings and palpable structures."[76] Gordon surveys the narrative works of authors such as Luisa Valenzuela and Toni Morrison and argues that we find an "unavoidability" in their novels, whereby their protagonists are forced to engage meaningfully with the ghosts with whom they come into contact. On the one hand, they must deal with "State Power or Slavery or Racism or Capitalism or Patriarchy, with their capital letters," but also with the structures of feeling that come with haunting: "of reckoning with the fundamentally animistic mode by which worldly power is making itself felt in our lives, even if that feeling is vague, even if we feel nothing."[77]

In *Aquí vivió*, the apartment itself is infused with a vitality it has acquired through previous habitation. Alicia, ever sensitive to others and to her own place in the world, is especially attuned to her home's animism, where its former denizens can still be felt to exert a force on her and her mother. That force has ethical ramifications, as she and her mother feel the need to make a place for them in their home, and in their present time. The people are gone, but they can still be sensed, strongly, unavoidably, and the overarching story of the graphic novel is the story of coming to terms with that force, and of making her home hospitable once again to the memory of the people who have been displaced by an inhospitable economic system.

BARCELONA: LOS VAGABUNDOS DE LA CHATARRA (2015)

Barcelona: Los vagabundos de la chatarra is a 2015 collective work of investigative journalism created by the artist Sagar Forniés (1974) and the writer Jorge Carrión (1976). It details the two men's exploration of legal and extralegal scavenging operations, large and small, in the former industrial sections of Barcelona, principally Poblenou, during the renovations and urban develop-

ment that accompanied the implementation of the 22@ plan.[78] Over the course of a year (2012–13), Sagar and Carrión rode their bicycles around these rapidly transforming urban spaces, observing how the global forces of deindustrialization were impacting the recycling economies of the city and interviewing the people displaced by those processes. Through a reflexive journalistic lens, the book explores living conditions in some of contemporary Barcelona's most vulnerable places. While portions of Rosa and Bueno's book take place in what looks like Barcelona, Bueno's drawings are sufficiently general as to promote a wider identification of urban space; *Aquí vivió* could ostensibly take place in Madrid, Valencia, or Seville, and the creators credit people associated with the PAH in Vallecas, Tetuán, Barcelona, and La Bordeta (Lleida). The Sagar and Carrión volume, on the other hand—as will be clear from its title—engages more specifically with the social and ecological impacts of economic processes of gentrification in modern-day Barcelona, particularly Poblenou.[79]

Catalonia is the most heavily industrialized region in Spain, and Poblenou was, from the nineteenth century until the late twentieth, the most robust industrial area in Barcelona. In the 1980s and 1990s, the bulk of heavy industry left the city center for the peripheries. From the 1970s through the 1980s, the city lost 250,000 industrial jobs but added nearly as many in the tertiary sector, retail and services.[80] As in Madrid, processes of urban renewal had a mixed impact on different populations in the city, pushing working classes and immigrants into the peripheries.[81] Although on the surface development was presented as a way to renew degraded or depressed sections of industrial areas, those projects have typically been driven by private interests and have not permitted public participation in decision making.[82] While Barcelona's urban planning in the postdictatorship years adhered to the General Metropolitan Plan of 1976, which followed clearly established rules for urbanization and relied more heavily on public participation, since 2000 the trend in Barcelona has been characterized by what Sabaté calls "opaque urbanism," which is embodied by urban strategies "marked by an attempt to transform the city into a global city without a general planning framework but rather through fragmented urban interventions marked by iconic buildings designed by architects belonging to the star system."[83]

Crucial community pieces of the 22@ plan—such as social housing projects—were not put into place by the private investors and urban planners directing the transformation of industrial Barcelona.[84] Commentators have noted the scarcity of "viviendas sociales" (public housing) in Spain, when its more progressive European neighbors have long offered subsidized

housing to its more economically vulnerable citizens. This is in spite of the fact that the right to housing is enshrined in the country's Constitution, although no laws yet exist to guarantee it.[85] As a result, the 22@ plan has been criticized for both its disregard of the city's industrial heritage sites and for the way that it has forced residents out of the city center.[86] As factories and industry have left the city, buildings in the Poblenou area have been sublet or subdivided by companies carrying out a range of short-term activities occupying legal gray areas.[87] These more informal contingent economies nevertheless served essential functions in the city. The *chatarreros* who appear in the Sagar and Carrión text, for example, provide crucial recycled building material to the city's network of metal recyclers, which in turn have contributed materials to the construction sector.

Land speculation has led to a loss of cheap public housing, creating significant social pressures in the city and throughout Spain. It is within this context of urban transformation that *Barcelona: Los vagabundos de la chatarra* unfolds. A prologue text, titled "Esta historia es antigua y acaba mal" (This story is ancient, and it ends poorly), reflects the critical tone of resignation that characterizes the entire work. The book opens with a brief dissertation on how economic precarity has fueled the global industry of scrap scavenging. Citing Rem Koolhaas, the authors describe the expanding world of "Junkspace": "El espacio residual, el mundo basura: el progreso es un mito inmaterial que deja a su paso un grueso y matérico rastro de mierda."[88] (Residual space, the waste-world: progress is an immaterial myth that leaves a broad and rich trail of shit behind it.) Having spent nearly a year in and around Poblenou, the author and illustrator interviewed some of the three hundred people who make their livings through the illegal trade in scrap metal, documenting in comics form the creative spaces, tensions, spaces of solidarity and hope, of poverty and survival that those people created for themselves in the city's peripheries. The authors' ground-based investigations and search for vernacular forms of knowledge situate them within a broader movement in Spain to explore new modes of academic and journalistic research.[89]

The prologue is followed by a two-page splash depicting Barcelona's Arch of Triumph, where a multitude of people bearing Catalan flags have joined together in a protest on September 11, 2012. The book has two central functions. First, centering on the 22@ project, it documents one year in the process of urban gentrification in one neighborhood of Barcelona. Second, and most importantly, the book gives a voice to the most precarious inhabitants of that urban zone. In an interview, Carrión compared his

script to the Baltimore-centered U.S. television drama *The Wire* (2002–8), specifically in relation to the series' complex interwoven plots. The work has been described as one of the first examples of comics journalism made in Spain,[90] reflecting on the lives of the more than 28 percent of Barcelona's population that currently lives below the poverty line.[91]

Approximately one thousand people live in the occupied vacant warehouses of Poblenou.[92] Sagar and Carrión argue that the economic crisis that began after the worldwide financial crash in 2007 is a historical regression that has taken broad swaths of the population from production to collection, from manufacturing to the collection and processing of scraps. Using the comics form allows the authors to deploy multiple perspectives on the economic crisis in Barcelona, drawing an array of different stories unfolding within the real city onto one page. The use of a drawn form of reportage was also strategic, since it allowed the authors to access place, stories, and people that they would not have been able to access using more traditional tools of the journalistic trade. As Sagar notes in a video posted online, "La cámara de photos es muy intimidatoria . . . la libreta es un término mucho más abstracto."[93] (Cameras are intimidating . . . a notebook is a much more abstract category.) To emphasize the point, Sagar includes several drawings in which people insist that the men not take photographs.

WASTE PEDAGOGY IN *BARCELONA:* *LOS VAGABUNDOS DE LA CHATARRA*

Comics production in Spain has increasingly devoted itself to representing the political, economic, social, and cultural impacts of austerity and recession. Aleix Saló's wildly successful comics critique of Spain's economic crisis, *Españistán: Este país se va a la mierda* (2011; Spainistan: This country is going to shit), is an irreverent and pithy elucidation of the processes by which the country went from booming European economy, in 2007, to recession and austerity.[94] *Barcelona: Los vagabundos de la chatarra*, for its part, may be the first Spanish comic authored and marketed as a teaching text. Both the authors' statements in interviews for the popular press and the book's prologue and introduction feature commentary and quotations from Rem Koolhaas,[95] Walter Benjamin, Agnès Varda, Ignacio Vidal-Folch,[96] and Joe Sacco,[97] which, considered together, suggest a comic book ready-made for cultural studies analysis. Moreover, the book, with its numerous allusions to contemporary geopolitics and network of cultural and scholarly references, offers a doubly coded model of this kind of analysis, combining

an ideological critique of postcrisis Barcelona with a reflexive meditation on comic-book aesthetics. Paratextual teaching aids found online provide an array of complementary texts and contexts within which to situate a critical reading of *Barcelona*. A "Guía Didáctica" includes discussion questions designed for high school students; Google maps of Barcelona contain pins demarcating where the action takes place; links to further reading provide contextual information on housing policies, austerity, and more; and the reader can also explore excerpts from reviews of the book.[98] The authors reflexively signal their commitment to raising awareness of social issues through comics in the epilogue, which is a drawn, inked, and colored interview with Joe Sacco in Barcelona.

In the world of waste and discard studies, Walter Benjamin and Agnès Varda are well known. The Benjamin quote included in the text is taken from his *Arcades Project,* in which the authors cite the *chatarrero* Fermín who prefers "los trastos viejos" that predate the shift toward repression and specialization.[99] The Varda quote is from *The Gleaners and I*: "Esta propiedad no puede ser robada porque no tiene dueño. Los que cogen el objeto son sus propietarios legales. . . . Una vez cogido, el objeto pertenece al recolector, irrevocablemente."[100] (This property cannot be stolen because it has no owner. Whoever picks up the object becomes its legal owner. . . . Once it has been picked up, the object belongs irrevocably to its collector.)

I noted in the introduction how Benjamin, via his appropriation of Baudelaire's *chiffonier,* is cited frequently in the theoretical work on waste and refuse. Varda is similarly visible in the trash canon thanks in part to her documentary on gleaning, which includes interviews and profiles of some of the most marginalized people in France, who make a living from the capharnum and waste that is left over or overlooked by society's better-off. The inclusion of Varda and Benjamin, among those other writers and artists mentioned above, serves to situate the Sagar-Carrión text within a broader theoretical and cultural context of trash studies.

The ensuing narrative embodies a trash studies approach to putting radical pedagogy into practice. Vasile, from Bucharest, is the authors' first interviewee, who recounts his past and how he began to work as a *chatarrero* when construction jobs began to disappear.[101] Abudu, from Senegal,[102] describes his peripatetic life, commenting on the injustice that *chatarreros* suffer at the hands of the men who purchase their junk: "Son empresarios españoles, particulares, los que hacen negocio con nuestra miseria: pero esa gente no da entrevistas."[103] (The people who do profit from our misery are Spanish entrepreneurs: but those people never grant interviews.) And later,

a man named Williams,[104] also from Senegal, walks the authors through the warehouse where he lived before it is demolished. A text box appearing in the top of three tiers of boxes labels the racial dynamics of construction and urban renewal in Barcelona: "Los obreros con máscara y traje blanco son hombres negros. Los capataces, sin necesidad de protegerse, son blancos."[105] (The workers with masks and white suits are black men. The overseers, who don't need to wear protection, are white.) The three hundred people who lived in the warehouses being demolished are displaced.[106] Williams laments that he was only able to live in his new home for two weeks before being *desalojado* (displaced; evicted).[107] A text box on the lower right of the page summarizes the failed efforts of the inhabitants of this urban zone to halt the *desalojos,* but they fail: "el desalojo se fijará para el día 24 de aquel mes. Es difícil no ver en esos escombros la imagen de ese futuro."[108] (The eviction has been set for the twenty-fourth of that month. It's difficult not to see in those ruins an image of the future.) The one-sixth-page panel depicting a bag of construction debris symbolizes the frustration of these displaced people,[109] whose hopes of a dignified place to live are constantly being trashed by a society that attempts to not even see them, even if the sound of their shopping carts rolling across cobblestones and asphalt embodies what Carrión describes as "la banda sonora de esta ciudad" (the soundtrack of this city).[110] A clever splash page appearing later summarizes the novelty that the shopping cart brought to modern forms of consumption, with a brief biography of its North American inventor, Sylvan Nathan Goldman. Carrión's script, in keeping with his cultural-studies approach, notes the inherent similarities between nomadism and consumerism, two activities facilitated by the shopping cart: "tres elementos propios del nomadismo y el consumo: la mochila, el carro de la compra y el carrito de supermercado" (three elements nomadism and shopping share: the bag, the pull cart, and the shopping cart).[111]

Across a two-page splash near the center of the book, the authors ride their bicycles through a busy street in Poblenou discussing how they will represent these stories;[112] they again draw reflexive attention to the comics form: "Durante las semanas siguientes regresamos varias veces. Todo comic, toda crónica, es un ejercicio de montaje."[113] (During the following weeks we returned various times. All comics, all chronicles, are an exercise in montage.) Part of the reflexive orientation of *Barcelona: Los vagabundos de la chatarra* is corrective. Throughout the text, the authors describe their aim to provide a deeper, more humanistic account of the economic crisis in Spain than has appeared in the mainstream media. For example, they

mention the 2012 *New York Times* report that brought international attention to conditions in Spain.[114] In the aftermath of that report, which was accompanied by a series of black-and-white photographs by the Catalan photographer Samuel Aranda, Spain's news outlets were flooded with follow-up coverage. Following the publication of the report, King Juan Carlos I, who was in New York for a conference sponsored by the Clinton Global Initiative, met privately with *New York Times* editors to offer a more nuanced account of the country's crisis.[115] But an article in *El País* noted how the *New York Times* report in fact showed a very different picture of the country than the one that Spain's prime minister of the time, Mariano Rajoy (PP), was describing to the General Assembly of the United Nations that same week.[116] The Spanish response to the 2012 *New York Times* photographic report was a preview of the response—described in chapter 2—to the international press coverage of the 2013 sanitation workers' strike in Madrid. There is a sense, in both instances, that the appearance of Spanish waste and extreme poverty in the worldwide media inspired a generalized fear that somehow the country's image, which had been carefully polished by its political and cultural elites over the last eighty years, was being tarnished.[117]

Throughout the book, Sagar and Carrión make clear that they are aiming for a deeper, more contextual account of Spanish urbanization processes and the people impacted by them. Because of the way that comics visualize space and time, the form is well suited to representing the complex interplay between architects, capital, cultural elites, working classes, and the poor.[118] The work is punctuated by two-page splashes of the construction project that would transform this industrial portion of Barcelona into 22@.[119] Each image is identified with a text box with the date, and the floating head of Fermín Vásquez, the real-life architect behind the open-air market Nous Encants project (which was finally named Encants Barcelona) and the now-iconic Agbar Tower, who offers to give the reader a tour of the construction site (fig. 21).[120]

The illustration of Vásquez as a disembodied head suggests visually the distance between the top-down relation of urban design and the more tactile, precarious world of the walkers who inhabit an urban space—at street level—that is being transformed by capital. Vásquez's white hard hat, glasses, and white lab coat all contribute to suggesting a practical and ideological distance from the material world he purports to shape. The architect's floating head represents the optical distance of the capitalist-as-voyeur, while the journalist and artist move through the tactile close-range experience of urban space.

As Sagar and Carrión explore the urban zones slated for demolition and new construction, they interview the "survivors" of Barcelona's urban renewal projects.[121] Floating boxes of news images of a "desalojo" of forty-seven people who were living in abandoned warehouses near a chatarrería on Calle Zamora on January 7, 2013.[122] The event was real, and the comic is faithful to the reporting on the incident found in El País.[123] The human impact of these desalojos is part of the authors' ethical engagement with the politics of urban development in Barcelona. A four-panel page represents aerial images of the men on their bicycles riding diagonally left to right across the frames.[124] Each panel offers an increasingly distant perspective of urban scale, and the bottom two panels are Google Earth images. Superimposed upon these maps of the city are speech bubbles pointing to the temporality of urban change: "Cada generación pierde una ciudad . . . que hereda la generación siguiente. [. . .] Como una rueda . . . es el pedaleo de la ciudad, lo que le permite avanzar hacia el futuro."[125] (Every generation loses a city . . . which the next generation inherits [. . .] Like a wheel . . . it is the pedaling of the city that allows it to advance towards the future.) The other man wonders how many kilometers the city's waste recyclers walk every day and about the anxiety they must feel living always on the verge of being exiled.[126]

The squats and temporary housing upon which immigrant communities rely for shelter correspond to the growing category of ephemeral places—or nonplaces—that Marc Augé describes as material products of supermodernity.[127] These are the "the fleeting, the temporary and the ephemeral" places that offer the anthropologist "a new object" of study: "transit points and temporary abodes are proliferating under luxurious or inhuman conditions."[128] On the one hand, there are the squats and refugee camps where the world's migrants find themselves, and on the other, there are the hotels, apartment blocks, airport lounges where the world's moneyed elites pass their time in transit. They are all nonplaces.

What the Sagar and Carrión book captures is a moment of transition when Barcelona is being transformed from a place into a nonplace. The authors represent a press conference, in which the inhabitants of one of the warehouse cooperatives speak against the city's planned demolition of their home.[129] The book documents a transitional time in the evolution of the city, during which the postindustrial spaces in which Barcelona's chatarreros live undergo a new phase of transformation into mixed-use developments organized around a neoliberal economic model. As the city evolved from an industrial center to a cultural center, the warehouses and factories of the

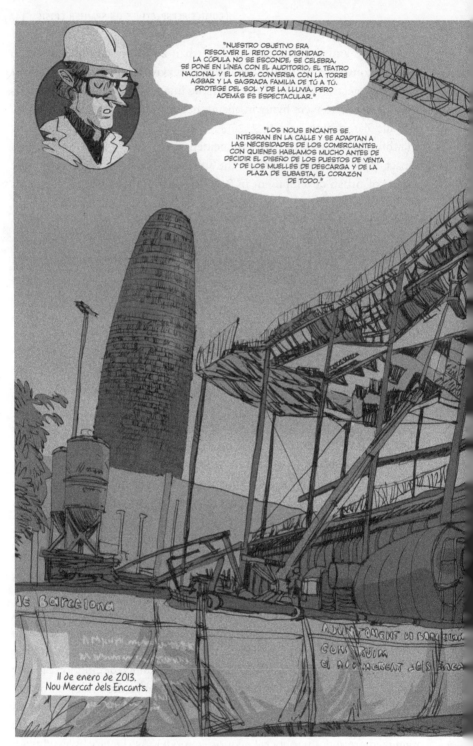

Figure 21. From *Barcelona: Los vagabundos de la chatarra,*
Sagar Forniés and Jorge Carrión, 2015.

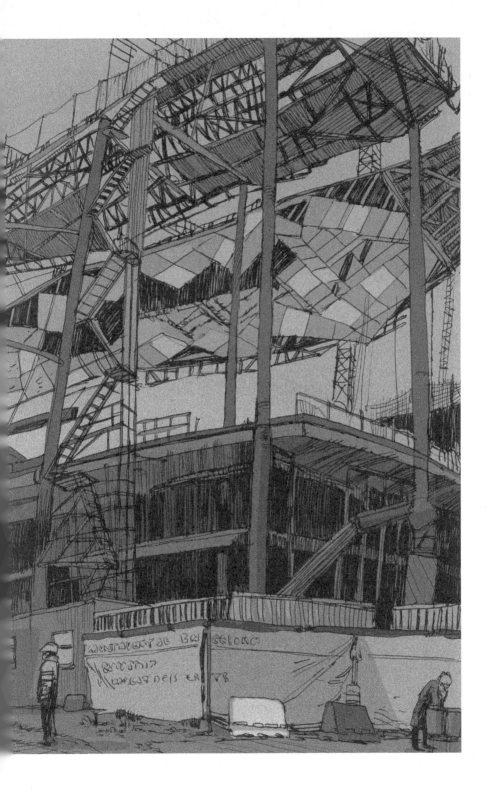

Poblenou were boarded up, forgotten, or abandoned. Irregular economies sprang up in these spaces, and the warehouses became homes, cooperatives, unofficial *chatarrerías*. When capital came back to reclaim those spaces for a new capitalist phase of space production, it found robust communities of people—many of them immigrants and people of color—making their livings in these "leftover" spaces. Those people had to be removed, and capital, together with political elites, began the process of reclaiming urban space through a politics of displacement (of *okupas, immigrants,* and other vulnerable people).

Like the Bueno and Rosa book analyzed in the first part of this chapter, *Barcelona: Los vagabundos de la chatarra* is most interested in exploring how the marginalized cultural practices of squatting and other alternative modes of social engagement and economic activity contest dominant notions of capital, community belonging, and aesthetics.[130] *Barcelona* might be profitably understood within the context of *okupas* literature, since it explores the human impacts of the processes of the commodification of space in the Ciudad Condal. The authors describe how the changing of the seasons marks the shifting demographics and housing opportunities of a city in flux: "Poblenou es, a nuestros ojos, un mapa lleno de agujeros negros y de puertas tapiadas."[131] (Poblenou is, from our perspective, a map full of black holes and barricaded doors.) Like *Aquí vivió*, the book draws attention to the massive proliferation of non-normative uses of space for living in the Spanish city after the economic crisis.[132]

Sagar and Carrión document how property owners begin locking up warehouses and ejecting extralegal occupants to capitalize on rising rents in Poblenou. A six-panel conversation between the author and the artist elaborates on the virtual invisibility of Barcelona's *chatarrero* communities: "Solo cuando me empecé a fijar en ellos empezaron a ser visibles. Y a multiplicarse" (Only when I started noticing them did they become visible to me. And to multiply), says Carrión.[133] Sagar responds, "Bueno, se multiplicaron de verdad: a medida que se iba hundiendo España, más chatarreros aparecían" (Well, they multiplied for real: as Spain continued to sink, more scrap collectors appeared).[134] As unemployment soared in the wake of the economic crisis in Spain, increasing numbers of people were forced to take to the streets to make a living however they could. Sagar sees comics journalism as an important tool in drawing attention to this problem: "Supongo que esa será la función del comic: señalar un problema" (I suppose that's the function of this comic: to draw attention to a problem),[135] to which Carrión responds, "Eso es lo que debería hacer el periodismo: poner el dedo en las

llagas de la realidad" (That's what journalism should do: put a finger in the wound of reality).[136]

Barcelona: Los vagabundos de la chatarra is a reflection on the problems created by a system that has only been able to modernize itself by creating and recycling its own ruins.[137] The work fittingly concludes with a series of images of demolition and construction, as the neighborhood is demolished and reshaped to make way for new development. Panoramic three-panel pages are interspersed with splash pages, all of which are linked formally and thematically by a progressive chain of official tweets authored by the city of Barcelona (@barcelona_cat). The tweets are reproduced as text boxes that replace any narration in the form of captions; instead, they offer the triumphalist rhetoric of politics and capitalist investment in urban renewal as the last warehouses are turned into *chatarra* and shipped overseas.[138]

Immediately following the authors' final interview with a man named Williams, a series of tweets authored by the city's Ayuntamiento points to the empty rhetoric of social justice that Barcelona politicians have used to erase its responsibility to its most vulnerable inhabitants. While the city says, via its official tweets, that "guarantizamos la cobertura social de todas las personas vulnerables de los asentamientos que lo pidan" (we guarantee social security for all vulnerable persons in the settlements that ask for it), and that "el Ayuntamiento trabaja para crear una cooperativa de trabajo de la chatarra y ocupar a las personas vulnerables" (the city government works to create a job cooperative for the *chatarra* and find employment for vulnerable persons), the scale of destruction depicted in the splash suggests forces unconcerned with the real effects on humans.[139] The production of steel I-beams facilitated by the demolition of nineteenth-century warehouse buildings is contrasted with the human impact of *desalojos*, vulnerability, and displacement that that production is causing.[140] Pages 92 and 93 render the transport and export of the I-beams to points unknown; a freighter speeds out of the Barcelona harbor in the final two-thirds-page panel (fig. 22).

The book begins with the two-page splash depicting the protest march at the Arch of Triumph on September 11, 2012,[141] and ends, one year later, with another two-page splash visualizing a very different kind of public social gathering: the inauguration of the new development. In this regard, the book is a chronicle of failed alternative economics and political action. The human story of *chatarreros* in Barcelona concludes, on pages 94 and 95, where Sagar has rendered a two-page aerial view of the Mercat Encants de Barcelona. The floating head of Fermín Vásquez smilingly recites architectural jargon: "La cúpula es como un gran espejo que introduce la ciudad en

Figure 22. From *Barcelona: Los vagabundos de la chatarra*, Sagar Forniés
and Jorge Carrión, 2015.

el mercado y proyecta el mercado en la ciudad. Han cambiado el nombre, de hecho, ya no se llama 'Encants Vells' sino 'Encants de Barcelona' . . . Se ha impuesto la marca Barcelona."[142] (The dome is like a great mirror that brings the city into the market while projecting the market out into the city. The name has been changed, so now it is not called "Encants Vells" but rather "Encants de Barcelona" . . . The Barcelona brand has been imposed on the space.)

ICONIC SOLIDARITY

As a spatial medium, comics are a propitious form for thinking about architecture and urban space. The system of narration in comics differs fundamentally from that of the cinema, particularly in terms of the visual discontinuity of the frames on the page which do not recede or disappear as new frames appear.[143] This chapter has outlined some of the ways that Spanish urban spaces—in Madrid and Barcelona—hold on to the traces (often waste objects) of the past. In *Aquí vivió,* the present-day apartment inhabited by Alicia and her mother, Carmen is simultaneously a container or frame for past-tense stories unfolding alongside present-tense lives. In *Barcelona: Los vagabundos de la chatarra,* the contemporary city where Sagar and Carrión undertake their project is a space filled with material reminders of the ongoing transformation of urban space by transnational capital.

Unlike the cinema, in comics it is the reader who dictates the flow of narrative and the progression of time. Most importantly for this discussion of urban space and access to the city, the system of comics monstration (showing, writ large) allows for the accumulation or collection of images and frames on the page, so that the totality of images continue to be viewable by the reader at any one time.[144] As a geographical medium, in the space of one page, comics can reveal simultaneously the broad cartographic view of the voyeur *and* the tactical small-scale perspective of the city walker. This is what Groensteen calls the "solidarité iconique" (iconic solidarity) of the comics form, which is comprised of interdependent images that are at once separate (appearing in frames on the page) yet connected (appearing together on the page).[145] Much of the dramatic power of the Sagar-Carrión text derives from the formal tension between the strategies of urban capital (architecture, gentrification) and the tactics employed by the men who provide the material scraps for making that vision possible (recycling, collecting, gleaning), and who seek out places to call home within that increasingly inhospitable urban milieu. They are separate, yet necessarily connected.

As a way of rendering an archaeological vision, comics are special because they can represent past and present at the same time. Unlike the cinema or television, the comics form does not create the illusion of a story or world unfolding before our eyes, but instead of a world that happened, in the past, and that has left its imprint on the present world. Drawings and words on the page put forward an impression of a narrator's perspective on those events, but not the event itself.[146] Recent comics on the Spanish housing crisis capture the "supplementary logic" of the ruin that Viney describes in his philosophy of waste.[147] The ruin is the place where temporalities mingle and mix, where continuities can be discerned but also discontinuities, connected yet separate. It is this vibrant mixture of tenses, times, uses and wasting that makes the modern ruin—and contemporary urban comics forms that seek to capture it—such a contradictory and pedagogically rich place.

6 Words and the Wasting Self in Rosa Montero's Fiction

We die. That may be the meaning of life. But we do
language. That may be the measure of our lives.
—Toni Morrison, 1993 Nobel Lecture

Stories are just things we fabricate, nothing more. We
search for them in a world besides our own, then leave
them here to be found, garments shed by ghosts.
—Viet Thanh Nguyen, *The Refugees*

Previous chapters of this book have reflected on the cultural and archaeo-
logical import of interactions between people and wasted materials, places,
and things. Here, in the book's final chapter, I want to shift my focus to the
ways that trash might encode the ways in which we conceptualize self-
hood. New materialist philosophy has reconceptualized how power and
agency work within and across material beings.[1] Material bodies—human
and nonhuman—never function in isolation. Things are always enmeshed
in relations with other materials and things. Jane Bennett's formulation of
"distributive agency" recognizes the complexity and interconnectedness
of material networks of actors and proposes novel methods of theorizing
the power relations and agencies that are embodied by materials that are
dependent upon each other. What I want to do in this chapter is to reread
Rosa Montero's *La hija del caníbal* (1997), and her more recent *La carne* (2016),
from a new materialist perspective, in order to consider how fiction that is
written mainly about identity might also consider the fact that people are
also things. How does the matter of the human biological self contribute
to the project of representing personal identity and human consciousness?

La hija del caníbal is a novel in which the self-conscious emphasis on the
narrative process comments upon the complexities of articulating subjec-
tivity.[2] Through her narration of the extraordinary events that spring from

her husband's kidnapping, Lucía Romero—the protagonist and principal narrator of the work—not only overcomes a midlife crisis but also attempts to figure out what it is that makes her who she is. The novel begins with a disconcerting disruption of Lucía's routine existence when her husband, Ramón, a low-level government bureaucrat, disappears just before boarding an airplane. While the plot centers on Lucía's search for her missing spouse, the progression of the narrative coincides with a more threatening struggle as she comes to terms with her own human "necesidad de permanencia" (need for permanence) as a biological and autobiographical being.[3]

JUNK SELVES

Over the course of this book, I have outlined how waste and waste-in-the-making function to make visible the cultural and political structures that comprise life and politics in contemporary Spain. I proposed that reading human interactions with trash produces new ways to understand the city, the production of urban space, the relation of the past with the present, politics, aesthetics, culture. Chapter 4, which focused on Benjamín Prado's archaeological fiction, also touched on how the Franco dictatorship saw non-nationalist others as waste that could be ejected from the body politic. But what happens when we take a new materialist approach to consider our own ontological selves as waste-in-the-making? John Scanlan notes that garbage is the by-product of "a more or less imperceptible contest between life and death—because death constitutes the human return to matter, and is in a sense, the 'garbaging' of the body."[4] In what follows, I read Montero's novel alongside Thierry Bardini's provocative proposal, elaborated in his book *Junkware* (2011), that waste is not just the end result of death but, rather, that junk constitutes the conceptual, material, and informatic stuff of human life itself.

Trash is everywhere, but it is often overlooked. Although waste and the systems and infrastructures that process it often remain opaque, according to Dietmar Offenhuber, garbage is in fact "physically embodied information."[5] You just have to know where to look. One of the ideas I am putting forward in this book is that by looking at the information embodied in trash, we can learn more about what is most important to us.[6] At the same time, apparently useless material is also a crucial part of what makes us who we are. Bardini begins his book by considering the startling fact that the human genome contains mostly junk DNA. Indeed, the material responsible for programming the human is comprised of only 1.2 percent of the total

genome. How does this fact impact the way that we understand the human condition? In previous chapters I explored how the language and logic of waste have been deployed as a way to exclude non-native or non-national others from the boundaries of the state and definitions of the human. One of the startling realizations that emerges when we study trash is that waste actually lies at the core of just about everything we do. Without culture, there is no trash. Yet when we look inward, at the information that comprises our genome, we also begin to perceive how waste is also encoded in our basic structure.

Without junk, there is no us. Junk is the name that scientists have assigned to that part of our DNA that does not appear to have a role. But, as Bardini outlines, "junk is more than a part in the compound expression 'junk DNA.'"[7] The term "junk" has been used across a broad band of epistemological endeavors to describe an array of activities. The amorphous, nonspecific category of junk functions linguistically and conceptually in a lot of ways:

> Junk is the cement of our cultural experience, the fractal principle that unifies our most intimate fiber (DNA) to the cosmos (space junk) and everything in between: what we ingest (junk food), where we live (junk space), what we trade frantically (junk bonds), our communications (junk mail), our (more or less) recreational drugs (just junk). Junk can be adequately used to describe any significant cultural experience in today's global culture: as everybody knows, TV is junk (hence reality TV), music is junk (recycled, sampled, etc.), movies are junk (especially romantic comedies: secondhand affects, i.e., sentimentality sold by the pound), art is junk (especially contemporary art).[8]

One part of Bardini's thesis is that junk is the stuff that holds the world together. In that regard, as I have proposed in earlier chapters, junk is both ontological and epistemological. As stuff, it exerts material force in the world, existing and making itself felt and bringing things together. But junk is also allegorical, metaphorical, symbolic, since it stands for other things, taboos, pollutants, actants, beings.

Bardini takes care to distinguish junk from trash or garbage, proposing that "junk is one step before garbage, its quasi-necessary fate. Junk is garbage ready to happen, trash in the making,"[9] but one of the points I have been trying to make in this book is that waste is something that always exists on the border between value and nonvalue. Nothing is ever always

or permanently trash. Things forever fall on a sliding scale between desired object and discarded thing. The distinction, therefore, between junk and trash is not a crucial one to make. Waste is junk is trash is garbage is excess is information.

What is most interesting about Bardini's formulation is the notion that junk functions as connector or medium, linking up different parts of systems. In this regard, waste is one of the most expressive materializations of the excesses of supermodernity.[10] One of the signal features of contemporary art is the ways in which it engages with the semiotic excess with which we come into contact every day.[11] Contemporary artists in Spain have developed strategies for making meaning out of the semiotic array, from the place-based art installations of Luzinterruptus to the trash art and activism of Zireja, and from the archival stories of Benjamín Prado to the archaeological images of Carrasco and Bernadó. In chapter 4, I described how contemporary Spanish fiction has deployed archaeological approaches to sorting through the obsessive structures of memory as a way to recenter Spanish history around critical forms of nostalgia and resentment. This is part of a broader political project of recovering memories and discourses that were discarded during the country's rapid modernization from the 1960s to the present.

Compared to the dynamic living structures of memory, history is altogether something else; it is fixed, written, inscribed, registered in books, films, television programs, registries, songs, often authored by history's winners to justify their victory.[12] In a cultural context in which history's losers were never allowed public memorialization, there is redemption to be found in the discards and waste cultures strewn through the geographical and cultural peripheries. Bardini proposes that "if today's subject is indeed this disaffected individual, the addicted consumer, the affect-less social android, the political schizoid, today's junk culture is her playground, the figure of his collective landscape. If today's subject is to escape the terminal identity, the nihilistic black hole of total dis-affection, it thus might be thanks to something found in junk. Yes, indeed, there might be peace in junk."[13]

What is useful about Bardini's celebration of junk and Jim Collins's reappraisal of supermodern semiotic surplus is how they both focus our attention on the "architectures of excess"—this is Collins's term; Bardini would likely call them "architectures of junk"—through which contemporary subjects have long sought a way out of the nihilism and disaffection that have increasingly occupied a central location in postmodern politics and historiography. In other words, modernity brings an excess of things with it,

but modern subjects have always had to learn to discern and make meaning out of that array. The work of the modern subject is the work of the cultural gleaner, the bricoleur, the collage artist. Bourriaud puts forward the idea of the *exform*—what he calls an aesthetics of exclusion—as one of the central ideological operations of a supermodernity that is constantly creating new ways of establishing and policing distinctions between products and waste, inclusion and exclusion, the productive and the unproductive: "the primary concern for contemporary aesthetics, its central problematic, is organizing multiplicity."[14]

The question of organizing multiplicity has always been at the center of Rosa Montero's work as a writer. Over a career spanning more than forty years, through her fiction and journalism she has explored many of the ways that people—especially women—struggle against the cannibalizing tendencies of an ever-accelerating and chaotic Spanish supermodernity inhospitable to the cultures of memory. The following sections of this chapter trace how her fiction explores the uncertain limits between body and self, junk and nonjunk, in a contemporary cultural context inflected by political corruption and economic precarity.

WASTE AND SOCIETY IN *LA HIJA DEL CANÍBAL*

The first line of *La hija del caníbal*—"La mayor revelación que he tenido en mi vida comenzó con la contemplación de la puerta batiente de unos urinarios" (My life's greatest revelation began with the contemplation of the swinging door of a urinal)[15]—represents a humorous juxtaposition of the psychological (revelation; contemplation) and the somatic (urinals), which points to the narrator's preoccupation with the interpenetration of consciousness and bodily function. The revelation to which she alludes is not only about the mystery of her husband's disappearance but also centers on a simultaneous process of self-discovery as Lucía comes to terms with her personal disaffection and ever-changing sense of self over time. This chapter argues that the narrator's development as an experiencing, narrating subject is linked to her consciousness of her existence as a material object: a body that exists in time whose physicality and corporal function are always related to the ways in which she understands and articulates her personal identity. That Lucía is able to come to an important realization while staring at a bank of urinals—which call to mind more basic corporal functions—hints at the importance that bodies (her own and in general) will have in understanding who she is, and that decadence and waste are constitutive

of that awareness. The novel's self-conscious, metafictional conceits—its linguistic and narrative self-consciousness, self-referentiality, montage structure, frame breaks (in the form of the explicit mention of Rosa Montero herself within the text), and use of the cannibal trope—in turn draw attention to the constituent parts of the *textual* body that shapes her subjectivity. In other words, Montero maps the material self onto a material textual body. Both are given to excess, decay, and wasteful structures.

The preoccupation with the junking of the body that we read in *La hija del caníbal* appears also in Montero's later fiction. Soledad, the protagonist of *La carne* (2016), for example, remarks, in the novel's concluding pages, that "el tiempo tictaqueaba inexorable hacia la destrucción final, como una bomba" (time inexorably tick-tocked toward the final destruction, like a bomb).[16] Montero's collected fiction offers reflections on and preoccupations with the ways in which the body works against the self, transforming itself into something "que te maltrata y aprisiona" (that mistreats and imprisons you).[17] In *La carne*, it is bodily maturity that is the enemy: "Al llegar a cierta altura de la madurez, el cuerpo empezaba a desbaratarse a trompicones y de la noche a la mañana aparecían todo tipo de síntomas alarmantes, heraldos de la enfermedad y la muerte."[18] (When you reach a certain point of maturity, in fits and starts your body begins to fall apart, and from one day to the next, all kinds of alarming symptoms start appearing: the heralds of sickness and death.) Time, as Scanlan notes, is the "primary agent of obsolescence," and trash is the primary indicator of our failure to escape time.[19] The passing of time is what proves that we are merely matter.[20] The culturally constructed divide between the human and the nonhuman collapses definitively after death.

Through a developing critical awareness of the materiality of her body, the experiences she describes, and her relationship with others, Lucía Romero cements together a mosaic narrative representation of self. The novel is preoccupied with the pieces of flesh that comprise her human embodied-ness. The book's title, for example, has its origins in a story that Lucía's father recounted during her childhood, when he was forced to use his knife to slice "un filete de brazo al amigo muerto" (a fillet from the arm of a dead friend) in order to survive a wartime winter.[21] This was the episode that earned her father his nickname "The Cannibal." Another example of garbaged flesh comes when kidnappers send Lucía a finger severed from her husband's hand. The arrival of this little piece of his body sparks one of her many reveries on mortality, ephemeral physicality, and decay: "Ahora ese pedazo de persona no era más que un fragmento de basura orgánica"

(Now that chunk of a person was nothing more than a fragment of organic waste).[22]

Studies of the novel have outlined Montero's use of the detective-story framework along with marked psychological and autobiographical conceits as representative elements of the novelist's move toward formal hybridity.[23] The work's generic hybridity, in other words, allows Montero to critique the discursive and practical structures of patriarchal Spanish society, while the novel's themes present an alternative to traditional feminine roles "perceived by their relation to others (as daughter, wife and mother)."[24] As the protagonist herself says at the conclusion of her tale—having come to terms with her past, her father's influence, her stifling relationship with her husband, and her sad acknowledgment of her inability to bear children—"Estoy sola, y me gusta" (I'm alone, and I like it).[25] But even while Lucía is able to free herself from the suffocating influence of her husband and father in order to achieve a kind of self-realization, she must still come to terms with an even more threateningly oppressive system: that of her ever-decaying material body.

Lucía Romero constantly alters, edits, and censors her narrative. The same fluidity with which she crafts her narrative is reflected also in the physical characteristics that she uses to describe herself. She is obsessed with the material mutations. While physical descriptions are not an uncommon method of describing characters in novels, what distinguishes Lucía's accounts of herself is that she not only focuses on her biological abnormalities, but she constantly fabricates, prevaricates, and modifies her physical and psychological descriptions. In the novel's opening pages, Lucía provides the details of her material self, drawing special attention to the marks and biological anomalies that appear on her abdomen, knee, and lips: "Cabe recurrir a las señas de identidad, siempre tan útiles: Lucía Romero, alta, morena, ojos grises, delgada, cuarenta y un años, cicatriz en el abdomen de apendicitis, cicatriz en la rodilla derecha en forma de media luna de una caída de bicicleta, un lunar redondo y muy coqueto en la comisura de los labios."[26] (It's worth mentioning her identifying markers, which are always so useful: Lucía Romero, tall, tanned, gray eyes, thin, forty-one years old, scar on her abdomen from an appendectomy, another scar on her right knee in the form of a half moon, from a bicycle accident, and a round coquettish mole at the corner of her mouth.) These marks and traces signal the mutability of her biological material self.

As the novel progresses, it becomes apparent that the body in all its variability is a significant metaphor for Lucía's understanding of an identity

that is uncertain and ever-shifting. In the above quotation, the emphasis on the scars on her abdomen and right knee serve as signs representing the hidden stories that have informed the construction of her identity. But these superficial signs and skin abnormalities are not mere visual markers, for she reveals later that they represent profound marks of violence that have affected her both externally and internally. As she becomes more comfortable with her role as storyteller, later in the novel Lucía will divulge that the damage she has received to her body, particularly the loss of her uterus and teeth in a car accident, plays a significant part in who she is.

The scars and skin defects that mark Lucía's body are concrete signs referring to experiences and stories from her past. Her history is written on her body. At the same time that she reads her material self for identifying signs, however, Lucía also ponders what it is that makes her believe that she is the same person today that she was yesterday. During moments of inaction while she awaits news from her husband's kidnappers, Lucía tends to reflect on broader issues of personal identity, wondering, for example, about what happened to the little girl that she once was: "¿Quién fue, por ejemplo, la niña que yo fui? ¿Dónde se ha quedado, qué pensaría de mí si ahora me viera?"[27] (Who was the girl that I used to be, for example? What ever happened to her, and what would she think about me now if she were to see me?)

Lucía's reveries about her identity are linked closely to her awareness of the constant cellular renovation of her body. The fact that she is not *physically* the same person today that she was several years ago causes her to reflect more than once on what human identity really might be. While our experiences have psychological effects on who we are, biologically speaking there is little about our material bodies at the present moment connecting them to what they were in our childhoods. She writes: "Tampoco mi cuerpo sigue siendo el mismo: no sé dónde leí que cada siete años renovamos todas las células de nuestro organismo. Así es que ni siquiera mis huesos, de los que hubiera esperado cierta contumacia y continuidad, son presencias fiables en el tiempo. Desde el astrágalo del pie al diminuto estribo del oído, todos esos huesecillos y huesazos han ido mutando con las décadas. Nada hay hoy en mí que sea igual a la Lucía de hace veinte años. Nada, salvo el empeño de creerme la misma."[28] (Nor is my body still the same: I don't remember where I read that every seven years our cells replace themselves. So that means that not even my bones, from which I would have expected a more reliable continuity, offer a solid presence over time. From the astragalus in my little toe to the little stirrup in my inner ear: all those bones, small and large, have been changing over the years. Today, nothing in me

is the same as what made up the Lucía of twenty years ago. Nothing but my endeavor to believe that I am still the same person.) Lucía sees personal identity as a provisional, ever-changing, self-imposed conception. The only thing linking the Lucía of today to the Lucía of twenty years ago is her own determination to believe that she is the same person. Indeed, not even her bones offer a reliable continuity or comforting solidity.

The conception of a continuous sense of self that might transcend the ever-renewing material body is one of the crucial paradoxes explored by the protagonists of *La hija del caníbal* and Montero's Bruna Husky series.[29] Montero's writing has almost always been concerned with exploring the material and psychological limits of the human condition. The unreliability of psychological and physical markers of identity are reflected in the indeterminate structures of *La hija del caníbal* and *La carne*. Those novels' metafictional conceits—their frame breaks, self-referentiality, and montage structures—serve to blur clear-cut distinctions between reality and fiction while emphasizing the complexity and indeterminacy of any account of personal identity.

There are two self-reflexive frame breaks in *La hija del caníbal* in which Lucía ponders the irrationality of her own stubborn insistence to believe that she is who she says she is. In the second of these metafictional moments, the narrator makes an overt reference to the novelist Rosa Montero, wondering why she could not indeed be more like the Spanish novelist. (Montero deploys a similar conceit in *La carne*.) Lucía conjectures:

O incluso podría ser la escritora Rosa Montero, ¿por qué no? Puesto que he mentido tantas veces a lo largo de estas páginas, ¿quién te asegura ahora que yo no sea Rosa Montero y que no me haya inventado la existencia de esta Lucía atolondrada y verborreica, de Félix y de todos los demás? Pero no. Yo no soy guineana, como la novelista, ni he escrito este libro originariamente en bubi y luego lo he autotraducido al castellano. Y además todo lo que acabo de contar lo he vivido realmente, incluso, o sobre todo, mis mentiras. Me parece, en fin, que hoy empiezo a reconocerme en el espejo de mi propio nombre. Se acabaron los juegos en tercera persona: aunque resulte increíble, creo que yo soy yo.[30]

(Or maybe I could be the writer Rosa Montero. Why not? Given that I have lied so many times over the course of these pages, who is to say that I am not Rosa Montero and that I haven't simply invented the existence of this stunned and logorrheic Lucía, of Félix and all the rest of them? But no.

I am not from Equatorial Guinea, like the novelist, nor did I write this novel first in Bubi before translating it into Castilian. And besides, I really lived everything that I have recounted here, including, or above all, my lies. I think that, finally, today I have begun to recognize myself in the mirror of my own name. The third-person games are over: although it sounds incredible, I think that I am me.)

Rosa Montero is not, of course, from Equatorial Guinea, and we know that the novel was not translated from an Equatorial Guinean language into Castilian. The above quotation functions, on the one hand, as an implicit intertextual reminder of the tradition of self-reference traced back to *Don Quixote,* but it also draws attention to the linguistic underpinnings of the narrative representation of Lucía's identity. The self-conscious inclusion of the author within her own text is used to similar ends in *La carne,* when Montero appears as a harried journalist with words of wisdom to share with the novel's protagonist, Soledad.[31]

Patricia Waugh authored the definitive analysis of how metafictional novels are based upon a fundamental opposition between the construction of a realist illusion and the laying bare of that illusion.[32] Metafiction, like its close, more recently famous cousin, autofiction, delights in the exploration of the uncertain terrain between the real and the fictional, the contextual and the textual. I want to suggest that Montero's metafiction is special because it fuses textual self-reference with biological self-awareness, braiding together the discursive and material. The link between a conceptualization of the world as language, on the one hand, and of the world as material, on the other, is perhaps best appreciated in the genre of autobiography, which necessarily involves a problematic separation of the narrating I from the biological Me.

Writing on Paul Ricoeur's well-known theorizations of narrative identity, Patrick Crowley has outlined how any "attempt to fix any life in words, however provisionally, is inevitably beset by the metonymic, supplemental, structure of language and once inscribed or recounted each life story is subject to further interpretations."[33] But language is not the only pitfall implicit in autobiographical discourse. There are also complexities that arise from the temporal distance that exists between narrating "I" and experiencing "I." Autobiography, like other kinds of writing, is vulnerable to "the temptations of fictionalizing memories, the tensions between competing versions of the self, the uncertainty that erodes the identity of the 'I' that attempts to

recover the past."[34] *La hija del caníbal* can be read as a fictionalized account of the same kind of struggle to square the autobiographical enterprise with material selfhood. The identity expressed through autobiography is but a dim reflection of the ontological self, a provisional expression "of the narcissistic subject that knows itself only through a mimetic mirror darkly."[35]

Metafiction recognizes and signals the limitations of narrative mimesis favored by realism while allowing the writer to acknowledge—perhaps more authentically—the provisional, ever-changing understanding of "reality," be it autobiographical, historical, cultural, or social.[36] If there is indeed no "true" way to write an autobiography, and if facts, as Barthes has suggested, "can only have a linguistic existence, as a term in a discourse,"[37] then perhaps the truest way to write an autobiography is to write the history of that autobiography. The metafictional play that we read in *La hija del caníbal* exposes the illusion of realist representation while emphasizing the novel's linguistic status, drawing attention to the text as signifier and its dependence on language for its referential power. At the same time—and this is my main point about the novel—Montero's characters work to signal also the physical and material structures that comprise their biological selves. Just as her metafictional novels are aware of their status as fiction, Montero's characters are aware of their status as material bodies and, relatedly, as junk-in-the-making. Metafiction shows what's behind the curtain. Waste fiction does, too.

La hija del caníbal is narrated from three points of view, two of which belong to Lucía. The third point of view belongs to her neighbor and new friend, Félix, whose historical autobiographical narrative unfolds in alternating chapters of the novel. Lucía's self is split into two conflicting voices, one which fabricates lies and the other which exposes those fabrications. Chapter 2 contains the first of such changes of narrative voice, in which the narrator overtly acknowledges the construction of her own text:

A veces Lucía Romero le parece estar contemplándose desde el exterior, como si fuese la protagonista de una película o de un libro; y en esos momentos suele hablar de sí misma en tercera persona con el mayor descaro. Piensa Lucía que esta manía le viene de muy antiguo, tal vez de su afición a la lectura; ya que esa tendencia hacia el desdoblamiento hubiera podido ser utilizada con provecho si se hubiera dedicado a escribir novelas, dado que la narrativa, a fin de cuentas, no es sino el arte de hacerse perdonar la esquizofrenia.[38]

(Sometimes Lucía Romero feels like she is contemplating herself from the outside, as if she were the protagonist of a movie or novel; and in those moments she tends to talk impertinently about herself in the third person. Lucía thinks that fixation began a long time ago, perhaps from her love of reading. Her tendency toward doubling might have worked well if she had become a novelist, since narrative—after all—is simply the art of explaining away one's schizophrenic tendencies.)

In this quotation, Lucía acknowledges her sympathy for narrative "schizophrenia," understood not in a strict clinical sense but as a method of viewing herself with critical distance. In effect, she describes a process by which she divides her consciousness into an omniscient narrator (consciousness) and a protagonist (body). This strategy allows her to give coherence to the various impulses, facets, and identities that make up her self while further emphasizing the linguistic underpinnings implicit in any biographical story. Mimesis corresponds to the material, diegesis to the psychological.

In transforming her life into a story, Lucía grapples with the central questions that must be answered in the writing: When we turn our lives into stories, who will be the protagonist and who will be the narrator? What is the best way to narrate the self? From which point of view will the story be told? How to represent alternative versions of a life story and identity? The metafictional text is perhaps best equipped for engaging with those alternative versions, since it allows for the rupture of mimesis and a rejection of spurious narrative coherence. The distance that Lucía creates between her first- and third-person perspectives—alongside her many prevarications and the novel's alternative endings—functions as a way to signal the impossibility of maintaining a perfectly stable self over time and to acknowledge the corollary difficulty of representing with language that changing identity.

Bodies, identities, and stories of self are mutable, precarious, ever-changing things that tend to evade our attempts to portray and understand them definitively. Lucía's existential angst and her desire for "permanencia" (permanence) are related to her skeptical, sometimes fragmented conception of reality and identity. Throughout the novel, her desire for permanence is related also to the mutability of her own physical form. Lucía writes, for example, "Yo me imagino a la pobre alma como una sombra flojamente entretejida en el vapor de una tela de araña; y esa sombra se aferraría con dedos transparentes a las células vertiginosas de la carne (células veloces que mueren y que nacen a toda prisa) intentando mantener la continuidad."[39] (I imagine my poor soul as a shadow that is weakly woven into the vapor

of a cobweb. With its transparent hands, that shadow clings to the vertiginous cells comprising my flesh—speedy cells that die and are born at high velocity—attempting to maintain continuity.)

If, on the road to its eventual garbaging, the body is constantly changing, how can any configuration of identity—narrative or otherwise—persist over time? The narrator's search for that continuity of personality goes much deeper than a sense of who she is. Her description of the vague relationship between the materiality of the body and the personality that inhabits it points to a generative relationship between mind and materiality. Identity, she suggests, might be traced to the cellular level. Those "vertiginous cells of the flesh" that are rapidly and continuously dying represent the uncertain material to which her identity clings. This is a materialist ontology by which body creates mind.

Félix, Lucía's octogenarian neighbor and fast friend, provides a third narrative point of view that complements Lucía's two voices. His tale takes the form of a memoir that is woven into her own tale. He offers a historical account of his experiences before, during, and after the Spanish Civil War. As a complement to Lucía's own ideas about existence, Félix also contemplates the importance of physicality to our experience of reality, emphasizing that material existence is a process of constant loss: "Vivir es perder . . . La vista, el oído, la agilidad, la memoria . . . vivir es irte despojando inexorablemente. Y así, creí, que mi mano manca no era sino el comienzo del acopio, cuando en realidad era el comienzo, sí, pero de la infinita decadencia"[40] (To live is to lose . . . your sight, your hearing, your agility, your memory . . . to live is to see yourself losing yourself inexorably. I thought that my lost hand was the beginning of an accumulation, but instead, in reality, it was a beginning, yes, but it was the beginning of an infinite decadence); "vivir es perder" (living is losing);[41] "la pérdida, cualquier pérdida, es un aperitivo de la muerte" (a loss, any loss, is an appetizer for death);[42] "Todo se pierde, antes o después, hasta llegar a la pérdida final" (You lose everything, sooner or later, until you get to the final loss).[43]

According to Félix, human experience is an "infinite decadence," by which physical and emotional losses are a foreword to death. It is only toward the end of his account that Félix tempers his fatalistic tone with a more positive meditation on the importance of language, words and stories as methods of combating the ravages of time and experience. His reflections comprise an important part of the novel's emphasis on language, the stuff from which stories are told and selves are narrated. Félix tells Lucía that even while his existence as a body is a constant process of loss and decay, stories

give form to our brief existence as material subjects: "Somos sólo palabras, palabras que retumban en el éter" (We are only words, words that echo in the ether);[44] "la palabra lo es todo para nosotros" (words are everything for us).[45]

Bodies and stories are in constant flux in the novel, appearing and disappearing with the passage of time. While Lucía seeks the permanence and continuity that will assuage her existential angst, body parts are blown off (in the case of Félix's hand); bodies decay, sag, and get wrinkles; body parts are destroyed (Lucía's teeth and reproductive organs); or simply sliced off. Instances of bodily mutilation, loss, and diminution pervade the novel: Lucía recounts a meaningful moment in which she bonds with a woman in the dentist's office who has lost all her hair;[46] and she considers the absurdity of insurance policies that assign with chilling efficiency a monetary value to each lost body part.[47] The many literal amputations described in the novel are accompanied also by symbolic amputations. Lucía mentions two types of discoveries: those that one seeks, as through academic or scientific study, and those that one stumbles upon, which amputate a part of you: "los conocimientos que se encuentran, por el contrario, suelen amputar una parte de ti" (the knowledge you encounter, and, on the contrary, the knowledge that amputates a part of you).[48]

The novel's central cannibal metaphor, too, points to the importance that material bodies and body parts play in the construction of personal identity, for it is through the literal and symbolic consumption of the bodies of others that Lucía's father has earned his nickname. Using the third-person point of view that the narrator uses to distance herself critically, she says that her father had also eaten her alive, symbolically, for many years: "Su padre se la había comido viva durante muchos años; y su madre estaba aún medio masticada y con señales de dientes por el cuerpo"[49] (Her father had eaten her for many years, and her mother was still half-eaten with teeth marks on her body.) In this respect, the identity of the father leaves physical marks on the bodies of the women with whom he has lived, imprinting them with his own identifying marks. As Johnson argues, this kind of anthropophagic imagery characterizes the male-dominated social structures of the novel.[50] Yet, narrative offers the protagonist a means of articulating her personal identity while symbolically distancing herself from "participation in the cannibalistic system."[51]

JUNK SELVES IN ROSA MONTERO'S FICTION

Following Johnson, we can read Lucía's essentially inchoate self as a by-product of post-totalitarian exchange systems,[52] but it is also possible to read

her development as a character and subject in terms of Bardini's theorization of the centrality of junk to late-capitalist modernity. Bardini asks important questions about the links between consumer economies, the proliferation of junk, and the fluctuating value of selfhood. If everything has a value, and everything can be bought and sold, what happens to the human?[53] These are crucial questions in a world in which selfhood itself, as Jia Tolentino puts it, "has become capitalism's last natural resource."[54]

Bardini points also to the biopolitical underpinnings of the contemporary state of humanity, asking: "Aren't everywhere unemployed workers treated as junk? Aren't we all potentially junk, disposable and recyclable labor force, disposable and recyclable consumers, disposable and recyclable spectators?"[55] Tracing the concept of junk from cybernetic structures to genetic codes and through communication networks, Bardini's thesis is that junk may represent both a symptom of and a cure for the economic, social, and technological systems that produce it: "Junk is one step ahead of waste, although this step might always be pure potential. There is an affect in junk, even if this affect might be the last remaining before disaffection: junk might look disaffected (like a derelict industrial space), but we still feel attached to it. And it is because of this attachment, of that affect, that it might not be totally ludicrous to look for redemption, peace at last, in junk."[56] The affect of junk lies in its uncertain status between being wanted and being discarded. In Montero's novel, each encounter with a junked piece of flesh triggers a feeling of attachment, of affect, and a corresponding reflection on the material limits of the human as thing.

Lucía always has bodies on her mind—her own and the bodies of the other people with whom she comes into contact during her adventure. Her awareness of the materiality of things and people leads her to project bodily imagery to her exterior surroundings. When she goes to the bank to collect the ransom money from Ramón's safe-deposit box, Lucía likens the experience to entering a kind of sordid, stinking body: "Toda la operación tenía algo de escatológico, algo de necesidad íntima inconfesable: la cripta era como un urinario subterráneo y el hombre como un ayudante de hospital acostumbrado a bregar con inmundicias. Lucía aguantó la respiración y abrió la tapa. Ahí estaban las vísceras, azuladas, impresionantes."[57] (The entire operation had something scatological about it, something unspeakably intimate. The vault was like a subterranean urinal and the employee was like a hospital orderly accustomed to working with filth. Lucía held her breath and opened the box. There were the viscera, bluish and impressive.) The bluish guts revealed in the safe-deposit box are bundles of euro

bills. The ransom money retrieved from the safe-deposit box represents the viscera of an inorganic but nonetheless rotten body, evidence of a corrupt political system. The overall characterization of this episode recalls the scatological tone evoked by the novel's first line, in which the narrator situates her vital revelation in front of a bank of urinals. Lucía uses the same kind of imagery to describe her first forays into Ramón's office in search of clues as to his disappearance, where she describes it as "una sensación obscena, casi escatológica, como si estuviera hurgando en las vísceras de un muerto" (an almost obscene sensation, almost scatological, as if I were rummaging through a dead person's entrails).[58]

Montero's insistence on mutable material bodies, waste products, body parts, genes, cells, blood, and flesh reaches a crescendo toward the end of the novel, when Lucía meditates on the tubes, bottles, vials, pomades, tonics, and lotions that she uses to stave off the ravages of time. Surveying the array of bathroom artifacts in front of her, she says, "Todos estos frascos, frasquitos, botellones, tubos, estuches, cajas, pomos, taros, ampollas, envases y botes se acumulaban de manera indecente en mi cuarto de baño del hotel de Ámsterdam, como un recordatorio de mi naturaleza decadente, tan cercana ya a la naturaleza muerta."[59] (All those jars, bottles, flasks, tubes, boxes, cases, blister packs, containers and tins accumulated indecently in the bathroom of my hotel room in Amsterdam, like a reminder of my decadent nature, already so close to death.) Echoing Félix, she concludes that living means losing something a little at a time: "Todos estos frascos, frasquitos, botellones, tubos, estuches, cajas, pomos, taros, ampollas, envases y botes eran la representación misma de mi vida. Al envejecer te ibas desintegrando, y los objetos, baratos sucedáneos del sujeto que fuiste, iban suplantando tu existencia cada vez más rota y fragmentada."[60] (All those jars, bottles, flasks, tubes, boxes, cases, blister packs, containers and tins represented my life. As you get older, you begin to disintegrate. In the meantime, objects—cheap replacements for the subject you once were—begin to take the place of your ever-more-broken and fragmented experience.)

Montero's inventory of health and beauty objects is central to the affect of the materiality of junk described by Bardini. This is the sense that the things with which we surround ourselves—and that we use to make meaning—will probably outlive us. Things are the "res non verba" captured in Óscar Carrasco's photography of wasted spaces and in the exuberant vitalism of Guillén's poetic object world. The "jars, bottles, flasks, tubes, boxes, cases, blister packs, containers and tins" that prop up Lucía's mate-

rial self will also become part of the archaeological evidence of her life, a mound of things representing her ecological afterlife. While she decays, falls apart, becomes decrepit, the things she carried with her will go on existing in the world—probably forever—as material traces of her time on Earth, another pile of anthropocenic artifacts.

The degenerative nature of her body causes Lucía more than a little distress. The vials, lotions, pomades, and unguents that she uses to prevent her physical disintegration are objects arrayed against an ever more fragmented perception of reality. And even while her own biological body ages, sags, wrinkles, and loses its hair, she observes also how institutionalized corruption and the secret fraudulent life that her husband led also point to the decadent economic body of contemporary Spain. Similar preoccupations haunt Soledad, the older protagonist of Montero's later novel *La carne*. Using similar language, Soledad catalogues the long list of stuff she carries in her suitcase on trips.[61] These are the things Soledad uses to work against her "cuerpo traidor" (treacherous body), which not only seems to want to humiliate her—through its softening, transforming, drooping, and deforming—but also, in the end, appears intent to kill her.[62]

In spite of the ubiquity of physical decay and her own inability to fight effectively against the evil that exists in her world, Lucía's existential fear and ontological distress do not win out in the end. As the novel concludes, both she and Félix put forward comforting alternatives to the equation—stated earlier in the novel—that links living to losing. The final line of the twenty-eighth chapter points to Lucía's acceptance of her decadent body, suggesting that perhaps storytelling can become a palliative to the troubles of midlife. In spite of the fact that she describes herself unflatteringly as an "hija cuarentona y talluda, una hija a medio deshacer en el camino de la vida" (overmature forty-year-old daughter, a half-ruined child making her life's journey),[63] she nevertheless views storytelling as a way to avoid disappearing completely into an existential ether.

In the second epigraph to this chapter, taken from Viet Thanh Nguyen's story "Black-Eyed Woman," the narrator remarks: "Stories are just things we fabricate, nothing more. We search for them in a world besides our own, then leave them here to be found, garments shed by ghosts."[64] What is particularly evocative about this line is how it distills the sense that words somehow transcend the limits of material existence. Lucía, as a precursor to and kindred spirit of Nguyen's traumatized protagonist, recognizes also that words are perhaps the only things that might bear witness to her existence:

"Aquí estoy, inventando verdades y recordando mentiras para no disolverme en la nada absoluta" (Here I am, inventing truths and remembering lies so I don't dissolve into nothingness).[65]

WRITING THE DECADENT SELF

In *La hija del caníbal,* material reflexivity (bodily self-awareness) works together with textual reflexivity (linguistic self-awareness) to explore the constitutive links between being and narration. Body and language are the mutually constitutive scaffolding upon which Lucía builds her self. Faced with the relentless decay and gradual ruination of the body, the narrator turns to the fabrication of stories as a way to anchor her ever-changing sense of personal identity. While the flesh deteriorates, disappears, becomes junk, the story she tells about it—at times fictional, at others historical—gives contingent meaning to the phenomenon of ontological being and provides a reassuring continuity to her evolving perception of the self. The redemptive value of storytelling lies in its power to bring humans together through the communicative act, while simultaneously creating—through language—the illusion of constancy and comprehensibility.[66]

Having learned from Félix's life narrative, Lucía appropriates some of his conclusions and aphorisms in the construction of her own. Like the "garments shed by ghosts" that Nguyen's narrator describes, Félix's stories are something he leaves behind: "un montoncito de palabras que he dejado en el aire. Para no morirme del todo, en fin, me he puesto en tus oídos. Que es como decir que me he puesto en tus manos."[67] (a little pile of words I left hanging in the air. In the end, in order to not die completely, I have put myself into your ears. Which is to say that I have put myself into your hands.) In bestowing his story to Lucía, Félix transfers the information embedded in his semiotic DNA. The communicative act functions to transmit something of the essence of what has made Félix who he is. In order to avoid absolute ontological annihilation, he offers his life story—indeed, himself—to Lucía's ears.

In spite of the indeterminate nature of language and our inability to comprehend completely the universe, narrative, like the praise poetry described by Susan Stewart, is capable of expressing embodied consciousness and can serve as an object "of recognition between persons beyond the contexts of their creation."[68] Even as authors such as Montero draw attention to the fictionality and incompleteness of their narratives, the forms and structures of literary creation can give us a knowledge "of somatic,

emotional, and social conditions beyond whatever meanings their language conveys."[69] In other words, as Marcel Merleau-Ponty theorized, it is our corporal awareness that allows our perceptual body to engage with the world.[70]

There is a paradoxical hope, expressed in Montero's novels, that perhaps identity may transcend the temporality of the body through the expression and extension of bodily consciousness through narrative. Elaine Scarry has emphasized the symbolic importance of the communicative act, even when it takes the form of a written text. She notes that through language and communication the voice of the subject finds an extension beyond the limits of the body: "The voice becomes a final source of self-extension; so long as one is speaking, the self extends out beyond the boundaries of the body, occupies a space much larger than the body . . . only in silence do the edges of the self become coterminous with the edges of the body it will die with."[71] Faced with the certainty of physical annihilation, both Félix and Lucía aspire to transcend the limits of their corporeality by constructing and sharing tales. Their stories, like all stories, are the afterlife of embodied living, traces of embodied selves, evidence of the self felt beyond itself. The Greek poet Odysseus Elytis captures this notion in his *Open Papers,* written after he had won the Nobel Prize in Literature: "This is why I write. Because poetry begins where death is robbed of the last word."[72]

The discourses of bodily wasting are omnipresent in Rosa Montero's fiction after 1997. Her later protagonists—exemplified by Lucía, in *La hija,* and Soledad, in *La carne*—perceive and describe their bodies as waste-in-the-making. Importantly, Lucía views her body as somehow defective or unusable after an accident destroyed her uterus and teeth. The questions she raises throughout the novel have to do with what it might mean for the female body to be unusable for reproduction. In what ways might her body be considered disposable? What does it mean for a woman in Spanish culture when her uterus is gone?[73] Lucía views her own body as somehow vacated, empty, and the stories she tells tend to be about how and why to make meaning out of failure—professional, writerly, matrimonial, affective, political.

It is here that I see a crucial link between the discourse of body-as-waste that permeates *La hija del caníbal* and the metafictional form that embodies it. The novel's self-conscious narrative strategy, along with its careful structuring of a narrative characterized by indeterminacy (Lucía's frequent lying and subsequent admissions, for example, and the appearance of Rosa Montero's name within the narrative) and meditations on failure, draw the reader's attention to the processes that the narrator undergoes as she reflects

on the memories, stories, and physical processes that make her who she is. In other words, the novel is oriented toward what we might call a rhetorical or narrative work of salvaging or gleaning.

Sidonie Smith has argued that the importance of narrative to understanding the human condition lies in the fact all humans exist as "storied selves." Storytelling is important, she writes, because "it is through . . . stories that we find other ways of understanding the materiality of autobiographical subjectivity."[74] In *La hija del caníbal*, the body in all its mutability is represented as a site of autobiographical knowledge.[75] Through narrative processes of discernment and recontextualization, Lucía rearranges the linguistic and rhetorical underpinnings of her tale in order to gather new meanings. Writers are ragpickers: Félix picks through the "montoncito de palabras" of his life story in order to share them with Lucía; Nguyen's characters judiciously select stories from among the piles of "garments shed by ghosts"; Lucía curates stories from her past as evidence of her ontological continuity. All these narrators transform heaps of wasted words into something valuable and communicable.

While Lucía Romero ultimately escapes the bonds of patriarchal power structures and approaches, toward the end of the novel, a new self-realization, the novel also engages critically with the inherent aporia of human consciousness. It complicates the Cartesian dualism of mind and body, questioning the problematic separation of life from matter, self from other. The interpenetration of Lucía's and Félix's stories and memories points to a relational ontology mediated through language. Novels, books, stories, and autobiographies are symbolic acts of remembering and telling that produce meaning for an ever-evolving and ever-decaying subject. They also allow for the transmission of thoughts and memories through a narrative process of prosthesis. Through the skillful melding of some of the tropes of the autobiographical genre with a metafictional narrative strategy, *La hija del caníbal* dramatizes the many processes by which bodies, selves, memories, heredity, and narrative all come together to make meaning out of experience.

In response to the question I posed in the opening pages of this chapter, Are we junk?, Lucía and Félix would undoubtedly say, "Yes, we are." But, like Bardini, they both know that provisional meaning is hidden in the semiotic and genetic array in which they are enmeshed. Through the narrative fabrication of their life stories, they come to believe in the power of words—some more valuable than others—not only to redeem us but also to outlive us. In the novel's penultimate chapter, Félix recounts an anecdote about the genetically coded solidarity that allows penguins to survive in extreme

climates. While we might read his story as a metaphor for human solidarity, Félix's penguin fable could also be interpreted as a gesture toward the importance of an unknown, untold quality residing somewhere within the materiality of the body, which comprises an important part of our selves, our memories and our consciousnesses, written into our DNA, housed in the 98.8 percent of noncoding junk DNA that makes us who we are. The penguins who instinctually share exposure to the harsh Antarctic cold in order to keep the group warm is evidence, according to Félix, of a metaphysical Good that exists in balance with Evil in the natural world.

Given the novel's preoccupation with bodies, body parts, corporal and somatic imagery, it is significant that Félix points to the genetic makeup of organic cellular matter as the cause of all this behavior: "Los pollos de los pingüinos, al contrario que nosotros, no entienden de palabras, y si se protegen los unos a los otros es porque así tienen más esperanzas de sobrevivir: es una generosidad dictada por la memoria genética, por la sabiduría bruta de las células."[76] (Penguin chicks, unlike us, don't understand words, so if they protect one another it's because that way they have a greater chance of living. It's a generosity dictated by genetic memory and the raw knowledge inscribed in their cells.) That Lucía chooses to conclude her story by recalling Félix's penguins emphasizes their importance to the interpretation of the novel.[77] Unlike humans, penguins are not possessed of a capacity for narrative. Instead, they must rely on the generosity that springs from their genetic memory in order to survive. The instinctual, biologically determined tendency toward collaboration is one of the things animals teach us about politics.[78] We can relate the penguins' instinctual politics to the material underpinnings of human behavior, personality, language, and consciousness. Humans differ from penguins in that it is our predisposition to language and narrative that comprises one of our primal instincts and drives us into the realm of relation with the other. Life is a progressive garbaging of the body, but language is one of the things that allows us to survive.

Citing Jerome Bruner's influential postulation that narrative is central to our understanding of the human condition,[79] Sidonie Smith notes that "the relationship between autobiographical memory and storytelling is mutually constitutive. The stories people use to tell about their lives in turn shape the memories that are encoded as significant . . . and thus the very materiality of our bodies. Thus, narrative is identity is embodiment is narrative."[80] Our existence as bodies makes it possible for us to tell stories about ourselves and consequently to make ourselves in the telling. In *La hija del caníbal*, narratives and bodies are mutually constitutive. The processes of narrative

creation coexist with the simultaneous bodily processes of aging and re-membering. In this way, the novel that Lucía writes *is* Lucía Romero. She is not only the "Daughter of the Cannibal": the novel that bears her name also reflects who she is and who she has become through its writing. The text's self-conscious literary conceits draw attention to the materiality of the textual body and thus can be read as a metaphor for Lucía's narrative construction of her subjectivity. Just as the body effects the protagonist's voyage of self-discovery and self-definition, so does the metafictional novel explore the nature of narrative in terms of its textual (rather than physical) underpinnings. *La hija del caníbal* offers a complex treatment of personal identity that takes into account not only the subjective and cognitive pro-cesses of identity formation but also the ways in which the body mediates—but also problematizes—those processes.

In her 1993 Nobel Lecture—echoing Elytis's *ars poetica* cited above—Toni Morrison remarked: "We die. That may be the meaning of life. But we do language. That may be the measure of our lives."[81] *La hija del caníbal* represents a compelling reflection on precisely that notion, and the idea that the stories we tell serve as measures of who we may have been in life. In the novel's final paragraph, Lucía says: "Hoy creo entender el mundo. Mañana dejaré de entenderlo, pero hoy me parece haber desentrañado su secreto."[82] (Today I think I understand the world. Tomorrow I will cease to understand it, but today I feel like I have unraveled its secret.) Lucía concludes her story by affirming the ontological underpinnings of the phenomenon of self. This is a dynamic process that is self-consciously set forth in *La hija del caníbal*. Metafiction, after all, revels in language, for it is through words, stories, and narration that we seek to bring order to the material experience of life. Our bodies are indeed junk. But it is the awareness of that fact that allows us to live ethically and aesthetically. In Toni Morrison's words, language is the measure of our life. The subjective awareness of our material selves inflects the construction and articulation of our subsequent self-image—be it narrative or visual, ethical or aesthetic. We are part of the material world; words and bones are what we leave behind when we are gone.

Conclusion
Two Plastic Things

This groundswell of garbage risks overwhelming the planet.
—The *Economist,* September 29, 2018

We live our lives in the middle of things. Material culture carries
emotions and ideas of startling intensity. Yet only recently
have objects begun to receive the attention they deserve.
—Sherry Turkle, *Evocative Objects: The Things We Think With*

With its case studies drawn from the geographically dispersed middens of
Spanish modernity, *Basura* is a rubbish ecology that explores what Patricia
Yaeger called the "ethically charged" and "aesthetically interesting" rela-
tionship between trash and culture.[1] It responds, in part, to Barry Allen's
proposition that "trash is generated where knowledge ends,"[2] but I have
inverted that equation to ask what knowledge is generated from trash, and
what garbage—as a social process—might tell us about how Spain has at-
tempted, unevenly, to come to terms with its authoritarian legacy and move
forward into an uncertain and unstable neoliberal future. Taking a cue from
the American anthropologist William Rathje, who suggested that the best
way to investigate contemporary material culture is through its apparently
useless garbage, the previous six chapters sifted through contemporary Span-
ish culture from the 1980s to the present. Part 1, "Waste Matters," focused on
the trash worlds where humans are enmeshed with the discarded material
objects they produce and discard, while part 2, "Waste Humanism," asked
questions about how the concept of the human itself has been produced or
limited or framed by the interrelated concepts of value, use, and disposability.

Basura is a cultural archaeology of contemporary Spain that, from the
bottom up, accounts for some of the tensions and contradictions underlying
the country's transformation from authoritarian autarky to ostensibly cos-
mopolitan postmodern nation. It argues that waste in contemporary Spain

works culturally to (1) critique the neoliberal state of Spanish democracy; (2) engage with the country's past; and (3) rethink the links between ethics and aesthetics. As this conclusion draws to a close, I want to look at two more discards, both made from plastic: an orange Garfield telephone and a red baby rattle. These two otherwise unrelated things can tell us a lot about the links between materiality and modernity, the specific and the general, the wasted and the wanted.

THING 1: THE GARFIELD TELEPHONE

Waste is winning. As I began writing this conclusion in 2019, the United Kingdom's Royal Statistical Society published their "Statistics of the Year," with the number-one spot going to the number 90.5 percent, which represents the percentage of the world's plastic that has never been recycled: "Estimated at 6,300 million metric tons, it's thought that around 12% of all plastic waste has been incinerated, with roughly 79% accumulating in either landfill or the natural environment."[3] The plastic industrialist Lloyd Stouffer's 1963 prediction that "the future of plastics is in the trash can" was more prescient than he could have imagined.[4] Less than 10 percent of all the plastic ever produced globally has been recycled.

Mr. McGuire's advice to young Benjamin Braddock, in Mike Nichol's *The Graduate* (1967), was indeed prophetic: "There's a great future in plastics. Think about it. Will you think about it?" Plastics really are everywhere, and there has been a lot of thinking devoted to solving the problem of their permanence and ubiquity within planetary ecologies. Having myself spent a good part of the last decade thinking about plastic, it is now impossible for me not to notice it, along with the other trash, garbage, discards with which it dwells, everywhere. So when, in March 2019, a French coastal community finally discovered the origins of the plastic Garfield telephones that had been washing up on the coast of Brittany for the last thirty-five years, I was struck again by the resiliency and symbolism of plastic as an artifact of the Anthropocene. It was fascinating that a long-lost shipping container should continue to leak—nearly forty years after it had run aground—orange anthropomorphic cat phones (fig. 23). It was also sobering to consider the archaeological implications that the Garfield phone—a garish symbol of some of the least transcendent cultural schlock produced by twentieth-century North American culture—might have for future students of twentieth-century European culture. Embodied permanently in orange plastic, Garfield the cat will likely outlive all humans alive today. Jim Davis's creation

Figure 23. The return of Garfield.

is not just a resilient cultural icon; it will also be a lasting testament to the power of stuff to keep on existing.

The Garfield phones are a reminder that postmodernity's celebration of excess and junk reveals an anxiety about living in a world in which nothing ever disappears.[5] Sometimes, clearly, it is good to let things go. But the material and technological scaffolding upon which we build our cultural lives does not easily disappear. Even apparently immaterial digital artifacts rarely vanish completely. Slavoj Žižek has described his unease with the fact that his computer's "recycle bin" can never be permanently emptied. The electronic trash bin is an immaterial place where undead digital trash can always be "undeleted," since the spectral remains of digital files never disappear.[6] The only way to destroy an electronic file completely is to burn or obliterate the disc that holds it and hope that there is no copy in the cloud.

It is no wonder then that the zombie has become one of Western culture's most recurrent figures. Zombified forms of life surround us.[7] Zombies are wasted humans who overwhelm the world with their teeming numbers and relentless hunger for human flesh. They are garbaged bodies who reproduce themselves though consumption. In Spain, the zombie's rapaciousness has made it a favored symbol of the voracious forms of real estate speculation that have ravaged the country since the mid-twentieth century: thousands of "zombie flats" can still be found scattered throughout the country. By one

estimate, there were 100,000 unoccupied unfinished zombie homes in the Autonomous Community of Madrid in 2011.[8] If, as Marshall Berman noted in 1982, the modern is that which makes all that is solid melt into thin air, the study of modernity's refuse shows that nothing vanishes completely.[9] The zombie in its many forms captures that idea flawlessly: the Garfield phone is a zombie artifact; plastic is a zombie material; Francisco Franco is a zombie dictator. Capitalism creates zombies and they keep coming back, long after they are dead, to gnaw on the cultural present.

Even while supermodernity offers us an array of aesthetic structures floating within a sparkling dematerialized world of pure image and light, accessible from any place on the planet through smartly designed technological-medial scaffolding (the smart phone, the tablet, the laptop computer, the video game, the virtual reality goggles), there will always be a plastic-electronic-material platform upon which those structures are made available. That is the stuff that really sticks. The sheer material scale of technological waste is dizzying. Chris Jordan is perhaps best known for his photographs of wastescapes strewn with discarded mobile phones (*Cell Phones, Orlando, 2004*), which represent the individualized objects of global interconnection become a swirling sea of undifferentiated plastic objects. His *Crushed Cars #2; Tacoma, 2004; Oil Filters, Seattle, 2003; Spent Bullet Casings, 2005;* and *Circuit Boards, Atlanta, 2004* are tableaux of technological obsolescence and apparently infinite economies of scale. *Circuit Boards, Atlanta, 2004,* depicts a landscape of discarded circuit boards arranged geometrically to resemble a rural landscape of farms or—thanks to the reflective nature of many of the boards—an array of rice paddies designed perhaps for the mass cultivation of food.

Jordan's ecological vision can also be discerned in his photographs of dead albatrosses with plastic bits in their bellies. His images capture the posthistory of the consumer communication world photographed by Brian Ulrich, where bored shoppers engage with vast arrays of consumer objects (*Chicago, Illinois [Cell], 2003*), and Jordi Bernadó. And Kevin McElvaney's photographic portraits of workers shrouded in toxic gray clouds in the electronic waste lots in Agbogbloshie, Ghana, are perhaps the most eloquent critiques of hypermedial supermodernity, since they reveal the environmental and humanitarian results of planned digital obsolescence, the ethical impacts of global electronics recycling regimes, and ecological disaster. The Garfield phone is a whimsical but nonetheless eloquent reminder of the material profligacy of Western-style capitalist democracy and culture.

THING 2: A BABY RATTLE

Following a perfunctory court-martial where no evidence was presented, at 5:30 p.m. on September 22, 1936, Catalina Muñoz Arranz was separated from her four children and taken from her home by Francoist authorities to be executed by firing squad alongside 250 other prisoners. All the victims of this episode of Francoist violence were residents of the town of Cevico de la Torre. Seventy-five years later, in 2011, the mass grave in which she and other victims were buried was finally located and exhumed from beneath a playground at Carcavilla Park, located near Palencia, Spain, where the municipal cemetery had once been located. That unmarked mass grave was just one of thousands of similar sites that still dot the Iberian Peninsula.

What was perhaps most unusual about the exhumation of Catalina Muñoz Arranz's bones was the fact that a well-preserved plastic baby rattle was also found alongside her mortal remains (fig. 24). Of the nearly six hundred mass graves exhumed in Spain so far, the encounter with a bright-red plastic toy surprised archaeologists and anthropologists, one of whom proposed that the object was "the most striking and moving object that ever came out of a Civil War grave."[10]

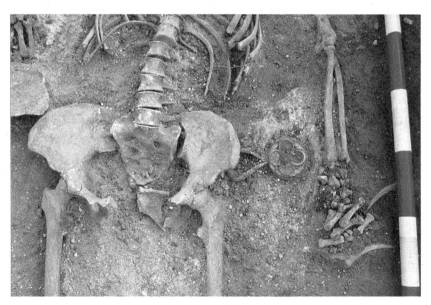

Figure 24. "The Woman Who Took a Baby Rattle to Her Execution."
(Sociedad de Ciencias Aranzadi; https://english.elpais.com/elpais/2019/05/08
/inenglish/1557327917_803284.html)

While osseous remains themselves hold a tremendous power to evoke the violence of the dictatorship, it is often when personal effects are found alongside them that we begin to picture the specific lives and identities of the people who were violently expelled from modern Spanish history. The archaeologist González-Ruibal, upon whose groundbreaking work portions of this book have been built, noted that the red plastic toy was perhaps one of the most evocative objects salvaged from archaeological sites in Spain: "The power of this type of archeology is not to retell an event that is already known, but to synthesize a moment in history through an image."[11] The photographic image works to provide a simulated if nonetheless powerful encounter with an object.

In another context, Felicity Bodenstein has described how objects in the museum, especially personal objects, have the capacity to evoke strong feelings of connection between museumgoers and historical events. Rather than fetish-objects for the veneration of famous men, she argues, the personal item does not endeavor to represent the past through an abstract form: "Objects that were once used, held, caressed, contemplated, smelt or even eaten are immediate, concrete and moreover of a fundamentally sensual nature. They are not only synecdochical figures of an historical event; they are synecdochical figures of the human experience of history."[12] Like the museums to which Bodenstein devotes deeper attention, even plastic objects can offer precisely this type of human-scaled, extremely direct contact with history and memory. Things offer us an emotionally charged engagement with historical memory through material entanglements, a reminder of the "awesome plenitude" of an object world that exists alongside our own.[13] Building in part on Bennett's work, Rita Felski has argued that things function as "co-actors and codependents, enmeshed in a motley array of attachments and associations" that in turn produce different meanings.[14] Things, both useful and forgotten, remind us that the past is never fully over, and that the present is always being pushed forward by a coterminous past. (Walter Benjamin's Angel of History crystallizes this concept.) Because the past is still here, our ethical responsibility to it can never fully realized.[15]

The trash object, like all things, is also "storied matter." As Iovino and Oppermann posit, all matter exists and works within "a material 'mesh' of meanings, properties, and processes, in which human and nonhuman players are interlocked in networks that produce undeniable signifying forces."[16] Preceding chapters have reflected on the multifarious methods in which wasted objects, places, people function within a postdictatorship culture crafted as clean, forward-looking, plastic. If the twentieth century

was indeed the era of capital, in Spain—as in much of the "developed" world—the century began with scarcity for most and ended with an abundance that was nonetheless unevenly shared between the Global North and the Global South.[17] That abundance has led variously to exuberance, excess, obsolescence, garbage, junk, trash, discards, waste, all distributed unevenly through planetary ecologies.

Following W. E. B. Du Bois's calculation that the color line would be the twentieth century's most pressing problem, Lawrence Buell remarked more recently that while racism shows no sign of abating, the more pressing question of the twenty-first century will be "whether planetary life will remain viable for most of the earth's inhabitants without major changes in the way we live now."[18] Following in this line, Patel and Moore have outlined how capitalism has always found ways to deploy the machineries of race, class, gender, and culture as grist for its relentless commodification and use of planetary life. And as Nishime and Williams, the authors of *Racial Ecologies,* note, environmental issues are also racial issues.[19] Wastescapes populated by "disposable" people have emerged and proliferated throughout Spain and the world. Discards and the disposable are still relegated to the dark side of Western modernity.[20] Even as the Anthropocene complicates the clear production of externalities,[21] it does not impact everyone in the same way.

Future work—the sequel to *Basura*—will have to focus more closely on the neocolonial futures of waste and space, mapping Spain's place within and contribution to the global flows of people and things as they circulate, enmeshed, in interpenetrating waste economies throughout the planet. One of the conclusions that I can offer here, at the end of this book on *basura,* is that there is no end to trash nor to the ends of trash.

Notes

INTRODUCTION

1. Guillén, *Poesía completa*, 245.
2. Guillén, "Happy Armchair!," 123.
3. Debicki, *Historia de la poesía española del siglo XX*, 43.
4. Bou, "Poetry between 1920 and 1940," in Gies, ed., *The Cambridge History*, 555.
5. Ciplijauskaité, *Guilleniana*, under "Deber de plenitud (1973)."
6. Brown, "Thing Theory," 4. Plotz calls thing theory "an approach to the margins of meaning" (Plotz, "Can the Sofa Speak?," 112).
7. Soufas, *The Subject in Question*, 141.
8. Soufas, *The Subject in Question*, 142.
9. "El poeta se enriquece al descubrir las esencias de los objetos que ve alrededor" (Ciplijauskaité, *Guilleniana*, under "Deber de plenitud [1973]").
10. Guillén, *Poesía completa*, 30.
11. Unless otherwise noted, the translations are my own.
12. Ciplijauskaité describes the *Cántico* as a song to "el existir humano elevado a su esencia, es decir, con sus vivencias fundamentales que no eran sujetas a un tiempo o a un espacio específicos" (human existence elevated to its essence, that is, whose fundamental experiences were not tied to any specific time or space). She describes the poet's later trilogy *Clamor* as a work that engaged more with the social dimension: "Aquí el hombre entra en el 'tiempo de historia', tratando de superar los obstáculos que amenazan truncar los gozos posibles" (Here man enters "historical time," attempting to overcome the obstacles that threaten to truncate possible future pleasures) (Ciplijauskaité, *Guilleniana*, under "Deber de pelnitud [1973]").
13. García Canclini, *Consumers and Citizens*, 37–47.
14. Gidwani, "The Afterlives of 'Waste,'" 1627.
15. Prádanos, *Postgrowth Imaginaries*, 181.
16. González-Ruibal, *An Archaeology*, 91, 189.
17. Paul Hamilos (@PaulHamilos), "Day 7 of Madrid street cleaners' strike. Rotting pig's leg and bra are now enjoying the autumn sun. They seem happy," Twitter, November 11, 2013, 5:04 a.m., https://twitter.com/paulhamilos/status/3998 85429354528768. Two days later, *El País* commissioned a follow-up piece from Hamilos, "La historia de una pata de jamón," *El País*, November 13, 2013.
18. A 2018 *Economist* report noted that global municipal waste production was

two billion tons per year, which amounted to about a pound six ounces produced daily for every human on Earth. Of course, industrial waste production was much greater, and not everyone contributes equally to the global production of waste. Developed nations are the principal producers of trash. This is in addition to the thirty billion tons of carbon dioxide that is dumped into the atmosphere each year. Sixteen percent of the world's population produces 34 percent of its trash, but the "developing" world is increasing its output rapidly. *The Economist* essay proposes "decoupling" waste production from economic growth and argues for the importance of a "circular" economy that would more efficiently absorb waste products ("A Load of Rubbish," Special Report on Waste, *The Economist*, September 29, 2018).

19. Ian Hodder, in his archaeological analysis of the relationships between things and people, remarks that "things pull together flows and relations into various configurations, whether the things are molecules and atoms, or whether they are books and computers, or whether they are institutions like schools and societies" (Hodder, *Entangled*, 8). I would add that trash, too, tends to draw people and things together. In *Mujeres al borde de un ataque de nervios* (chapter 1), Pedro Almodóvar deploys the combinatory power of refuse as a central organizing feature.

20. Only the most intransigent of cultural commentators express any doubt about humans' impact on climate catastrophe. "Anthropocene" is a word that has acquired increasing currency in scientific and humanistic descriptions of "a geologic epoch in which humans have become the major force determining the continuing livability of the earth" (Gan et al., *Arts of Living*, G1). This geologic epoch, as Dipesh Chakrabarty has suggested, will and should have a profound impact on the way that scholars understand the world, collapsing traditional humanist distinctions between Natural and Human history (201–7), qualifying and modifying humanist histories of modernity and globalization (207–12), drawing attention to the interpenetration of capitalist- and species-specific histories of the human (212–20), and, in sum, complicating straightforward attempts to contain historical understanding (Chakrabarty, "The Climate of History," 220–22). González-Ruibal levels a balanced critique of the term "Anthropocene," proposing instead "supermodernity" as the concept that might best capture the political and material specificities characterizing the ruptures and excesses of modernity (González-Ruibal, *An Archaeology*). Iñaki Prádanos puts it very clearly: "Any environmental humanities scholar with a basic knowledge of the global energy and environmental situation clearly understands that capitalist civilization is facing a systemic—although unevenly distributed—collapse due to the impossibility of maintaining its ever-growing social metabolism" (Prádanos, "Energy Humanities").

21. Nancy Spector, the curator of the Guggenheim Museum, is reported to have offered the Cattelan sculpture in response to the White House's request to borrow a Van Gogh. Cattelan describes his sculpture as a social "leveler": "Whatever you eat, a $200 lunch or a $2 hot dog, the results are the same, toilet-wise" (Matt Stevens, "A Golden Throne, Apparently Not for the White House," *New York Times*, January 27, 2018, A11). Perhaps perversely, Cattelan's sculpture has since been stolen.

22. Bourriaud, *The Exform*, x.

23. Bourriaud, *The Exform*, xi.

24. Seymour, *Bad Environmentalism.*

25. Whiteley points out that "the use of trash as a raw material for art-making is currently not just preponderant, it is endemic" (Whiteley, *Junk,* 151). Nevertheless, the raw material of waste has metaphorical functions "to signify cultural radicalism and political subversiveness" (ibid.); "abandoned and discarded objects feed the imagination" (ibid., 156).

26. Offenhuber, *Waste Is Information,* 3. Donna Haraway suggests that we seek out pollution deliberately in order to realize "the possibilities inherent in the breakdown of clean distinctions between organism and machine" (Haraway, "A Manifesto for Cyborgs," 32, quoted in Gabrys, "Sink," 679). Strasser argues that "waste is central to our lives" (Strasser, *Waste and Want,* 13).

27. Gabrys, "Sink," 668.

28. Prádanos, *Postgrowth Imaginaries,* 165.

29. Prádanos describes how "progress perceived as constant economic growth is . . . an epistemological trap with dire semiotic and material consequences" (Prádanos, *Postgrowth Imaginaries,* 167).

30. Here I am thinking of the more accurate and ontologically generous new materialist approach outlined by Iovino and Oppermann in *Material Ecocriticism,* 1–17.

31. Bennett, *Vibrant Matter.*

32. Pardo, *Nunca fue tan hermosa la basura,* 163.

33. Bélanger, "Airspace," 150.

34. Bélanger, "Airspace," 154.

35. Douglas, *Purity and Danger,* 44.

36. Nina Chestney, "Global Carbon Emissions Hit Record High in 2017," Reuters, March 22, 2018, https://www.reuters.com/article/us-energy-carbon-iea/global -carbon-emissions-hit-record-high-in-2017-idUSKBN1GY0RB.

37. Lepawsky, *Reassembling Rubbish,* 143.

38. Prádanos, "Energy Humanities."

39. Prádanos, "Energy Humanities."

40. Brenner, *Critique of Urbanization,* 2000.

41. Pardo, *Nunca fue tan hermosa la basura,* 164–65.

42. Raj Patel and Jason W. Moore, *History of the World in Seven Cheap Things* (Berkeley: University of California Press, 2018).

43. Here I am indebted to Sara Ahmed's radical reevaluation of the uses of use.

44. "Arte urbano con tus botellas de plástico en la Plaza Mayor," *Diario de Madrid,* May 31, 2017, https://diario.madrid.es/blog/2017/05/31/arte-urbano-con-tus-botellas -de-plastico-en-la-plaza-mayor/.

45. Whiteley, *Junk,* 3: "All confrontations with artworks are embodied experiences."

46. Fictilis, *Museum of Capitalism,* 18.

47. Jean-Pierre Dupuy calls this the "invisibility of harm" of late-capitalist modernity (Dupuy, *The Mark of the Sacred,* 36).

48. Gabrys, "Sink," 668.

49. I am grateful to Lizabeth Paravisini-Gebert and my colleague Charlotte Rogers for alerting me to some of these artists' work. In the United States, Barry

Rosenthal's *Found in Nature* series takes a similar ecocritical approach to curating and photographing plastics that the artist has found in New York Harbor. Zubiaurre reads Durán's work alongside the more politically charged photography of Jason de León (Zubiaurre, *Talking Trash*, 95–100).

50. Winkiel, "Introduction: Hydro-criticism."

51. Oppermann, "Storied Seas and Living Metaphors," 446.

52. Oppermann, "Storied Seas and Living Metaphors," 446.

53. Prádanos, *Postgrowth Imaginaries*, 187–88.

54. Hernández Adrián, "Tomás Sánchez on Exorbitance," 18.

55. DeLoughrey points out that "island writers and artists have long engaged such questions of modernity, rupture, and ecological violence that result from empire" (DeLoughrey, *Allegories of the Anthropocene*, 10). Via a discussion of the relations between allegory (with its "propensity to figure rupture, ruins, and the destabilization of the signifying potential of language with the history of empire and crisis" [ibid., 14]), she uses the island as a place for thinking about the complex relations between the local and the global in the Anthropocene.

56. Zireja, "Carnaval cara 'b' de basura," http://www.zireja.com/project/2019 -carnaval-tenerife-cara-b/.

57. Ramzy notes in his article on Henderson Island, a UNESCO World Heritage site, that scientists estimate that there are 17.6 tons of plastic debris on this remote uninhabited Pacific island. The waste hails mostly from China, Japan, and Chile (Austin Ramzy, "A Tiny Pacific Island Awash in Tons of Trash," *New York Times*, International ed., May 17, 2017, A4).

58. Ramzy, "A Tiny Pacific Island Awash in Tons of Trash," A4.

59. Liboiron, "The Plastisphere."

60. It is estimated that some fifty tons of trash have been deposited by climbers on Mount Everest ("Climbing Mt. Everest? Nepal Says Bring Back Garbage," March 3, 2014, https://www.nytimes.com/2014/03/04/world/asia/climbing-mt-everest-nepal -says-bring-back-garbage.html).

61. Zubiaurre devotes several pages to Laderman Ukeles's work (Zubiaurre, *Talking Trash*, 86–87).

62. In her authoritative analysis of Francisco de Pájaro's trash art, Zubiaurre outlines how his garbage assemblages "confront human misery head on," by denouncing profligate waste and poverty (Zubiaurre, *Talking Trash*, 36).

63. Zubiaurre, *Talking Trash*, 35–42.

64. Prádanos, *Postgrowth Imaginaries*, 183–84.

65. Map, "Basurama," http://basurama.org/en/mapa/.

66. Scanlan, *On Garbage*, 95.

67. Here I have in mind *Taburete de papel maché*, *Pantalones sobre bastidor*, and *Silla y ropa*, all from 1970 and all housed in the Museo y Centro de Arte Reina Sofía.

68. The list of contemporary artists working with waste is too long to enumerate here. Lea Vergine has curated a near-definitive survey of trash art in her book *When Trash Becomes Art*.

69. Rafael Alberti, "La primera ascensión de Maruja Mallo al subsuelo," *La Gaceta Literaria*, July 1, 1929.

70. Alberti, "La primera ascensión de Maruja Mallo al subsuelo."

71. Andrew Anderson, "Paysage d'âme and Objective Correlative: Tradition and Innovation in Cernuda, Alberti, and García Lorca," 179.

72. Zubiaurre, *Talking Trash*, 63–66.

73. The quote appears in her book *Lo popular en la plástica española a través de mi obra 1928–1936*, 23–24. I am grateful to Andrew Anderson for alerting me to Mallo's and Alberti's fascination with trash and with each other.

74. Dewey, *Art as Experience*, 9.

75. Kreitman, "Attacked by Excrement," 343. Alexander Bay remarks that the rectum "was one of the spaces where bodies and landscapes interfaced" (Bay, "Nation from the Bottom Up," 141–42).

76. Ghosh, *The Great Derangement*, 5.

77. Yaeger, "Editor's Column," 335.

78. Yaeger, "Editor's Column," 336.

79. Yaeger, "Editor's Column," 336.

80. Yaeger, "Editor's Column," 337.

81. Douglas, *Purity and Danger.*

82. Bennett, "Encounters with an Art-Thing," 13.

83. McKemmish, Gilliland, and Ketelaar, "Communities of Memory," 2.

84. González-Ruibal, *An Archaeology*, 5.

85. Morrison, *The Literature of Waste*, 8. The essays collected in the Stephanie Foote and Elizabeth Mazzolini volume *Histories of the Dustheap: Waste, Material Cultures, Social Justice* (2012), for example, use trash as a way to explore the complex relationship between the material and the symbolic, and elaborate on what those meanings say about politics and social justice. Susan Signe Morrison's later book *The Literature of Waste: Material Ecopoetics and Ethical Matter* (2015) traces waste, both material and metaphorical, through the English literary canon. Margaret Ronda's *Remainders: American Poetry at Nature's End* (2018) and David Farrier's *Anthropocene Poetics* (2019) take ecocritical views of how American and international poetry has forged new forms and figures for thinking through human agency in an age of ecological calamity. Combining literary criticism, contemporary philosophy, and theoretical biology, Cary Wolfe's *Ecological Poetics; or, Wallace Stevens's Birds* (2020) takes an ecopoetical approach to understanding the relations between the human and the nonhuman in the poetry of Stevens. The novelist Amitav Ghosh's *The Great Derangement* (2016) is a forceful analysis of environmental catastrophe that underlines how literary fiction itself has not been up to the task of representing the unthinkable scales that come with climate disaster.

86. While she is not specifically interested in waste objects, Jill Robbins's book *Poetry and Crisis* on poetry and memorial practices after the 2004 terrorist bombing in Madrid offers moving reflections on the power of material objects to evoke physical presence through affect.

87. Kellyanne Tang, "Honors 44 Turns Trash into Art as Students Examine Waste Management," *Daily Bruin*, June 6, 2013, https://dailybruin.com/2013/06/06/honors-44-turns-trash-into-art-as-students-examine-waste-management/.

88. Feinberg and Larson, "Cultivating the Square," 136–37.

89. In an essay on cultural hybridity and the aesthetics of garbage, Robert Stam writes that "garbage defines and illuminates the world. . . . Garbage offers a data base of material culture off of which one can read social customs or values" (Stam, "Specificities," 287).

90. Bauman, *Wasted Lives*, 23.

91. Bauman, *Wasted Lives*, 9–33.

92. Huyssen, *Present Pasts*.

93. Morrison, *The Literature of Waste*, 3.

94. Moretti writes: "The slaughter of literature. And the butchers—readers: who read novel A (but not B, C, D, E, F, G, H, . . .) and so keep A 'alive' into the next generation, when other readers may keep it alive into the following one, and so on until eventually A becomes canonized. Readers, not professors, make canons: academic decisions are mere echoes of a process that unfolds fundamentally outside the school: reluctant rubber-stamping, not much more" (Moretti, "The Slaughterhouse of Literature," 209).

95. Moraña, ed., *Ideologies of Hispanism*, xx.

96. P. J. Smith, "Oxford Hispanic Studies," v.

97. Labanyi, "Doing Things," 223.

98. Buchli, ed., *The Material Culture Reader*, 17, 16.

99. González-Ruibal, "The Dream of Reason," 179, 196. Michael Shanks has advocated for a poetics of archaeology (180–93), remarking that "archaeological work may be both serious and frivolous; there can be extended technical precision and poetic ambiguity. . . . Archaeology excels in its visual appeal and pleasures" (Shanks, *Experiencing the Past*, 181).

100. Olsen, *In Defense of Things*, 17. Olsen's "eclectic attitude," which he also describes as a kind of "theoretical bricolage," is a fitting approach to understanding the complexity of waste objects and things: "Things themselves have repeatedly proved to be too complex, different, and unruly to be captured by any single philosophy or social theory" (ibid., 18–19). The film critic and theorist Robin Wood employs a similar method, which he describes as a "synthetic criticism" that draws "on the discoveries and particular perceptions of each theory, each position, without committing exclusively to any one" (Wood, "Ideology, Genre, Auteur," 593). Gillian Whiteley argues that when we talk about material culture "a bricolage approach is an essential counter to linear, sequential thinking, narratives and practices" (Whiteley, *Junk*, xii).

101. Gan et al., eds., *Arts of Living*, M7.

102. Sima Godfrey, review of "Antoine Compagnon, *Les Chiffonniers de Paris*," *H-France Review* 19, no. 123 (July 2019): 1–2.

103. Baudelaire, quoted in Benjamin, *The Writer of Modern Life*, 108: "Here we have a man whose job it is to gather the day's refuse in the capital. Everything that the big city has thrown away, everything it has lost, everything it has scorned, everything it has crushed underfoot he catalogues and collects. He collates the annals of intemperance, the capharnaum of waste. He sorts things out and selects judiciously; he collects, like a miser guarding a treasure, refuse which will assume the shape of useful or gratifying objects."

104. Philippe Hauser, *Madrid bajo el punto de vista medico-social*, 248, cited in La-

banyi, *Gender and Modernization*, 195. The nighttime circulation of waste collectors is a legacy inherited from the nineteenth century.

105. Benjamin, *Writer of Modern Life*, 108.

106. Benjamin, *Writer of Modern Life*, 108.

107. Benjamin, *Writer of Modern Life*, 108.

108. Camnitzer, *Conceptualism in Latin American Art;* Whiteley, *Junk.*

109. Gómez de la Serna, *El rastro*, 231.

110. Gómez de la Serna, *El rastro*, 197.

111. Gema García, "Imágenes inéditas del Rastro de Madrid," *El País*, November 22, 2017, https://elpais.com/elpais/2017/04/02/album/1491146610_067806.html#foto_gal_3.

112. Yarza describes Almodóvar's aesthetics as an authentic flea market *ethos*, 49.

113. Jesús Ruiz Mantilla, "Un paseo por el Rastro un domingo de 1985," *El País*, July 14, 2019, Madrid Supplement, 4–5.

114. Larson and Woods, eds., *Visualizing Spanish Modernity*, 97.

115. Certeau, *The Practice of Everyday Life*, xii.

116. Villarta, *Mi vida en la basura*, 35.

117. Villarta, *Mi vida en la basura*, 35–36.

118. Villarta, *Mi vida en la basura*, 71.

119. Villarta, *Mi vida en la basura*, 39.

120. Ramón Gómez de la Serna, "El Rastro," *La Gaceta Literaria*, July 1, 1929, 4. Gómez de la Serna includes a hand-drawn map of the Rastro, noting: "Cada vez creo más en el Rastro . . . es el sitio donde yo aprendo más realidad del mundo." (Every day I believe more in the Rastro . . . it's the place where I learn the most about the world.)

121. Villarta, *Mi vida en la basura*, 75–76.

122. Scanlan, *On Garbage*, 3.

123. Villarta, *Mi vida en la basura*, 40.

124. "La caída de los Ángeles," *Callejeros*, Mad TV, July 11, 2019, https://www.mitele.es/programas-tv/callejeros/57b1dd9ec815dab4288b4c48/player/.

125. Graham and Sánchez, "The Politics of 1992," 410.

126. Vilarós, *El mono del desencanto*, 13–14.

127. G. Martínez, *CT*, 11–12.

128. Fishman and Lizardo, "How Macro-Historical Change Shapes Cultural Taste," 224.

129. Fishman and Lizardo, "How Macro-Historical Change Shapes Cultural Taste," 224.

130. Alba Rico and Fernández Liria, *Dejar de pensar.*

131. Vilarós, *El mono del desencanto*, 164.

132. Balfour and Quiroga, *The Reinvention of Spain*, 45–46.

133. Jameson, *The Cultural Turn.*

134. Gan et al., eds., *Arts of Living*, G10.

135. Labrador Méndez, "España, una mierda," 236.

136. Vidal-Beneyto, *Memoria democrática.*

137. Balfour and Quiroga, *The Reinvention of Spain*, 125.

138. Prado, *Mala gente que camina*, 259.

139. Felski, "Context Stinks!," 589.

140. Boscagli, *Stuff Theory,* 228.

141. The phrase appears in Benjamin's essay "The Work of Art in the Age of Mechanical Reproduction," 237.

142. Sze, "First Snow," in *Sight Lines,* 33.

143. González-Ruibal, "The Dream of Reason," 186.

144. Huyssen, *Present Pasts.*

145. Bourriaud, *The Exform,* viii.

146. Labrador Méndez calls these kinds of narratives, which multiplied during the economic crisis, stories of subprime lives (Labrador Méndez, "Las vidas 'subprime,'" 570).

147. Escudero Rodríguez, *La narrativa de Rosa Montero,* 21.

1. PEDRO ALMODÓVAR'S MODERN PROJECTIONS

1. Stapell, *Remaking Madrid,* 26–29.

2. Stapell, *Remaking Madrid,* 26.

3. Stapell, *Remaking Madrid,* 40.

4. Stapell, *Remaking Madrid,* 52–53.

5. Stapell, *Remaking Madrid,* 54–55.

6. Stapell, *Remaking Madrid,* 40–41.

7. Longhurst, "Culture and Development;" Sánchez León, "El ciudadano"; Izquierdo, *El rostro de la comunidad.*

8. The city's growing population and increased consumerism also contributed to making public waste "a major problem" (Stapell, *Rethinking Madrid,* 55).

9. Labrador Méndez, "España, una mierda," 241.

10. Labrador Méndez, "España, una mierda," 243: "a través de la exaltación de la mierda era posible hacer explotar las cloacas de lo social, manchando de un modo definitivo a la sociedad en este esfuerzo."

11. Florido Berrocal et al., eds., *Fuera de la ley.*

12. "Suck It to Me" is also heard, over the radio, in *Entre tinieblas.* See Allinson for the complete lyrics to Alaska's song, which she performs on-screen with members of her band, Kaka de Luxe, in *Pepi, Luci, Bom y otras chicas del montón* (Allinson, "Alaska: Star of Stage and Screen and Optimistic Punk," 226).

13. Michel Serres, *Malfeasance,* 41.

14. Garrote describes how *Movida* trash culture in particular functioned as a joyful contestatory aesthetic that worked against the more established norms of Spanish progressive political culture during the 1970s and 1980s (Garrote, "Demasiado hetero para ser de la Movida," 240–41).

15. G. Martínez, *CT.*

16. Moreno-Caballud, *Cultures of Anyone,* 83.

17. Fittingly, Labrador Méndez calls Almodóvar "un icono del felipismo pop" (an icon of pop Felipism). Víctor Lenore, "Los maoístas del PP. Auge y caída de la contracultura española," *El Confidencial,* May 23, 2017, www.elconfidencial.com/cultura/2017-05-23/german-labrador-contracultura-culpables-po-la-literatura_1386490. The

noun "felipismo" refers to Felipe González, who served as the PSOE's first prime minister, and Spain's third (1982–96).

18. Stapell, *Remaking Madrid,* 26. Susan Larson outlines how the city's urban restructuring plan, published in 1982, included a volume titled Recuperar Madrid, which reflected its political elites' desire to recover the city from its Francoist traditions and structures (Larson, "Architecture, Urbanism, and *la Movida madrileña,*" 185).

19. Vilarós, *El mono del desencanto,* 240: "una voluntad de construcción de un pasado histórico, dedicado no sólo a no mostrar ninguna de sus lacras sino, más agresivamente, a reconformar este pasado."

20. Merino and Song, eds., *Traces of Contamination,* 15. Between 1968 and 1986 an authentic interclass counterculture existed in Spain. Not unlike the politically committed 15M movement that emerged in the wake of the 2008 financial crisis, the late 1960s and 1970s were a key moment in Spain when culture and politics were linked briefly in a radical experiment that affected many things: "el amor, el trabajo, los cuerpos, el espacio público y el privado" (love, work, bodies, public and private space) (Labrador Méndez, *Culpables por la literatura,* book jacket). As Labrador Méndez and Stapell note, that postdictatorship creative energy was soon co-opted and repressed by the emergent neoliberal politics that were institutionalized with the Constitution of 1978 and the *Movida* of the 1980s (Labrador Méndez, *Culpables por la literatura*). Silvia Bermúdez makes a compelling case for the ways in which the *Movida* underwent a process of "accelerated fossilization" after the 1980s and thus stands permanently in the archive as a distant "glorious and glamorous past," removed from the problems of the present (Silvia Bermúdez, "Memory and Archive," 302).

21. Stapell, *Remaking Madrid,* 55–56.

22. Roberto Bécares, "La publicidad del Ayuntamiento sobre las obras desata odios y pasiones," *El Mundo,* November 15, 2006, https://www.elmundo.es/elmundo /2006/11/15/madrid/1163605443.html.

23. Stapell, *Remaking Madrid,* 65.

24. "La Comunidad de Madrid sigue adelante con sus planes para la instalación de vertederos," *El País,* July 31, 1985, https://elpais.com/diario/1985/07/31/madrid /491657054_850215.html.

25. Andrés Manzano, "Un vertedero con control sanitario absorberá la basura de los 785.000 habitantes de la zona sur," *El País,* October 15, 1984, https://elpais.com /diario/1984/10/15/madrid/466691056_850215.html.

26. "Madrid genera cada año 64.000 toneladas de productos tóxicos y peligrosos," *El País,* December 3, 1986, https://elpais.com/diario/1986/12/03/madrid/533996661 _850215.html.

27. "El vertedero de Pinto entrará en servicio dentro de una semana," *El País,* October 30, 1986, https://elpais.com/diario/1986/10/30/madrid/531059062_850215.html.

28. Andrés Manzano, "Un vertedero con control sanitario absorberá la basura de los 785.000 habitantes de la zona sur," *El País,* October 15, 1984, https://elpais.com /diario/1984/10/15/madrid/466691056_850215.html.

29. "Reparto gratuito de 100.000 bolsas de basura en las carreteras madrileñas," *El País,* May 2, 1987, https://elpais.com/diario/1987/05/02/madrid/546953061_850215 .html.

30. "Comienza en Madrid el primer encuentro ecologista de Amantes de la Basura," *El País*, November 2, 1985, https://elpais.com/diario/1985/11/02/madrid /499782258_850215.html.

31. Using a robust set of sociological data, Max Liboiron makes the forceful argument that it is changing infrastructure, not individual behavior, that will have a broader impact on reducing waste: "The advantage to dealing with infrastructure is twofold: first, most environmental and other society-wide problems are not due to individual intent and behavior to begin with, but rather the social, economic, political, and other systems that make some decisions and behaviors more likely or possible than others" (Liboiron, *Discard Studies*, January 23, 2014, https://discardstudies.com /2014/01/23/against-awareness-for-scale-garbage-is-infrastructure-not-behavior/). In other words, consumption is socially embedded. I owe my discovery of Szasz and Maniates to Liboiron. Maniates shows that "when responsibility for environmental problems is individualized, there is little room to ponder institutions, the nature and exercise of political power, or ways of collectively changing the distribution of power and influence in society" (Maniates, "Individualization," 33).

32. "7.400 jeringuillas y 1.440.000 colillas, recogidas en un solo día en las calles del distrito de Centro," *El País*, March 19, 1987, https://elpais.com/diario/1987/03/19 /madrid/543155066_850215.html. The urban cleanup crews averaged 16,745 kilos of trash per day. They also found thirty-three mattresses, one piano, fifteen chairs, twelve armoires, seven tables, ten armchairs, and three refrigerators.

33. "Actualidad gráfica," *El País*, October 4, 1987, Madrid edition, 8–9. In an editorial column published later the same month, Lorenzo López Sancho criticized the Madrid government and Cogesep, who, according to the author, "tercermundizan" ("third-world-ize") the city. López Sancho refers to a visit he made to two European cities whose cleanliness only made Madrid appear even dirtier. He also criticizes what he sees as the failure of the city's projects of "concienciación" (awareness) when they clearly fail to keep its streets clean (Lorenzo López Sancho, "El Madrid que no reluce," *ABC*, October 29, 1987, Madrid edition, 34). I found at least two letters to *El País* expressing similar sentiments around those dates, one authored by a Swedish exchange student (Gustafsson 1988) and another signed by elementary students (Mata and Montejo 1987), all of whom lamented Spaniards' inability to dispose of their waste properly (Ylva Gustafsson, "El país limpio," Cartas al Director, *El País*, February 17, 1988, https:// elpais.com/diario/1988/02/17/opinion/572050804_850215.html; Laureano Mata and José Antonio Montejo, "Esto es basura," Cartas al Director, *El País*, November 26, 1987, https://elpais.com/diario/1987/11/26/opinion/564879608_850215.html).

34. Ismael Fuente Lafuente, "Generalísimo se convierte en paseo de la Castellana," *El País*, January 26, 1980, https://elpais.com/diario/1980/01/26/madrid /317737456_850215.html.

35. Cited in Stapell, *Remaking Madrid*, 65.

36. Vernon, "Melodrama against Itself," 28.

37. Aguilar and Payne, *Revealing New Truths about Spain's Violent Past*, 30.

38. Berger, *Ways of Seeing*, 86–87.

39. Gabrys, "Shipping and Receiving."

40. Stapell, *Remaking Madrid*, 7.

41. There is an ample bibliography on Spain's Transition culture, its capitalist underpinnings, and its omissions. In addition to Stapell and Vilarós, see also Fishman and Lizardo, "How Macro-Historical Change Shapes Cultural Taste;" Duch Plana, *¿Una ecología de las memorias colectivas?*; Escudero Rodríguez, *La narrativa de Rosa Montero*; Burns Marañón, *De la fruta madura a la manzana podrida*; Labrador-Méndez, *Culpables por la literatura*; and Martínez-Alier and Roca, "Spain after Franco."

42. Stapell, *Remaking Madrid*, 148.

43. Stapell, *Remaking Madrid*, 180.

44. Gorostiza calls the Barajas Airport "another symbol of Franco's modernity" (Gorostiza, "Backdrops and Miniatures," 7).

45. Gorostiza, "Backdrops and Miniatures," 37.

46. Jameson, *The Cultural Turn*.

47. In an essay on the wounded body in Almodóvar's films, Martínez-Expósito proposes that the director plays with coincidence and chance in order to construct worlds based on the uncontrollable passions of people who appear to be victims of a fatal destiny (Martínez-Expósito, "Contempla mis heridas," 97).

48. Vernon's essay (2009) on sound and sound-design in Almodóvar's films is authoritative. She elaborates on how the director has always "acknowledged and even solicited [the] ambiguously charged potential of music" and sound, "granting song and soundtrack a foregrounded role in his films" (Vernon, "Queer Sound," 52). More recently, Kinder has described how Almodóvar exploits sound design as part of his broader macro-melodrama project that draws on a "database" of songs, plots and characters (Kinder, "Re-Envoicements and Reverberations").

49. Kinder has persuasively analyzed Almodóvar's use of "re-invoicement" in terms of the subversive ways in which the dialogue between voices of authority and the director's own voice allow him to dismantle ideological constructions of gender and genre.

50. Sánchez Noriega calls the telephone a tool of conflict in Almodóvar's world (Sánchez Noriega, *Universo Almodóvar*, 351). The typewriter appearing in *La ley del deseo* (1987) bears a similarly negative charge; Pablo Quintero (Eusebio Poncela) hurls it from an apartment window with a dramatic flourish that anticipates Pepa's similar defenestration of her answering machine in *Mujeres*.

51. Gabrys, "Media in the Dump," 162.

52. Andrew, "Film and History," 181.

53. Straw, "Exhausted Commodities," quoted in Gabrys, "Media in the Dump," 162.

54. Vincent, "Plastics, Materials and Dreams of Dematerialization," 25.

55. Vincent, "Plastics, Materials and Dreams of Dematerialization," 23.

56. Given the centrality of plastic to Almodóvar's filmmaking, it is curious that the material merits only passing mention in the collected essays comprising the Vernon and D'Lugo *Companion*, and not at all in Sánchez Noriega. Nevertheless, Pérez Melgosa's essay in the Vernon and D'Lugo volume does devote important attention to the apparently trivial objects appearing in the filmmaker's movies that function

to "wrestle away from memory its power to dictate the present, and from trauma its ability to freeze the lives of those who are targeted as its victims" (Pérez Melgosa, "The Ethics of Oblivion," 181). Of the five mentions of "plastic" in the Epps and Kakoudaki volume, three refer only to plastic surgery.

57. Gabrys, Hawkins, and Michael, "Introduction: From Materiality to Plasticity," 2.

58. Girelli, "The Power of the Masquerade," 256.

59. Stouffer, "Plastics Packaging," 1.

60. Gabrys, *Digital Rubbish*, 78.

61. Kinder, "Re-Envoicements and Reverberations," 285.

62. Gabrys, *Digital Rubbish*, 15.

63. Gabrys, "Media in the Dump," 162.

64. Gorostiza, "Backdrops and Miniatures," 45: "The Madrid in miniature that Almodóvar shows us can also be a model of the city which at times is difficult to find its own identity" [*sic*].

65. Gabrys, "Shipping and Receiving," 293.

66. Boscagli, *Stuff Theory*, 229.

67. Bauman, *Wasted Lives*, 23.

68. Bauman, *Wasted Lives*, 27.

69. Marsh, "Missing a Beat," 348. Marsh's comments center on his perceptive analysis of *Volver*, in which these threshold locations play a crucial role in the development of the plot: the storage room in the restaurant, "the highway, the airport, the cemetery, and the riverbank" (348).

70. Elsaesser, "Tales of Sound and Fury," 89.

71. Elsaesser, "Tales of Sound and Fury," 72.

72. Elsaesser, "Tales of Sound and Fury," 75.

73. Elsaesser, "Tales of Sound and Fury," 76.

74. Elsaesser, "Tales of Sound and Fury," 76.

75. Elsaesser, "Tales of Sound and Fury," 76.

76. Elsaesser, "Tales of Sound and Fury," 82.

77. D'Lugo, *Pedro Almodóvar*; Yarza, *Un caníbal en Madrid*; Allinson, *Un laberinto español*; P. J. Smith, *Desire Unlimited*. Smith has described "the determining influence of environment on character" and the "primacy of mise-en-scène" in the director's films (P. J. Smith, *Desire*, 55). In Almodóvar's film world, things are imbued with emotion. Urios-Aparisi mentions the director's ample use of objects to create associations for his characters (Urios-Aparisi, *Puro teatro*, 151). Sánchez Noriega points to closeup images of art objects, telephones, foodstuffs, typewriters, maps of Spain, sunglasses, and hospital materials that appear across the filmography (Sánchez Noriega, *Universo Almodóvar*, 350–53).

78. Kracauer, *Theory of Film*, 265.

79. "Slow-motion shots parallel the regular close-ups; they are, so to speak, temporal close-ups achieving in time what the close-up proper is achieving in space" (Kracauer, *Theory of Film*, 268).

80. Kracauer, *Theory of Film*, 269.

81. Kracauer, *Theory of Film,* 269.

82. Kracauer, *Theory of Film,* 269.

83. Thill, *Waste,* 79.

84. P. J. Smith, "Resurrecting the Art Movie?"

85. P. J. Smith, "Reading Almodóvar through TV Studies," 161–62.

86. Lash, "Reflexive Modernization," 2–3.

87. Collins proposes that "despite its uneven development and the ongoing labeling mania that relentlessly renames it or pronounces it dead, postmodernism as a style and as a condition has indeed evolved from the terror of pure excess to the manipulation of available information" (Collins, *Architectures of Excess,* 5). He argues that the shock of excess that marks the shift away from modernism evolves in postmodern cultures to its "domestication, when the *array* of signs becomes the basis for new forms of art and entertainment that harness the possibilities of semiotic excess" (5). Collins analyzes how a broad range of cultural products work to mediate, domesticate, absorb, reject or somehow control that excess.

88. Lash, "Reflexive Modernization," 10.

89. Graham and Sánchez, "The Politics of 1992," 410.

90. Eloy Merino describes how foreign journalists traveling in Spain in 2007 remarked on the "ufana limpieza de sus ciudades" (Merino, "Aspectos de la representación y el tema de España," 226).

2. TRASH, CULTURE, AND DEMOCRACY IN CONTEMPORARY MADRID

1. @frauklimt, "Calle Fuencarral," Twitter, November 11, 2013, 9:47 a.m., https://twitter.com/frauklimt/status/399956485058207744.

2. Feinberg and Larson, "Cultivating the Square," 113.

3. Feinberg and Larson, "Cultivating the Square," 129.

4. Compitello, "From Planning to Design," 201.

5. Harvey, *The Urban Experience* (1989); David Harvey, *The Condition of Postmodernity* (Malden, MA: Blackwell, 1990); David Harvey, *Justice, Nature and the Geography of Difference* (Malden, MA: Blackwell, 1996).

6. Compitello notes that Harvey builds and expands on the theoretical scaffolding established by Henri Lefebvre (Compitello, "From Planning to Design").

7. Gómez López-Quiñones, "Aviso para navegantes," 85.

8. Compitello, "From Planning to Design" 199–200.

9. Harvey, *The Urban Experience,* 231.

10. Harvey, *The Urban Experience,* 229–55.

11. Harvey, *The Urban Experience,* 247.

12. The song appears on the band's 1987 release, *Bazar.*

13. Rathje, Scanlan, Strasser, Thompson, Hawkins, and Boscagli have been crucial to my thinking on trash.

14. Compitello, "Recasting Urban Identities."

15. Graham and Labanyi, eds., *Spanish Cultural Studies;* Gómez López-Quiñones, "Aviso para navegantes," 91; Balfour and Quiroga, *The Revinvention of Spain,* 40–41.

16. Gómez López-Quiñones, "Aviso para navegantes," 91.

17. Stapell notes how this process only accelerated after 1986 (Stapell, *Remaking Madrid*, 7).

18. Compitello, "Recasting Urban Identities."

19. Lukinbeal, "Cinematic Landscapes," 5.

20. "Madrid está muy preparada para grabar. Es barato, tiene infraestructuras y un buen equipo" (María Comes Fayos, "Ciudad, luces, cámara y ¡acción!" *El País*, July 26, 2014, http://ccaa.elpais.com/ccaa/2014/07/25/madrid/1406309936_009515 .html).

21. In the same article, Hilario Alfaro, president of the Confederación de Comercio de Madrid, said that in 2013 he signed an agreement with the Madrid Film Commission to facilitate filming in the city: "Las ciudades que han sido escenario de películas, series de televisión o, incluso, publicidad, han incrementado notablemente el número de visitantes. A nosotros, como comerciantes, nos interesa que aumente el turismo porque tendremos más posibilidades de venta" (Comes Fayos, "Ciudad, luces, cámara y ¡acción!"). (Those cities in which films, television series, or even commercials have been shot have seen a notable increase in the number of visitors. We, as businesspeople, want to see tourism increase because that way our commercial opportunities increase.)

22. Lukinbeal, "Cinematic Landscapes," 8.

23. Rodríguez Campo, Fraiz Brea, and Rodríguez-Toubes Muñiz, "Tourist Destination Image."

24. "Vicky Cristina Barcelona: España según Woody Allen," *Turespaña. Ministerio de Industria, Energía y Turismo*, http://www.spain.info/es/reportajes/vicky_cristina _barcelona_espana_segun_woody_allen.html. Comes Fayos says that "el impacto del cine en el turismo y, por tanto, en la economía de las ciudades en las que se rueda, es incuestionable" (the impact of movies on tourism and, thus, on the economy of the cities where they are shot is clear) (María Comes Fayos, "Ciudad, luces, cámara y ¡acción!" *El País*, July 26, 2014, http://ccaa.elpais.com/ccaa/2014/07/25/madrid /1406309936_009515.html).

25. Acland, *Screen Traffic*, 55.

26. Amago, *Spanish Cinema*, 155–58.

27. Europa Press, "Madrid estrena 'manzana del cine,'" *El País*, December 18, 2008, https://elpais.com/elpais/2008/12/18/actualidad/1229591827_850215.html.

28. Javier Rodríguez Godoy, "La ruta Almodóvar, de película," *Escapada Rural* (blog), May 3, 2011, http://www.escapadarural.com/blog/la-ruta-almodovar-de -pelicula/.

29. Martínez Bouza, "La sensibilidad purista de Adolfo Domínguez," 49, quoted in Compitello, "Recasting Urban Identities."

30. Urry, *The Tourist Gaze*, 147. Although optical vision tends to dominate critical accounts of how the cinema works, there is an array of techniques by which filmmakers can activate other bodily senses during the cinema experience. Given the theme of this book, here we might think of the opening sequence of Tom Tykwer's *Perfume* (2006), or the garbage truck sequence in Peter Greenaway's *The Cook, the Thief, His Wife & Her Lover* (1989), both of which feature a putrescent mise-en-scène that appeals

chiefly to the viewer's olfactory and gustatory senses through an immersive deployment of a haptic visuality.

31. Bruno García Gallo Pilar Álvarez, "Madrid, impotente ante la basura," *El País*, November 12, 2013, http://ccaa.elpais.com/ccaa/2013/11/12/madrid/1384289661_884014.html.

32. Leo Wieland, "Hauptstadt des Mülls, *Frankfurter Allgemeine*, November 11, 2013, http://www.faz.net/aktuell/gesellschaft/madrid-hauptstadt-des-muells-12658880.html; Agence France-Press, "Madrid transformée en poubelle géante," *Le Monde*, November 12, 2013, https://www.lemonde.fr/europe/video/2013/11/12/madrid-transformee-en-poubelle-geante_3512174_3214.html. According to *El País*, as a result of the new labor contract negotiated by Ana Botella, in 2013 there were two thousand fewer sanitation workers working in Madrid. In only two years, the city had lost 40 percent of its street sweepers (Beatriz Guillén, "La reducción de barrenderos por Navidad agrava la suciedad," *El País*, January 11, 2016, https://elpais.com/ccaa/2016/01/08/madrid/1452285478_519108.html).

33. "'En Navidad hay más actividad económica, y en consecuencia se genera mucha más basura, por lo que la falta de trabajadores se ha visto reflejada en la situación de las calles,' explican fuentes de CC OO" (Beatriz Guillén, "La reducción de barrenderos por Navidad agrava la suciedad," *El País*, January 11, 2016, https://elpais.com/ccaa/2016/01/08/madrid/1452285478_519108.html). Wieland, "Hauptstadt des Mülls").

34. Bruno García Gallo and Pilar Álvarez, "Madrid, impotente ante la basura," *El País*, November 12, 2013, https://elpais.com/politica/2013/11/12/actualidad/1384289740_283439.html.

35. Zubiaurre, *Talking Trash*, 61.

36. Hawkins, "Sad Chairs," 60.

37. Žižek, "Multiculturalism," 44, cited in Gómez López-Quiñones, "Aviso para navegantes," 84.

38. Clearly, the nation and nationalism are not going anywhere. But Žižek does describe how other forms of attachment can compete with feelings of national belonging. Frank Trentmann, *Empire of Things: How We Became a World of Consumers, from the Fifteenth Century to the Twenty-First* (New York: Harper, 2016) traces commodity culture from its origins and onward. Our role as consumers has been shaped not only by capitalism but also by culture, politics, and evolving notions of morality and value.

39. Bauman, *Wasted Lives*, 23.

40. Hodder, *Entangled*, 208–9. Hodder's evocative thesis is that things and people depend on each other; they are entangled: "Things have lives of their own that we get drawn into and society depends on our abilities to manage this vibrancy of things effectively, to produce the effect of stability" (ibid., 209).

41. Hawkins, "Sad Chairs," 55.

42. The exponential expansion of single-use containers has contributed massively to this problem (see Giles Tremlett, "Spanish Sperm Whale Death Linked to UK Supermarket Supplier's Plastic," *The Guardian*, March 8, 2013, https://www.theguardian.com/world/2013/mar/08/spain-sperm-whale-death-swallowed-plastic).

43. Prádanos, *Postgrowth Imaginaries.*

44. In 2008, 67 percent of Spanish trash went to the dump. Between 1996 and 2008, the production of garbage increased by 10 percent, whereas in the rest of Europe it reduced by 28 percent. All this translates into 327 kilos of waste produced per inhabitant per year, which makes Spain eighth among the twenty-seven countries in the European Union in terms of waste production. In 2009, Madrid produced 3,257,852 tons of trash (Esther Sánchez, "Los números de la basura en España, *El País,* April 14, 2011, https://elpais.com/sociedad/2011/04/15/actualidad/1302818412 _850215.html).

45. Prádanos, "Energy Humanities," 35.

46. Monedero, "15M and Indignant Democracy," 27–28.

47. Muñoz, *Cruising Utopia,* 61.

48. Compitello, "Recasting Urban Identities"; Gómez López-Quiñones, "Aviso para navegantes"; Stapell, *Remaking Madrid;* Moreno-Caballud, *Cultures of Anyone.*

49. Bennett, "Encounters with an Art-Thing," 17.

50. Image 17, "Una calle de Malasaña con graves destrozos," attributed to Alex, *El País,* November 13, 2013, https://elpais.com/ccaa/2013/11/12/album/1384258108 _571481.html.

51. Boscagli, *Stuff Theory,* 231.

52. Following in this line, Zubiaurre describes how city refuse can become "the repository and the trigger for powerful and often contradictory emotions" (Zubiaurre, *Talking Trash,* 14).

53. Scanlan, *On Garbage,* 9.

54. Boscagli, *Stuff Theory,* 231.

55. Image 12, "Un montón de residuos al lado del centro de salud La Alameda," attributed to Antonio Souto, *El País,* November 13, 2013, https://elpais.com/ccaa/2013 /11/12/album/1384258108_571481.html.

56. Fernando Rubio (@weynando), "Salida de emergencia obstruida por la basura a menos de 100m del km 0 de España!" Twitter, November 11, 2013, 8:26 a.m., https://twitter.com/weynando/status/399936218412363776.

57. Image 15, "Alrededores de la Plaza de España," attributed to Juan Manuel Vidal, *El País,* November 13, 2013, https://elpais.com/ccaa/2013/11/12/album /1384258108_571481.html.

58. Image 1, "Contenederos llenos de basura cerca de la ronda de Segovia," attributed to Juan Fran Varela, *El País,* November 13, 2013, https://elpais.com/ccaa/2013 /11/12/album/1384258108_571481.html.

59. Image 25, "El olor que produce la acumulación de basura llega hasta los domicilios," attributed to Fuencisla Miguel, *El País,* November 13, 2013, https://elpais .com/ccaa/2013/11/12/album/1384258108_571481.html.

60. Rathje and Murphy, *Rubbish!.*

61. Gabrys, Hawkins, and Michael, "Introduction," 3.

62. Image 18, "Oficina de Bankia con una montaña de basura apilada," attributed to Gemma Fernández, *El País,* November 13, 2013, https://elpais.com/ccaa/2013/11/12 /album/1384258108_571481.html.

63. Here I am referring to the existential ethics that Jane Bennett situates at the

center of her thesis on the political ecology of things in *Vibrant Matter: A Political Ecology of Things*.

64. Hawkins, "Sad Chairs," 59.

65. Bennett, "Encounters with an Art-Thing," 7.

66. Image 19, "Alrededores de la plaza de Tirso de Molina," attributed to María M. Valencia, *El País*, November 13, 2013, https://elpais.com/ccaa/2013/11/12/album/1384258108_571481.html.

67. Rafael Alberti, "Primera ascensión de Maruja Mallo al subsuelo," *La Gaceta Literaria*, July 1, 1929.

68. Bennett, *Vibrant Matter*, 6.

69. Boscagli, *Stuff Theory*, 29. This concept forms part of Boscagli's longer discussion of Walter Benjamin's vital materialist moments.

70. Scanlan, *On Garbage*, 40–41.

71. Ian Hodder's *Entangled* has a lot to say about the messy and productive entanglement of things and people.

72. Stapell, *Remaking Madrid*, 199.

73. See Loxham, "Barcelona under Construction"; and Vilaseca, *Barcelonan Okupas*, too.

74. Davidson, "Barcelona: The Siege City," 110.

75. Rogers, *Gone Tomorrow*; Strasser, *Waste and Want*.

76. María Comes Fayos, "Ciudad, luces, cámara y ¡acción!" *El País*, July 26, 2014, http://ccaa.elpais.com/ccaa/2014/07/25/madrid/1406309936_009515.html.

77. Scanlan, *On Garbage*, 136.

78. Bennett, "Encounters with an Art-Thing," 6.

79. Scanlan describes how "dead matter is always taking another form, being 'reborn' as something else" (Scanlan, *On* Garbage, 115).

3. JUNKSPACE PHOTOGRAPHY

1. Zubiaurre, *Talking Trash*, 1–8.

2. Olsen and Pétursdóttir, *Ruin Memories*, 5.

3. Brenner was influenced by Henri Lefebvre, who argued, in *The Urban Revolution*, that "society has been completely urbanized" (1, quoted in Brenner, *Critique of Urbanization*, 194). I am grateful to Iñaki Prádanos for pointing me in Brenner's direction. Brenner argues that the social and economic processes of capitalist urbanization are not only limited to urban spaces but are spread across the entire planet in levels of "varying density, thickness and activity" (Brenner, *Critique of Urbanization*, 194). Brenner proposes that "the capitalist form of urbanization increasingly crosscuts, engulfs and supersedes the erstwhile urban/rural divide, stretching across and around the earth's entire surface, as well as into subterranean and atmospheric realms" (194).

4. Brenner, *Critique of Urbanization*, 197.

5. Brenner, *Critique of Urbanization*, 200.

6. Federici, *Re-enchanting the World*, 190.

7. Prádanos, "Energy Humanities."

8. Prádanos, "Ecología y estudios culturales ibéricos en el siglo XXI."

9. Labanyi, *Gender and Modernization,* 346. While the beginning of the novel has been traditionally understood as "a symbolic representation of Julián's 'descent' from civilization into barbarism, in the sense of a natural world untouched by civilization," Labanyi proposes instead that "it is more accurately read as a descent into the barbarism resulting from the attempt to implant a modern central State apparatus in a backward rural country" (353).

10. Fernández de Rota y Monter, "Evocación antropológica."

11. Pardo Bazán, *Los pazos de Ulloa,* 139.

12. Pardo Bazán, *Los pazos de Ulloa,* 148.

13. Edensor, *Industrial Ruins,* 12.

14. Hemingway, *Emilia Pardo Bazán,* 18. Hemingway notes that the Pardo Bazán quotation denotes a "melancholic sense that past splendors and beauties are coming to an end" (18).

15. N. Anderson, "To Be or Not," 71.

16. Molino, *La España vacía.*

17. Edensor, *Industrial Ruins,* 165.

18. Emmett, "Anthropocene Aesthetics," 165.

19. Viney, "Ruins of the Future," 138.

20. Edensor, *Industrial Ruins,* 101.

21. Augé, *Le temps en ruines;* González-Ruibal, "The Dream of Reason," 186.

22. Viney, "Ruins of the Future," 151.

23. Viney, "Ruins of the Future," 156.

24. García Canclini, *Hybrid Cultures,* 47.

25. González-Ruibal, "The Dream of Reason," 178.

26. See the blog *Abandonalia,* on abandoned places in Spain, which also provides a list of other blogs on ruins and architectural decay ("La cárcel abandonada de Carabanchel," *Abandonalia* [blog], March 15, 2007, http://www.abandonalia.com/2007/03 /la-crcel-abandonada-de-carabanchel.html). Olsen and Pétursdóttir note that there is a broad and growing corpus of artworks focusing on modern decay and abandonment (Olsen and Pétursdóttir, *Ruin Memories,* 3).

27. Olsen and Pétursdóttir, *Ruin Memories,* 3.

28. Berman, *All That Is Solid.*

29. Bernadó, Calvenzi, and Lahuerta, *Welcome to Espaiñ.*

30. Saltzman, "Response: Searching for and Reactivating Agency."

31. Koolhaas, "Junkspace," 175.

32. González-Ruibal, *An Archaeology,* 158.

33. Koolhaas, "Junkspace," 180.

34. Koolhaas, "Junkspace," 182.

35. Pardo, *Nunca fue tan hermosa la basura,* 174–77. "La neutralidad de los nuevos edificios deriva también de su carácter de elementos de inversión en el mercado global; para que alguien pueda comprar o vender fácilmente desde Manila cien mil metros cuadrados de espacio de oficinas en Londres, es preciso que el espacio tenga la uniformidad y la transparencia del dinero" (ibid., 177).

36. Augé, *Le temps en ruins,* 79.

37. Augé, *Le temps en ruins*, 1.

38. Augé, *Le temps en ruins*, 3.

39. Augé, *Le temps en ruins*, 77–78.

40. Brenner and Katsikis, "Is the Mediterranean Urban?," 454–55, quoted in Prádanos, "Energy Humanities."

41. The collaborative work of journalism that Ana Tudela and Antonio Delgado published as *Playa burbuja* (Beach bubble) is a photographic and narrative tour de force that captures the historical and material roots of tourism investment and corruption in Spain.

42. Brenner, *Critique of Urbanization*, 197.

43. Augé, *Le temps en ruins*, 109.

44. Augé, *Le temps en ruins*, 118.

45. In the epilogue to his work on the nonplace, Augé suggests that the peculiar conjuncture of supermodernity may necessitate the invention of what he calls an "ethnology of solitude" (Augé, *Le temps en ruins*, 120).

46. Edensor, *Industrial Ruins*, 16.

47. Drucker, "Temporal Photography," 24. Drucker describes how "the time of exposure, historical time, time of development, cropping, the time of reception and circulation—like any other cultural artefact, photographs are caught up in a web of varying temporalities. In that sense, a photograph, like any artefact or cultural document, is never fixed, but made in each viewing circumstance" (ibid., 23).

48. Kitty Hauser, *Shadow Sites*, 57–104; Peter G. Dorrell, *Photography in Archaeology and Conservation* (Cambridge: Cambridge University Press, 1994).

49. Hauser, *Shadow Sites*, 58. Hauser links photography, which provides traces of the material world, to the emergence of an array of disciplines in the mid- to late nineteenth century: "Telling (hi)stories from traces became the working method of paleontology, forensic science, psychoanalysis, and archaeology, as it had been the method of primitive hunters and trackers" (ibid., 62).

50. Hauser, *Shadow Sites*, 59.

51. Koolhaas, "Junkspace," 180.

52. González-Ruibal, *An Archaeology*, 4.

53. Carrasco, *Madrid OFF.*

54. Carrasco, *Madrid OFF.*

55. González-Ruibal, *An Archaeology*, 139.

56. González-Ruibal, *An Archaeology*, 162–63.

57. Carrasco, *Madrid OFF.*

58. Williams, *Paterson*, 7, 10, 174.

59. Porter, *The Origins of Aesthetic Thought in Ancient Greece*, 11. I first heard the Porter quote in a talk delivered by my colleague Allison Bigelow.

60. Francisco J. Rodríguez, "La alta velocidad detuvo el tiempo en Algodor," *La tribuna de Toledo,* November 15, 2015, https://www.latribunadetoledo.es/noticia/z4716935b-c0e7-535b-3beca3b9494997c5/201511/la-alta-velocidad-detuvo-el-tiempo-en-algodor.

61. Feinberg and Larson, "Cultivating the Square," 134.

62. Daniel Borasteros, "Interior obtendrá cerca de 70 millones con la cárcel de Carabanchel," *El País*, June 17, 2008, https://elpais.com/diario/2008/06/17/madrid/1213701859_850215.html.

63. "La cárcel de Carabanchel pide un hueco en la memoria histórica," Eugenia Redondo, Soitu, September 19, 2008, http://www.soitu.es/soitu/2008/09/19/actualidad/1221825289_483160.html.

64. Berger, *Ways of Seeing*, 29.

65. González-Ruibal, *An Archaeology*, 67.

66. Alberto G. Palomo, "El bar que se saltó la Transición," *El País*, April 19, 2014, https://elpais.com/politica/2014/04/16/actualidad/1397669544_510362.html.

67. Gabrys, Hawkins, and Michael, "Introduction," 2.

4. ARCHAEOLOGICAL FICTION

1. Manuel Morales, "70 novelas al año en España sobre la Guerra Civil," *El País*, October 19, 2018, https://elpais.com/cultura/2018/10/18/actualidad/1539877402_718909.html.

2. Rosa, *¡Otra maldita novela sobre la guerra civil!*, 11.

3. Gómez López-Quiñones, *La guerra persistente*; Labanyi, "The Politics of Memory."

4. Laura Pérez Maestro and Aimee Lewis, "Controversial Exhumation of Franco Takes Place in Spain," CNN, October 24, 2019, https://www.cnn.com/2019/10/24/europe/franco-exhumation-spain-intl/index.html.

5. Foster, "An Archival Impulse," 4.

6. Foster, "An Archival Impulse," 5. Other artists who deploy a similar approach to representing the archive are the Scotsman Douglas Gordon, the Englishman Liam Gillick, the Irishman Gerard Byrne, the Canadian Stan Douglas, the Frenchmen Pierre Huyghe and Philippe Parreno, the Americans Mark Dion and Renée Green (ibid., 4).

7. Foster, "An Archival Impulse," 5.

8. Mbembe, "The Power of the Archive and Its Limits," 20.

9. Quoted in Bourriaud, *The Exform*, 52.

10. In this regard, I see the contemporary Spanish archaeological novel as responding to the broader work of anthropologists and archaeologists, such as Francisco Ferrándiz, "The Intimacy of Defeat"; and Alfredo González-Ruibal, "Making Things Public."

11. Bourriaud, *The Exform*, 56.

12. Bourriaud, *The Exform*, 57.

13. In *Postmodernism, or, The Cultural Logic of Late Capitalism*, Fredric Jameson describes what he sees as the postmodern "crisis in historicity" (22), and undertakes an analysis of the "depthlessness" (9) of a late-capitalist society that is characterized by a culture of the image or "simulacrum," in which the genuinely historical is eclipsed by a retro sensibility (12–13).

14. Nearly 280 mass graves were exhumed in Spain between 2000 and 2012, revealing approximately five thousand bodies (Moreno-Nuño, *Haciendo memoria*, 83). Hundreds of thousands more remain to be recovered.

15. Stephanie Golob calls the Spanish Transition a "transition *without* transitional justice" (Golob, "Volver," 127). In a similar line, Sebastiaan Faber wonders if Spain might have been forced to acknowledge collective guilt for atrocities committed during the Civil War and subsequent dictatorship had it sought admittance to the EU at a later date: "Spain was lucky to get into the European club when the moral membership requirements were less strict. And if truth be told, the country is still not really taken to task. Compared to other, more recent cases such as Chile, Argentina, or South Africa, international pressure on Spain to redefine its relationship to its own past has been remarkably light" (Faber, "The Debate about Spain's Past," 185).

16. Faber, "The Debate about Spain's Past," 185.

17. Faber, "The Debate about Spain's Past," 185.

18. Judt, *Postwar*, 803, cited in Faber, "The Debate about Spain's Past," 185.

19. The quotation is from Margaret Jull Costa's 2016 translation of the novel (Marías, *Thus Bad Begins*, 32). The original passage reads: "todo el mundo aceptó la condición, no sólo porque era la única forma de que la transición de un sistema a otro se desarrollara más o menos en paz, sino porque los más damnificados no tenían alternativa, no estaban en situación de exigir" (*Así empieza lo malo*, 44).

20. Duch Plana, *¿Una ecología de las memorias colectivas?*, 172.

21. Labrador Méndez, "enterrando las heces del pasado en una fosa aséptica" ("España, una mierda," 240).

22. Kitty Hauser describes the archaeological imagination in her book *Shadow Sites*, 32.

23. Gómez López-Quiñones, "A propósito de las fotografías," 89.

24. Gómez López-Quiñones, "A propósito de las fotografías," 90; Andrés Trapiello, *La noche de los cuatro caminos* (Madrid: Aguilar, 2001); Javier Cercas, *Soldados de Salamina* (Barcelona: Tusquets, 2001); Ignacio Martínez de Pisón, *Enterrar a los muertos* (Barcelona: Seix Barral, 2005).

25. Gómez López-Quiñones, "A propósito de las fotografías," 90.

26. Gómez López-Quiñones, "A propósito de las fotografías," 103.

27. Gómez López-Quiñones, "A propósito de las fotografías," 104.

28. Benjamín Prado, *Operación Gladio* (Madrid: Alfaguara, 2011).

29. Benjamín Prado, *Ajuste de cuentas* (Madrid: Alfaguara, 2013).

30. See Montse Armengou Martín, "Investigative Journalism."

31. Benjamín Prado, "Yo, periodista en Malasaña," *El País*, May 3, 2007, https://elpais.com/diario/2007/05/03/madrid/1178191466_850215.html.

32. Pastor Verdú, "Un balance crítico," 303.

33. The practice continued well into the 1960s (EFE, "Una maternidad justificó en 1964 robos de niños diciendo que habían muerto, *El País*, June 29, 2009, https://elpais.com/elpais/2009/06/29/actualidad/1246263441_850215.html).

34. In an interview with the author, Stacey Dolgin Casado calls it "una novela documental" (Dolgin Casado, "Benjamín Prado," 109). Pablo Gil Casado classifies it an "excepcional novela" whose technique is akin to a "realismo documental" in which "los sucesos se convierten en un testimonio verídico con implicaciones críticosociales" (Gil Casado, "Benjamín Prado," 75).

35. Gil Casado, "Benjamín Prado," 75.

36. Gil Casado, "Benjamín Prado," 77.

37. Gil Casado, "Benjamín Prado," 86.

38. García Urbina, "No basta con que callemos."

39. I am grateful to Jessica Folkart for reminding me of this problematic aspect of nationalist discourses of healing.

40. González-Ruibal, *An Archaeology*, 78.

41. "Que más allá de datos y fechas, los sentimientos y los relatos anónimos pueden ayudar a comprender mejor el curso de nuestras vidas, pues la literatura y el arte no son sino otra vía para comprender la realidad" (García Urbina, "No basta con que callemos").

42. Prado, *Mala gente que camina*, 336–38.

43. He imagines 1980s Madrid: "íbamos del Pentagrama a El Sol y del Rock Ola a La Vía Láctea, cenábamos un bocadillo de ni se sabe qué en medio de la calle hacia las seis de la mañana, y éramos felices; o al menos lo fuimos los primeros años, mientras creíamos respirar, como dice Pessoa, 'el perfume que los crisantemos tendrían si lo tuviesen'" (Prado, *Mala gente que camina,* 34; see also 268 and 322 for an impressionistic interpolation of images of the Madrid *Movida* as lived and remembered by the narrator).

44. Prado, *Mala gente que camina*, 46.

45. In the concluding chapter, the narrator reveals that he was forced to publish his research as a novel instead of a monograph in order to avoid a lawsuit brought by Serma's adopted son, Carlos Lisvano, whom the narrator discovers is in fact one of the disappeared children of Francoism.

46. Prado, *Mala gente que camina*, 38.

47. The phrase is borrowed from Labrador Méndez's book *Culpables por la literatura* on the political imaginary of the Spanish Transition: "El pasado habla con el futuro a través de sus poéticas."

48. Bergson, *Creative Evolution*, 48.

49. Bergson, *Creative Evolution*, 5.

50. I am indebted here to Bernadette Bensaude Vincent's Bergsonian reading of plastics as materialized duration: "They cannot be abstracted from the heterogenous and irreversible flux of becoming" (Vincent, "Plastics, Materials and Dreams of Dematerialization," 24).

51. It is hard to overstate the impact that Labanyi's essay "History and Hauntology; or, What Does One Do with the Ghosts of the Past? Reflections on Spanish Film and Fiction of the Post-Franco Period" has had on the field. Building on Derrida's *Specters of Marx*, Benjamin's material historicism, and Avery Gordon's sociology of ghosts, Labanyi was the first to describe postmodern Spanish culture as inhabited by ghosts. Keller's *Ghostly Landscapes* is an authoritative recent return to this theoretical territory.

52. González-Ruibal, *An Archaeology*, 81.

53. González-Ruibal, *An Archaeology*, 79.

54. González-Ruibal, *An Archaeology*, 81.

55. Prado, *Mala gente que camina*, 13. Indeed, Schyfter, Bruner, Johnson, Foster and el Saffar have all written important essays on Laforet's *Nada*.

56. Prado, *Mala gente que camina*, 59.

57. Prado, *Mala gente que camina*, 203.

58. Prado, *Mala gente que camina*, 211.

59. Dolgin Casado, "Benjamín Prado," 109.

60. Dolgin Casado, "Benjamín Prado," 111–12.

61. Prado, *Mala gente que camina*, 259.

62. Prado, *Mala gente que camina*, 259.

63. Prado, *Mala gente que camina*, 259–60.

64. González-Ruibal, *An Archaeology*, 162–63.

65. González-Ruibal, *An Archaeology*, 84.

66. Here I am indebted to Néstor García Canclini's formulation of "multitemporal heterogeneity," which he interprets as an indicator of the uneven development of cultural modernity of Latin America, where "modern culture is a consequence of a history in which modernization rarely operated through the substitution of the traditional and the ancient" (García Canclini, *Hybrid Cultures*, 47). This notion of temporal simultaneity reflects Prado's own appreciation of the contradictory nature of Spanish modernity reflected in the novel.

67. González-Ruibal, *An Archaeology*, 91.

68. González-Ruibal, *An Archaeology*, 136.

69. Prado, *Mala gente que camina*, 260.

70. González-Ruibal, *An Archaeology*, 19.

71. Prado, *Mala gente que camina*, 264.

72. Vilarós, *El mono del desencanto*, 56.

73. Sánchez León, "El ciudadano."

74. Vilarós, *El mono del desencanto*, 240.

75. Merino and Song, eds., *Traces of Contamination*, 15. The editors are paraphrasing Valis, *The Culture of Cursilería*, 282–83.

76. Eduardo Subirats, quoted in Vilarós, *El mono del desencanto*, 240. Balfour and Quiroga note that although the past "hardly makes any appearance in the constitutional text," during the drafting of the Spanish Constitution in 1978 the past nevertheless "weighed heavily on the minds of all involved in its design" (Balfour and Quiroga, *The Reinvention of Spain*, 45).

77. Merino and Song, eds., *Traces of Contamination*, 12.

78. Merino and Song, eds., *Traces of Contamination*, 22.

79. Ferrándiz, "The Intimacy of Defeat," 311–12.

80. Ferrándiz, "The Intimacy of Defeat," 313.

81. Ferrán, *Working through Memory*, 16.

82. González Ruibal, *An Archaeology*, 102.

83. Rodríguez Fischer, "Una mezcla mareante," 49. Rodríguez Fischer states that "tenía en sus manos una preciosa y estremecedora historia . . . al autor se le escurre todo entre las manos, porque la ficción queda asfixiada no por la realidad o por la historia, sino por la información" (ibid.). For their part, Ignacio Soldevila Durante and Javier Lluch Prats suggest that the novel "roza esa perfección rara en estos tiempos de desinterés general por la literatura responsable" (Durante and Prats, "Novela histórica," 43).

84. Durante and Prats, "Novela histórica," 43.

85. Huyssen, *Present Pasts*, 74.

86. Huyssen, *Present Pasts*, 74,

87. Huyssen, *Present Pasts*, 74–75.

88. González-Ruibal, "A Time to Destroy," 258.

89. I am working here with concepts proposed by González-Ruibal, "A Time to Destroy"; Terdiman, *Present Past*; Matsuda, *The Memory of the Modern*; and Connerton, "Cultural Memory."

90. González-Ruibal, "A Time to Destroy," 259.

91. González-Ruibal, "A Time to Destroy," 259. González-Ruibal argues that the work of archaeology must be political: "Archaeologists have to make things visible and public" (ibid., 260). "We need to use archaeology as a tool of radical critique, opposed to ideological mechanisms for sanitizing the past" (ibid., 261). González-Ruibal's proposed archaeology of supermodernity is a genealogical and sociotechnical approach that would reveal the interconnections that produce and reproduce relations of power, not only between humans but also things and nonhuman life (ibid.).

92. Foucault, *The Archaeology of Knowledge*, 25–26.

93. Foucault, *The Archaeology of Knowledge*, 26.

94. Foucault, *The Archaeology of Knowledge*, 147.

95. Bezhanova, "Javier Cercas y Benjamín Prado."

96. Enwezor, *Archive Fever*, 22.

97. Foucault, *The Archaeology of Knowledge*, 8.

98. See Pablo Gil Casado, "Benjamín Prado," for discussion of the authenticity of the various documentary sources included in the novel.

99. Enwezor, *Archive Fever*, 33.

100. Enwezor, *Archive Fever*, 47.

5. COMICS PERSPECTIVES ON SPANISH CRISIS

1. "Los desahucios sumaron 60.754 en 2017, un 3,6% menos según el CGPJ," *RTVE*, March 5, 2018, http://www.rtve.es/noticias/20180305/desahucios-sumaron-60754-2017-36-menos-segun-cgpj/1689100.shtml.

2. "Los desahucios en la Comunidad de Madrid aumentan un 5,5% con respecto al año pasado," *El País*, June 14, 2017, https://elpais.com/ccaa/2017/06/14/madrid/1497436017_182978.html.

3. "Los desahucios en la Comunidad de Madrid aumentan un 5,5% con respecto al año pasado."

4. "Catalunya lidera al aumento interanual de desahucios en España," *La Vanguardia*, October 8, 2018, https://www.lavanguardia.com/economia/20181008/452233272204/desahucios-spana-datos.html.

5. Alfredo L. Congostrina, "El 93% de los desahucios en Barcelona son por impago en el alquiler," *El País*, November 4, 2016, https://elpais.com/ccaa/2016/11/04/catalunya/1478259548_015080.html.

6. Scholars of contemporary Spain have devoted increasing attention to the

"stories of subprime lives," as Germán Labrador Méndez calls them in his 2012 essay. These stories relate recurrent contemporary historical experiences of people "en situación de grave riesgo biopolítico" (in situations of grave biopolitical risk) within the current economic conjuncture (Labrador Méndez, "Las vidas 'subprime,'" 570). Britland offers a compelling reading of one such story, María Folguera's *Los primeros días de Pompeya* (2016), in terms of how the novel promotes emotional engagement and social mobilization in response to the crisis. Bezhanova's *Literature of Crisis* is also very useful.

7. Klein, *The Shock Doctrine;* Loewenstein, *Disaster Capitalism.*

8. Carabancheleando, *Diccionario de las periferias,* 17.

9. "No queremos una España de proletarios sino de propietarios," *ABC,* May 2, 1959, Morning edition, 41.

10. Pere López Sánchez (1986) has described the gentrification of Barcelona's Barrio de Santa Caterina and the Portal Nou (López Sánchez, *El centro histórico*); Mercè Tatjer (2008) analyzes the urban renovation of the Poblenou neighborhood that is the subject of *Barcelona: Los vagabundos de la chatarra,* (Tatjer, "El patrimonio industrial de Barcelona"); and Jordi Nofre i Mateo (2010) mentions the new high-velocity train station in Sagrera that has impacted working-class neighborhoods that surround it. Nofre i Mateo relates this process, which can be seen across these various urban zones, to the "hidden cultural agenda" that has resulted in the progressive homogenization of urban space in Barcelona (Nofre i Mateo, "Políticas culturales," 156). His surprising conclusion is that these processes of "social hygienization" can be traced through both the conservative *and* progressive governments that have obviated or ignored the "working-class question" (ibid., 157).

11. Carabancheleando, *Diccionario de las periferias,* 104–5.

12. Amparo Baca. "La crisis deja su huella en un sinfín de urbanizaciones fantasma en Sevilla," *ABC,* July 22, 2012, https://sevilla.abc.es/sevilla/sevi-urbanizaciones-fantasma-aljarafe-201207220000_noticia.html.

13. "Casas vacías: Las nuevas ruinas," RTVE: Documentos TV, dir. Manuel Sánchez Pereira, prod. Aurora Llorente, December 1, 2014, http://www.rtve.es/alacarta/videos/documentos-tv/documentos-tv-casas-vacias-nuevas-ruinas/2884818/.

14. González-Ruibal, *An Archaeology,* 33.

15. Bourriaud, *The Exform,* viii.

16. Vilaseca, *Barcelonan Okupas.*

17. Europa Press, "La tasa de paro de España baja del 20% por primera vez en seis años," *El Mundo,* July 1, 2016, https://www.elmundo.es/economia/2016/07/01/57764afcca4741894a8b463f.html. As of this writing, Spanish unemployment hovers just above 16 percent.

18. Marta Peiro, "Desahucio de 27 familias de okupas en un bloque de Majadahonda," *El Mundo,* April 24, 2017, http://www.elmundo.es/madrid/2017/04/24/58fda7af22601dc93b8b45b7.html.

19. Bauman, *Wasted Lives,* 77.

20. Marta Peiro, "Desahucio de 27 familias de okupas en un bloque de Majadahonda," *El Mundo,* April 24, 2017, http://www.elmundo.es/madrid/2017/04/24/58fda7af22601dc93b8b45b7.html.

21. Bauman, *Wasted Lives*, 76.

22. I am grateful to Joanne Britland for sharing this title with me.

23. Rosa and Bueno, *Aquí vivió*, 5–8.

24. Rosa and Bueno, *Aquí vivió*, 9.

25. Rosa and Bueno, *Aquí vivió*, 14–15.

26. Rosa and Bueno, *Aquí vivió*, 30.

27. Rosa and Bueno, *Aquí vivió*, 20.

28. Rosa and Bueno, *Aquí vivió*, 33–34.

29. Rosa and Bueno, *Aquí vivió*, 50.

30. McCloud, *Understanding Comics*, 69.

31. Ahrens and Meteling, *Comics and the City*; Christine M. Martínez, in "Urban Ecology and Comics Journalism in Carrión and Forniés's *Barcelona*," points out that "the comics form is adept at communicating atmospheres of tangled conflict as writ upon city space" (169).

32. Rosa and Bueno, *Aquí vivió*, 128.

33. Rosa and Bueno, *Aquí vivió*, 132.

34. Rosa and Bueno, *Aquí vivió*, 137.

35. Rosa and Bueno, *Aquí vivió*, 81–116.

36. González-Ruibal, *An Archaeology*, 115.

37. Rosa says that he wanted the house to play "un papel protagonista en esta historia, pero no como valor material sino como contenedor de vidas y de recuerdos" (Rut de las Heras Bretín, "Sobre las ruinas de un desahucio," *El País*, April 11, 2016, https://elpais.com/cultura/2016/04/05/actualidad/1459810253_769875.html).

38. Rosa and Bueno, *Aquí vivió*, 121.

39. Chute, *Disaster Drawn*, 18.

40. Rosa and Bueno, *Aquí vivió*, 150.

41. "Cada casa tiene su pasado, sus fantasmas, y hay que vivir con ellos" (Rosa and Bueno, *Aquí vivió*, 153).

42. Rosa and Bueno, *Aquí vivió*, 147.

43. Rosa and Bueno, *Aquí vivió*, 154.

44. Rosa and Bueno, *Aquí vivió*, 155.

45. Rosa and Bueno, *Aquí vivió*, 149.

46. Rosa and Bueno, *Aquí vivió*, 149–50.

47. Rosa and Bueno, *Aquí vivió*, 184–92.

48. 15M is a grassroots anti-austerity movement that emerged against the Spanish government's response to the 2008 financial crisis. Jordi Mir Garcia describes how the PAH in particular has played an important role in contemporary Spanish politics, educating and empowering people to take active roles as political actors through coordinated publicity campaigns and strategic civil disobedience (Mir Garcia, "PAH, the Platform for People Affected by Mortgages").

49. Plataforma de Afectados por la Hipoteca, *Libro verde*, 5.

50. Plataforma de Afectados por la Hipoteca, *Libro verde*, 5.

51. The PAH is one of several social movements that emerged in the wake of 15M whereby "ordinary, everyday, unauthorized knowledge and abilities 'of anyone'" have allowed "those affected by the crisis of neoliberalism to defend themselves from

its consequences" (Moreno-Caballud, *Cultures of Anyone*, 200). Mir Garcia credits the PAH with bringing the word "ethics" back to the realm of politics and democracy in Spain.

52. After 1986, Barcelona and Madrid, like many global metropolises, shifted away from more progressive, distinctive regional and municipal cultural investment in favor of a model more like a globally legible yet historically indistinct form of an urban theme park (Lefebvre, *Le droit à la ville* (1968) and *La production de l'espace* [1974]; Edensor, *Industrial Ruins* [1998]; Hannigan, *Fantasy City* [1998]; Judd, "El turismo urbano y la geografía de la ciudad" [2003]; Nofre i Mateo, "Políticas culturales" [2010]). This is the process known today as gentrification. As I noted in chapter 3, Jordi Barceló's photographs make this process the center of his visualization of an atemporal place ready to be developed by multinational capital.

53. Rosa and Bueno, *Aquí vivió*, 202–3.

54. Rosa and Bueno, *Aquí vivió*, 203.

55. Rosa and Bueno, *Aquí vivió*, 204.

56. Rosa and Bueno, *Aquí vivió*, 205.

57. Rosa and Bueno, *Aquí vivió*, 202.

58. Certeau, *The Practice of Everyday Life*, 93.

59. Rosa and Bueno, *Aquí vivió*, 207.

60. Rosa and Bueno, *Aquí vivió*, 208.

61. Rosa and Bueno, *Aquí vivió*, 202.

62. Rosa and Bueno, *Aquí vivió*, 205.

63. Rosa and Bueno, *Aquí vivió*, 197–98.

64. Rosa and Bueno, *Aquí vivió*, 214.

65. Rosa and Bueno, *Aquí vivió*, 217.

66. Rosa and Bueno, *Aquí vivió*, 225–31.

67. Rosa and Bueno, *Aquí vivió*, 229–30.

68. Between 1951 and 1970, nearly four million people immigrated from small rural communities to the city, creating a housing shortage that the Franco regime was slow to address (Shubert, *A Social History of Modern Spain*, 210). The housing shortage, particularly in Madrid, became a popular theme for many Spanish films of the 1950s and 1960s. Aside from *El pisito* (The little apartment) and *El verdugo* (The executioner), *Esa pareja feliz* (1951; That happy couple), the first film by Juan Antonio Bardem and Luis García Berlanga, and *La vida por delante* (1958; Our lives are ahead of us) by Fernando Fernán Gómez also dealt with the scarcity of suitable housing. Although Bardem and Berlanga felt compelled to give their films a happy ending, Marvin D'Lugo points out that "throughout the 1950s, Spanish filmmakers attempted to use plots involving the extreme housing shortage as the basis for veiled critiques of the regime" (D'Lugo, *Guide to the Cinema of Spain*, 89).

69. Rosa and Bueno, *Aquí vivió*, 254.

70. Rosa and Bueno, *Aquí vivió*, 250–55.

71. Bauman, *Wasted Lives*, 131.

72. Bauman, *Wasted Lives*, 132.

73. Bauman, *Wasted Lives*, 132.

74. Rosa and Bueno, *Aquí vivió*, 256.

75. Gordon, *Ghostly Matters*, 201.

76. Gordon, *Ghostly Matters*, 201.

77. Gordon, *Ghostly Matters*, 202.

78. In his narratological analysis of the work, Faye writes that "Carrión y Sagar observan mutaciones: la de la chatarra, la de los chatarreros, la de Barcelona, cuestionando la relación entre texto y contexto, entre realidad, ficción y no ficción"; Faye, "El reportaje gráfico," 207. (Carrión and Sagar observe mutations: of the scrap metal, of the scrap workers, of Barcelona, questioning the relation between text and context, between reality, fiction, and nonfiction.)

79. In Faye's words, the book explores "la influencia del contexto social [en] la construcción de la diégesis y en la elaboración de la estética iconotextual" (the influence of social context on the construction of the diegesis and on the elaboration of the iconic-textual aesthetics) (Faye, "El reportaje gráfico," 206).

80. Guillamón, "¿Del Manchester catalán al Soho barcelonés?" 137, quoted in Duarte and Sabaté, "22@Barcelona," 10.

81. Sabaté, *Luces y sombras;* Sabaté, "De la plaza de las Glorias al Forum"; Carabancheleando, *Diccionario de las periferias.*

82. Duarte and Sabaté, "22@Barcelona," 10; Carabancheleando, *Diccionario de las periferias,* 15–28.

83. Duarte and Sabaté, "22@Barcelona," 10.

84. Duarte and Sabaté, "22@Barcelona," 13.

85. Mir Garcia, "PAH, the Platform for People Affected by Mortgages," 243.

86. Mir Garcia, "PAH, the Platform for People Affected by Mortgages," 243.

87. Duarte and Sabaté, "22@Barcelona," 14. Madrid's historic center has seen similar processes spanning decades (Fernando Peinado, "El patio oscuro de las 'casas bonitas,'" *El País,* August 9, 2019, https://elpais.com/ccaa/2019/07/09/madrid/1562689659_524040.html).

88. Carrión and Forniés, *Barcelona,* 5.

89. In Madrid, the Carabancheleando collective has done important work in documenting community histories, forms of belonging and knowledge production in that city's peripheries.

90. Constenla labels the book an example of "periodismo ilustrado" (Tereixa Constenla, "Noticias dibujadas desde la chatarra," *El País,* July 23, 2014, https://elpais.com/cultura/2014/07/23/actualidad/1406127195_363648.html). In his appreciative structuralist account, Faye describes how "los autores innovan en la vía del periodismo *gonzo*" (the authors' innovation lies in the line of gonzo journalism) (Faye, "El reportaje gráfico," 220).

91. Carrión and Forniés, *Barcelona,* 27.

92. Carrión and Forniés, *Barcelona,* 27.

93. Norma Editorial, "Barcelona: Los vagabundos de la chatarra," Vimeo video, Sagar speaking, May 8, 2015, https://www.normaeditorial.com/bcn-vagabundos-chatarra/obra.html.

94. Matthew Marr describes how Sailó's book and its accompanying online promotional video "embarks on a memorably irreverent, though lucid and incisive,

comic deconstruction of a series of government policies and consumerist practices that paved Spain's gilded road to the housing bubble and its aftermath in the post-2008 recession: without a doubt, the most seismic period in Spanish history since the late years of Francoism, the subsequent transition to constitutional democracy, and the development of an economy more fully embedded in the structures global capitalism" (Marr, "Building a Home for Crisis Narrative," 137).

95. Carrión and Forniés, *Barcelona*, 5.

96. Carrión and Forniés, *Barcelona*, 8.

97. Carrión and Forniés, *Barcelona*, 98–101.

98. "Guía didáctica, *Barcelona. Los vagabundos de la chatarra*," Norma Editorial, accessed June 26, 2017, https://www.normaeditorial.com/bcn-vagabundos-chatarra /guia.html.

99. Carrión and Forniés, *Barcelona*, 8.

100. Carrión and Forniés, *Barcelona*, 8.

101. Carrión and Forniés, *Barcelona*, 26–31.

102. Carrión and Forniés, *Barcelona*, 42–53.

103. Carrión and Forniés, *Barcelona*, 53.

104. Carrión and Forniés, *Barcelona*, 84–88.

105. Carrión and Forniés, *Barcelona*, 87.

106. Carrión and Forniés, *Barcelona*, 88.

107. Carrión and Forniés, *Barcelona*, 86.

108. Carrión and Forniés, *Barcelona*, 88.

109. Carrión and Forniés, *Barcelona*, 88.

110. Carrión and Forniés, *Barcelona*, 5.

111. Carrión and Forniés, *Barcelona*, 36.

112. Carrión and Forniés, *Barcelona*, 54–55.

113. Carrión and Forniés, *Barcelona*, 55.

114. Suzanne Daley, "Spain Recoils as Its Hungry Forage Trash Bins for a Next Meal," *New York Times*, September 24, 2012, https://www.nytimes.com/2012/09/25 /world/europe/hunger-on-the-rise-in-spain.html; Samuel Aranda's photographs appeared in a separate section: "In Spain, Austerity and Hunger," *New York Times*, September 24, 2012, https://www.nytimes.com/slideshow/2012/09/24/world/europe /20120925-SPAIN.html.

115. María J. Mateo, "'The New York Times' Sorprende con un reportaje fotográfico sobre 'el hambre' en España," *20 Minutos*, September 24, 2012, https://www .20minutos.es/noticia/1597350/0/new-york-times/reportaje-fotografico/hambre -espana/.

116. "El hambre en España según 'The New York Times,'" *El País*, September 26, 2012, https://elpais.com/internacional/2012/09/26/actualidad/1348648245_626649 .html.

117. Even Carrión and Sagar seem to take umbrage with the representation of the country in the *New York Times* piece. Sagar says: "Bueno, el cómic será en color. Por suerte no retrataremos sólo la pobreza y no lo haremos en blanco y negro, como el reportaje del New York Times sobre la crisis española"; Carrión and Forniés, *Bar-*

celona, 55. (Well, our comic will be in color. Luckily, we will not only represent the poverty and we will not do it in black-and-white, like the *New York Times* report on the Spanish crisis.)

118. In "Urban Ecology" Martínez offers a sophisticated and theoretically robust analysis of the book through the lens of urban ecology, noting that the comics form allows the authors to engage with the complexities of the city as an urban ecosystem.

119. Carrión and Forniés, *Barcelona*, 24–25, 60–61, 94–95.

120. Carrión and Forniés, *Barcelona*, 25.

121. Carrión and Forniés, *Barcelona*, 62–65.

122. Carrión and Forniés, *Barcelona*, 64.

123. Carlos Faneca, "Cerco a los chatarreros del Poblenou," *El País*, January 7, 2013, http://ccaa.elpais.com/ccaa/2013/01/07/catalunya/1357552107_452150.html.

124. Carrión and Forniés, *Barcelona*, 66.

125. Carrión and Forniés, *Barcelona*, 66.

126. Carrión and Forniés, *Barcelona*, 66.

127. Augé, *Le temps en ruines*, 78.

128. Augé, *Le temps en ruines*, 78.

129. Carrión and Forniés, *Barcelona*, 75–79.

130. Stephen Vilaseca's book *Barcelonan Okupas* (2013) offers an authoritative account of the *okupas* from political and historical perspectives, tracing the emergence of the phenomenon during the Transition years through to the present day. He also addresses some of the representations of the *okupas* in mainstream media and cultural production, including some *okupas*-produced works.

131. Carrión and Forniés, *Barcelona*, 82.

132. Carabancheleando, *Diccionario de las periferias*, 133–34.

133. Carrión and Forniés, *Barcelona*, 83.

134. Carrión and Forniés, *Barcelona*, 83.

135. Carrión and Forniés, *Barcelona*, 83.

136. Carrión and Forniés, *Barcelona*, 83

137. Faye, "El reportaje gráfico," 220.

138. The tweets are part of what Faye calls the heterogeneity of the comic's reality effect (Faye, "El reportaje gráfico," 215).

139. Carrión and Forniés, *Barcelona*, 90.

140. Carrión and Forniés, *Barcelona*, 90–91.

141. Carrión and Forniés, *Barcelona*, 6–7.

142. Carrión and Forniés, *Barcelona*, 95.

143. Groensteen describes how "Comics images do not create the illusion that the events are taking place as we read" (Groensteen, *The System of Comics*, 82).

144. Groensteen, *The System of Comics*, 82.

145. Groensteen quoted in Bordes, *Cómic, arquitectura narrativa*, 29.

146. Groensteen quoted in Bordes, *Cómic, arquitectura narrativa*, 29.

147. Viney argues that the modern ruin evinces "a logic that includes a commingling of tense, continuities and discontinuities, presence and absence, collation and dispersal, all of which are central to the system of contradiction that makes waste an articulated and articulate thing in time" (Viney, "Ruins of the Future," 156).

6. WORDS AND THE WASTING SELF IN ROSA MONTERO'S FICTION

1. Bennett, *Vibrant Matter*.

2. The novel won Spain's first Premio Primavera in 1997 and spent eleven months at number-one on the bestseller list. In 2003 the novel was adapted into a feature-length film, titled *Lucía Lucía*, directed by Antonio Serrano and starring Cecilia Roth in the title role.

3. Montero, *La hija del caníbal*, 34.

4. Scanlan, *On Garbage*, 9.

5. Offenhuber and Ratti, *Decoding the City*, 1.

6. During the COVID-19 pandemic, as the virus spread through densely populated communities, wastewater testing allowed engineers and public health officials to detect infections rapidly and to gauge the relative success of quarantining. The method may not be stylish, but human waste contains vital information (Whitman, "Inside the Science of Testing Wastewater at UVA").

7. Bardini, *Junkware*, 169.

8. Bardini, *Junkware*, 169.

9. Bardini, *Junkware*, 8.

10. González-Ruibal, *An Architecture*, 5.

11. Collins, *Architectures of Excess*, 8.

12. Carabancheleando, *Diccionario de las periferias*, 118.

13. Bardini, *Junkware*, 170.

14. Bourriaud, *The Exform*, 47.

15. Montero, *La hija del caníbal*, 9

16. Montero, *La carne*, 229.

17. Rosa Montero, "Cuando el cuerpo duele," *El País*, October 26, 2014, https://elpais.com/elpais/2014/10/21/eps/1413920551_623761.html.

18. Montero, *La carne*, 147.

19. Scanlan, *On Garbage*, 33.

20. Scanlan, *On Garbage*, 36.

21. Montero, *La hija del caníbal*, 113.

22. Montero, *La hija del caníbal*, 104.

23. Postlewate, "The Use of the Detective Story," 143. Harges, *Synergy and Subversion in the Second Stage Novels of Rosa Montero*.

24. Postlewate, "The Use of the Detective Story," 144.

25. Montero, *La hija del caníbal*, 325.

26. Montero, *La hija del caníbal*, 12.

27. Montero, *La hija del caníbal*, 51.

28. Montero, *La hija del caníbal*, 51.

29. *Lágrimas en la lluvia* (Barcelona: Seix Barral, 2011; *Tears in the Rain*, 2012), *El peso del corazón* (Barcelona: Seix Barral, 2015; *Weight of the Heart*, 2016), *Los tiempos del odio* (Barcelona: Seix Barral, 2018; The days of hate).

30. Montero, *La hija del caníbal*, 336.

31. Montero, *La carne*, 175–80.

32. Waugh, *Metafiction*, 6.

33. Crowley, "Paul Ricoeur," 8.

34. Crowley, "Paul Ricoeur," 9.

35. Crowley, "Paul Ricoeur," 10.

36. In his essay "Mimesis and Diegesis in Modern Fiction," David Lodge postulates that the self-conscious foregrounding of the narrative act represents one of the defining formal characteristics of postmodernist fiction. Tracing the continuum of several hundred years of literary development, Lodge argues that postmodernist fiction emphasizes diegesis (telling), as an alternative to the realist emphasis on mimesis (showing) (183). Lodge argues that modernist stream of consciousness becomes, in postmodern fiction, a stream of narration.

37. Barthes, "The Discourse of History," 121.

38. Montero, *La hija del caníbal*, 21.

39. Montero, *La hija del caníbal*, 52.

40. Montero, *La hija del caníbal*, 94.

41. Montero, *La hija del caníbal*, 104.

42. Montero, *La hija del caníbal*, 107.

43. Montero, *La hija del caníbal*, 108.

44. Montero, *La hija del caníbal*, 317.

45. Montero, *La hija del caníbal*, 320.

46. Montero, *La hija del caníbal*, 108.

47. Montero, *La hija del caníbal*, 107.

48. Montero, *La hija del caníbal*, 139.

49. Montero, *La hija del caníbal*, 114.

50. Johnson, "Eating Her Heart Out," 457.

51. Johnson, "Eating Her Heart Out," 465.

52. Johnson, "Eating Her Heart Out," 465.

53. Bardini, *Junkware*, 9.

54. Tolentino, *Trick Mirror: Reflections on Self Delusion*, 12.

55. Bardini, *Junkware*, 9.

56. Bardini, *Junkware*, 169–79.

57. Montero, *La hija del caníbal*, 43.

58. Montero, *La hija del caníbal*, 26.

59. Montero, *La hija del caníbal*, 209–10.

60. Montero, *La hija del caníbal*, 210.

61. The list is long. Montero, *La carne*, 77–78.

62. Montero, *La carne*, 30.

63. Montero, *La hija del caníbal*, 316.

64. Nguyen, "Black-Eyed Woman," in *The Refugees*, 21.

65. Montero, *La hija del caníbal*, 316.

66. Building on Rosi Braidotti's concept of the "nomadic subject," Pérez-Carbonell and Congdon propose that the unity of Montero's characters derives from their evolving awareness of their bodily metamorphoses.

67. Montero, *La hija del caníbal*, 324.

68. Stewart, "What Praise Poems Are For," 235.

69. Stewart, "What Praise Poems Are For," 235.

70. Merleau-Ponty, *The Primacy of Perception*.

71. Elaine Scarry, *The Body in Pain*, 33. I owe my discovery of Scarry to Jessica Folkart's essay, "Body Talk: Space, Communication, and Corporeality in Lucía Etxebarría's *Beatriz y los cuerpos celestes*," *Hispanic Review* 72, no. 1 (2004): 43–63, which is the definitive analysis of Etxebarría's novel.

72. Elytis, *Open Papers*, 25.

73. This paragraph was written in conversation with Jessica Folkart.

74. S. Smith, "Material Selves," 107.

75. Postlewate notes that Montero's playful appropriation of an open-ended autobiographical narrative functions to blur boundaries between literary genres and between subjects (Postlewate, "The Use of the Detective Story," 143).

76. Montero, *La hija del caníbal*, 321.

77. Peregrina Pereiro has argued that this ending points to an ethical alternative to more pessimistic accounts of postmodern culture, since Lucía's existential angst appears to be replaced by a more positive holistic worldview, or what Pereiro calls "una alternativa al desencanto y la pasividad [y un] regreso a la simplicidad y a la comunidad" (Pereiro, *La novela española de los noventa*, 132).

78. Massumi, *What Animals Teach Us about Politics*.

79. Bruner, "Life as Narrative."

80. S. Smith, "Material Selves," 94.

81. Toni Morrison, "Nobel Lecture: December 7, 1993," The Nobel Prize, https://www.nobelprize.org/prizes/literature/1993/morrison/lecture/.

82. Montero, *La hija del caníbal*, 337.

CONCLUSION

1. Yaeger, "Editor's Column," 338.

2. Allen, in Knechtel, *Trash*, 204.

3. Royal Statistical Society, "2018 Statistics of the Year."

4. Stouffer, "Plastics Packaging," 1.

5. "Garfield Phones Beach Mystery Finally Solved after 35 Years," *BBC News*. March 28, 2019, https://www.bbc.com/news/world-europe-47732553.

6. Žižek, *The Ticklish Subject*, 310.

7. Jack Halberstam, "Wild Things: Zombie Humanism at the End of the World," Carolina Conference on Romance Studies, keynote address, UNC-Chapel Hill, April 2, 2016.

8. María Isabel Serrano, "SOS para 100.000 'pisos zombie,'" *ABC*, December 5, 2011, https://www.abc.es/espana/madrid/abcp-para-pisos-zombie-201112050000_noticia.html.

9. Berman, *All That Is Solid*.

10. These are the words of Almudena García-Rubio, quoted in Nuño Domínguez, https://elpais.com/elpais/2019/05/08/inenglish/1557327917_803284.html.

11. https://elpais.com/elpais/2019/05/08/inenglish/1557327917_803284.html.

12. Bodenstein, "The Emotional Museum: Thoughts on the 'Secular Relics' of Nineteenth-Century History Museums in Paris and their Posterity," http://cm.revues .org/834.

13. Bogost, *Alien Phenomenology*, 134.

14. Felski, "Context Stinks!," 589.

15. González-Ruibal, *An Archaeology*, 84.

16. Iovino and Oppermann, "Introduction," 1–2.

17. Lilley, "The End of Capitalism," 129.

18. Buell, *The Future of Environmental Criticism*, vi.

19. Nishime and Williams, *Racial Ecologies*.

20. Federico Luisetti, "Unsustainable Art and the Zero Waste Economy," forthcoming in *Sobras espectrales: hacia una crítica estético-política de restos y basura*, ed. Valeria Wagner and Adriana López-Labourdette.

21. Iovino, *The Reverse of the Sublime:* "There is no outside anymore, whether in space (ocean, atmosphere, colonial lands, the poor's backyards) or in time (the future). . . . The end of externalities means that everything stays here: we have to deal with the consequences of what we do, of our actions as well as our visions" (2). Luisetti notes that "in the Anthropocenic state of nature, the fading away of externalities brings all eco-social realities into the planetary domain of human-nonhuman relations, absorbing trash into the Earth's ecosystems." The Earth System has no externalities.

Works Cited

Acland, Charles. *Screen Traffic: Movies, Multiplexes, and Global Culture*. Durham, NC: Duke University Press, 2003.

Aguilar, Paloma, and Leigh A. Payne. *Revealing New Truths about Spain's Violent Past: Perpetrators' Confessions and Victim Exhumations*. London: Palgrave Macmillan, 2016.

Ahmed, Sara. *What's the Use? On the Uses of Use*. Durham, NC: Duke University Press, 2019.

Åhrén, Eva. *Death, Modernity, and the Body: Sweden 1870–1940*. Rochester, NY: University of Rochester Press, 2013.

Ahrens, Jörn, and Arno Meteling. *Comics and the City: Urban Space in Print, Picture and Sequence*. New York: Continuum, 2010.

Alba Rico, Santiago, and Carlos Fernández Liria. *Dejar de pensar*. Madrid: Akal, 1986.

Allinson, Mark. "Alaska: Star of Stage and Screen and Optimistic Punk." In *Constructing Identity in Contemporary Spain*, edited by Jo Labanyi, 222–36. Oxford: Oxford University Press, 2002.

———. *Un laberinto español: Las películas de Pedro Almodóvar*. Madrid: Ocho y Medio, 2003.

Amago, Samuel. *Spanish Cinema in the Global Context: Film on Film*. New York: Routledge, 2013.

Amago, Samuel, and Matthew J. Marr, eds. *Consequential Art: Comics Culture in Contemporary Spain*. Toronto: University of Toronto Press, 2019.

Anderson, Andrew. "Paysage d'âme and Objective Correlative: Tradition and Innovation in Cernuda, Alberti, and García Lorca." *Modern Language Review* 110 (2015): 166–83.

Anderson, Neil. "To Be or Not: The Rural Village in Post-Rural Times." *Galicia 21, Journal of Contemporary Galician Studies*, F (2014–15): 60–76.

Andrew, Dudley. "Film and History." In *The Oxford Guide to Film Studies*, edited by Richard Dyer, E. Ann Kaplan, and Paul Willemen, 176–89. Oxford: Oxford University Press, 1998.

Armengou Martín, Montse. "Investigative Journalism as a Tool for Recovering Historical Memory." In *Unearthing Franco's Legacy: Mass Graves and the Recovery of Historical Memory*, edited by Carlos Jerez-Ferrán and Samuel Amago, 156–67. South Bend, IN: University of Notre Dame Press, 2010.

Augé, Marc. *Le temps en ruines*. Paris: Éditions Galilée, 2003.

Balfour, Sebastian, and Alejandro Quiroga. *The Reinvention of Spain: Nation and Identity since Democracy*. Oxford: Oxford University Press, 2007.

Bardini, Thierry. *Junkware*. Minneapolis: University of Minnesota Press, 2011.

Barthes, Roland. "The Discourse of History." In *The Postmodern History Reader*, edited by Keith Jenkins, 120–23. London: Routledge, 1997.

Bauman, Zygmunt. *Wasted Lives: Modernity and Its Outcasts*. Cambridge: Polity, 2004.

Bay, Alexander. "Nation from the Bottom Up: Disease, Toilets and Waste Management in Prewar Japan." *Historia Scientiarum* 22, no. 2 (2012): 142–58.

Bélanger, Pierre. "Airspace." In *Trash*, edited by John Knechtel, 132–55. Cambridge: MIT Press, 2007.

Bermúdez, Silvia. "Memory and Archive: La Movida, Alaska, and Processes of Cultural Archaeology." In *Toward a Cultural Archive of la Movida: Back to the Future*, edited by William J. Nichols and H. Rosi Song, 293–306. Lanham, MD: Fairleigh Dickenson University Press, 2014.

Bernadó, Jordi, Giovanna Calvenzi, and Juan José Lahuerta. *Welcome to Espain̄*. Barcelona: Actar, 2009.

Benjamin, Walter. "The Work of Art in the Age of Mechanical Reproduction." In *Illuminations*, edited by Hannah Arendt; translated by Harry Zohn, 217–57. New York: Schocken, 1968.

———. *The Writer of Modern Life: Essays on Charles Baudelaire*. Cambridge, MA: Harvard University Press, 2006.

Bennett, Jane. "Encounters with an Art-Thing." *Salvage Art Institute*. (January 16, 2014). http://salvageartinstitute.org/janebennett_encounterswiththesartthing.pdf.

———. *Vibrant Matter: A Political Ecology of Things*. Durham, NC: Duke University Press, 2010.

Berger, John. *Ways of Seeing*. New York: Penguin: 1972.

Bergson, Henri. *Creative Evolution*. London: Macmillan, 1911.

Berman, Marshall. *All That Is Solid Melts into Air: The Experience of Modernity*. New York: Verso, 1983.

Bezhanova, Olga. "Javier Cercas y Benjamín Prado: Dos acercamientos a la Guerra Civil." *Bulletin of Spanish Studies: Hispanic Studies and Researches on Spain, Portugal, and Latin America* 93, no. 3 (March 2016): 455–73.

———. *Literature of Crisis: Spain's Engagement with Liquid Capital*. Lewisburg, PA: Bucknell University Press, 2017.

Bodenstein, Felicity. "The Emotional Museum. Thoughts on the 'Secular Relics' of Nineteenth-Century History Museums in Paris and their Posterity." *Conserveries mémorielles. Revue transdisciplinaire* 9 (2011). http://journals.openedition.org/cm/834.

Bogost, Ian. *Alien Phenomenology, or, What It's Like to Be a Thing*. Minneapolis: University of Minnesota Press, 2012.

Bordes, Enrique. *Cómic, arquitectura narrativa*. Madrid. Cátedra, 2017.

Boscagli, Maurizia. *Stuff Theory: Everyday Objects, Radical Materialism*. New York: Bloomsbury, 2014.

Bou, Enric. "Poetry between 1920 and 1940." In *The Cambridge History of Spanish Literature*, edited by David Gies, 555–68. Cambridge: Cambridge University Press, 2007.

Bourriaud, Nicolas. *The Exform*. Translated by Erik Butler. London: Verso, 2016.

Brenner, Neil. *Critique of Urbanization: Selected Essays*. Basel: Birkhäuser, 2017.

Brenner, Neil, and Nikos Katsikis. "Is the Mediterranean Urban?" In *Implosions/Explosions: Towards a Study of Planetary Urbanization*, edited by Brenner, 428–59. Berlin: Jovis, 2013.

Britland, Joanne. "New Voices and Creative Protest in Post-2008 Spain: María Folguera's *Los primeros días de Pompeya*." *Bulletin of Spanish Studies* (2020): 1–19.

Brown, Bill. "Thing Theory." *Critical Inquiry* 28, no. 1 (2001): 1–22.

Bruner, Jerome. "Life as Narrative." *Social Research* 54, no. 1 (Spring 1987): 11–32.

Buchli, Victor, ed. *The Material Culture Reader*. Oxford: Berg, 2002.

Buell, Lawrence. *The Future of Environmental Criticism*. Malden, MA: Blackwell, 2009.

Burkhart, Diana. "The Disposable Immigrant: The Aesthetics of Waste in *Las cartas de Alou*." *Journal of Spanish Cultural Studies* 11, no. 2 (2010): 153–65.

Burns Marañón, Tom. *De la fruta madura a la manzana podrida: El laberinto de la Transición española*. Barcelona: Galaxia Gutenberg, 2015.

Camnitzer, Luis. *Conceptualism in Latin American Art: Didactics of Liberation*. Austin: University of Texas Press, 2007.

Carabancheleando. *Diccionario de las periferias: Métodos y saberes autónomos desde los barrios*. Madrid: Traficantes de sueños, 2017.

Carrasco, Óscar. *Madrid OFF*. Exhibition catalogue. Madrid: Ministerio de Educación, Cultura y Deporte, 2013.

Carrión, Jorge, and Sagar Forniés. *Barcelona: Los vagabundos de la chatarra*. Barcelona: Norma Editorial, 2015.

"Casas vacías: Las nuevas ruinas." RTVE: Documentos TV. Directed by Manuel Sánchez Pereira. Produced by Aurora Llorente. 1 December 2014. http://www.rtve.es/alacarta/videos/documentos-tv/documentos-tv-casas-vacias-nuevas-ruinas/2884818/.

Certeau, Michel, de. *The Practice of Everyday Life*. Translated by Steven Rendall. Berkeley: University of California Press, 1984.

Chakrabarty, Dipesh. "The Climate of History: Four Theses." *Critical Inquiry* 35, no. 2 (2009): 197–222.

Chute, Hillary. *Disaster Drawn: Visual Witness, Comics, and Documentary Form*. Cambridge, MA: Harvard University Press, 2016.

Ciplijauskaité, Biruté. *Guilleniana*. Madison: University of Wisconsin Press, 2002. http://digital.library.wisc.edu/1711.dl/IbrAmerTxt.Spa0014.

Collins, James C. *Architectures of Excess: Cultural Life in the Information Age*. New York: Routledge, 1995.

Compitello, Malcolm. "From Planning to Design: The Culture of Flexible Accumulation in Post-Cambio Madrid." *Arizona Journal of Hispanic Cultural Studies* 3 (1999): 199–220.

———. "Recasting Urban Identities: The Case of Madrid 1977–1997. Mapping Urban Spaces and Subjectivities." *Arachne* 2, no. 1 (2002). https://www.libraries.rutgers.edu/rul/projects/arachne/vol2_1compitello.html.

Connerton, Paul. "Cultural Memory." In *Handbook of Material Culture*, edited by Chris Tilley, Webb Keane, Susanne Küchler, Mike Rowlands, and Patricia Spyer, 315–24. London: Sage, 2006.

Crowley, Patrick. "Paul Ricoeur: The Concept of Narrative Identity, the Trace of Autobiography." *Paragraph: A Journal of Modern Critical Theory* 26, no. 3 (2003): 1–12.

Davidson, Robert. "Barcelona: The Siege City." In *A Companion to Catalan Culture*, edited by Dominc Keown, 97–116. Woodbridge: Tamesis, 2011.

Debicki, Andrew. *Historia de la poesía española del siglo XX: Desde la modernidad hasta el presente.* Madrid: Gredos, 1997.

Deleuze, Gilles. *Cinema 2: The Time-Image.* Translated by Hugh Tomlinson and Robert Caleta. Minneapolis: University of Minnesota Press, 1989.

DeLoughrey, Elizabeth M. *Allegories of the Anthropocene.* Durham, NC: Duke University Press, 2019.

Derrida, Jacques. *Archive Fever: A Freudian Impression.* Translated by Eric Prenowitz. Chicago: University of Chicago Press, 2008.

Dewey, John. *Art as Experience.* New York: TarcherPerigee, 2005.

D'Lugo, Marvin. *Guide to the Cinema of Spain.* Westport, CT: Greenwood, 1997.

———. *Pedro Almodóvar.* Urbana: University of Illinois Press, 2006.

D'Lugo, Marvin, and Kathleen M. Vernon, eds. *A Companion to Pedro Almodóvar.* Chichester: Wiley-Blackwell, 2013.

Dolgin Casado, Stacey. "Benjamín Prado: La literatura es lo contrario del olvido." *Ojáncano* 33 (2008): 103–13.

Douglas, Mary. *Purity and Danger: An Analysis of Concepts of Pollution and Taboo.* London: Routledge, 2015.

Drucker, Johanna. "Temporal Photography." *Philosophy of Photography* 1, no. 1 (2010): 22–28.

Duarte, Fábio, and Joaquín Sabaté. "22@Barcelona: Creative Economy and Industrial Heritage: A Critical Perspective." *Theoretical and Empirical Researches in Urban Management* 8, no. 2 (2013): 5–21.

Duch Plana, Montserrat. *¿Una ecología de las memorias colectivas? La transición española a la democracia revisitada.* Lleida: Milenio Publicaciones, 2014.

Dupuy, Jean-Pierre. *The Mark of the Sacred.* Translated by M. B. Debevoise. Stanford, CA: Stanford University Press, 2013.

Edensor, Tim. *Industrial Ruins: Space, Aesthetics and Materiality.* Oxford: Berg, 2005.

———. *Tourists at the Taj: Performance and Meaning at a Symbolic Site.* New York: Routledge, 1998.

Elsaesser, Thomas. "Tales of Sound and Fury: Observations on the Family Melodrama." In *Imitations of Life: A Reader on Film and Television Melodrama*, edited by Marcia Landy, 68–91. Detroit, MI: Wayne State University Press, 1991.

Emmett, Robert S. "Anthropocene Aesthetics." In *Future Remains: A Cabinet of Curiosities for the Anthropocene*, edited by Gregg Mitman, Marco Armiero, and Emmett, 159–65. Chicago: University of Chicago Press, 2017.

Enwezor, Okwui. *Archive Fever: Uses of the Document in Contemporary Art.* New York: International Center of Photography, 2008.

Epps, Brad, and Despina Kakoudaki, eds. *All about Almodóvar: A Passion for Cinema.* Minneapolis: University of Minnesota Press, 2009.

Escudero Rodríguez, Javier. *La narrativa de Rosa Montero: Hacia una ética de la esperanza.* Madrid: Biblioteca Nueva, 2005.

Faber, Sebastiaan. "The Debate about Spain's Past and the Crisis of Academic Legitimacy: The Case of Santos Juliá." *Colorado Review of Hispanic Studies* 5 (2007): 165–90.

Farrier, David. *Anthropocene Poetics: Deep Time, Sacrifice Zones, and Extinction.* Minneapolis: University of Minnesota Press, 2019.

Faye, Thomas. "El reportaje gráfico: Una alternativa del compromiso periodístico: Representación contextual y estrategias narrativas en *Barcelona. Los vagabundos de la chatarra.*" *Diablo Texto Digital* 1 (2016): 206–21.

Federici, Silvia. *Re-enchanting the World: Feminism and the Politics of the Commons.* Oakland, CA: PM Press, 2019.

Feinberg, Matthew, and Susan Larson. "Cultivating the Square: Trash, Recycling and the Cultural Ecology of Post-Crisis Madrid." In *Ethics of Life: Contemporary Iberian Debates,* edited by Katarzyna Beilin and William Viestenz, 113–42. Nashville, TN: Vanderbilt University Press, 2016.

Felski, Rita. "Context Stinks!" *New Literary History* 42, no. 4 (2011): 573–91.

Fernández de Rota y Monter, José Antonio. "Evocación antropológica de la novelística de la Condesa de Pardo Bazán." *Revista de Dialectología y Tradiciones Populares* 60, no. 1 (2005): 123–39.

Fernández Mallo, Agustín. *Teoría general de la basura (cultura, apropiación, complejidad).* Barcelona: Galaxia Gutenberg, 2018.

Ferrán, Ofelia. *Working through Memory: Writing and Remembrance in Contemporary Spanish Narrative.* Lewisberg, PA: Bucknell University Press, 2007.

Ferrándiz, Francisco. "The Intimacy of Defeat: Exhumations in Contemporary Spain." In *Unearthing Franco's Legacy: Mass Graves and the Recovery of Historical Memory in Spain,* edited by Carlos Jerez-Ferrán and Samuel Amago, 304–25. South Bend, IN: University of Notre Dame Press, 2010.

Fictilis. *Museum of Capitalism.* Los Angeles: Inventory, 2017.

Fishman, Robert M., and Omar Lizardo. "How Macro-Historical Change Shapes Cultural Taste: Legacies of Democratization in Spain and Portugal." *American Sociological Review* 78, no. 2 (2013): 213–39.

Florido Berrocal, Joaquín, Luis Martín-Cabrera, Eduardo Matos-Martín, and Roberto Robles Valencia, eds. *Fuera de la ley: Asedios al fenómeno quinqui en la transición española.* Granada: Comares, 2015.

Foote, Stephanie, and Elizabeth Mazzolini, eds. *Histories of the Dustheap: Waste, Material Cultures, Social Justice.* Cambridge, MA: MIT Press, 2012.

Foster, Hal. "An Archival Impulse." *October* 110 (Autumn 2004): 3–22.

Foucault, Michel. *The Archaeology of Knowledge.* Abingdon: Routledge Classics, 2005.

Gabrys, Jennifer. *Digital Rubbish: A Natural History of Electronics.* Ann Arbor: University of Michigan Press, 2013.

———. "Media in the Dump." In *Trash*, edited by John Knechtel, 156–65. Cambridge, MA: MIT Press, 2007.

———. "Shipping and Receiving: Circuits of Disposal and the Social Death of Electronics." In *Aesthetic Fatigue: Modernity and the Language of Waste*, edited by John Scanlan and John F. M. Clark, 274–97. Newcastle upon Tyne: Cambridge Scholars Publishing, 2013.

———. "Sink: The Dirt of Systems." *Environment and Planning D: Society and Space* 27 (2009): 666–81.

Gabrys, Jennifer, Gay Hawkins, and Mike Michael. "Introduction: From Materiality to Plasticity." In *Accumulation: The Material Politics of Plastic*, edited by Gabrys, Hawkins, and Michael, 1–14. New York: Routledge, 2013.

Gan, Elaine, Anna Tsing, Heather Swanson, and Nils Bubandt, eds. *Arts of Living on a Damaged Planet: Ghosts and Monsters of the Anthropocene*. Minneapolis: University of Minnesota Press, 2017.

García Canclini, Néstor. *Consumers and Citizens: Globalization and Multicultural Conflicts*. Minneapolis: University of Minnesota Press, 2001.

———. *Hybrid Cultures: Strategies for Entering and Leaving Modernity*. Minneapolis: University of Minnesota Press, 1995.

García Urbina, Gloria. "No basta con que callemos. *Mala gente que camina*, de Benjamín Prado: Una reivindicación de la historia completa." *Espéculo: Revista de Estudios Literarios* 33 (July-October 2006). http://www.ucm.es/info/especulo/numero33/malagen.html.

Garrote, Valeria. "Demasiado hetero para ser de la Movida, demasiado *queer* para ser de la pre-Movida: *¿Qué hace una chica como tú en un sitio como este?* (Colomo, 1978) y *Pepi, Luci, Bom y otras chicas del montón* (Almodóvar, 1980)." *Hispanic Research Journal* 14, no. 3 (2013): 227–43.

Ghosh, Amitav. *The Great Derangement: Climate Change and the Unthinkable*. Chicago: University of Chicago Press, 2016.

Gidwani, Vinay. "The Afterlives of 'Waste': Notes from India for a Minor History of Capitalist Surplus." *Antipode* 43 no. 5 (2011): 1625–58.

Gies, David T., ed. *The Cambridge Companion to Modern Spanish Culture*. Cambridge: Cambridge University Press, 2007.

———. *The Cambridge History of Spanish Literature*. Cambridge: Cambridge University Press, 2009.

Gil Casado, Pablo. "Benjamín Prado: de 'la nueva novela' al realismo documental." *Ojáncano* 35 (2009): 67–88.

Girelli, Elisabetta. "The Power of the Masquerade: *Mujeres al borde de un ataque de nervios* and the Construction of Femininity." *Hispanic Research Journal* 7, no. 3 (2006): 251–58.

Godfrey, Sima. Review of "Antoine Compagnon, *Les Chiffonniers de Paris*." *H-France Review* 19, no. 123 (July 2019): 1–5.

Golob, Stephanie. "Volver: The Return of/to Transitional Justice Politics in Spain." *Journal of Spanish Cultural Studies* 9, no. 2 (2008): 127–41.

Gómez de la Serna, Ramón. *El rastro*. Valencia: Sociedad Editorial Prometeo, 1910. https://archive.org/details/elrastro00gmuoft.

Gómez López-Quiñones, Antonio. "A propósito de las fotografías: Políticas de la reconstrucción histórica en *La noche de los cuatro caminos, Soldados de Salamina* y *Enterrar a los muertos.*" *Revista Hispánica Moderna* 6, no. 1 (2008): 89–105.

———. "Aviso para navegantes: La crítica del capitalismo y sus im/posibilidades (Notas para un mapa conceptual de la crisis de 2008)." *Revista de ALCES XXI: Journal of Spanish Literature and Film* 1 (2013): 68–135.

———. *La guerra persistente: memoria, violencia y utopía: representaciones contemporáneas de la Guerra Civil española.* Madrid: Vervuert/Iberoamericana, 2006.

González-Ruibal, Alfredo. *An Archaeology of the Contemporary Era.* New York: Routledge, 2019.

———. "The Dream of Reason: An Archaeology of the Failures of Modernity in Ethiopia." *Journal of Social Archaeology* 6, no. 2 (2006): 175–201.

———. "Making Things Public: Archaeologies of the Spanish Civil War." *Public Archaeology* 6, no. 4 (2007): 203–26.

———. "A Time to Destroy: An Archaeology of Supermodernity." *Current Anthropology* 49, no. 2 (April 2008): 247–79.

Gordon, Avery F. *Ghostly Matters: Haunting and the Sociological Imagination.* Minneapolis: University of Minnesota Press, 1997.

Gorostiza, Jorge. "Backdrops and Miniatures: The Other Madrid Built by Almodóvar." Translated by Diane Rolnick. *Cine y . . . Journal of Interdisciplinary Studies on Film in Spanish/ Revista de Estudios Interdisciplinarios Sobre Cine en Español* 1, no. 2 (2008): 35–48.

Graham, Helen, and Antonio Sánchez. "The Politics of 1992." In *Spanish Cultural Studies: An Introduction: The Struggle for Modernity,* edited by Graham and Jo Labanyi, 406–18. Oxford: Oxford University Press, 1995.

Graham, Helen, and Jo Labanyi, eds. *Spanish Cultural Studies: An Introduction: The Struggle for Modernity.* Oxford: Oxford University Press, 1995.

Groensteen, Thierry. *The System of Comics.* Translated by Bart Beaty and Nick Nguyen. Jackson: University Press of Mississippi, 2007.

Guillamón, Marrero. "¿Del Manchester catalán al Soho barcelonés? La renovación del barrio del Poblenou en Barcelona y la cuestión de la vivienda." *Scripta Nova* 7, no. 146 (2003): 137. http://www.ub.edu/geocrit/sn/sn-146(137).htm.

Guillén, Jorge. "Happy Armchair!" *Roots and Wings: Poetry from Spain, 1900–1975: A Bilingual Anthology.* Edited by Hardie St. Martin. Translated by Charles Guenther. Buffalo, NY: White Pine, 2005.

———. *Poesía completa.* Vol. 1, *Aire nuestro. Cántico.* Edited by Claudio Guillén and Antonio Piedra. Valladolid: Diputación de Valladolid, 1987.

Hannigan, John. *Fantasy City: Pleasure and Profit in the Postmodern Metropolis.* New York: Routledge, 1998.

Haraway, Donna. "A Manifesto for Cyborgs: Science, Technology, and Socialist Feminism in the 1980s." In *The Haraway Reader,* 7–45. New York: Routledge, 2004.

Harges, Mary. *Synergy and Subversion in the Second Stage Novels of Rosa Montero.* New York: Peter Lang. 2000.

Harvey, David. *The Urban Experience.* Baltimore, MD: Johns Hopkins University Press, 1989.

Hauser, Kitty. *Shadow Sites: Photography, Archaeology, and the British Landscape 1927–1955.* Oxford: Oxford University Press, 2007.

Hauser, Philippe. *Madrid bajo el punto de vista medico-social.* Edited by Carmen del Moral. 2 vols. Madrid: Editora Nacional, 1979.

Hawkins, Gay. *The Ethics of Waste: How We Relate to Rubbish.* Oxford: Rowman and Littlefield, 2006.

———. "Sad Chairs." In *Trash*, edited by John Knechtel, 50–61. Cambridge, MA: MIT Press, 2007.

Hemingway, Maurice. *Emilia Pardo Bazán: The Making of a Novelist.* Cambridge: Cambridge University Press, 1983

Hernández Adrián, Francisco-J. "Tomás Sánchez on Exorbitance: Still Lifes of the Tropical Landfill." *Global South* 6, no. 1 (Spring 2012): 15–37.

Hodder, Ian. *Entangled: An Archaeology of the Relationships between Humans and Things.* Malden, MA: Wiley-Blackwell, 2012.

Huyssen, Andreas. *Present Pasts: Urban Palimpsests and the Politics of Memory.* Stanford, CA: Stanford University Press, 2009.

Iovino, Serenella. *The Reverse of the Sublime: Dilemmas (and Resources) of the Anthropocene Garden.* Munich: Rachel Carson Center Perspectives, 2019.

Iovino, Serenella, and Serpil Oppermann, eds. *Material Ecocriticism.* Bloomington: Indiana University Press, 2014.

Izquierdo, Jesús. *El rostro de la comunidad: la identidad del campesino en la Castilla del antiguo régimen.* Madrid: Consejo Económico y Social de Madrid, 2002.

Jameson, Fredric. *The Cultural Turn: Selected Writings on the Postmodern, 1983–1998.* London: Verso, 2009.

———. *Postmodernism, or, The Cultural Logic of Late Capitalism.* Durham, NC: Duke University Press, 1991.

Jerez-Ferrán, Carlos, and Samuel Amago, eds. *Unearthing Franco's Legacy: Mass Graves and the Recovery of Historical Memory in Spain.* South Bend, IN: University of Notre Dame Press, 2010.

Johnson, Warren. "Eating Her Heart Out: An Anthropophagic Reading of Rosa Montero's *La hija del caníbal.*" *Revista Hispánica Moderna* 60, no. 2 (2002): 457–66.

Jordan, Barry, and Rikki Morgan-Tamosunas, eds. *Contemporary Spanish Cultural Studies.* London: Arnold, 2000.

Judd, Dennis R. "El turismo urbano y la geografía de la ciudad." *Revista Eure* 29, no. 87 (2003): 51–62.

Judt, Tony. *Postwar: A History of Europe since 1945.* New York: Penguin, 2005.

Keller, Patricia M. *Ghostly Landscapes: Film, Photography, and the Aesthetics of Haunting in Contemporary Spanish Culture.* Toronto: University of Toronto Press, 2016.

Ketelaar, Eric, Sue McKemmish, and Anne Gilliland-Swetland. "'Communities of Memory:' Pluralising Archival Research and Education Agendas." *Archives and Manuscripts* 33, no. 1 (2005): 146–74.

Kinder, Marsha. "Re-Envoicements and Reverberations in Almodóvar's Macro-Melodrama." In *A Companion to Pedro Almodóvar*, edited by Marvin D'Lugo and Kathleen M. Vernon, 281–303. Chichester: Wiley-Blackwell, 2013.

Klein, Naomi. *The Shock Doctrine: The Rise of Disaster Capitalism.* London: Penguin, 2008.

Knechtel, John, ed. *Trash.* Cambridge: MIT Press, 2007.

Koolhaas, Rem. "Junkspace." *October* 100 (Spring 2002): 175–90.

Kracauer, Siegfried. *Theory of Film.* Oxford: Oxford University Press, 1960.

Kreitman, Paul. "Attacked by Excrement: The Political Ecology of Shit in Wartime and Postwar Tokyo." *Environmental History* 23, no. 2 (2018): 342–66.

Labanyi, Jo. "Doing Things: Emotion, Affect, and Materiality." *Journal of Spanish Cultural Studies* 11, nos. 3–4 (2010): 223–33.

———. *Gender and Modernization in the Spanish Realist Novel.* Oxford: Oxford University Press, 2000.

———. "The Politics of Memory in Contemporary Spain." *Journal of Spanish Cultural Studies* 9, no. 2 (2008): 119–25.

Labrador Méndez, Germán. *Culpables por la literatura. Imaginación política y contracultural en la Transicion española (1968–1986).* Madrid: Akal, 2017.

———. "'España, una mierda': Política, excrementos y poesía en la Transición." In *Fragmentos para una historia de la mierda: Cultura y transgresión,* edited by Luis Gómez Canseco, 221–46. Huelva: Universidad de Huelva, 2010.

———. "Las vidas 'subprime': La circulación de 'historias de vida' como tecnología de imaginación política en la crisis española (2007–2012)." *Hispanic Review* 80, no. 4 (2012): 557–81.

Larson, Susan. "Architecture, Urbanism, and *la Movida madrileña.*" In *Toward a Cultural Archive of la Movida: Back to the Future,* edited by William J. Nichols and H. Rosi Song, 181–201. Lanham, MD: Fairleigh Dickenson University Press, 2014.

Larson, Susan, and Eva Woods, eds. *Visualizing Spanish Modernity.* Oxford: Berg, 2005.

Lash, Scott. "Reflexive Modernization: The Aesthetic Dimension." *Theory, Culture & Society* 10, no. 1 (1993): 1–23.

Lefebvre, Henri. *La production de l'espace.* Paris: Éditions Anthropos, 1974.

———. *Le droit à la ville.* Paris: Éditions Anthropos, 1968.

———. *The Urban Revolution.* Translated by Robert Bononno. Minneapolis: University of Minnesota Press, 2003.

Lepawsky, Josh. *Reassembling Rubbish: Worlding Electronic Waste.* Cambridge, MA: MIT Press, 2018.

Liboiron, Max. "The Plastisphere and Other 21st-Century Waste Ecosystems." *Discard Studies,* July 22, 2013. https://discardstudies.com/2013/07/22/the-plastisphere-and-other-21st-century-waste-ecosystems/.

Lilley, Sasha. "The End of Capitalism." In Fictilis, *Museum of Capitalism,* 129. Los Angeles: Inventory Press, 2017.

Lodge, David. "Mimesis and Diegesis in Modern Fiction." In *The Post-Modern Reader,* edited by Charles Jencks, 181–95. London: Academy Editions: 1992.

Loewenstein, Antony. *Disaster Capitalism: Making a Killing Out of Catastrophe.* London: Verso, 2017.

Longhurst, Carlos Alex. "Culture and Development in Spain: The Impact of 1960s 'desarrollismo.'" In *Contemporary Spanish Cultural Studies,* edited by Barry Jordan and Rikki Morgan-Tamosunas, 17–28. London: Arnold, 2000.

López, Isidro. "Consensonomics: La ideología económica en la CT." In *CT o la Cultura de la Transición: crítica a 35 años de cultura española,* edited by Guillem Martínez, 77–88. Barcelona: Random House Mondadori, 2012.

López Sánchez, Pere. *El centro histórico: un lugar para el conflicto: Estrategias del capital para la expulsión del proletario del centro de Barcelona: el caso de Santa Caterina y el Portal Nou.* Barcelona: Publicacions i Edicions de la Universitat de Barcelona, 1986.

Loxham, Abigail. "Barcelona under Construction: The Democratic Potential of Touch and Vision in City Cinema as Depicted in *En construcción* (2001)." *Studies in Hispanic Cinemas* 3, no. 1 (2006): 33–46.

Luisetti, Federico. "Unsustainable Art and the Zero Waste Economy." Forthcoming in *Sobras espectrales: Hacia una crítica estético-política de restos y basura,* edited by Valeria Wagner and Adriana López-Labourdette.

Lukinbeal, Chris. "Cinematic Landscapes." *Journal of Cultural Geography* 23, no. 1 (Fall/Winter 2005): 3–22.

Mallo, Maruja. *Lo popular en la plástica española a través de mi obra, 1928–1936.* Buenos Aires: Losada, 1939.

Maniates, Michael F. "Individualization: Plant a Tree, Buy a Bike, Save the World?" *Global Environmental Politics,* 1, no. 3 (2001): 31–52.

Marías, Javier. *Así empieza lo malo.* Madrid: Alfaguara, 2014.

———. *Thus Bad Begins.* Translated by Margaret Jull Costa. New York: Knopf, 2016.

Marr, Matthew J. "Building a Home for Crisis Narrative: Aleix Saló's *Españistán* Project." In *Consequential Art: Comics Culture in Contemporary Spain,* edited by Samuel Amago and Marr, 137–63. Toronto: University of Toronto Press, 2019.

Marsh, Steven. "Missing a Beat: Syncopated Rhythms and Subterranean Subjects in the Spectral Economy of *Volver.*" *All about Almodóvar: A Passion for Cinema,* edited by Brad Epps and Despina Kakoudaki, 339–56. Minneapolis: University of Minnesota Press, 2009.

Martín Gaite, Carmen. *El cuarto de atrás.* Barcelona: Destino, 1978.

Martínez, Christine M. "Urban Ecology and Comics Journalism and Carrión and Forniés's *Barcelona.*" In *Consequential Art: Comics Culture in Contemporary Spain,* edited by Samuel Amago and Matthew J. Marr, 164–91. Toronto: University of Toronto Press, 2019.

Martínez, Guillem, ed. *CT o la cultura de la Transición: Crítica a 35 años de cultura española.* Barcelona: Random House Mondadori, 2012.

Martínez-Alier, J., and Jordi Roca. "Spain after Franco: From Corporatist Ideology to Corporatist Reality." *International Journal of Political Economy* 17, no. 4 (Winter 1987/1988): 56–87.

Martínez Bouza, Rogelio. "La sensibilidad purista de Adolfo Domínguez." *AIC* 29 (1986): 44–51.

Martínez-Expósito, Alfredo. "Contempla mis heridas: El cuerpo mancillado en Almodóvar." *AUMLA: Journal of the Australasian Universities Modern Language Association* 94 (2000): 83–108.

Massumi, Brian. *What Animals Teach Us about Politics.* Durham, NC: Duke University Press, 2014.

Matsuda, Matt K. *The Memory of the Modern.* Oxford: Oxford University Press, 1996.

Mbembe, Achille. "The Power of the Archive and Its Limits." In *Refiguring the Archive*, edited by C. Hamilton, V. Harris, M. Pickover, G. Reid, R. Saleh, and J. Taylor, 19–28. Dordrecht, Netherlands: Kluwer, 2002.

McCloud, Scott. *Understanding Comics: The Invisible Art*. New York: Harper Perennial, 1994.

Merino, Eloy E. "Aspectos de la representación y el tema de España en los editoriales de varios diarios norteamericanos (1975–2007)." In *Ventanas sobre el Atlántico: Estados Unidos-España durante el postfranquismo (1975–2008)*, edited by Carlos X. Ardavín Trabanco and Jorge Marí, 219–33. Valencia: Publicaciones de la Universitat de València, 2011.

Merino, Eloy E., and H. Rosi Song, eds. *Traces of Contamination: Unearthing the Francoist Legacy in Contemporary Spanish Discourse*. Lewisburg, PA: Bucknell University Press, 2005.

Merleau-Ponty, Marcel. *The Primacy of Perception*. Evanston, IL: Northwestern University Press, 1964.

Minter, Adam. *Junkyard Planet: Travels in the Billon-Dollar Trash Trade*. New York: Bloomsbury, 2013.

———. *Secondhand: Travels in the New Global Garage Sale*. New York: Bloomsbury, 2019.

Mir Garcia, Jordi. "PAH, the Platform for People Affected by Mortgages: A Transformative and Poliethical Mobilization." In *Spain after the Indignados/15M Movement: The 99% Speaks Out*, edited by Óscar Pereira-Zazo and Steven L. Torres, 239–51. London: Palgrave Macmillan, 2019.

Molino, Sergio del. *La España vacía: viaje por un país que nunca fue*. Madrid: Turner, 2016.

Monedero, Juan Carlos. "15M and Indignant Democracy: Legitimation Problems within Neoliberal Capitalism." In *Spain after the Indignados/15M Movement: The 99% Speaks Out*, edited by Óscar Pereira-Zazo and Steven L. Torres, 21–63. London: Palgrave Macmillan, 2019.

Montero, Rosa. *La carne*. Madrid: Penguin Random House Debolsillo, 2017.

———. *La hija del caníbal*. Madrid: Espasa Bolsillo, 1999.

Morales, Rafael. *Obra poética completa 1943–1999*. Madrid: Calambur, 1999.

Moraña, Mabel, ed. *Ideologies of Hispanism*. Nashville, TN: Vanderbilt University Press, 2009.

Moreno-Caballud, Luis. *Cultures of Anyone: Studies on Cultural Democratization in the Spanish Neoliberal Crisis*. Translated by Linda Grabner. Liverpool: Liverpool University Press, 2015.

Moreno-Nuño, Carmen. *Haciendo memoria: Confluencias entre la historia, la cultura y la memoria de la Guerra Civil en la España del siglo XXI*. Madrid: Iberoamericana/Vervuert, 2019.

Moretti, Franco. "The Slaughterhouse of Literature." *MLQ: Modern Language Quarterly* 61, no. 1 (March 2000): 207–27.

Morrison, Susan Signe. *The Literature of Waste: Material Ecopoetics and Ethical Matter*. New York: Palgrave Macmillan, 2015.

Muñoz, José Esteban. *Cruising Utopia: The Then and There of Queer Futurity*. New York: NYU Press, 2009.

Nguyen, Viet Thanh. *The Refugees.* New York: Grove, 2017.

Nishime, LeiLani, and Kim D. Hester Williams. *Racial Ecologies.* Seattle: University of Washington Press, 2018.

Nofre i Mateo, Jordi. "Políticas culturales, transformaciones urbanas e higienización social en la Barcelona contemporánea." *Anales de Geografía* 30, no. 2 (2010): 133–61.

Offenhuber, Dietmar. *Waste Is Information: Infrastructure Legibility and Governance.* Cambridge, MA: MIT Press, 2017.

Offenhuber, Dietmar, and Carlo Ratti, eds. *Decoding the City: Urbanism in the Age of Big Data.* Basel: Birkhäuser, 2014.

Olsen, Bjørnar. *In Defense of Things: Archaeology and the Ontology of Objects.* Lanham, MD: AltaMira, 2010. ProQuest Ebook Central. http://ebookcentral.proquest.com /lib/uva/detail.action?docID=616256.

Olsen, Bjørnar, and Pora Pétursdóttir. *Ruin Memories: Materialities, Aesthetics and the Archaeology of the Recent Past.* New York: Routledge, 2014.

O'Neill, Kate. *Waste.* Cambridge: Polity, 2019.

Oppermann, Serpil. "Storied Seas and Living Metaphors in the Blue Humanities." *Configurations* 27, no. 4 (2019): 443–61.

Pardo, José Luis. *Nunca fue tan hermosa la basura: artículos y ensayos.* Barcelona: Galaxia Gutenberg, Círculo de Lectores, 2010.

Pardo Bazán, Emilia. *Los pazos de Ulloa.* Madrid: Alianza, 1993.

Pastor Verdú, Jaime. "Un balance crítico de la Transición política española." In *La Transición española: Nuevos enfoques para un viejo debate,* edited by Marie-Claude Chaput and Julio Pérez Serrano, 295–304. Madrid: Biblioteca Nueva, 2015.

Pereiro, Peregrina. *La novela española de los noventa: Alternativas éticas a la postmodernidad.* Madrid: Editorial Pliegos, 2002.

Pérez Andújar, Javier, and Joan Guerrero Luque. *Milagro en Barcelona: emigrantes hoy, porque emigrante soy.* Barcelona: Ariel, 2014.

Pérez-Carbonell, Marta, and Renee Congdon. "On Identity, or How Two Contemporary Spanish Novels Shape and Shake up the Limits of the Self." *Anales de literatura Española* 45 no. 1 (2020): 97–117.

Pérez Melgosa, Adrián. "The Ethics of Oblivion: Personal, National, and Cultural Memories in the Films of Pedro Almodóvar." In *A Companion to Pedro Almodóvar,* edited by Marvin D'Lugo and Kathleen Vernon, 176–99. Chichester: Wiley-Blackwell, 2013.

Pérez-Sánchez, Gema. *Queer Transitions in Contemporary Spanish Culture: From Franco to la movida.* Albany: State University of New York Press, 2007.

Plataforma de Afectados por la Hipoteca. *Libro verde de la PAH: una guía básica sobre la PAH.* Barcelona: Plataforma de Afectados por la Hipoteca, 2016.

Plotz, John. "Can the Sofa Speak? A Look at Thing Theory." *Criticism* 47, no. 1 (2005): 109–18.

Porter, James. *The Origins of Aesthetic Thought in Ancient Greece: Matter, Sensation, and Experience.* Cambridge: Cambridge University Press, 2010.

Postlewate, Marisa. "The Use of the Detective Story Framework as a [Pre]text for Self-Realization in *La hija del caníbal.*" *Letras Femeninas* 28, no. 1 (2002): 131–46.

Prádanos, Luis Iñaki. "Energy Humanities and Spanish Urban Cultural Studies: A Call

for a Radical Convergence." In *Environmental Cultural Studies Through Time: The Luso-His-panic World*, edited by Kata Beilin, Kathleen Conolly, and Micah McKay. *Hispanic Issues Online* 24 (2019): 27–45.

———. "Ecología y estudios culturales ibéricos en el siglo XXI." *Arizona Journal of Hispanic Cultural Studies* 23 (2020): 133–44.

———. *Postgrowth Imaginaries: New Ecologies and Counterhegemonic Culture in Post-2008 Spain*. Liverpool: Liverpool University Press, 2018.

Prado, Benjamín. *Mala gente que camina*. Madrid: Alfaguara, 2007.

———. "Yo, periodista en Malasaña." *El País*, May 3, 2007. https://elpais.com/diario /2007/05/03/madrid/1178191466_850215.html.

Rathje, William L, and Cullen Murphy. *Rubbish! The Archaeology of Garbage*. New York: HarperCollins, 1992.

Robbins, Jill. *Poetry and Crisis: Cultural Politics and Citizenship in the Wake of the Madrid Bombings*. Toronto: University of Toronto Press, 2020.

Rodríguez Campo, Lorena, José Antonio Fraiz Brea, and Diego Rodríguez-Toubes Muñiz. "Tourist Destination Image Formed by the Cinema: Barcelona Positioning through the Feature Film *Vicky Cristina Barcelona*." *European Journal of Tourism, Hospitality and Recreation* 2, no. 2 (2011): 137–54.

Rodríguez Fischer, Ana. "Una mezcla mareante." *Revista de Libros* 119, no. 6 (2006): 49.

Rogers, Heather. *Gone Tomorrow: The Hidden Life of Garbage*. New York: New Press, 2005.

Ronda, Margaret. *Remainders: American Poetry at Nature's End*. Stanford, CA: Stanford University Press, 2018.

Rosa, Isaac. *¡Otra maldita novela sobre la guerra civil!* Barcelona: Seix Barral, 2007.

Rosa, Isaac, and Cristina Bueno. *Aquí vivió: Historia de un desahucio*. Barcelona: Penguin Random House, 2016.

Royal Statistical Society, "2018 Statistics of the Year." http://www.rss.org.uk/RSS/Get _involved/Statistic_of_the_year/RSS/Get_involved/Statistic_of_the_Year_.aspx.

Royte, Elizabeth. *Garbage Land: On the Secret Trail of Trash*. New York: Back Bay, 2005.

Sabaté, Joaquín. "De la plaza de las Glorias al Forum. Luces y sombras en el proyecto del urbanístico reciente de Barcelona." *Cartas urbanas* 11 (2007): 26–49.

———. "Globalización y estrategias urbanísticas: un balance del desarrollo reciente de Barcelona." *Cuaderno Urbano* 7 (2008): 233–60.

———. *Luces y sombras en el proyecto urbanístico reciente de Barcelona en globalización y grandes proyectos urbanos*. Buenos Aires: Ediciones Infinito, 2006.

Saltzman, Megan. "Response: Searching for and Reactivating Agency in Trash and Non-Space." *Arizona Journal of Hispanic Cultural Studies* 23 (2019): 167–74.

Sánchez León, Pablo. "El ciudadano, el historiador y la democratización del conocimiento del pasado." In *El fin de los historiadores: pensar históricamente el siglo XXI*, edited by Sánchez León and Jesús Izquierdo Martín, 115–51. Madrid: Siglo XXI, 2008.

———. "Encerrados con un solo juguete: Cultura de clase media y metahistoria de la transición." In "Lo llamaban Transición," special issue, *Mombaça* 8 (2010): 11–17.

Sánchez Noriega, José Luis. *Universo Almodóvar: Estética de la pasión en un cineasta posmoderno*. Madrid: Alianza, 2017.

Scanlan, John. *On Garbage*. London: Reaktion, 2005.

Scanlan, John, and John F. M. Clark, eds. *Aesthetic Fatigue: Modernity and the Language of Waste*. Newcastle upon Tyne: Cambridge Scholars Publishing, 2013.

Scarry, Elaine. *The Body in Pain: The Making and Unmaking of the World*. New York: Oxford University Press, 1985.

Schulz-Dornburg, Julia. *Ruinas modernas: Una topografía de lucro*. Barcelona: Àmbit, 2012.

Serres, Michel. *Malfeasance: Appropriation through Pollution?* Translated by Anne-Marie Feenberg-Dibon. Stanford, CA: Stanford University Press, 2011.

Seymour, Nicole. *Bad Environmentalism: Irony and Irreverence in the Ecological Age*. Minneapolis: University of Minnesota Press, 2018.

Shanks, Michael. *Experiencing the Past: On the Character of Archaeology*. London: Routledge, 1992.

Shubert, Adrian. *A Social History of Modern Spain*. London: Routledge, 2003.

Smith, Paul Julian. *Desire Unlimited: The Cinema of Pedro Almodóvar*. Verso, 1994.

———. "Oxford Hispanic Studies." In *Gender and Modernization in the Spanish Realist Novel*, edited by Jo Labanyi, v. Oxford: Oxford University Press, 2000.

———. "Reading Almodóvar through TV Studies." *Hispanic Research Journal* 7, no. 2 (2006): 157–62.

———. "Resurrecting the Art Movie? Almodóvar's Blue Period." In *Contemporary Spanish Culture: TV, Fashion, Art and Film*, edited by Smith, 144–68. Cambridge: Polity, 2003.

Smith, Sidonie A. "Material Selves: Bodies, Memory, and Autobiographical Narrating." In *Narrative and Consciousness: Literature, Psychology, and the Brain*, edited by Gary D. Fireman, Ted E. McVay Jr., and Owen J. Flanagan, 86–111. Oxford: Oxford University Press, 2003.

Soldevila Durante, Ignacio, and Javier Lluch Prats. "Novela histórica y responsabilidad social del escritor: El camino trazado por Benjamín Prado en *Mala gente que camina*." *Olivar* 8 (2006): 33–44.

Soufas, C. Christopher. *The Subject in Question: Early Contemporary Spanish Literature and Modernism*. Washington, DC: Catholic University Press, 2007.

Stam, Robert. "Specificities: From Hybridity to the Aesthetics of Garbage." *Social Identities* 3, no. 2 (1997): 275–90.

Stapell, Hamilton M. *Remaking Madrid: Culture, Politics, and Identity after Franco*. New York: Palgrave Macmillan, 2010.

Stewart, Susan. "What Praise Poems Are For." *PMLA* 120, no. 1 (2005): 235–45.

Stouffer, Lloyd. "Plastics Packaging: Today and Tomorrow." National Plastics Conference, November 19–21, 1963, Section 6-A, 1–3.

Strasser, Susan. *Waste and Want: A Social History of Trash*. New York: Henry Holt, 1999.

Straw, Will. "Exhausted Commodities: The Material Culture of Music." *Canadian Journal of Communications* 25, no. 1 (2000). https://www.cjc-online.ca/index.php/journal/article/view/1148/1067.

Szasz, Andrew. *Shopping Our Way to Safety: How We Changed from Protecting the Environment to Protecting Ourselves*. Minneapolis: University of Minnesota Press, 2007.

Sze, Arthur. *Sight Lines*. Port Townsend, WA: Copper Canyon, 2019.

Tatjer, Mercè. "El patrimonio industrial de Barcelona entre la destrucción y la conservación, 1999–2008." *Scripta Nova: Revista electrónica de geografía y ciencias sociales* 12, no. 270 (August 2008): 140. http://www.ub.edu/geocrit/sn/sn-270/sn-270-140.htm.

Terdiman, Richard. *Present Past: Modernity and the Memory Crisis*. Ithaca, NY: Cornell University Press, 1993.

Thill, Brian. *Waste (Object Lessons)*. New York: Bloomsbury, 2015.

Thompson, Michael. *Rubbish Theory: The Creation and Destruction of Value*. Oxford: Oxford University Press, 1979.

Tolentino, Jia. *Trick Mirror: Reflections on Self Delusion*. New York: Random House, 2019.

Tudela, Ana, and Antonio Delgado. *Playa burbuja: Un viaje al reino de los señores del ladrillo*. Madrid: Datadista, 2018.

Turkle, Sherry. "Introduction: The Things that Matter." *Evocative Objects: The Things We Think With*. Edited by Turkle, 3–10. Cambridge, MA: MIT Press, 2007.

Urios-Aparisi, Eduardo. *Puro teatro: Metáfora y espacio en el cine de Pedro Almodóvar*. Madrid: Libertarias, 2010.

Urry, John. *The Tourist Gaze*. London: Sage, 2002.

Valis, Noël. *The Culture of Cursilería: Bad Taste, Kitsch, and Class in Modern Spain*. Durham, NC: Duke University Press, 2002.

Vergine, Lea. *When Trash Becomes Art: Trash, Rubbish, Mongo*. Milan: Skira, 2007.

Vernon, Kathleen. "Melodrama Against Itself: Pedro Almodóvar's *What Have I Done to Deserve This?*" *Film Quarterly* 46, no. 3 (Spring 1993): 28–40.

———. "Queer Sound: Musical Otherness in Three Films by Pedro Almodóvar." In *All about Almodóvar: A Passion for Cinema*, edited by Brad Epps and Despina Kakoudaki, 51–70. Minneapolis: University of Minnesota Press, 2009.

Vidal-Beneyto, José. *Memoria democrática*. Tres Cantos: Foca, 2007.

Vilarós, Teresa M. *El mono del desencanto: Una crítica cultural de la transición española (1973–1993)*. Mexico City: Siglo XXI, 1998.

Vilaseca, Stephen. *Barcelonan Okupas: Squatter Power!* Madison, NJ: Fairleigh Dickinson University Press, 2013.

Villarta, Ángeles. *Mi vida en la basura*. Madrid: El Grifón, 1955.

Vincent, Bernadette Bensaude. "Plastics, Materials and Dreams of Dematerialization." In *Accumulation: The Material Politics of Plastic*, edited by J. Gabrys, G. Hawkins, and M. Michael, 17–29. London: Routledge, 2013.

Viney, William. "Ruins of the Future." In *Aesthetic Fatigue: Modernity and the Language of Waste*, edited by John Scanlan and John F. M. Clark, 138–58. Newcastle upon Tyne: Cambridge Scholars Publishing, 2013.

Vinyes, Ricard, Montse Armengou, and Ricard Belis. *Els nens perduts del franquisme*. Barcelona: Proa, 2002.

Waugh, Patricia. *Metafiction: The Theory and Practice of Self-Conscious Fiction*. London: Methuen, 1984.

Whiteley, Gillian. *Junk: Art and the Politics of Trash*. London: I. B. Tauris, 2011.

Whitman, Wende. "Inside the Science of Testing Wastewater at UVA for Evidence

of COVID-19." *UVA Today.* October 9, 2020. https://news.virginia.edu/content/inside-science-testing-wastewater-uva-evidence-covid-19.

Williams, William Carlos. *Paterson.* Middlesex: Penguin, 1983. https://archive.org/stream/PatersonWCW/Paterson-William_Carlos_Williams_djvu.txt.

Winkiel, Laura. "Introduction. Hydro-criticism." *English Language Notes* 57, no. 1 (April 2019): 1–10.

Wolfe, Cary. *Ecological Poetics; or, Wallace Stevens's Birds.* Chicago: University of Chicago Press, 2020.

Wood, Robin. "Ideology, Genre, Auteur." In *Film Theory and Criticism: Introductory Readings,* 7th ed., edited by Leo Braudy and Marshall Cohen, 592–601. New York: Oxford University Press, 2009.

Yaeger, Patricia. "Editor's Column: The Death of Nature and the Apotheosis of Trash; or, Rubbish Ecology." *PMLA* 123, no. 2 (March 2008): 321–39.

Yarza, Alejandro. *Un caníbal en Madrid: La sensibilidad camp y el reciclaje de la historia en el cine de Pedro Almodóvar.* Madrid: Libertarias, 1999.

Žižek, Slavoj. "Multiculturalism, or, the Cultural Logic of Multinational Capitalism." *New Left Review* 225 (1997): 28–51.

———. *The Ticklish Subject: The Absent Center of Political Ontology.* London: Verso, 2009.

Zubiaurre, Maite. *Talking Trash: Cultural Uses of Waste.* Nashville: Vanderbilt University Press, 2019.

Index

Recent books in the series
UNDER THE SIGN OF NATURE: EXPLORATIONS IN ECOCRITICISM